D1124654

THE TROUBLE WITH BEAUTY

THE TROUBLE WITH BEAUTY

WENDY STEINER

WILLIAM HEINEMANN : LONDON

First published in the United Kingdom in 2001 by William Heinemann

1 3 5 7 9 10 8 6 4 2

Copyright © Wendy Steiner 2001
Wendy Steiner has asserted her right under the Copyright, Designs and Patents Act, 1988
to be identified as the author of this work

This book is sold subject to the condition that it shall not, by way of trade or otherwise,
be lent, resold, hired out, or otherwise circulated without the publisher's prior consent in
any form of binding or cover than that in which it is published and without a similar
condition including this condition being imposed on the subsequent purchaser

William Heinemann
The Random House Group Limited
20 Vauxhall Bridge Road, London SW1V 2SA

Random House Australia (Pty) Limited
20 Alfred Street, Milsons Point, Sydney,
New South Wales 2061, Australia

Random House New Zealand Limited
18 Poland Road, Glenfield
Auckland 10, New Zealand

Random House South Africa (Pty) Limited
Endulini, 5a Jubilee Road,
Parktown, 2193, South Africa

The Random House Group Limited Reg. No. 954009

www.randomhouse.co.uk

A CIP catalogue record for this book is available from the British Library

Papers used by Random House are natural, recyclable products made from wood grown
in sustainable forests. The manufacturing processes conform to the environmental
regulations of the country of origin

Typeset by SX Composing DTP, Rayleigh, Essex
Printed and bound in the United Kingdom by
Mackays of Chatham PLC, Chatham, Kent

ISBN 0 4340 0735 8

The author and publisher have made all reasonable efforts to contact copyright holders for
permission, and apologise for any omissions or errors in the form of credits given. Corrections may
be made to future printings.

To Emma and Emil

CONTENTS

LIST OF ILLUSTRATIONS

ACKNOWLEDGEMENTS

This book owes both long- and short-term debts, so many, in fact, that it seems best simply to list the generous people who have educated and inspired me: Bill Beckley, Sacvan Bercovitch, Ellen M. Berman, Homi Bhabha, Stanley Cavell, Peter Conn, Margreta de Grazia, Helen Drutt English, Heinz Ickstatt, John Kindness, Mark Liberman, Maria Rosa Menocal, Elisa New, Erin O'Connor, John Ollmann, Kathy Panama, Bob Perelman, Peter Stallybrass, John Sturrock, Judith Tannenbaum, Alan Thomas, Stephen Urice, Mary-Kay Wilmers. I am especially grateful to Susan Stewart and Jean-Michel Rabaté, who took the time to read through the manuscript in an early stage and offer helpful suggestions, and to John Heon, who assisted with data searches and good humour. I have learned much from the audiences of my lectures at various institutions, most recently Amerikahaus in Munich, Cranbrook College of Art, the Museum of Modern Art, Southern Methodist University, Davidson College, and Stanford. I am fortunate in my agents, Gill Coleridge and Kris Dahl, and my editors, Chad Conway, Liz Maguire and Ravi Mirchandani, who posed questions that led me to rethink many issues. My colleagues in the English Department and the Comparative Literature Program at the University of Pennsylvania are as stimulating and admirable a group as I could wish, and I gratefully acknowledge the support of Penn and the Richard L. Fisher Chair. To my children, Emma and Emil, I owe the pleasure of belonging.

Philadelphia, 2000

We are products of the past and we live immersed in the past, which encompasses us. How can we move towards the new life, how create new activities without getting out of the past and without placing ourselves above it? And how can we place ourselves above the past if we are in it and it is in us? There is no other way out except through thought, which does not break off relations with the past but rises ideally above it and converts it into knowledge.

– Benedetto Croce, 1938

PROEM:
PSYCHE'S PLEASURE

We have no sympathy but what is propagated by pleasure.

— William Wordsworth, 1800

One does not see anything until one sees its beauty.

— Oscar Wilde, 1889

A culture's work is never done. Like a troubled psyche working through dimly perceived distress, the artists and thinkers of an age churn out dreams and visions, theories and pronouncements, constantly processing a 'world' which their efforts help bring into being in the first place. Little wonder that we long to grasp their meaning, since our identity is so entangled in their struggle. For viewers and readers, there is always more at stake in art than books and pictures and symphonies: the world we inhabit, our being in it.

Yet never have artists exacted a higher price for our understanding than during the twentieth century. In modernism, the perennial rewards of aesthetic experience – pleasure, insight, empathy – were largely withheld, and its generous aim, beauty, was abandoned. Modern artworks may often have been profoundly beautiful, but theirs was a tough beauty, hedged with deprivation, denial, revolt. 'Contemporary aesthetics has established the beauty of ugliness,' Mario Vargas Llosa tells us, 'reclaiming for art everything in human experience that artistic representation had previously rejected.'[1]

It was in this century, too, that feminists confronted the 'beauty

myth' and rejected the 'temptation to be a beautiful object'. 'Beauty creates shame,'[2] says the performance artist Vanessa Beecroft, and Howard Barker's artist-heroine in *Scenes from an Execution* declares: 'I tell you I would not, I do not trust beauty, it is an invention and a lie, trust my face, I am a woman who has lived a little.'[3] As we shall see, no one is in a better position to speak about the modern trouble with beauty than a female artist who has lived a little.

But think what changes Barker's line reveals. Before modernism, few women could speak publicly about how it felt to be an artist, a person concerned with beauty, a woman who had lived a little. There were not many female visual artists, period, if the official history is to be believed. And yet, female subjects were everywhere to be found in the arts. In the nineteenth century, in fact, they symbolized artistic beauty as such. The twentieth-century avant-garde, by contrast, could barely bring itself to utter 'woman' and 'beauty' in the same breath.

My first inkling of this shift came some years ago when I was on vacation in Paris. I went one morning to the Musée d'Orsay, a predominantly nineteenth-century collection. It was full of paintings with female subjects – feminine pulchritude in a thousand guises – as if 'paintings' and 'paintings of women' were more or less synonymous, and both, a celebration of beauty. In the afternoon, I visited the Centre Pompidou, a twentieth-century collection. There, the morning's beauties were nowhere in evidence. True, some paintings had subjects that could be construed as female, but their femininity, beauty, and indeed 'subjecthood' were swamped by other factors. The contrast with the morning was puzzling. What could it mean that through much of the nineteenth century, artists routinely depicted female beauty 'offered in isolation, as an end in itself',[4] whereas during modernism and after, the female subject was either absent or incidental in art?

A cover of *The New Yorker* by Russell Connor **[Pl.1]** pokes fun at this discrepancy. Here, female subjects from the two centuries confront each other in a cheval glass without the slightest mutual recognition. On one side, inverted left-to-right like a proper reflection, stands John Singer Sargent's nineteenth-century *femme fatale, Madame X.* What she

'reflects' is one of Picasso's Cubist 'wives' stationed before the mirror – a fabrication whose allure lies in its wit and formal virtuosity rather than in its evocation of female beauty. This modernist subject looks in the glass – or she would if her eyes could focus – at the elegant figure she once was. It is hard to gauge her reaction – something like perplexity, or perhaps a stubborn obliviousness to that other woman. More likely, she does not believe in art as mirroring. 'Who's the fairest of them all?' 'You must be kidding,' she replies, shrugging her space relations.

Clearly, the nineteenth and twentieth centuries do not reflect each other faithfully when it comes to the meaning of women in art – and just as clearly, when it comes to the meaning of beauty. For I found myself making this leap almost instantly, reading the turn from the female subject as a turn from beauty as such, or at least from a long-standing idea of beauty.[5] This move has reverberated through every aspect of modern life, affecting our understanding of communication, domesticity, gender relations, pleasure, love.

Trained by modernists and their heirs, contemporary experts and artists have been slow to recognize this all-pervasive 'trouble with beauty' and the psychic havoc it has wrought. But now, suddenly, we seem to be making up for lost time. Newspapers have become as lively a forum for aesthetic debate as the average humanities classroom. Major museums are mounting exhibitions of work that only a few decades ago was considered far too pretty or sensuous or complacent to have been taken seriously: the paintings of Gustave Moreau, Alphonse Mucha, Pierre Bonnard, Remedios Varo, Maxfield Parrish, Norman Rockwell; Victorian fairy painting, Pre-Raphaelite portraits, pin-up art, couturier design. Such novelists as Penelope Fitzgerald, Andrei Makine, Philip Roth and John Cunningham are pointing us back towards beauty as if it were the most compelling problem for anyone trying to make sense of twenty-first century existence, and scholarly conferences and monographs shuffle beauty through the deck of contemporary cruxes: beauty and race, beauty and justice, beauty and evolutionary psychology. Invoking beauty has become a way of registering the end of modernism and the opening of a new period in culture. In 1999, the

Hirshhorn Museum marked its twenty-fifth anniversary with an exhibition entitled 'Regarding Beauty: A View of the Late Twentieth Century', and France's official celebration of the millennium turned Avignon into a giant viewing space for 'La Beauté'.

Beauty is certainly a magnet for the cultural anxieties of our day: the readjustment of gender roles that has been in the works since the Enlightenment, the commodification of the body in consumer culture, the genetic and evolutionary discoveries changing our understanding of human nature. In the eyes of the geneticist, for example, female beauty is a competitive packaging that increases a woman's chances of perpetuating her genes; for the beauty industry, this packaging perpetuates multinational profits. One way or the other, female freedom and self-realization would seem to require resistance to such an aesthetics. But eschewing beauty comes at a high price if it closes off passion and procreation and self-understanding. For many women, beauty appears to set freedom and pleasure at odds.

Indeed, this is true for men as well. The Enlightenment may have celebrated beauty as an experience of freedom from contingency, but in our day beauty seems anything but a liberation – bearing witness, instead, to our socialization or biology. Are we *taught* to identify certain traits – in people, nature, art – as beautiful, or do we come into the world wired to admire? If the response to beauty is learned, then how should we react to the fact of this acculturation? Beauty in a multi-ethnic society, for example, would seem suspect unless every race can lay equal claim to being beautiful, and that is still far from the case in many countries. But perhaps, on the contrary, our aesthetic socialization is a good thing, every touch with beauty amounting to an all too rare experience of community and shared values.

Biological determinism leads to equally contradictory conclusions. If evolution has hard-wired humans for beauty, we are victims – or happy heirs – of our biology. The turn away from beauty in twentieth-century art, in such a case, has been alienating us from our deepest nature. Thus, Nancy Etcoff argues in *The Survival of the Prettiest* that a particular ratio between female waist and hip measurements universally evokes a

positive male response, which she identifies as aesthetic. Equally essentialist, a fictive music theorist in Ian McEwan's novel *Amsterdam* declares: 'we were born into an inheritance, we were *Homo musicus*, defining beauty in music must therefore entail a definition of human nature.'[6] In short, it is unclear at the moment whether we should embrace beauty or hold it at bay, or more to the point, whether we have any choice in the matter.

Among the myriad issues surrounding beauty, the particular concern of this book is the female subject, so long its primary symbol in art. Avant-garde modernists were often repulsed by this symbolism. Indeed, the history of twentieth-century élite art is in many respects a history of resistance to the female subject as a symbol of beauty. This resistance, in its turn, is related to real-world struggles during the past century – the past two centuries, in fact – as society learned (and continues to learn) to consider women fully human.

In general, the avant-garde stood contemptuously aloof from this struggle, disdainful of woman in either her traditional or emerging meanings. Modernists vilified aesthetic pleasure, defining the sublime aspirations of art as unrelated or antipathetic to the pleasures of feminine allure, charm, comfort. At the same time, they treated the 'new woman' and the goal of female self-realization as equally irrelevant to the laboratory of the modern. Though we might deplore their failure to inspirit women during this crucial period of history, the avant-garde inadvertently aided the women's movement in treating 'the weaker sex' with so little sympathy. Their motives, of course, were utterly different: modernist misogyny is something to behold! Nevertheless, their violent break from an aesthetics of passive allure now frees us, paradoxically, to contemplate new possibilities in beauty and its female symbolism. For both feminist and modernist reasons, it is impossible to return to the old stereotypes of woman in the arts. The task that awaits us is nothing less than the reimagination of the female subject as an equal partner in aesthetic pleasure.[7]

This reconsideration requires a new myth. In age-old fables about female beauty, the fair maiden creates hierarchy and competition: all

men want to possess her, and other women are so jealous of her superior rank that they try to undermine her. 'Beauty' or 'Belle' wins out in the end, her triumph reaffirming the inequality that was the problem in the first place. Modernists had nothing but contempt for this myth, which they considered an absurd overvaluation of women, and feminists excoriated it for reinforcing inequality, divisiveness, and patriarchal values. Moreover, the extraordinary forces that such stories mobilized in aid of threatened heroines – superhuman magic, male heroism, royal power – have been keeping a low profile of late. By the twentieth century, many factors were contributing to the end of the 'Belle Epoque'.

Another beauty myth arose to express this change, a story in which good looks actually destroy good women. Rather than triumphing over adversity, heroines frequently die in modernist fiction, symbols of the passing of the romance era in which they held such central value. Beauty in this new myth is victimization. As the century wore on, medicine and psychiatry reinforced the view that beauty is dangerous to women, exacting a huge price on female health, self-confidence, and sisterly empathy. Far from a God-given virtue, beauty now appears an impossible ideal set by voracious financial and sexual interests. Even women who survive this oppression do not emerge unscathed. Naomi Wolf, for example, tells of her bouts with anorexia and low self-image in the best-selling *The Beauty Myth*, but puts her attractive image on the cover. As a result, her story of victimization by men and the media ends up looking a lot like self-advertising. Women cannot win as long as beauty is seen as exclusive and controlling, regardless of whether they exert this power themselves or others exert it upon them. The problem is how to imagine female beauty, in art or outside it, without invoking stories of dominance, victimization, and false consciousness.

For a start, I think, we must stop treating beauty as a thing or quality, and see it instead as a kind of communication. We often speak as if beauty were a property of objects: some people or artworks 'have' it and some do not. But *pace* Kant and Burke, the judgement of beauty in a person or artwork varies enormously from one person to the next, and

in the course of time, even within the same person. These shifts and differences are meaningful and valid, and not 'fallings away' from some 'truth' or 'higher taste'. Beauty is an unstable property because it is not a property at all. It is the name of a particular interaction between two beings, a 'self' and an 'Other': 'I find an Other beautiful'. This act of discovery, we shall see, has profound implications.

It might appear that some form of inequality is already invoked here, before we have gone beyond the first step in our discussion. The 'self' judging the beauty of art, for example, is a perceiver and hence a conscious subject, whereas the 'Other' is merely the object of this perception. If the Other is an artwork, it is inanimate by definition, and many people would argue that the perception of a woman (or man or child) *as beautiful* reduces her to the status of a thing. Indeed, in the perennial symbolism surrounding beauty, the perceiver (the self) is active and 'hence' male, and the artwork or woman (the Other) is passive (to-be-seen) and 'therefore' female.

However, dominant as the perceiver may appear in the act of judgement, the aesthetic object turns out to be no shrinking violet. In the course of aesthetic experience, the perceiver may be overwhelmed by this 'mere object', overcome with emotion, altered to the very roots of his being. 'You are my creator,' says Dr Frankenstein's monster, 'but I am your master; obey!'[8] The experience of beauty involves an exchange of power, and as such, it is often disorienting, a mix of humility and exaltation, subjugation and liberation, awe and mystified pleasure. Even if we invoke the traditional model of a self gendered 'male' and an artwork gendered 'female', they would resemble Shakespeare's Benedick and Beatrice, with Beatrice giving out as good as she got. However, many people, fearing a pleasure they cannot control, have vilified beauty as a siren or a whore. Since at one time or another, though, everyone answers to 'her' call, it would be well if we could recognize the meaning of our succumbing as a valuable response, an opportunity for self-revelation rather than a defeat.

Unfortunately, modernism has trained us against such an understanding. The avant-garde operated with a one-way model of

power, attempting to limit the artwork to the status of a thing – a form, a machine, an ethnographic fetish, the merest hint of an idea, a nought. The perceiver, perplexed and ungratified by such a work, had no choice but to see the artist as the real centre of attention. A wizard hiding behind the curtain perhaps, the artist was the prime and only 'mover'. If perceivers experienced any pleasure or transport in contemplating such cerebral, alienating works, they could credit the artist's genius, or perhaps his uncompromising honesty in presenting this minimal pleasure as all that modern life could afford. So much for pleasured beauty!

In this way, twentieth-century modernism perpetrated a cultural deprivation from which we are only now recovering. It involved a double dehumanization: art reduced to thing; audience reduced to thing – the caricature of the bourgeois philistine incapable of appreciating beauty. Our emergence from these avant-garde assumptions reflects much more, however, than a renewed desire for the gratification of beauty. It entails a flexibility and empathy towards 'Others' in general and the capacity to see ourselves as both active and passive without fearing that we will be diminished in the process.

In the hope of contributing to this process, I would offer a twenty-first-century myth of beauty, freely adapted from the Hellenistic past: the story of Psyche and Cupid.[9] In this tale, the mortal Psyche (the Soul) is married to the divine Cupid (Love), but does not know his identity or even what he looks like. He visits her only in darkness and disappears with the dawn. Psyche's sisters, however, jealous of the riches he has showered upon her, claim that he must be a monster and urge her to investigate. So one night, Psyche lights a candle and gazes on her sleeping husband. She finds the opposite of a monster and is so overcome with his beauty that her hand trembles and a drop of burning wax falls on the god's still form, awakening him. Seeing her disobedient, unworthy gaze (she is awed, burning), Cupid deserts her, flying up towards the heavens. Psyche grabs on to his leg and is carried up briefly, but she soon falls to earth, for she is a mere mortal. Yearning to be reunited with Cupid's heavenly beauty, she performs a series of

superhuman tasks that earn her immortality. She then dwells in heaven as Cupid's equal, and the offspring of their union is a divine child, Pleasure.

This myth is a little allegory of aesthetic pleasure, as the soul, moved by beauty, becomes worthy of love and its delights. It might be seen as a friendly amendment to romanticism as well. Exactly two hundred years ago, William Wordsworth wrote, 'We have no sympathy but what is propagated by pleasure.'[10] The Psyche myth rewrites that maxim: we have no *pleasure* but what is propagated by *sympathy*. Sympathy is the product of the interaction that we call beauty, an interaction in which both parties become aligned in value and, in the process, become in some sense equal. Given the differences among the gods and monsters and mere mortals who are parties to the experience of art, this equality is a signal achievement.

Value is thus always central to the meaning of beauty. We often say that something or someone is beautiful, in fact, when what we mean is that they have value *for us*. Parents find their infants inexpressibly beautiful for this reason – because so much of what they care about is focused in this tiny creature. Even when we use the term in a purely artistic context, a beautiful object is something we value, and we value it because it touches our dearest concerns. In our gratitude towards what moves us so, we attribute to it the *property* of beauty, but what we are actually experiencing is a special *relation* between it and ourselves. We discover it as valuable, meaningful, pleasurable *to us*. In this interchange, the one found beautiful is honoured with a wondrous gift – the attribute of beauty – in a compliment stirring in proportion to the judge's sympathetic refinement.

This attribution, though, is only the beginning of the experience of beauty. Psyche discovers Cupid's beauty as a thrilling, overpowering force that is at the same time unavailable to her. Beauty may provoke awe, admiration, and fear, but much more valuable are the insight, understanding and empathy to which it may lead. Just as Psyche earns her right to Pleasure by surpassing her previous limits, finding something or someone beautiful entails becoming worthy of it – in

effect, becoming beautiful, too – and recognizing oneself as such. The experience of beauty involves a challenge to achieve the value or beauty of the Other. This elevation requires effort – interpretation, openness – but once achieved, however fleetingly or vicariously, the result is a pleasure different in kind from normal experience.

Thus, the judgement of beauty is not a one-way street. One discovers a valuable Other, and rises to recognize oneself in it. In doing so, one 'participates' in beauty. This gratifying self-expansion produces profound generosity towards the beautiful Other in the form of compliment, infatuation, love, critical rave. The person or artwork claims nothing, but receives all; the lover or critic is validated, but credits the Other. This is a win-win situation if ever there was one, and occasions great pleasure. It also occasions utter confusion as to the direction of agency involved, for the object or person who can elicit the perceiver's pleasure through its passivity does not seem passive at all. The 'power of beauty' is a mystification of the perceiver's magnanimity, but how grateful we are to a force that can show us ourselves so great in spirit.

None of this pleasurable and complex reciprocity occurs in the experience of the Kantian sublime, which was the aesthetic model for high modernism. In the sublime, as we shall see, aesthetic experience is specifically the *non*-recognition of the self in the Other, for the Other is inhuman, chaotic, annihilating. Awe, admiration, and fear are the cardinal emotions of the sublime, seen as ends in themselves or else proof of the perceiver's heroic ability to persist amid such forces. Here, the Soul does not even try to hold on to the god in his upward flight, for it knows it is not his equal. Its value lies in its ability to grasp the immensity of this gap, leaving the Other untouched and unrecognized except as Other. The self in this interchange may be sublimely unfettered, but it is also unfastened, unconnected to the object of its awe.

Compared to this thrilling detachment, sometimes called 'freedom', the experience of beauty appeared to modern artists to involve unreasonable and constricting demands: solicitations for admiration,

involvement, reciprocity, empathy. So did the main symbol of such beauty, the female subject. The avant-garde were utterly hostile towards the 'feminine aesthetics' of charm, sentiment, and melodramatic excess, which they associated with female and bourgeois philistinism. Their lack of sympathy with the Other rendered the experience of artistic (and often human) beauty an experience of alienation. 'April is the cruellest month' in the twentieth century.

At the same time that the avant-garde declared its contempt for the 'soft aesthetics' of the past, feminists were campaigning against a view of woman as passive and inferior. In such a climate, the female subject was too symbolically fraught to initiate anything like the generous mutuality achieved through Psyche's experience of beauty. This is a pity, not because we should want to return to the unliberated days before feminism, but because the mutuality implied in the female analogy is an immensely valuable possibility in art. So was the train of thought about art and women that modernism suspended. The entailment of beauty and woman will not go away simply by avant-garde or feminist fiat. And neither can artists proceed much longer ignoring their audience's desire for pleasure. The time has come for a change, and the sudden, widespread fascination with beauty in our day indicates a cultural readiness to move on.

It is the task of contemporary art and criticism to imagine beauty as an experience of empathy and equality. If we can discover the bonds between value and mutuality forged in aesthetic response, the female subject of art (and ultimately the male subject, too) will be available once again to symbolize a beauty that moves us to pleasure. And that pleasure will be seen as life-enhancing rather than exclusive or oppressive. This book is meant as an incitement to that discovery. It tells a history of the twentieth-century trouble with beauty in order to help extricate us from that trouble – a tenuous strategy to be sure, but the only one at hand. 'And how can we place ourselves above the past if we are in it and it is in us?' asked the historian Benedetto Croce more than half a century ago. 'There is no other way out except through thought, which does not break off relations with the past but rises ideally above

it and converts it into knowledge.'[11] I offer this story of beauty, then, in the hope that knowledge of the past will allow us to imagine a more pleasurable aesthetic future.

THE MONSTER SUBLIME

For the creator himself to be the child new-born he must also be
willing to be the mother and endure the mother's pain.

— Friedrich Nietzsche, 1895

Man owes it to his incongruously developed reason that he is
grotesque and ugly. He has broken away from nature. He thinks
that he dominates nature. He thinks he is the measure of all
things. Engendering in opposition to the laws of nature, man
creates monstrosities.

— Hans Arp, 1948

In the twentieth century, the avant-garde declared a clean break with
history, but their hostility to the female subject and the beauty she
symbolized had deep roots in the past. It arose from the Enlightenment
notion of the sublime and from a disgust towards women and the
bourgeoisie that had been building throughout the nineteenth century
among increasingly disaffected artists and writers. During the very
period, in fact, when the female subject was the predominant symbol of
beauty in all the arts, an ideology was taking shape that would displace
her entirely, and that ideology became the basis of the twentieth-
century avant-garde.

Though few modernist artists were trained in systematic philosophy,
like most people they were influenced by 'leading ideas', and the
Enlightenment had flooded the western imagination with ideas about

art. This was the period when philosophical aesthetics came into being, most notably through the writings of Immanuel Kant. Kant taught that when we judge something beautiful, we do so as beings standing outside the contingencies of flesh-and-blood existence, freed of individual interest, become ideal, pure, almost godlike in our consciousness. The experience of beauty provides a taste of transcendent freedom from the human condition, and the avant-garde were strongly drawn to it in their Promethean striving.

However, women, according to the popular prejudice of the day, were unsuited to such transcendence. As what Madonna would later call 'material girls', they were incapable of enjoying it or inspiring it, too frivolous and physical for aesthetic elevation. Though sometimes possessed of beauty, they used it for gain rather than as an end in itself, employing their attractions to acquire the respectability, financial support, and children that came with marriage. In this respect, they were just like the rising bourgeois classes, always turning value into profit. And the product women sold was often as shoddy as the bourgeois's, degenerating into domestic anomie or vampiric parasitism as soon as the deal was struck. The avant-garde conclusion was clear: woman and bourgeois alike were Mammon, enemies of transcendent, liberating art.

The avant-garde portrayed their resistance to philistines – women, the middle classes – as a heroic martyrdom, and they were so convincing in this role that it is hard even today not to believe in and respect their self-sacrifice. Like Socratic gadflies or Shakespearian fools, avant-garde artists told a truth that undermined the pious hypocrisies of conventional existence. They suffered (or embraced) ostracism for their pains, but that isolation from everyday life was, after all, what aesthetic experience was in fact all about. The artist *lived* art in his counter-cultural alienation. What could be nobler?

If we have trouble finding fault with this stance or imagining any other for the serious artist, we might remind ourselves that in the early nineteenth century, producing art was not yet synonymous with experiencing alienation from the values of one's society. A nineteen-

year-old woman of the day took one look at Kantian aesthetics, however, and saw that it would lead in just that direction. Horrified, she registered her concern in a novel that still terrifies us, though for other reasons: *Frankenstein: or, The Modern Prometheus*. Mary Shelley prophesied the modernist trouble with beauty with astonishing percipience.[1] Her misguided scientist is a Kantian artist and the inevitable product of his dehumanizing creativity is a monster disjoined from any possibility of love, beauty, or connection to everyday existence. The scientist's 'art' destroys what we value in life.

Mary Shelley had read closely in Madame de Staël's multi-volumed study, *De L'Allemagne*, 'the importance of which to *Frankenstein* has not so far been recognized'.[2] There she would have found an admiring assessment of Kant as the greatest force in German thought of his own and the following generation. She would have discovered that the philosopher did not venture into the realm of passion, but remained solitary throughout his life, and that his dry, didactic reasoning was meant to oppose the philosophizing of dreamers, with whom he had no patience. His overarching aim, de Staël wrote, was to overcome the effects of materialist philosophy, which had reduced the beautiful to the agreeable, thereby locking it within the realm of sensations where it was subject to the accidents of individual differences. Instead, the beautiful must belong to the ideal, universal sphere.

Madame de Staël also provided an account of the Kantian sublime, an experience of beauty as superhuman chaos and might. In the sublime, 'the power of destiny and the immensity of nature are in infinite contrast to the miserable dependence of the earthly creature; but a spark of sacred fire in our breast triumphs over the universe . . . The first sublime effect is to crush man; the second, to raise him up again.'[3] Mary Shelley seems to have had her doubts as to whether 'a creature of the earth' could ever recover from such an overwhelming and inhuman beauty, and indeed, whether beauty that required the transcendence or annihilation of everyday reality was not, instead, monstrous. Her critique of Kantian aesthetics has given us one of the most haunting myths of alienation since Genesis.

Though she was only nineteen when she wrote *Frankenstein*, Mary Shelley had packed more experience of life and ideas into those years than most people do in a lifetime. Her mother, Mary Wollstonecraft, who had written *A Vindication of the Rights of Woman*, died just days after her birth, leaving a daughter bereft of maternal love, like the monster the girl was to imagine. With only treatises on women's rights to mother her, Mary Shelley grew amid the radical social reformism of her famous father, William Godwin, whose friends were the leading literary and political figures of the day. Coleridge recited 'The Rime of the Ancient Mariner' in their living-room, and Mary met her future husband, Percy Bysshe Shelley, when he was respectfully calling on her father. At seventeen, she ran off with the married Percy to the Continent, where they stayed in Switzerland with Lord Byron. She had lost a baby daughter and given birth to a son by the time the talented young people, bored by the confinement of inclement weather, entered into a competition to write ghost stories. *Frankenstein* was the gothic product of their game. Within a few short years, Percy's estranged wife had killed herself, Mary's half-sister had drowned, and two more of her children had died, followed swiftly by Percy himself and then by Bryon. From this perspective, the monstrous *Frankenstein* had a staying power rare in Mary Shelley's experience. It would survive as a parable of her life, in which reproduction, creativity, and loss were inextricably mingled.

Frankenstein is as important an investigation of creativity and aesthetic experience in the realm of fiction as Kant's *Critique of Judgement* was in the realm of philosophy. In the novel, a scientist fabricates a living being out of inert body parts, but is appalled at the ugliness of his creation and judges it a monster. The monster, in turn, becomes a yearning connoisseur, constantly observing people from afar without himself being seen. He watches through windows or from hiding places, or finds sleeping beings to stare at – human images as unavailable to him as stage characters or statues or portraits. Unlike the scientist, the monster finds the creatures he beholds surpassingly beautiful and is moved by that beauty to love them. He tries to improve himself so as

to become worthy of these beauteous beings, but no matter how knowledgeable and refined he becomes, as soon as they see him they flee in terror and the monster's love turns to hate. Finally, he asks Frankenstein to fabricate a bride as ugly as he is, so that he will at least have a companion in his sad existence. The scientist refuses, fearing to give his creature the power to become a creator himself and overrun the earth with monsters.

This fable of aesthetic creation and judgement is replete with the anxieties of its day. For Mary Shelley, steeped in literature, reformism and loss, the models of creativity occupying public attention were distressing: the cold, overreaching adventurism of science, the mechanical productivity of industrialism, the greed and oppression of empire. Even art was not immune from this dehumanization. Kant and Burke had bequeathed to the West a taste for the sublime, an aesthetic experience in which beauty is a confrontation with the unknowable, the limitless, the superhuman. The sublime turned the act of aesthetic judgement into a brush with abstraction, alienation, death. Here was no joyous birth, no discovery of the self in an Other, no gratitude for that recognition or striving to attain to the Other's worth. All mutuality is blocked or denied in the sublime as the puny self shivers in the presence of the unknowable immensity of the Other.

Kant had argued that beauty existed both in nature and in art, and that it came, in either case, in two varieties: the beautiful and the sublime.

> The beautiful in nature is a question of the form of the object, and this consists in limitation, whereas the sublime is to be found in an object even devoid of form, so far as it immediately involves, or else by its presence provokes, a representation of *limitlessness*, yet with a super-added thought of its totality.[4]

The experience of the sublime is provoked when nature exceeds human limits. 'It is rather in its chaos,' Kant wrote, 'or in its wildest and most irregular disorder and desolation provided it gives signs of magnitude

and power, that nature chiefly excites the ideas of the sublime.'[5] The Alps and the polar ice-cap were Kant's archetypes of the sublime, and these are precisely the blasted landscapes of Frankenstein and his alienated monster.

Kant believed that the perceiver does not experience this chaos as actually life-threatening. Remember that the judgement of beauty occurs in a state removed from normal needs and desires. If the chaos one encounters makes one fear for one's life, self-interest would destroy the aesthetic purity of the experience, making it 'monstrous'. A moment is sublime for Kant when the perceiver can take in, securely, the sheer magnitude, limitlessness, and chaos of the scene and see it whole. And thus, the monstrous and the sublime are antithetical. 'For in representation of [the sublime] nature contains nothing monstrous . . . the magnitude apprehended may be increased to any extent provided imagination is able to grasp it all in one whole. An object is *monstrous* where by its size it defeats the end that forms its concept.'[6]

This is the apparent crux of Mary Shelley's opposition to Kantian aesthetics. For in *Frankenstein*, she presents sublimity as monstrous by definition. It defeats 'the end that forms its concept' by turning a person into an abstraction. Thus, Victor Frankenstein disdains home and family to become a scientific titan, a 'modern Prometheus'. The creature that comes of his art is a sublime monster, and the experience of its sublimity is filled with horror and self-destruction. The sublime eliminates the experience of beauty as a part of normal life or even a pleasurable ideal. Its thrill is a glittery-eyed madness in which the perceiver is released from the constraints of the human condition. In *Frankenstein*, chaos is never experienced in a state of control, and the rational suspension of interest is nothing but inhumane heedlessness. Transcending human limits for Mary Shelley means losing all that is human; the monster is likewise doomed to an existence of loneliness and homelessness. Sublimity, supposedly transcendent in value, is in fact a destruction of the common values and pleasures of human existence.

Mary Shelley signals the inhumanity of the sublime in the terrible dream that overcomes Frankenstein immediately after he creates the

monster. His fiancée Elizabeth appears to him 'in the bloom of health
. . . Delighted and surprised, I embraced her; but as I imprinted the first
kiss on her lips, they became livid with the hue of death; her features
appeared to change, and I thought that I held the corpse of my dead
mother in my arms; a shroud enveloped her form, and I saw the grave-
worms crawling in the folds of the flannel.'[7] The creation of the
monster, a superhuman triumph of scientific inquiry, brings about not
sublime uplift but the death of a beautiful loved one, symbolic incest,
and contact with physical decomposition.

Dr Frankenstein's monster is a reflection not only of the Kantian
sublime but of industrial production. Mary Shelley traced the genesis of
the novel to a discussion with Byron and Percy Shelley about the
'nature of the principle of life', in which they considered whether
'perhaps the component parts of a creature might be manufactured,
brought together and endued with vital warmth'.[8] This notion of
reproduction through factory assembly recalls ancient fables of com-
position: Apelles forced to cull one feature here, another there, from the
many lovely faces he examined as models for Helen of Troy; or Zeuxis
selecting from five beautiful maidens of Kroton the perfect limbs of one,
the perfect breasts of another for his *Aphrodite*. The search-and-assembly
procedure 'reappears in the earliest treatise on painting of the
postantique world, Alberti's *Della Pittura*', writes Sir Kenneth Clark.
'Dürer went so far as to say that he had "searched through two or three
hundred." The argument is repeated again and again for four
centuries.'[9] In these stories, the artist picks and chooses among body
parts like a male-chauvinist grave-robber, or like the dark scientist
Frankenstein.

This classical recipe for beauty (assemble the parts and add life,
electricity,[10] art) was a cause of anxiety by Mary Shelley's day. Industrial
manufacture had produced Blake's 'dark Satanic mills', and the
mechanical metaphor of creativity threatened to disconnect art from
nature altogether. Mary Shelley's mother, the feminist Mary
Wollstonecraft, had insisted on Coleridge's notion that art was an
organic whole rather than a mere assemblage: 'It was not . . . the

mechanical selection of limbs and features; but the ebullition of an heated fancy that burst forth . . . it was not mechanical, because a whole was produced – a model of that grand simplicity, of those concurring energies, which arrest our attention and command our reverence.'[11] Likewise, Mary Shelley's contemporary, the philosopher Arthur Schopenhauer, stated that 'The opinion . . . is absurd . . . that the Greeks discovered the established ideal of human beauty empirically, by collecting particular beautiful parts, uncovering and noting here a knee, there an arm.'[12] Percy Shelley and Byron's conversation about 'the nature of the principle of life' ran counter to romantic aesthetics, and of course the two must have known this, however fascinating the possibility of such 'mechanical reproduction' must have seemed. Mary Shelley likewise understood, for she demonstrated the error in her monster, assembled out of beautiful but oversized body parts and electrified by the maniacal scientist, Victor Frankenstein. 'I had selected his features as beautiful. Beautiful! Great God!'[13]

If beauty is an idea in the artist's soul made real in the act of creation, there should be a bond of likeness between the creator and his creature. This is specifically what Dr Frankenstein will not acknowledge: his kinship to his offspring, in effect, his fatherhood. The belief in this subject–object unity – in perception or in art – was, according to the historian Peter Gay, the crux of 'the quarrel between the heirs of the Enlightenment and the romantics . . . What the natural scientists in Goethe's, Schelling's, and Coleridge's day were deploring as a liability that investigators must train themselves to overcome, the romantics took to be humanity's greatest asset in the quest for the divine', as they fought for 'the re-enchantment of the world'.[14] A loving mother and author, Mary Shelley herself accepted the analogy between artwork and child, despite the gothic horror of her monstrous creation. 'I bid my hideous progeny go forth and prosper,' she wrote in the Introduction to the third edition of *Frankenstein: or, The Modern Prometheus*. 'I have an affection for it, for it was the offspring of happy days.'[15]

Dr Frankenstein's lack of sympathy with his creation makes him not only a mechanical artist and a failed father but a perverse lover. In

traditional myths of aesthetic creation, such as Pygmalion and Galatea, a male artist produces a female artwork that is warmed into a real woman by his love. But sublimity denies the possibility of empathy between creator and creation. Thus, a sublime Pygmalion would give life to Galatea, but be unable to love her. This is just the case in George Bernard Shaw's *Pygmalion*, though in the musical adaptation of *My Fair Lady* Professor Higgins grudgingly admits, 'I've grown accustomed to her face' and ends up marrying his creation. To create a work of art or a woman in sublime logic, however, is to bring a beauty into the world that one holds at bay, feeling awe towards it, but not connection. For Mary Shelley, this is not beauty at all, but a horror.

The audience of sublime art suffers a similar alienation. In the various scenes where the monster stares at sleeping people or at pictures, he becomes the perceiver of an Other. He happens upon Frankenstein's little brother William, for instance, who is wearing a miniature of his beautiful mother – the same woman whose worm-eaten corpse appears in Frankenstein's dream. 'I saw something glittering on his breast,' the monster narrates. 'I took it; it was a portrait of a most lovely woman. In spite of my malignity, it softened and attracted me. For a few moments I gazed with delight on her dark eyes, fringed by deep lashes, and her lovely lips; but presently my rage returned: I remembered that I was for ever deprived of the delights that such beautiful creatures could bestow.'[16] Furious, the monster kills the little boy. Here Mary Shelley is echoing a passage in *Paradise Lost* in which Satan is so struck at the sight of Eve's beauty that he is stopped in his tracks, becoming 'stupidly good'. However, realizing that such beauty can never be his, he reverts to his destructive ways and brings about the fall of humankind. Female beauty in this tradition has the power almost to transform the King of Darkness into a virtuous being, except that Satan knows this beauty is not *for him*. Beauty cut off from the spectator's life – suspended from his interest, his pleasure – is an outrage rather than a blessing, and 'disinterested beauty' looses the same violence as Frankenstein's unloving procreation.

For Mary Shelley, this is the human cost of a sublime aesthetics, as

applied – or no doubt, misapplied – to gender relations. And people *have* applied it, however imprecisely, in just this way. Male-female relations have perennially been used to understand those between artist and artwork, and correspondingly, the experience of art has been compared to infatuation, lust, and love. 'Be beautiful if you want to be loved' is the insistent message of western culture to its women. But if being beautiful means evoking a disinterested, dehumanized state of consciousness, the beautiful woman is artifactual, formal, and cut off from warmth and concern. Twentieth-century 'glamour' is one version of this untouchable state of beauty, inducing adoration but not connection. The interconnection of human and artistic beauty in western culture has had far-reaching results for both art and female identity, and the dilemma of the beautiful woman in a culture at war with beauty is a repeated theme in early twentieth-century fiction.

It is worth stopping briefly to review what Kant actually said about beauty, since though his ideas may have reinforced these problems, the *Critique of Judgement* is not overtly a treatise on gender relations. We have noted his famous concept of disinterested interest in which taste involves the experience of pleasure without interest: '*Taste* is the faculty of estimating an object or a mode of representation by means of a delight or aversion *apart from any interest*. The object of such a delight is called *beautiful*.'[17] This judgement of beauty, since it is suspended from particular interests, is universal, 'making a rightful claim upon the assent of all men'.[18] Further, it is definitionally unconcerned with the actuality of the subjects represented: 'One must not be in the least prepossessed in favour of the real existence of the thing, but must preserve complete indifference in this respect, in order to play the part of judge in matters of taste.'[19] As a result, for Kant taste is the only experience of pleasure that is free, and hence it is intrinsically human: 'beauty has purport and significance only for human beings . . . taste in the beautiful may be said to be the one and only disinterested and *free* delight; for, with it, no interest, whether of sense or reason, extorts approval . . . FAVOUR is the only free liking.'[20] Aesthetic judgement thus permits the exercise of the most essentially human of our aspirations, freedom.

Frankenstein, as we have seen, presents this heroic freedom in an opposite light, as cruel and destructive of social relations. It is detrimental to what humans value *as* human: gratification, love, comfort. Kant had differentiated the pleasure associated with beauty and that associated with charm or the agreeable. 'The *agreeable* is what GRATIFIES a man,'[21] Kant wrote, and what is gratified is desire, need, interest. There is nothing universal about gratification, and when the adage '*chacun à son goût*' is invoked, it is not taste but gratification that is at issue. For the man of taste, many things may 'possess charm and agreeableness – no one cares about that; but when he puts a thing on a pedestal and calls it beautiful, he demands the same delight from others. He judges not merely for himself, but for all men, and then speaks of beauty as if it were a property of things.'[22] Note that for Kant, judgement of the beautiful should lead to an objectivity in which beauty becomes 'a property of things'. This is precisely the opposite of the interactive experience of beauty modelled in the myth of Psyche and Cupid, in which beauty provokes desire and love and a striving for equality.[23] But for Kant, any representation that evokes appetite is outside the realm of the beautiful; a notion of beauty as a human interaction rather than a 'property of things' risks the introduction of impure interests.

Mary Shelley takes Kantian aesthetics to task for its disqualification of charm from aesthetic experience. Frankenstein may roam the Alps or the polar ice-cap, but the natural habitat of his Wordsworthian friend Henry Clerval is the Rhine valley, a romantic setting of gentleness and spiritual soothing. 'The mountains of Switzerland,' Henry says, 'are more majestic and strange, but there is a charm in the banks of this divine river that I never before saw equalled.'[24] He goes on: 'Oh, surely the spirit that inhabits and guards this place has a soul more in harmony with man than those who pile the glacier or retire to the inaccessible peaks of the mountains of our own country.'[25] Frankenstein himself is moved by these surroundings: 'Even I, depressed in mind, and my spirits continually agitated by gloomy feelings, even I was pleased.'[26] Drawn as the scientist was to this charm, however, he renounced it in the pursuit of knowledge, leaving it to his doomed friends and loved ones.

Henry is steeped in chivalry and romance, and Frankenstein's betrothed, Elizabeth, 'was the living spirit of love to soften and attract'.[27] Like a proper man of taste, Frankenstein disdains charm, softness, love, and attraction in favour of reason. 'While my companion contemplated with a serious and satisfied spirit the magnificent appearances of things,' he says of Elizabeth, 'I delighted in investigating their causes.'[28] As a scientist, he revels in the discovery of causes, not remembering that it was specifically the eating of the Tree of the Knowledge of Good and Evil that Satan promised would allow Adam and Eve 'to discern/Things in thir Causes'.[29] Elizabeth, in contrast, is satisfied by appearances, in an anti-Platonic turnabout of values in which Mary Shelley elevates the pleasing surface of experience over the ideal (or tortuous) depths below.

Throughout the novel, the more the scientist separates himself from love and domesticity, the more he undermines the affective basis of his values. He becomes a wanderer in a hostile world, and produces the same fate in his creature and his loved ones. His father loses most of his family to the monster's depredations and enters an internal sublime, the chaos of madness and death: 'His eyes wandered in vacancy, for they had lost their charm and their delight.'[30] If Kant associates the charming and agreeable with meretricious beauty, sentiment, and the allure of surfaces, Mary Shelley redeploys his terminology to explain her belief in 'the amiableness of domestic affection, and the excellence of universal virtue'.[31] For her, the agreeable and the good coincide in an aesthetics of charm, which for Kant would be a contradiction in terms.

This 'soft', 'feminine' aesthetics was problematic in Mary Shelley's day, as it is in ours, not only because it contradicts Kant but because it raises the spectres of sentimentality, seductiveness, and domesticity associated with the allegedly inferior mentality of women. One cannot imagine a less Kantian view than the suffering monster's reproach to his creator Frankenstein that God, the Arch-Creator, had 'made man beautiful and alluring, after his own image'.[32] 'Alluring' goes further even than 'charming'; it suggests desire and sexuality, facets of experience that are suppressed in a sublime aesthetics.[33] This impure

aesthetics is connected to the spontaneity and ecstasy of Wordsworthian nature. In a direct quotation from 'Tintern Abbey', Frankenstein says that nature for his friend Henry was 'An appetite, a feeling, and a love.'[34]

Henry's death prompts a 'gush of sorrow' in the scientist, whose heart is 'overflowing with the anguish which his remembrance creates'.[35] These words may seem to echo Wordsworth's definition of poetry in the preface to the *Lyrical Ballads* as 'the spontaneous overflow of powerful feelings' originating in 'emotion recollected in tranquillity',[36] but they in fact parody it, revealing how distant Wordsworthian creativity is from the Frankensteinian sublime. The scientist's recollections are never tranquil, and even the word 'recollection' sounds too pacific for the hideous memories that torment him. In fact, the plot of *Frankenstein* is a demonic parody of the epiphanic 'spots of time' in Wordsworth's *The Prelude*. Every episode in the novel is the same trauma nightmarishly repeated: the loss of a loved one. Frankenstein himself declares that surviving another's death is far worse than dying oneself: the dead 'can no longer be a subject for pity; we must reserve that for his miserable survivors'.[37] But he cannot see the implication of this truth, instead maniacally pursuing the monster rather than defending his loved ones at home. The monster's threat, 'I shall be with you on your wedding-night',[38] goes right over Frankenstein's head. No reader is in doubt as to its meaning, however: that the fiend is planning to attack not him, but Elizabeth. The monster, denied loved since his engendering, understands that the worst pain is deprivation, bereavement. The demonic torture of Frankenstein's 'recollections' is just the opposite of the recuperative warmth and charm of Wordsworth's poetic memory.

Mary Shelley thus pointed out the irony of the sublime: that in providing supposedly the most human of mental states, freedom, it utterly disregards love and family and pleasure, which have at least as much claim as freedom to define 'the human'. Creativity and aesthetic experience should follow a different model. She presents it by allusion to the scene in *Paradise Lost* in which Adam awakens after God has used

his rib to create Eve. Frankenstein's monster, however, is never permitted to dream his Other into existence. Frankenstein refuses to make him a bride, and so he never experiences the coincidence of wish and reality that is companionate love. Neither does his heartless creator, although Frankenstein's dream of Elizabeth as a corpse certainly comes true!

Keats, writing at the same time as Mary Shelley wrote *Frankenstein*, saw Adam's dream as an allegory of the imagination. He compared the imagination to Adam's 'waking dream' in *Paradise Lost*, in which Adam 'awoke and found it truth'.[39] He dreamt Eve and woke to find her actually alive. Unlike Kant, the value of the imagination and art for Keats lies in its capacity to 'come true'. Art is dream realized, and this is why we value it – as an earnest that our dreams might be realized in life. The experience of art is thus a profoundly 'interested' mental state; we are not indifferent to the possibility that what it depicts may be real. This is one way to construe Keat's 'Beauty is truth, truth beauty': that beauty is this realization of the ideal on earth.

Moreover, Adam's dream creation, made from one of his ribs, is intrinsically connected to him – an expression of his very being, a companion to him, and an object therefore of his love. To love Eve is to love himself, for she is flesh of his flesh. We recall the monster's reproach to his creator that God had 'made man beautiful and alluring, after his own image'. Creators and creations echo each other in this model, and are tied in a bond of love that involves self-realization. The engine of this imaginative connection is beauty. But the monster is monstrous – ugly, bereft of beauty. His creator dreamed him into reality and then despised him, denying him love, a mate, a dream come true.

It is not irrelevant that Adam's dream is a story of the creation of Woman, or that for Mary Shelley the imagination involves a recognition of identity between male and female, subject and object, creator and creation. If Kant wanted to detach aesthetic experience from self-concern, she shows that this detachment leads to a devaluation and indeed a dehumanization of the feminine and the domestic leading to the direst of consequences: war and political oppression. She has her

saddened scientist realize in retrospect that 'if no man allowed any pursuit whatsoever to interfere with the tranquillity of his domestic affections, Greece had not been enslaved, Caesar would have spared his country, America would have been discovered more gradually, and the empires of Mexico and Peru had not been destroyed'.[40]

Of course, Kant did not limit beauty to the sublime. The other variety of aesthetic experience was termed, somewhat confusingly, 'the beautiful'. Taste is the judgement of beauty, which occurs in two forms: the beautiful proper and the sublime.

> . . . the beautiful is directly attended with a feeling of the furtherance of life, and is thus compatible with charms and playful imagination. On the other hand, the feeling of the sublime is a pleasure that only arises indirectly, being brought about by the feeling of a momentary check to the vital forces followed at once by a discharge all the more powerful, and so it is an emotion that seems to be no sport, but dead earnest in the affairs of the imagination. Hence charms are repugnant to it; and, since the mind is not simply attracted by the object, but is also alternatively repelled thereby, the delight in the sublime does not so much involve positive pleasure as admiration or respect . . . a negative pleasure.[41]

The language of this passage, as of others in Kant, renders the beautiful *feminine* (connected with charm and the furtherance of life) and the sublime *masculine* (involving a 'discharge all the more powerful' and a business-like 'dead earnest in the affairs of the imagination'). But the crucial Kantian distinction between charm and beauty – and hence, between mere gratification and taste – is utterly unstable. The beautiful is distinguished from the sublime through its positive pleasure, its boundedness, its charms, its furtherance of life, and its imaginative play-fulness, whereas the sublime is related to negative pleasure, limitlessness, reason, a check to the vital forces, 'no sport, but dead earnest', a repugnance to charm. Kant goes on to associate the beautiful with love, and the sublime with esteem. 'The beautiful prepares us to love

something, even nature, apart from any interest: the sublime to esteem something highly even in opposition to our (sensible) interest.'[42] Though Kant describes the beautiful as preparing us to love something apart from any interest, its connection to charm and the furtherance of life would seem to interfere with this purity. William Blake suggests this in his opposition: 'The head Sublime . . . the genitals Beauty'[43] (although Blake viewed the role of the genitals in art with a very un-Kantian enthusiasm).

In other words, in the course of the contrast between the beautiful and the sublime, the beautiful and the charming fall together, both are connected to the female and to love,[44] and the sublime ends up the only uncompromised experience of beauty. Though Kant stated overtly that the beautiful was as legitimate an experience of beauty as the sublime, modernists responded to the metaphoric undertones of his words. The ideology of the avant-garde was based on the uncompromising, 'masculine' distance of the sublime.

But though the problem with feminine beauty is presumably its threat of impurity, Mary Shelley saw that even a pure version of the beautiful was vulnerable. She shows the monster looking upon the sleeping Justine, a virtuous family servant of the Frankensteins. He finds her beautiful, but almost immediately he realizes that if she woke up and saw him, she would flee from his ugliness. Her beauty is not 'for him'; that is, it is separate from his interests. This distance infuriates him. In revenge, he incriminates Justine in a murder that leads to her execution. Like the heroine of Sade's eponymous novel, this beautiful Justine is oppressed by monstrous male forces who ultimately bring about her death.

We do not know whether Mary Shelley had in fact read Sade, but the coincidence of 'Justine' in both authors is worth considering. In *Frankenstein*, Kantian aesthetics seems to be responsible for a dehumanization of women that has certain parallels to Sade's violent pornography. When the monster realizes that Justine's beauty is inaccessible to him, she becomes a hateful deprivation, an object to which he owes no ethical responsibility. She is not his, but irredeemably

Other, and as such, she is an affront, a threat that must be eliminated. The need to destroy the power of this beautiful Other is an outcome of her very purity, her separateness from the perceiver's interest. Thus, as Mary Shelley presents it, the purity of Kantian beauty is a deprivation that inevitably evokes the enmity of the perceiver, who wants to punish it for its inaccessibility and distance. When woman is the embodiment of that beauty, she is at risk.

This 'logical' progression from ideal beauty to inaccessible woman to dehumanized object to corpse is the horror story lurking in Sade, who sometimes seems a parodic alter-ego of Kant. Indeed, as Octavio Paz describes him, Sade seems a veritable embodiment of the sublime: 'Volcanoes fascinated him. He saw them as the incarnation of his thought: the gigantism, disproportion, isolation, and reconcentration of the libertine; the inhuman heat and cold; lava, hotter than semen and blood; ashes, frozen stone. Creation and destruction sealed in violence.'[45]

Sade's male libertine is 'a solitary who cannot ignore the presence of others', according to Paz, for their existence is a precondition of his: 'if I wipe out that consciousness, my pleasure and my own consciousness, my own being, will disappear'. Thus, the libertine must establish a 'negative relation' to the other; 'the erotic object must enjoy a sort of conditional consciousness, to be dead in life or an automaton'.[46] The female Other is either a helpless victim or a cruel tyrant, Justine or Juliette. Both are images of each other, and both, ironically, are images of the libertine in his inability to know himself.[47] Sublimity turns woman into a victim or a victimizer, but never an empathetic equal. The pure abstraction of Kant and the pure pornography of Sade were to become the two faces of the twentieth-century avant-garde.

Caught in a sublime disinterest, twentieth-century art hunted the female subject into the ground. Like Frankenstein raging over the Arctic in pursuit of his despised creation, modernist artists have hounded and destroyed their female subjects, whom they, after all, created in the first place. 'Qui suis-je?' demanded the surrealist André Breton at the start of *Nadja*,[48] asking 'Who am I?' and 'Whom do I

follow?' in the same breath. The artist is endlessly in pursuit because he is hopelessly pursuing himself. For Frankenstein, the monster appears to destroy everything of value in his life, but Mary Shelley lets us know directly that the monster is as innocent a victim as the others who die in the novel, with the unloving creator the real cause of the destruction. In art, the female subject is turned into a monster – an animal, an exotic, a prostitute – and killed off in the name of purity and civilized virtues. She is the self the male creator cannot recognize or will not claim his own.

Mary Shelley's gothic fantasy helps explain why the conception of beauty as allure, charm, and sensuousness was exiled or vilified in avant-garde art and in the process, why the female subject became so problematic. From a Kantian standpoint, a non-idealized female subject could produce only an impure response because she appealed to the flesh-and-blood 'interest' of the perceiver. But for Mary Shelley, even an idealized female subject, such as Justine or Elizabeth, would have to be eliminated in art, since her purity and inaccessibility were so threatening to the perceiver that he would have to destroy her. Pollution or deprivation, the female subject became an untenable symbol of beauty, or if she could not be separated from what she had symbolized for so long, the logical response was for artists to reject beauty altogether.

As the nineteenth century proceeded, this misogyny fused with a growing hostility to the middle classes. In *The Pleasure Wars*, Peter Gay claims that the romantics were the first artists to define themselves in opposition to society: specifically, in opposition to the bourgeois. 'Throughout virtually all of recorded history, the makers of high culture were fully integrated into their society . . . Then, toward the end of the eighteenth century and the beginning of the nineteenth, this tacit, durable cultural compact was radically subverted . . . [A]s the Victorian century went its way, painters, composers, and the rest formed avant-gardes to fight lively and implacable pleasure wars in which they confronted the dominant, hopelessly conventional middle class with all the energy at their command.'[49] Flaubert signed himself

'Bourgeoisophobus',[50] but was too self-indulgent to dismiss middle-class pleasure entirely: 'one should live like a bourgeois and think like a demi-god,' he declared.[51] George Sand was less compromising: 'Axiom: Hatred of Bourgeois is the beginning of all virtue.'[52] Gay shows how 'Quarrels over the arts became quite directly quarrels over politics.'[53] Class conflict was fundamental to the avant-garde.

In the early twentieth century, the Dadaist Hans Arp described this artistic class struggle as slapstick comedy:

> The bourgeois regarded the Dadaist as a dissolute monster, a revolutionary villain, a barbarous Asiatic, plotting against his bells, his safe-deposits, his honors. The Dadaist thought up tricks to rob the bourgeois of his sleep. He sent false reports to the newspapers of hair-raising Dada duels, in which his favorite author, the 'King of Bernina,' was said to be involved . . . [Dada games] were devised to show the bourgeois the unreality of his world, the nullity of his endeavors, even of his extremely profitable patrioteerings. This of course was a naïve undertaking on our part, since actually the bourgeois has less imagination than a worm, and in place of a heart has an over-life-size corn which twitches in times of approaching storm – on the stock exchange.[54]

The Dadaist is a self-styled monster whose mission is to torment the bourgeoisie. However, unlike Mary Shelley's monster, who longs for wife and home and reproductive warmth, as Tristan Tzara wrote, 'Every product of disgust capable of becoming a negation of the family is Dada.'[55]

Post-Enlightenment artists may have defined themselves in opposition to the bourgeoisie, but they did not consider themselves part of the proletarian masses either. Indeed, Marx had done them no favour in arguing that the rise of the bourgeoisie had simplified the European class structure into these two categories. For just as surely as the avant-garde denied any kinship to capitalists, they (for the most part) fled from the masses. Individualism was a crucial value for them. Kierkegaard had

claimed that 'a crowd in its very concept is the untruth',[56] and Nietzsche denounced the 'universal green pasture-happiness of the herd'.[57] Bohemian poverty was not the same as proletarian poverty; the difference in consciousness between the suffering artist and the underfed masses was decisive. When artists likened themselves to the people, this was often only a kind of ethnographic slumming; class primitivism was thus a crucial aspect of modernist aesthetics even before the racial primitivism of Gauguin and Picasso.

Even the consolidation of the bourgeoisie and the proletariat into a unified 'viewing audience' in our day has not led artists to make their peace with either class. The public is meant to receive art as manna from the demi-god artist and to accept the insult that goes along with it: that they are, by virtue of their status as non-artists and capitalists, incapable of truly understanding high culture. They should consume art, because that is all they know how to do with anything, but leave the judgement of art to its priests. The attitude has changed little since Flaubert expressed it in the 1850s:

> In an age when all common bonds are snapped, and when Society is just one huge brigandage . . . more or less well organized, when the interests of flesh and spirit draw apart like wolves and howl in solitude, one must act like everyone else, cultivate an ego (a more beautiful one naturally) and live in one's den. The distance between myself and my fellow men widens every day. I feel this process working in my heart and I am glad, for my sensitivity towards all that I find sympathetic continually increases, as a result of this very withdrawal.[58]

Nineteenth-century painters, as we might expect, found formal as well as semantic means to torment their audience. The critic Brian O'Doherty describes the difficulties that even Impressionism imposed on its first audiences, who lost the subject as soon as they tried to verify its presence by going closer to the picture. The 'Spectator began to utter his first complaints: not only "What is it supposed to be?" and "What

does it mean?" but "Where am I supposed to stand?" Problems of deportment are intrinsic to modernism. Impressionism began that harassment of the Spectator inseparable from most advanced art.' O'Doherty isolates hostility to the audience as 'one of the key coordinates of modernism'.[59]

This hostile, isolationist strain in the avant-garde further exaggerated the virtues of the sublime over the beautiful. The beautiful is an experience of measure, stability, order, and harmony, whereas the sublime entails limitlessness, dynamism, chaos, and self-annihilating threat. Kant himself dissociated taste from the application of principles and stable rules: 'In forming an estimate of Objects merely from concepts, all representation of beauty goes by the board.'[60] In the German *Sturm und Drang*, the connection between rule-abiding artists and burghers was clear. 'A man who follows the rules will produce a "correct" work of art, just as a good bourgeois who obeys the rules of society will live a correct life.'[61] The early romantic, William Blake, ever outspoken, wrote that 'Prudence is a rich, ugly old maid courted by Incapacity.'[62] Whether one was a rationalist or a romantic, to be lawless, boundless, even monstrous was to prove one's true artistic nature and one's disdain for all things bourgeois.

And who was more the enemy of titanic striving than women? Mary Wollstonecraft herself reminds us that Zeus punished Prometheus for his theft of the divine fire by creating Pandora, the first woman, whose curiosity loosed evil into the world. Woman was subversive of the sublime in all ways. Female beauty was hopelessly compromised – interested – since women *used* it, gaining power over men by means of it. 'Taught from their infancy that beauty is woman's sceptre,' Wollstonecraft writes, 'the mind shapes itself to the body, and, roaming round its gilt cage, only seeks to adorn its prison.' Such instruction causes women to be 'gentle, domestic brutes', she claims, and 'if women then do not resign the arbitrary power of beauty – they will prove that they have *less* mind than men'.[63]

Wollstonecraft criticized women's utilitarian approach to beauty in order to urge equality of education, and she was not alone. Jane Austen

satirized well-bred women who took a turn about the drawing-room in order to show off their figures to advantage, or played the piano, however indifferently, in order to display their dimpled arms and graceful shoulders. Schopenhauer, unconcerned with improving the lot of women, believed that they were incapable of aesthetic experience altogether. Like the middle classes, they talked during the theatre and despite endless painting lessons they had never produced a work of art worth the name: 'women are, and remain, thorough-going philistines, and quite incurable,' he concluded.[64]

Of course, Schopenhauer was a complete misogynist, alienated from his mother and convinced that love 'is rooted in the sexual impulse alone'.[65] For him there was no danger of seeing the female form as an expression of Kantian beauty. 'It is only the man whose intellect is clouded by his sexual impulses that could give the name of *the fair sex* to that undersized, narrow-shouldered, broad-hipped, and short-legged race . . . Instead of calling them beautiful, there would be more warrant for describing women as the unaesthetic sex.'[66] Others detached the feminine from the beautiful for different reasons. The neoclassical aesthetician Winckelmann had found reinforcement of his homo-sexuality in the aesthetic principles of the Greeks, believing that 'a beautiful male body is the precondition for valuing great art, and . . . only men stirred by male comeliness possess the true sense of beauty'.[67]

Abigail Solomon-Godeau argues that the artistic ideal shifted from male to female beauty after the French Revolution. At this great historical turning point, 'the beautiful male body ceded its dominant position in élite visual culture to the degree that the category "nude" became routinely associated with femininity'.[68] Sir Kenneth Clark writes that by the mid-nineteenth century, 'naked women took the place of men as the models in art schools',[69] but women were not allowed to attend these schools until much later. With woman the predominant subject of art, the preferred model for art, but seldom the maker of art,[70] the 'nineteenth-century female nude [emerged], a body designed for display and delectation, a "legitimized" sensuality that henceforth the male body must nominally abjure'.[71]

Dominant in art but powerless in life, a woman's beauty was a sign of her social inferiority. And this inferiority, according to Mary Wollstonecraft, made women slaves to their sensations. They 'look for happiness in love, refine on sensual feelings, and adopt metaphysical notions respecting that passion'. Kept from participating in important concerns, for them 'sentiments become events'.[72] As a result, they are enthralled by 'the stupid novelists' rather than 'serious' literature, which sold in pitifully few copies at the time. Female beauty was weakness and women's taste was sentimentalism, according to the 'angry and disheartened camp of high literature'.[73]

The split between bourgeois and high taste coincided with a full-scale critique of the ideology of love, which continued into modernism. Fairytales, medieval quest romances, and the Courtly Love tradition launched by twelfth-century troubadours may have been the stuff of romantic and Pre-Raphaelite poetry, but nineteenth-century realists and the twentieth-century avant-garde subjected the idealization of love to devastating irony. It was declared a matter of feminine excess, undisciplined emotionalism, melodrama. The value of women was similarly demoted. Mary Wollstonecraft had specifically blamed the inferior situation of women on the romance ideology of love: 'Novels, music, poetry, and gallantry,' she wrote, 'all tend to make women the creatures of sensation.'[74] And the misogynist Schopenhauer is only too grateful to Byron for teaching him the errors of gallantry. Schopenhauer wants to eliminate the honorific 'lady' altogether as a word and an idea.

In Europe the *lady*, strictly so-called, is a being who should not exist at all; she should be either a housewife or a girl who hopes to become one; and she should be brought up, not to be arrogant, but to be thrifty and submissive . . . even Lord Byron says: *Thought of the state of women under the ancient Greeks – convenient enough. Present state, a remnant of the barbarism of the chivalric and the feudal ages – artificial and unnatural. They ought to mind home – and be well fed and clothed – but not mixed in society. Well educated, too, in religion – but to read neither poetry nor politics – nothing but books of piety and cookery. Music – drawing –*

dancing – also a little gardening and ploughing now and then. I have seen them mending the roads in Epirus with good success. Why not, as well as haymaking and milking?[75]

'The barbarism of the chivalric and feudal ages' turned women into ladies; rationalism should turn them back into the domestic philistines they are! No wonder Mary Shelley filled the gentle Henry Clerval with thoughts of chivalry and gallantry. The aestheticizing of women was thoroughly endangered, even by those like her mother who were on the side of women. Whereas for Wollstonecraft courtly romance had kept women unliberated, and for Bryon and Schopenhauer it had misrepresented their nature and given them inappropriate social expectations, for Mary Shelley romance was the necessary precondition for an ethical aesthetics in which subject and object, creator and creature, could experience value and emotional depth. If the romantics sought to 're-enchant the world', this could never happen, Mary Shelley understood, if they discredited the ideology of romance.

In the assault on chivalry, the beauty of the romance heroine was not an incidental factor. Beauty was the most consistent symbol of the heightened value of woman, the hallmark of romance. Heroes take on any danger or sacrifice in order to win the fair maiden. Moreover, good characters in romances are beautiful, whereas evil ones are ugly. Aesthetics and ethics coincide. There may be a lot of to-ing and fro-ing here, as when an apparently beautiful woman turns out to be a hideous sorceress, or when a virtuous crone is revealed to be a princess suffering under a spell. The coincidence of beauty with goodness allowed sophisticated romances to function as aesthetic allegories in which the beautiful woman played a double role as both the heroine of a love story and the symbol of the beauty and value of the work in which she figured.

Nineteenth-century critics of the romance disjoined the beautiful from the good. This separation of ethics from aesthetics had been a philosophical aim of Kant's as well, and was entwined in the reformist or misogynistic beliefs of Wollstonecraft and Schopenhauer, respec-

tively. It has an age-old currency in Christian anti-ornamentalism and distrust of appearance. Umberto Eco quotes the medieval St Bernard, that 'Interior beauty is more comely than external ornament, more even than the pomp of kings.'[76] Mary Shelley is quite unconventional in depicting Frankenstein's beloved Elizabeth as unapologetically enthralled by the 'magnificent appearances of things'.

But for many nineteenth-century female novelists who followed her, for example, Charlotte Brontë or George Eliot, the unlinking of beauty from virtue was an important goal in the creation of aesthetic and human sympathy, for love was not a response to surface appearance but to deep character. Brontë's Jane Eyre is unredeemedly plain, and consents to marry her lover only when she is financially independent of him and invisible to his blinded eye. George Eliot makes her pretty characters foolish and her complex heroines plain. 'All honour and reverence to the divine beauty of form!' she writes. 'But let us love that other beauty too, which lies in no secret of proportion, but in the secret of deep human sympathy.' For Eliot, love and sympathy produced the experience of beauty – value – and not the reverse. 'Yes! thank God; human feeling is like the mighty rivers that bless the earth: it does not wait for beauty – it flows with resistless force and brings beauty with it.'[77] Eliot and Brontë were wise, but the men who set out to dismantle the romance association of beauty and virtue were not typically motivated by sympathy for plain women. Indeed, sympathy was what they were fleeing altogether.

In the general anxiety over the ideology of the literary romance, the nineteenth century reworked it in a variety of distortions: the gothic novel, melodrama, and the stylized revivals of the Decadents. One of the standard scenes in literary romances, and one that challenged the disinterested interest of neoclassical aesthetics as none other, was the stripping of the heroine. We think of this as the stuff of bodice-rippers or burlesque theatres, but scenes in which a heroine is stripped of her clothing or threatened with such stripping are found in the most classic of romances, for example, Edmund Spenser's *The Faerie Queene*. Sometimes a veil is removed to reveal a celestial purity that had

previously been kept from profane eyes. Or sometimes, in diametrical opposition, a heroine such as Oscar Wilde's Salome sheds veil after veil in an accession of female power. Mary Wollstonecraft suggests the complexity of this motif in the following statement: 'while [women] have been stripped of the virtues that should clothe humanity, they have been decked with artificial graces that enable them to exercise a short-lived tyranny'.[78] Throughout the discussion of women, it is unclear as to whether female virtue is a matter of covering or uncovering, and what covers or is uncovered in the process.

Whatever the meaning of stripping in a given romance – and there is a huge range of such meanings – it points to one of the most volatile issues associated with woman: the ethics of ornament. Women are stripped because women are ornamented. E. H. Gombrich describes the long association between ornament and women in aesthetic and moral thought in *The Sense of Order*, noting that neoclassicism perennially identifies 'crowded ornament with feminine taste' and suppresses it in the name of decorum.[79] Kant was thus typical of his age in condemning ornament or '*parergon*' as an instance of charm: 'if it is introduced like a gold frame merely to win approval for the picture by means of its charm – it is then called *finery* and takes away from the genuine beauty'.[80]

In her reformist zeal, Wollstonecraft expresses the typical association of ornament with feminine triviality and moral weakness: 'can that soul be stamped with the heavenly image, that is not perfected by the exercise of its own reason? Yet outwardly ornamented with elaborate care, and so adorned to delight man, "that with honour he may love," [a quotation from *Paradise Lost*] the soul of woman is not allowed to have this distinction.'[81] Whenever a woman, ornamented or plain, is rendered in art, she threatens the purity of the judgement of taste, conjuring up charm, or in extreme form, prurient allure. These have no place in a 'high' aesthetics, but belong to the bourgeois marketplace of culture. Artists themselves were only too aware of this fact. For example, the Victorian painter William Mulready wrote in his sketch-book: 'female beauty and innocence will be much talked about, and sell well. Let it be *covertly* exciting.'[82] To this day, the asking prices for

premodernist paintings with female subjects are typically higher than for paintings with male subjects by the same painter, and if the subjects are young women, the price is higher still.

In contrast, an art based on the beauty of form eliminates the problem of charm or titillation. Manet's *Olympia*, an openly erotic nude that did not employ the subterfuge of an allegorical or mythological title, caused a scandal in its day. Zola defended it by claiming that the subject of the painting was not a naked woman but form. Zola 'dismissed the question whether the painting was charming or obscene as simply irrelevant. Manet's nude was a purely formalist composition exhibited by an "analytical painter" far less concerned with bodily shapes than with "vivid contrasts and bold masses".'[83]

This alchemy, in which a female subject is transmuted into pure form, may be witnessed, too, in Edgar Allan Poe's 1846 essay 'The Philosophy of Composition'. In this remarkable rationalist analysis (or spoof?), which became a touchstone for twentieth-century formalist aesthetics, Poe explains the genesis of his poem 'The Raven'. The poem had nothing to do with creative frenzy, he claims, but like all art grew out of a sequence of rational decisions: first, the choice of the effect, then of the tone, the length, and the desired impression. Properly Kantian, Poe wanted his poem to be 'universally appreciable' and thus opted for an impression of beauty. 'Beauty is the sole legitimate province of the poem . . . That pleasure which is at once the most intense, the most elevating, and the most pure, is, I believe, found in the contemplation of the beautiful.'[84]

An impression of beauty required a sad tone, and a striking refrain would create the pleasure of repetition in the expression of that sadness. The most effective refrain, Poe reasoned, would be a single word, and the saddest would be one with the sounds of long *o* and *r*. 'Nevermore' was the inevitable choice. But what would be the vehicle of this repetition? A parrot would do perhaps. No, a raven would be more suitable for melancholy. And what theme would be most conducive to all this sadness?

I asked myself — 'Of all melancholy topics, what, according to the *universal* understanding of mankind, is the *most* melancholy?' Death — was the obvious reply. 'And when . . . is this most melancholy of topics most poetical?' . . . the answer . . . is obvious — 'When it most closely allies itself to *Beauty*: the death, then, of a beautiful woman is, unquestionably, the most poetical topic in the world.'[85]

In Poe's formalist account of poetic beauty, the death of a beautiful woman is the perfect subject. The pursuit of beauty in a rationalist framework elevates form to the highest value. In the process, the female subject, whose being is reduced to form, becomes a mere trace, a memory unendingly mourned by the artist who has excised her yet does not take responsibility for his act. He is much more engrossed in the logic of his formalist decision-making than in the woman he has sacrificed to it.

Poe's essay was beloved by French realists and symbolists alike, and twentieth-century Russian Formalists treated it as prophetic. For all of them, the substitution of reason for emotion and of fetishized form for woman is a cause of celebration, not despair. Edmond and Jules de Goncourt's account of reading Poe in the 1860s is exemplary:

> After reading Edgar Allan Poe. Something the critics have not noticed: a new literary world, pointing to the literature of the twentieth century. Scientific miracles, fables on the pattern A + B; a clear-sighted, sickly literature. No more poetry, but analytic fantasy. Something monomaniacal. Things playing a more important part than people; love giving way to deductions and other sources of ideas, style, subject, and interest; the basis of the novel transferred from the heart to the head, from the passion to the idea, from the drama to the dénouement.[86]

Flaubert went so far as to state that 'What seems beautiful to me, what I should like to write, is a book about nothing, a book dependent on nothing external, which would be held together by the strength of its

style.'[87] His mother apparently complained that 'The mania for phrases has dried up your heart',[88] but Flaubert had just such a 'pitiless'[89] art in mind, impersonal, scientific, formal. 'The price of beauty is self-denial,'[90] he boasted, denying his mother.

If woman is too implicated in ornament, charm, and gratification to produce a pure aesthetic experience, or on the contrary, too inaccessible and threatening in her purity, then artists have no choice but to kill her off by transmuting her into form. Otherwise, they encounter formidable risks to purity: the barbaric, the obscene, the idolatrous. 'Taste that requires an added element of *charm*,' says Kant, '. . . has not yet emerged from barbarism.'[91] 'Surely these weak beings [women] are only fit for a seraglio!' exclaims Wollstonecraft, and elsewhere: '[C]hastity will never be respected in the male world till the person of a woman is not, as it were, idolized.'[92] It is perhaps not surprising that in tracts on aesthetics and feminism a certain space is always devoted to animadversions on impurity and fetishization. What *is* surprising is that these tend to be such similar animadversions in each case, and that they take up so much room. The casting out of ornament and the trans-mutation of the female subject into form seem to go hand-in-hand with an almost obsessive preoccupation with woman as an exotic fetish – primitive, prostituted, idolized.

In *Evil Sisters: The Threat of Female Sexuality and the Cult of Manhood*, Bram Dijkstra describes the association of the female and the primitive in the figure of the twentieth-century vampire, the vamp. 'The later nineteenth century used Darwin's discoveries,' Dijkstra writes, 'to transform the scattershot gender conflicts of earlier centuries into a "scientifically grounded" exposé of female sexuality as a source of social disruption and "degeneration". At the opening of the new century, biology and medicine set out to prove that nature had given *all* women a basic instinct that made them into predators, destroyers, witches . . . a harbinger of death to the male.' Whereas man strove for rationality and 'higher' values, woman, 'the feminine principle of nature, was the thief of progress. She was interested only in quantity, in species survival, in maintaining life in all its forms. She had no interest in "quality", in the

"virile", elitist principles of the evolutionary advance.'[93] As in the contemporary world, an interpretation of Darwin buttresses male fears by picturing women as unalterably Other. In early modernism, the thrill and danger of this exotic figure played directly into the Kantian sublime, causing artists to recast the female subject in frightening and dehumanized ways.

It is interesting that the ideology of the avant-garde was driven by such seemingly contradictory impulses: on the one hand, the retreat from the deathliness and dirt of the ornamental woman into the purity of form, and on the other, the fascination with exoticism and fetish. The fetish itself enshrines this contradiction, as Anthony Shelton suggests: '"Fetishism" has paradoxical meanings. In early theories of religion, in psychiatry, and in the work of Freud and Lacan, "fetishism" comes to be associated with deficiency, loss and disavowal, while for others, including Marx, Bataille and Baudrillard, it signifies excess. Frequently, deficiency and excess occur in the work of the same writer.'[94] Of course, modernists often pretended to be taming the excess of the fetish by appropriating merely its formal qualities, as with African sculpture, but it is hard to maintain such discipline in the act of borrowing. When you appropriate an aspect of something, other aspects of it may come along for the ride, appropriating you.

Primitivism, the engine of modernist fetishism, is obviously connected to the genre of the gothic, of which *Frankenstein* is a prime example. Gothic fetishes are everywhere in nineteenth-century fiction. In Sheridan Le Fanu's novella 'Green Tea', for example, the protagonist devotes himself to the study of ancient religion and art. 'Paganism is all bound together in essential unity, and, with evil sympathy, their religion involves their art, and both their manners . . . It thoroughly infected me. You are to remember that all the material ideas connected with it were more or less of the beautiful, the subject itself delightfully interesting.'[95] This 'delightfully interesting' subject, beauty, leads to the protagonist's suicide, as he is haunted by, of all things, a monkey. Though 'Green Tea' leaves something to be desired as fiction, it is a clear example of the late-nineteenth-century entailment of beauty in the fetish.

Mary Shelley represents this fetishism symbolically in Victor Frankenstein's love-hate relation to his creature, his meddling with corpses and alchemy, and his glittery-eyed fascination with 'chimeras of boundless grandeur'.[96] There seems to be a psychic algebra in play here. If you deny yourself gratification, seeking beauty in abstract form rather than femininity, charm, allure, domesticity, and love, you must compensate for this loss with some other source of gratification. But one gratification is as bad as another unless you can show that you are not really gratified by it, that it belongs to someone else – an exotic, a primitive, a being far below you. You are unmoved by the ornamental, sexualized fetishes that fill the primitive imagination, though as a modern person you have enough ethnographic curiosity and formal sensitivity to 'appreciate' the fetishes that fill primitive peoples with awe and desire. You may include some of these fetishes in your art to show yourself reading through desire to pure form. It is a good lesson to instill in your audience as well.

Modernists regularly embraced this mystification, eliminating ornament, turning the female subject into pure form, and then sneaking in desire, passion, charm, and gratification through the back door in the form of safe quotations from dangerous sources.[97] This is the recipe for modernist art: a laboratory in which creators chose form and fetish over a more 'agreeable' beauty. Abstraction, alienation, and sublime thrill are the result – marks of the Promethean 'Victor', modernist experimentalism.

Mary Shelley offered a different wisdom: that we accept the humanizing pleasure of art, and thus reinstate a circuit of 'natural affection' between the moral and the aesthetic spheres. Her warning, however reasoned and erudite, has sounded merely timid next to the heroic challenge of Frankensteinian inquiry, and posterity has preferred horror over healing. I have an intimation that now, after more than two centuries of rationalist aesthetics, things are starting to change. But we can make this judgement only by tracking the fortunes of those touchstones of twentieth-century beauty: form, fetish, ornament, and woman.

THE BURDEN OF THE IMAGE

The time for Beauty is over.

— Gustave Flaubert, 1852

In Andy Warhol's 'shoe' works of the late 1950s, the future Pop master paints a number of very beautiful shoes with legends adapted from literature: 'A la recherche du shoe perdu', 'Beauty is shoe', and so on. As a camp undermining of one of the great aphorisms of romanticism, Keats's 'Beauty is truth, truth beauty', 'Beauty is shoe' says a lot about the meaning of beauty in the twentieth century. In particular, it suggests the extreme ambivalence we now feel towards beauty both within and outside art. We distrust it; we fear its power; we associate it with the compulsion and uncontrollable desire of a sexual fetish. Embarrassed by our yearning for beauty, we demean it as something tawdry, self-indulgent, or sentimental.

This aesthetic anxiety is especially evident in the treatment of one of the perennial images of artistic beauty, woman. Symptomatic is the title of a watercolour by the South African/Dutch artist Marlene Dumas, *The Image as Burden* [**Pl. 3**]. In this work, a man carries a woman, who stands for 'the image' — the representational subject of art, the allure of the visual, all that has perennially been symbolized as woman. This has become a burden. He holds her lovingly and with great concern, though she is heavy, not easy for him to support. Her head is thrown

back in unconsciousness or death, and it is dark and schematically rendered, like the mask figures of Picasso's Cubism. Against her immaculate white robe, his hand creates a dark pubis for her, since her own sex is hidden. Unlike Titian's *Venus of Urbino* or Manet's *Olympia* [Pl. 4], in which the woman's hand hides and at the same time presents her pubis in a visual simulation,[1] here it is the man whose supporting hand must perform this scandalous ostentation, for she is no longer able to do so on her own. The hand is like a palm frond – a stylization or design of public hair, as if painted on by the man's hand – *his* addition rather than her essence. In this way he creates her sex. But since traditional depictions of female nudes are in fact male creations, it is only just that the man openly takes responsibility for designing this pubis, by his hand.

The woman here – the female image – seems to be dead. Indeed, it is hard to avoid seeing the pose of the two figures as a secular *pietà*, with the sorrowing man a mournful Mary and the female image a crucified Christ. The fact that the sexes of the two are slightly ambiguous merely reinforces this reference. In a *pietà*, Mary grieves at the death of her son and with him, Christian love. The archetype of pictorial pathos until the Enlightenment, the crucified God is now replaced by a crucified woman – the symbol of the secular beauty and love and salvation that art promised when religion waned, now sacrificed in their turn as well.

In a catalogue of her work, Dumas reveals the source of this pose:[2] a film still from George Cukor's movie *Camille*, with Robert Taylor carrying the swooning Greta Garbo in his arms. This arch-romantic image shows the man strong and dark, the woman weak and pale. In Dumas's rendering, female beauty faints from a 'consumption' so pervasive in our culture that it threatens all images, all art, perhaps all women. The female 'image' is dead, and, contemplating its demise – her demise – those who have witnessed this martyrdom or caused it are left to mourn, bereft, baffled, burdened with responsibility for their unaccountable crime. This is Poe's 'Philosophy of Composition' in its modern-day realization. If Warhol's 'Beauty is shoe' reduces modern art to a fetish or a quotation, this watercolour reveals what has been

sacrificed along the way: woman as an aesthetic subject and as the vehicle of centuries of idealism and value (and, no doubt, hypocrisy and false consciousness as well).

As we have seen, woman in art was not always this creature of pathos. Before modernism – indeed, throughout much of the history of art – female subjects are abundant, vibrant with life, and positive in value. They behold their images in mirrors with a narcissistic pleasure that is meant to echo or incite the viewer's, or simply present themselves to the view's gaze as objects of beauty or desire. We might recall the elegant female portraits of Sargent and Whistler, the odalisques and bold peasants of Manet and Courbet, the allegorical or exotic nudes of Ingres. The beauty and allure of these subjects are unashamed analogues to the appeal of the art in which they figure, even in the second half of the nineteenth century, when this analogy was becoming a source of avant-garde unease.

We might consider a few of these traditional images of the female subject from the history of art: the languorous object of Zeus's passion in Titian's gorgeous *Danaë* **[Pl. 2]**; the invitation to voyeurism of the playful lady in Fragonard's *The Swing*; the premise of allegory as an occasion for the nude in Ingres's *La Source* **[Pl. 5]**; Manet's unashamed seductress *Olympia*; Courbet's peasant exhibitionist in *La Femme aux bas blancs*; and a major step towards the modernist transformation of the female subject into pure form: Whistler's *Arrangement in Black: Lady Meux*. This list encompasses a wide variety of attitudes to the female subject, but all are built on an analogy between the viewing of women and the viewing of art. The woman may give herself to be viewed or be observed unawares (paradigmatically in paintings of Susannah and the Elders). She may be the representation of a flesh-and-blood person or an idea. But always the experience of viewing her and the experience of viewing the art in which she figures fall together. Art is about pleasure and gratification, the message seems to be: the pleasure a heterosexual man (the implied artist or viewer) has in looking at a woman, the pleasure a heterosexual woman has in being seen by a man as beautiful.

Though the female subject has long served as a symbol of beauty in art, as we saw in the previous chapter, she is especially prevalent in the nineteenth century. It was then that the 'nude' became equated with the female nude in particular,[3] which more than any other subject connoted 'Art . . . [A]n icon of western culture, a symbol of civilization and accomplishment.'[4] Even clothed, the female subject played this overdetermined role as a symbol of beauty and artistic achievement. For the alienated avant-garde artist, however, in revolt against bourgeois values and enthralled by sublime transcendence, she was quite another thing. She threatened to drag art into the realm of desire, contingency, and 'interest' or to overpower the perceiver with her inaccessible beauty. The female subjects in avant-garde paintings were frequently expressions of these issues rather than celebrations of the correspondence between female and artistic beauty.

By the twentieth century, it is hard to think of a major artist who depicted women as symbols of the beauty and pleasure of art. Typical is a modernist like Willem de Kooning, who painted endless works called 'woman', none of which attends to the female subject of the title except through the lushness of flesh-toned paint and the horror of its vampiric maw **[Pl. 6]**. Of course, one could argue that not only women disappeared in modernism, but men did, too. In fact, any sort of beautiful – or ugly – representational subject matter fell out of painting at this time. Since representation itself was suspended or attenuated, the disappearance of woman as subject could be just an instance of this general turn. But as we have seen, woman was not just any other subject. Eliminating her from art was the most programmatic way to reveal the logic of the sublime, to divorce avant-garde art from bourgeois values, and to dismantle the ideology of female value enshrined in chivalric romance.

This assault on woman as a symbol of art arose in the most disparate artists and thinkers. In 1894, for example, Leo Tolstoy declared the beautiful woman inadequate as an aesthetic ideal on the grounds that she was merely a blind for sexual passion and hence low and impermanent. As Tolstoy stated,

Guy de Maupassant grew up and formed himself among those who believed that feminine beauty and feminine passion were . . . the only true subject of real art. This theory, in all its terrible inanity, enslaved Guy de Maupassant as soon as he became a fashionable writer; and, as could have been foretold, this false ideal led him into a whole series of mistakes.

Tolstoy's rhetoric rises to a crescendo of misogynist disgust as he describes de Maupassant's feeling for woman's beauty by confronting it with 'the pain of pregnancy, of childbirth; the unwelcome children; then deceit, cruelty, moral suffering; then – old age, and – death':

is this 'beauty' real beauty? Of what use is it? . . . thin and grizzled hair, toothlessness, wrinkles, tainted breath; even long before the end all becomes ugly and repellent; visible paint, sweat, foulness, hideousness. Where, then, is the god of my idolatry? Where is beauty?[5]

Whatever women may be good for, Tolstoy finds them disastrous as symbols of artistic beauty, which must be universal, transcendent, safe from vicissitude and death.

The very advent of the modern has been described through the death of a woman. In 1900, Henry Adams depicted the twentieth century as a shift in master symbols: from the Virgin to the Dynamo. His realization was provoked by the death of a real woman, his sister. With her demise, he lost not only a loving and admirable person, but the Christian/chivalric worldview that she had enshrined. A God of love could not have permitted such unjust suffering, he decided. No, life was cruel, ruled by forces as inhumane as the great machines of industry. The only beauty available now was a technological sublime.

Adams famously contrasted the two ideologies in the figures of the Virgin and the Dynamo: the first, a Christian vision of the world filled with love and charity; the second, a mechanistic atheism in which nature is a system of pitiless forces harnessed by the Promethean

engineer. Referring to himself throughout the *Education* in the third person, Adams wrote that he 'greatly preferred his eighteenth-century education when God was a father and nature a mother' and woman 'conceived herself and her family as the centre and flower of an ordered universe which she knew to be unity because she had made it after the image of her own fecundity; and this creation of hers was surrounded by beauties and perfections which she knew to be real because she herself had imagined them'.[6] This is Mary Shelley's ideal precisely, with the creator a mother who loves the creature whom she has formed in her own image.

This domestic vision of life made in the image of a loving woman was now lost. Modernity had nullified it, educating Adams in a chilling reality that eerily echoes the Kantian sublime. 'For the first time,' Adams wrote, 'the stage-scenery of the senses collapsed; the human mind felt itself stripped naked, vibrating in a void of shapeless energies, with resistless mass, colliding, crushing, wasting, and destroying what these same energies had created and labored from eternity to perfect. Society became fantastic, a vision of pantomime with a mechanical motion.' For Adams, 'the dynamo became a symbol of infinity'. He stopped in the Great Hall of Dynamos in the Columbia Exposition of 1900 and found himself in awe of the power of the gigantic turbine. 'Before the end, one began to pray to it; inherited instinct taught the natural expression of man before silent and infinite force.'[7]

Tolstoy and Adams represent emotional poles in the early-modernist retreat from the symbol of woman. Adams considers the failure of this symbol a personal and social tragedy. Numbed with pain, he turns from the worship of woman-as-ideal to the worship of machine-as-power. Tolstoy, in contrast, participates in the undermining of the female symbol, denying her beauty and associating her with degradation and death. It was Tolstoy's religious beliefs, perhaps, that led him to disdain woman as a symbol of the transcendent, but many completely amoral and atheistic modernists did the same, reducing the idealized image of the beautiful woman to a flawed and grotesque horror. Among the Russian Futurists, Ivan Terentyev describes a 'blotch-nosed Aphrodite'[8]

and Sergej Tretyakov calls poetry before Futurism 'a worn-out wench'.[9] Denying any value to woman as a symbol of the Kantian beautiful (harmony, form, universality), the avant-garde traded her for the fascinating horror of the Kantian sublime (chaos, inhuman scale, power), either eliminating her altogether or presenting her as grotesque and deathly. It is hard not to regard this move as a kind of scapegoating, with the violent shift in values associated with modernism being used as an excuse to remove the feminine from culture in any but a transgressive or sentimentalized form.

Often, as we would expect, the beautiful woman was invalidated as a symbol of art because of the previous equation of woman and bourgeoisie. The avant-garde movements of the early twentieth century were consistent in their disdain for middle-class values, particularly as expressed among conventional critics. 'Mademoiselle Criticism. I'll show "her"!' Vladimir Mayakovsky swore in 1914.[10] Likewise, the Futurist poet Kruchenykh called the detractors of the movement 'the seven nannies'.[11] In his manifesto for Italian Futurism, F. T. Marinetti claimed that a roaring car is more beautiful than the *Victory of Samothrace*,[12] and that not only war but scorn towards woman should be glorified. 'We want to demolish museums, libraries, fight against moralism, feminism, and all opportunistic and utilitarian cowardices', he declared in his 'Futurist Manifesto'.

Even D. H Lawrence, who disagreed with Marinetti and who allegedly gloried in the physicality and mythic potency of women, manages to erase the female subject in the process of defending her:

When Marinetti writes: '. . . The heat of a piece of wood or iron is in fact more passionate, for us, than the laughter or tears of a woman' – then I know what he means. He is stupid, as an artist, for contrasting the heat of the iron and the laugh of the woman. Because what is interesting in the laugh of the woman is the same as the binding of the molecules of steel or their action in heat; it is the inhuman will, call it physiology, or like Marinetti – physiology of matter, that fascinates me. I don't so much care about what the

woman *feels* – in the ordinary usage of the word. That presumes an ego to feel with. I only care about what the woman *is* – what she IS – inhumanly, physiologically, materially – . . . what she *is* as a phenomenon (or as representing some greater, inhuman will), instead of what she feels according to the human conception.[13]

Whereas Henry Adams's belief in a benevolent, fostering world was destroyed by the cruel death of his sister, Lawrence traces this loss to the trauma of World War I, when men suffered and died 'beyond the help of wife or mother, and no wife nor mother nor sister nor any beloved could save him from the guns. This fact went home in his heart, and broke the image of mother and Christ-child, and left in its place the image of Christ crucified.'[14] As Marlene Dumas's watercolour reveals, the next step would be a vengeful crucifixion of the image of woman.

In his programmatic 1913 poem 'Explodity', Kruchenykh seeks reinforcement for his hostility to the female subject in the gender ideology of language:

> because of a foul
> contempt for
> women and
> children in our
> language there will be
> only the masculine
> gender[15]

Cold, cerebral logic was to replace the sentimentality associated with art-as-woman. The Russian Futurists took the nineteenth-century Symbolist Aleksander Blok to task for writing a poem cycle dedicated to 'the beautiful lady'. In their 1913 manifesto, *The Word as Such*, Kruchenykh and Khlebnikov stated that 'in recent times [artists] tried to turn womanhood into the eternal feminine, into the beautiful lady, and in this way the *skirt* became *mystical* (this must not confuse the uninitiated – on the contrary! . . .)'.[16] And soon after, Kruchenykh wrote:

Pushkin is watery – and so is Lermontov and all the Realists and Symbolists: . . .

> *the eternal feminine now*
> *in an imperishable body walks the Earth . . .* (V. Solovyev)

It is sickening to live, sickening to breathe amidst this puffing and piffling.[17]

The chivalric romance, under these circumstances, was seen as a mystification of sex, and fictions about the plight of women – melodrama – were treated as an inferior genre. In a 1914 manifesto of the French 'Cérébraliste' movement, R. Canudo criticizes sentimental melodrama and its heroine, the generic 'Margot':

> This art marks the deathly border of all sentimental art: banal, facile, intolerable finally because it is inadequate. It is more and more clear that a melodrama with Margot crying is without doubt a stupid melodrama which can give us the same emotion – immediate, trivial, reductive, as a news item. No exaltation of the individual, no elevation of the spirit. In contrast, against all sentimentalism in art and in life, we want a nobler and purer art which does not touch the heart, but which stirs the brain, *which does not charm, but makes us think.*[18]

'Indifferent to Margot's plump tears' and to the concomitant 'charm' that Kant had also disdained, the cerebralist modern had nothing but contempt for melodrama and its beautiful, suffering heroine, outdoing even Poe in its negation of the female in the name of reason.

This rejection was often framed as the elimination of a muse or some other mythological female figure. Marinetti, for example, used the heroic symbolism of quest romance to describe the Futurists, picturing them as hunters pursuing a leopard spotted with crosses through a fantastic mauve sky. However, these questers have no female inspiration behind their adventure: 'we had no ideal Mistress high as the clouds, no cruel Queen to whom to offer our corpses twisted into Byzantine rings! Nothing to die for besides the desire to rid ourselves of our too weighty

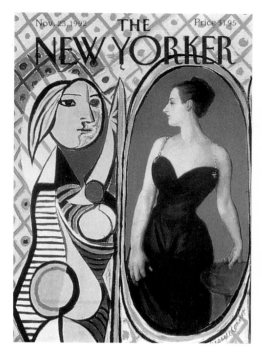

1. Cover from *The New Yorker*, November 23, 1992. Drawing by Russell Connor.
Reprinted by permission. Copyright © 1992 The New Yorker Magazine, Inc. All Rights Reserved.

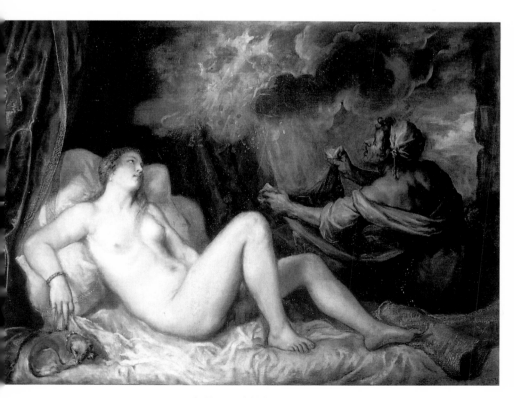

2. *Danaë*, 1553. Titian
Photo: AKG London/Erich Lessing.

3 *The Image as Burden*, 1993, Marlene Dumas

4. *Olympia*, 1863. Manet
Photo: AKG London/Erich Lessing.

5. *The Source*, 1856. Ingres
Photo: AKG London/Erich Lessing.

6. *Woman, Sag Harbor*, 1964.
Willem de Kooning
Courtesy of Hirshhorn Museum and Sculpture
Garden, Smithsonian Institution.
Gift of Joseph H. Hirshhorn, 1996.
Photo: Lee Stalsworth.

7. *Les Demoiselles d'Avignon*, Paris, June-July 1907. Pablo Picasso
Oil on canvas, 8' × 7' 8" (243.9 × 233.7 cm).
The Museum of Modern Art, New York.
Acquired through the Lillie P. Bliss Bequest.
Photograph © 2001 The Museum of Modern Art, New York.

8. *Nude Descending a Staircase, no. 2*, 1912. Marcel Duchamp
Photo: AKG London.

9. *Woman*, 1910. Braque

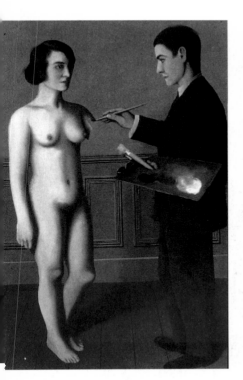

10. *Attempting the Impossible*, 1928.
René Magritte

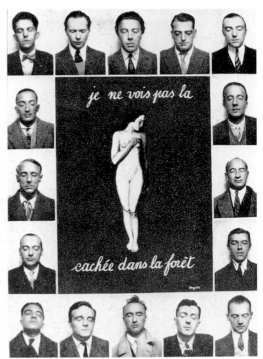

11. *Je ne ne vois pas la … cachée dans la forêt*, 1929.
René Magritte

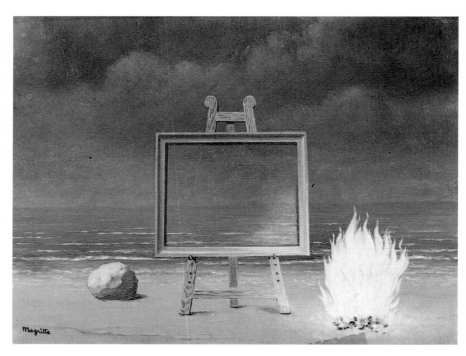

12. *La Belle Captive*, 1950. René Magritte
Photo: AKG London.

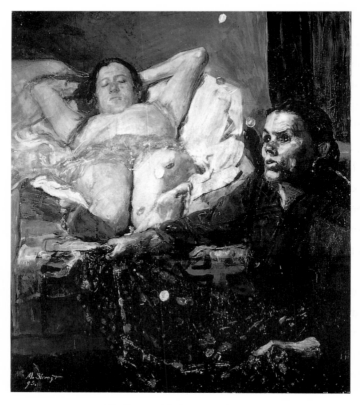

13. *Danaë*, 1895. Max Slevogt
Photo: AKG London.

courage!'[19] The romance quest is on, but without an ideal in the form of a woman. Indeed, the whole traditional structure of aesthetic communication is denied here. The artist does not create a work in the image of a beloved model or inspiration in order to give pleasure to an audience remade by that delight, and the soul Psyche is not elevated by recognizing its beauty in a beautiful Other. At the hands of the formalist 'wordwrights' of Futurism, Kruchenykh and Khlebnikov, the perceiver drops out of the account altogether and only a reified beauty remains: 'since we – the Futurian bards – paid more attention to the word than to Psyche, which our predecessors had reduced to a trite cliché, she died in isolation, and now it is in our power to create a new one . . . do we want to? . . . No!'[20]

Of course, many modernists were fascinated with the romance. Pound wrote his first book on the subject, allusions to romances fill Eliot's *The Waste Land*, and the central genre of modern fiction in the West throughout the century has been the anti-romance, the story of the failure of this plot to resolve itself in pleasure. The medieval romance was an expression of Western aristocratic values, built on the ideals of chivalry, *caritas*, and the sublimation of ordinary pleasures in the quest for perfection. Late nineteenth-century studies in Comparative Religion had turned up the primordial roots of romance in myth and fertility ritual, transformed unrecognizably under the pressure of Christian and neoplatonic ideologies. Defining modernist works, such as *The Waste Land*, presented the continuity of human aspiration from ancient myth to high romance as now shattered by modernity. For some like Eliot, this was a devastating break in human history. For others, such as Nietzsche, this was the chance to start again, closer to where we began, without constraint or sentimentality:

Let us tell ourselves without indulging ourselves how every superior culture on earth got its *start!* Men whose nature was still natural, barabarians in every frightful sense of the word, men of prey, men still in possession of unbroken strength of will and power-drives – such men threw themselves upon weaker, better-behaved, more

peaceable races . . . The distinguished caste in the beginning was always the barbarian caste; their superiority lay not primarily in their physical but in their psychic power; they were more whole as human beings (which on every level also means 'more whole as beasts').[21]

Modernists such as Pound, Eliot, Marinetti, and Nietzsche recast the romance as a revelation of male power and not as the search for an ideal associated with art and the feminine. Indeed, the final version of *The Waste Land* is full of deprecating images of women. Pound mercifully removed still more virulent sections from the manuscript, for example, those portraying Belinda from Pope's *The Rape of the Lock* lifted into a mock-heroic boudoir where she reads Richardson on 'the needful stool' and masks with perfume her 'good old hearty female stench'.[22] Eliot's romance Lady will not be the one to redeem the wasteland. Even Nietzsche, who described romantic love in approving terms, did so because of the aristocratic values it enshrines and not for anything that women contribute to these values: 'love *as passion* (our European specialty) must be of distinguished origin; we know it was invented by the Provençal knightly poets, those magnificent inventive men of *gai sabre* – to whom Europe owes so much, and almost itself'.[23]

If not a muse or a romance heroine, the doomed figure of woman in modernism sometimes appeared as a nude. In this 1913 poem by the 'Ego–Futurist', I.V. Ignatyev, she 'wanes out' into a bloody ornament:

> And in the bespattered park among the fireworks
> Of summons and phrases, ecstasies and poses
> A naked woman sadly waned out,
> Standing on a bench in her gloves of roses . . .
> At her feet a little girl in lilac
> And on her cheeks tears flowed like rhymes
> And when the woman trustingly wanted
> To squeeze milk out of her drooping breasts,
> Blood trickled down her body and traced
> A pattern of rococo–styled red lace.[24]

The urge to mother fails this ageing, moribund nude. Her efforts produce not comfort and nourishment but grotesque, over-elaborate ornament, which, as we shall see, was the ultimate anathema for modern purists.

The amount of time twentieth-century writers spent dismantling the ideality of woman as an artistic subject is remarkable. 'Verses must not be like a woman, but like a gnawing saw,' wrote Terentyev.[25] The hostility only increased with time. In the name of 'a new vision of human experience, one based on community, freedom, spontaneity and love', the Beats were openly misogynistic, making women into 'a sacrifice on the altar of bogus masculinity and dishonest sexuality'.[26] William Burroughs shot his wife Joan in a dare echoing William Tell; indeed, violence against wives was a kind of trope in modernism – for example, with Hemingway and Mailer – in which male identity is expressed as a romance adventure spoiled by the bourgeois domesticity of women.

Even for as woman-identified a poet as Yeats, the beautiful woman served as a symbol of the modern artist's frustration at his inability to function transcendentally. 'Many years ago I saw, between sleeping and waking, a woman of incredible beauty shooting an arrow into the sky,' he wrote in 1918. But he realized that he could not be like such a woman. 'I think that we who are poets and artists, not being permitted to shoot beyond the tangible, must go from desire to weariness and so to desire again, and live but for the moment when vision comes to our weariness like terrible lightning, in the humility of the brutes.'[27] At least Yeats had the grace to blame his own inadequacy or the difficulties of the modern condition for this failure, and not the woman who symbolized his aspiration to transcendence.

Exhausted, repelled, or disillusioned, the great majority of modernists replaced the beauty of woman with the beauty of form. If Cézanne's triangle in *The Eternal Feminine* and the many Mont Sainte-Victoire works was a blind for the female geometry of the *mons Veneris*,[28] the twentieth-century artists who followed him were still more direct in their substitution of form for woman. As Georges Braque told an

interviewer in 1910, 'I couldn't portray a woman in all her natural loveliness. I haven't the skill. No one has. I must, therefore, create a new sort of beauty, the beauty that appears to me in terms of volume, of line, of mass, of weight, and through that beauty interpret my subjective impression . . . I want to expose the Absolute, and not merely the factitious woman.'[29] André Derain made a strikingly similar statement in the same year: 'Why, what, after all, *is* a pretty woman? It's a mere subjective impression − what you think of her. That's what I paint, another kind of beauty of my own . . . [I]n my ideal, I . . . bring that beauty forth in terms of line or volume.'[30] Wassily Kandinsky's early paintings are often female images whose clothing is an abstract pattern that bleeds out and merges with the background. Franz Marc slyly hid Art Deco flappers in the abstracted forest-mazes of his paintings.

This replacement of woman with form is anticipated in Balzac's *Le Chef-d'oeuvre inconnu* (1832), whose painter-protagonist insists on the identity of art and woman. His painting 'is not a canvas, it is a woman! a woman with whom I weep and laugh, and talk and think'.[31] In order to protect her from the rude gaze of men, he proceeds to cover her in a scrawl of colour and 'curious lines which form a wall of painting', a formal barrier against impurity. In a less gallant move some decades later, Flaubert claimed that his heroine Madame Bovary was unimportant as a character but only as a colour: grey![32] And in the early twentieth century, Ezra Pound described the genesis of his imagist poem 'In a Station of the Metro' as the transformation of one beautiful woman's face after another[33] in the Metro into 'an equation . . . not in speech, but in little splotches of colour. It was just that − a "pattern".'[34]

James Joyce in *A Portrait of the Artist as a Young Man* had his fictional alter-ego, Stephen Dedalus, argue that the death of a woman reported in the papers is in no important sense 'tragic', since it has nothing to do with the terror and pity of Aristotle's *Poetics*. The tragic, the beautiful, involve a balance and stasis unrelated to the fate of a woman as such but only to formal factors that suspend the audience of art from normal, interested experience. The fact that Stephen's friend Lynch was moved

to write his name on 'the backside of the Venus of Praxiteles' merely indicates Lynch's error in responding libidinously to art as if to woman. Any theory of art that argues otherwise, according to Stephen, 'leads to eugenics rather than to esthetic'. Instead, when we see beauty in women or female images in art, this is due to the fact that they, like all phenomena, may embody relations that give rise to an aesthetic response:

> The Greek, the Turk, the Chinese, the Copt, the Hottentot, said Stephen, all admire a different type of female beauty. That seems to be a maze out of which we cannot escape. I see, however, two ways out. One is this hypothesis: that every physical quality admired by men in women is in direct connexion with the manifold functions of women for the propagation of the species. It may be so. The world, it seems, is drearier than even you, Lynch, imagined . . . This hypothesis . . . is the other way out: that, though the same object may not seem beautiful to all people, all people who admire a beautiful object find in it certain relations which satisfy and coincide with the stages themselves of all esthetic apprehension. These relations of the sensible, visible to you through one form and to me through another, must be therefore the necessary qualities of beauty.[35]

The meaning of form differed drastically from artist to artist, but virtually every modernist at one time or another extolled its virtues. Hans Arp wanted to eliminate a view of nature according to the measure of man and to present instead what Kant had termed the sublime: 'all things and man were to be like nature, without measure. I wanted to create new appearances, extract new forms from man.'[36] To escape the 'tragic existence' called up by reason's uprooting of people from nature, Arp sought to make an art of things, a concrete art, in which people would be elements analogous to any other objects. In this sense, he approaches Tristan Tzara's 'calm level state of mind that makes everything equal and without importance'.[37] Here 'abstract' and 'concrete' are so mystified in meaning that they fall together, for when

art stops mirroring nature and instead creates forms, its products are as concrete as any 'forms' in nature. As Guillaume Apollinaire noted, 'Wishing to attain the proportions of the ideal, to be no longer limited to the human, the young painters offer us works which are more cerebral than sensual. They discard more and more the old art of optical illusion and local proportion, in order to express the grandeur of metaphysical forms.'[38]

For many artists, Futurists in particular, form was equated with the spirit of modernity. 'No matter how much we talk about the city, we will not convey the city by our talk,' Vadim Shershenevich wrote in 1916. 'The rhythm of our epoch lies only in its form, and therefore a formal method must be found.'[39] Ezra Pound claimed that 'Every concept, every emotion, presents itself to the vivid consciousness in some primary form. It belongs to the art of this form.'[40] Accordingly, Pound loved analytic geometry for its ability to generate pure forms out of the abstraction of numbers, and he and Joyce and Eliot and many other modernists advocated an impersonal art in which the creator's character and biography played no role in the meaning of the work. Paul Valéry valued only consciousness 'at its most abstract' as a resistance to the lure of the senses, claiming that 'our *personality* itself, which, stupidly, we take to be our most intimate and deepest *possession*, our sovereign good, is only a thing, and mutable and accidental in comparison with this other most naked ego'.[41]

This emphasis on the abstracting mind turns up in many modernists, who, like Paul Klee, were actually more interested in the human capacity to generate forms than the forms of nature. The artist examines nature, says Klee, and 'The deeper he looks, the more readily he can extend his view from the present to the past, the more deeply he is impressed by the one essential image of creation itself, as Genesis, rather than by the image of nature, the finished product.'[42] The abstractive capacity of the imagination is the supreme value. Thus, Wallace Stevens criticized romanticism for its hobbling of the imagination by concentrating on nature, just as sentimentalism, he believed, hobbles feeling. 'The imagination is the only genius. It is intrepid and eager and

the extreme of its achievement lies in abstraction. The achievement of the romantic, on the contrary, lies in minor wish-fulfillments and is incapable of abstraction.'[43] As André Malraux exclaimed, 'I name that man an artist who *creates* forms.'[44]

Through the imperative of form and the notion of genius in abstraction, avant-garde modernists attempted to separate themselves from romanticism. Instead of recognizing the 'human face divine' in nature, the avant-garde artist used his abstractive imagination to discern forms in nature, which in turn confirmed his genius since he had actually created the forms in the first place. Apollinaire rewrites the Promethean myth to reflect this dynamics. 'I love the art of today,' he says, 'because above all else I love the light, for man loves light more than anything; it was he who invented fire.' This is the 'Modern Prometheus' whom Mary Shelley so dreaded, but a Prometheus who has not stolen fire from the gods but invented it himself. Apollinaire pictures this titantic artist in search of a beauty purged of human charm in an impersonal, Kantian rationalism:

> The modern school of painting seems to me the most audacious that has ever appeared. It has posed the question of what is beautiful in itself.
>
> It wants to visualize beauty disengaged from whatever charm man has for man, and until now, no European artist has dared attempt this. The new artists demand an ideal beauty, which will be, not merely the proud expression of the species, but the expression of the universe, to the degree that it has been humanized by light.[45]

Ideal beauty and the 'enlightened' universe were to be expressed in a new, formalized viewing space: the white cube. As the critic Brian O'Doherty describes it in his brilliant monograph on the ideology of the modernist gallery:

> The white cube is usually seen as an emblem of the estrangement of the artist from a society to which the gallery also provides access. It

is a ghetto space, a survival compound, a proto-museum with a direct line to the timeless, a set of conditions, an attitude, a place deprived of location . . . It is mainly a formalist invention, in that the tonic weightlessness of abstract painting and sculpture left it with a low gravity.

O'Doherty reads this space of sanitized geometry as illustration of the fact that 'alienation may now be a necessary preface to experience'.[46]

Of course, the pathos of Apollinaire's Promethean beauty purged of charm is only too apparent. As Kierkegaard had pointed out half a century earlier, 'It is easier to indulge in abstract thought than it is to exist.'[47] Moreover, even this self-protectively inhuman stance requires a superhuman self-discipline that few artists could maintain. As the avant-garde dodged the pathos of existence with their Promethean abstraction, they denounced sentiment and sensuality and stressed the purity of form and the self-containment of the aesthetic experience.

The contrast with nineteenth-century aesthetes such as Walter Pater is instructive here. Pater agrees with the Enlightenment Voltaire that we are all condemned to death, but finds in art a heightening that is worthwhile – 'pulsations' that must be packed in if life is to be bearable. 'Only be sure it is passion – that it does yield you this fruit of a quickened multiplied consciousness. Of such wisdom, the poetic passion, the desire of beauty, the love of art for its own sake, has most. For art comes to you proposing frankly to give nothing but the highest quality to your moments as they pass, and simply for those moments' sake.'[48] The Futurists, deifying speed and the machine, could not be more emotionally distant from their Victorian predecessors caught in the spiralling heights of art.

For this reason, primitive art was a tremendously useful blind for avant-garde emotion. We need only remind ourselves of Conrad's *Heart of Darkness*, Henry James's 'Beast in the Jungle', the place of bullfighting and Africa in Hemingway's personal aesthetics, and the ethnographic sentimentality of James Agee, humbled by the noble-savage sharecroppers of *Let us Now Praise Famous Men*. Picasso appro-

priated African masks and photographs of naked African women for his formalized prostitutes in *Les Demoiselles d'Avignon* **[Pl. 7]**.[49] From expatriatism to the Jazz Age and the Surrealists' fascination with Poe's 'Imp of the Perverse' and the Marquis de Sade, modernists sought out the thrilling 'Other' as a substitute for the allure and charm they had eliminated from their art. In Apollinaire's excited description of the mysterious 'fourth dimension', we discern the modernists' explicit connection between primitivism and the Kantian sublime:

> the fourth dimension . . . has come to stand for the aspirations and premonitions of the many young artists who contemplate Egyptian, negro, and oceanic sculptures, meditate on various scientific works, and live in the anticipation of a sublime art.[50]

Those artists who still wanted to adapt woman to their aesthetic purposes had their work cut out for them. To prevent the confusion of the beauty of woman with the beauty of art and to avoid the complex emotions that might arise from her evocation, modernists stylized the female subject, transforming her into something she both is and is not. Sometimes this involved treating her as a female principle generating endless, often contradictory multiples, such as Joyce's Milly/Molly in *Ulysses* or his Anna Livia Plurabelle in *Finnegans Wake* in which femininity is a river running through the land/book and beauty is plural, fecund, and abstract. Max Ernst's *La Femme 100 Têtes* creates an endlessly fetishizing fort-da: woman with one hundred (*cent*) heads, woman without (*sans*) a head: woman with one hundred natures, woman without a nature; woman brimming with reason, woman without reason; woman with a hundred tits (*tétines, tétons*), woman without tits; woman with a hundred testes (*testicules*), woman without testes; and so on.[51] When woman is made so 'plurabelle', so various in her beauty, she is generalized out of existence.

Picasso, like other modern painters, transformed the allure of the female subject into the formal beauty of line and volume, and in the process, transferred our response from admiration of her beauty to

admiration of his virtuosity. His epoch-defining painting, *Les Demoiselles d'Avignon*, takes a standard nineteenth-century subject – prostitutes in a brothel – and replaces their allure with the extraordinary achievements of form that launched modernism. But in the very moment in which female allure cedes to formal éclat, Picasso introduces the African fetish object – someone else's manna, someone else's source of fascination. Out goes the woman; in comes the discipline of form, which just happens to mimic the look of the primitive cult object. If modernist art was too sophisticated to confuse the desire aroused by a subject (woman) with the Kantian perfection of its form, it did not eliminate desire altogether. It simply quoted the desire and power of those not so 'advanced', and translated the bearers of that manna into form.

This substitution was not limited to the female image in art. If woman had served as a symbol of art, art equally served as a symbol of woman, and twentieth-century novelists concerned with the place of women in society played out the same scenario as modernist artists. Their heroines morph without warning into formal patterns and exotic masks. In Jean Rhys's *Quartet*, for example, the heroine Marya 'realized that the drawings were beautiful. Groups of women. Masses of flesh arranged to form intricate and absorbing patterns.' Pursued by an insensitive, manipulative lover, suddenly her 'cheek-bones looked higher and more prominent, the nostrils wider, the lips thicker. A strange little Kalmuck face. [Her seducer] whispered, "Open your eyes, savage. Open your eyes, savage."'[52]

It was during this time that Joan Rivière's pathbreaking article, 'The Feminine Masquerade',[53] described femininity as a visual and behavioural disguise that women learned to assume. Far from the Victorian cult of 'true womanhood', in which the image of the feminine is one with its essence, in the twentieth century every woman becomes a modernist artist, creating herself as female through a stylized, exotic, and non-natural mask. As we saw in the previous chapter, this female artistry produced much ambivalence among nineteenth-century painters and writers. 'The process by which a woman could be transformed from a mere female into the epitome of feminine desirability

exerted a considerable fascination over artists in the late nineteenth century', according to Tamar Garb.

> Especially popular were pictures of women assuming their public faces, their modern masks, in the ostensibly private sanctuaries of their dressing rooms . . . For many contemporary commentators, the theme suggested a comparison between the superficial artistry of women, endlessly and sometimes futilely preoccupied with their own self-preservation and presentation, and the elevated, disinterested concerns of Art and the Ideal to which the serious male artist aspired.[54]

Realism and naturalism had set themselves the task of removing pretty masks that covered the unpleasant truth below, mainly because these masks had become so patently inadequate. 'We have plenty of these masks around us still,' wrote George Bernard Shaw in 1890, debunking the ideology of marriage, 'some of them more fantastic than any of the Sandwich islanders' masks in the British Museum. In our novels and romances especially we see the most beautiful of all the masks: those devised to disguise the brutalities of the sexual instinct . . . the basis of sexual relationship being in the main mere physical appetite.'[55] August Strindberg presents the aristocratic value of honour as likewise a vestige of the chivalric age which now, no longer tenable, is a dangerous façade undoing the upper classes.[56] As modernism proceeded, rather than stripping away the mask, artists chose to strip away reality to reveal the paradoxical 'truth' of the mask above.

There is something obviously contradictory about art presented as this fetish object – ravishing, evoking shudders and awe, and at the same time an embarrassment to the post-Enlightenment mind. Borrowed from another culture, it was defanged and manageable, as the impulse behind the designation 'fetish' suggests. This was the word that sixteenth-century Portuguese sailors gave to African religious symbols, implying that though the Africans believed these objects to contain godhead, they were obviously mistaken to do so. The crosses the

Catholic sailors wore were, of course, *not* fetishes from their point of view. The whole concept of the fetish involves the patronizing critique of the belief system of a 'more primitive' culture by a more sophisticated one. Freud's sexual fetish names a similar displacement of power, as does Marx's commodity fetish. In these, the pagan, the neurotic, the bourgeois, all are seen to be in error about where power and value lie. 'The word "fetishism", of obscure origins and disputed etymology, has worked its way through the rationalising discourses of the European Enlightenment; connoting over-valuation and displacement, its job was to signal error, excess, difference and deviation. Perhaps one of the key phantoms of the dream of reason, it helped to structure and enforce distinctions between the rational and irrational, civilised and primitive, normal and abnormal, natural and artificial.'[57]

The designation 'fetish' is thus a primary tool of colonialist ideology and of the ethnographic inquiries that it spawned. The term creates a reassuring zone of safety for the culture that uses it, since by seeing through the Other's fetish it affirms its own rationalism and authority. Moreover, the superior culture can deal with the fetish with impunity, since for them it is only an object, though one especially valued by an Other. Paul Eluard praised Picasso's ability to see in 'primitive' religious fetishes the sophistication of modernist form. Form, from a Kantian standpoint, is an 'authentic' rather than delusional value; the sublime, despite Mary Shelley's dramatization of its primitivism, would likewise not be considered a fetish by a modernist. A little flirtation with other cultures' witchcraft is safe and can be invigorating and enlightening. But remember Le Fanu. You never know when the monkey will get you.

The modernists had lost this gothic fear entirely, and were entranced with the formal stylization of the fetish objects of Africa and Oceania, filled with energy and virility. According to Picasso, 'Primitive sculpture has never been surpassed.'[58] Not tied to styles or historical eras or academicizing conformity (at least as far as the modernists could see), primitive art was at the furthest reach from bourgeois values. Tristan Tzara made this point, perhaps unintentionally, in his 'Dada Manifesto' of 1918:

If I cry out:

> Ideal, ideal, ideal,
>
> Knowledge, knowledge, knowledge,
>
> Boomboom, boomboom, boomboom,

I have given a pretty faithful version of progress, law, morality and all other fine qualities that various highly intelligent men have discussed in so many books, only to conclude that after all everyone dances to his own personal boomboom.[59]

Though he was denouncing order, convention, and progress, Tzara's parallelism suggests the twentieth-century fulfilment of rationalism through primitivism. Kantian ideal and primitivist boomboom were two sides of the same coin.

It is fascinating to observe how consciously the epoch-making works of modernism transform woman, the nineteenth century's arch-symbol of art, into abstract form, and female beauty into the alienated allure of the fetishized image. The beginning of futurism and ultimately conceptualism, Duchamp's *Nude Descending a Staircase* [Pl. 8], translates the nude into a system of lines and planes in motion, suggesting the modern fetish of the machine. In his *Large Glass: Bride Stripped Bare by Her Bachelors, Even*, the romance topos of the stripping of the beautiful woman is announced in the title but denied in the work, which contains no recognizable bride but does strip art down to the transparency of glass and abstract markings. In this sceptical report of a 1910 interview with Georges Braque in 'The Wild Men of Paris', the progression from female image to form to fetish is plainly present, along with the typical modernist disdain for ornament, which we will soon discuss. Braque gave his interviewer, Gelett Burgess,

> a sketch for his painting entitled 'Woman' [Pl. 9] in the Salon des Indépendents. To portray every physical aspect of such a subject, he said, required three figures, much as the representation of a house requires a plan, an elevation and a section. His chief preoccupation is the search for violence . . . for a primitive emotion. He looks at

Nature in order to possess it emotionally. In his sketch there is a 'harmony of volume', which is a step further than any mere flat decorative effect. It is a spiritual sentiment.[60]

In Surrealism, too, this translation of woman into form was central. The thoroughgoing realism of Magritte's painting was contradicted by the surrealism of his subjects, which were often women. The female form inhabits clothing in *Philosophy in the Boudoir*, but there is no woman present. Many of Magritte's works have titles associated with the place of women in the romance or melodrama,[61] for example, *La Belle Captive* **[Pl. 12]**, but in these works, the beautiful woman is absent, replaced by a repertoire of puzzling objects such as tubas, fish, a fire, or works of art. One of Magritte's canvases is a virtual allegory of this situation: *Attempting the Impossible* **[Pl. 10]**. Here, in a typical, meticulously realistic rendering, Magritte shows a painter with his brush poised before his work: a nude woman painted in thin air, as real as he is. But he has not been able to complete her; one of her arms is missing. It is an impossible task for a modern artist to paint a woman. The closest he gets is to paint a nude, murdered mannequin in *The Murderer Threatened* or a fragment of a female nude in *Representation*, in which the bodily contours look like a mirror image 'no more real than its painted counterpart . . . It is the representation of a painting, not a woman's body',[62] and certainly not a whole woman.

The same procedure is apparent in the figure of Rrose Sélavy, devised by Duchamp. This joke itself replaces a woman with a theory ('Eros, c'est la vie'), in the process turning woman into passion and passion into principle. An image by Magritte takes this further: *Je ne vois pas la . . . cachée dans la forêt* **[Pl. 11]**. Here my ellipses stand in for the image of a nude. In the painting, she is there, in the midst of the lettering, but her presence has excised the word that stands for her, 'FEMME'. Moreover, she is 'not seen' by the ornamental frame of male Surrealists who surround her image, whose eyes are closed, no doubt in order for them to see further into the forest of symbols that is the haunt of the Surreal artist. Though 'eros is life', the woman (that stuttering

Rose) is rendered invisible to the artist, hidden in the forest; even the word 'woman' is absent, deliberately omitted. Likewise, Duchamp's graffito – the mark he adds to the history of art with his moustache on the *Mona Lisa* – is another excision of the female subject in Surrealism, and a mocking one, too. Entitled *L.H.O.O.Q.*, it recasts Da Vinci's lady, a paradigm of female beauty in art, as a vulgar sexpot ('Elle a chaud au cul' – politely translated, 'She's got the hots') in yet another taming of the prostitute-woman by an act of male conceptualist rewriting. André Breton showed his grasp of this gender dynamics when he offered as the consummate absurdist joke: 'Kant distracted by women.'[63]

In short, modernist artists turned the viewer's attention from subject matter to form, and symbolized this switch by subverting or eliminating the image of woman. In the process, they made the work a fetish, valuable in itself, compelling, a formal compensation for a problematic reality. How interesting that at the very moment when art was being reconceived as a self-referential, self-contained, self-valuable object, the perennial symbol of such narcissism and fetishistic allure – woman – was rejected from it.

This was the situation, at least, in élite art. The newer, lower arts of photography, film, and advertising performed no such symbolic murder. Indeed, this contrast is one of the most striking characteristics of twentieth-century aesthetics. The photographic arts, in which form and subject matter are so much harder to dissociate than in painting or sculpture, intensified that difficulty by using a subject matter that specifically evokes desire – woman. Think of Busby Berkeley musicals in which female dancers form themselves into ornamental designs with their elaborately costumed bodies, or the sexualized female images in the comics, advertising, and fashion photography, or the fetish of the movie star – Greta Garbo caressed by the camera. Popular pornography grew bolder and bolder in presenting the allure of the female image, and the more abstracted the nude became in painting, the more literally the female body was depicted in photography. The allure of the female nude in a heterosexual (or perhaps lesbian) aesthetic becomes all but

indistinguishable from the allure of the art in which this subject appears. No doubt, this 'vulgar', quasi-pornographic confusion, in which the viewer responds to content rather than form, is one of the factors that caused the photographic arts to be considered 'low' in the first place. This class politics of medium follows from a gender politics in aesthetics inherited from the Enlightenment.

Thus, one can view the history of twentieth-century aesthetics in terms of four interconnected symbols of beauty: form, fetish, woman, and ornament (soon to be discussed). The 'supreme fiction' of the avant-garde would then be a melodrama in which the ornamental woman was dishonoured and rejected in favour of her purer rival: form; but her allure – and hence pleasure – were secretly smuggled in in disguise through the fetish. These four symbolic subjects are more crucial for modernism than the mirror (or for that matter, the lamp) of previous centuries. As Oscar Wilde wrote at the advent of modernism: 'Art finds her own perfection within, and not outside of, herself. She is not to be judged by any external standard of resemblance. She is a veil, rather than a mirror.'[64] The *New Yorker* cover discussed earlier shows the inadequacy of mirroring in modern aesthetics, even when it is a matter of art reflecting art rather than life. If art is a veil rather than a mirror, male modernists, purporting to lift it, instead compulsively embroidered it with the awesome exoticism of mask, machine, and abstraction.

In modernism, just as woman was banished and yet not banished, so ornament was prohibited and yet constantly at issue. Manifesto after manifesto vilifies artistic ornament: from Pound's Imagist manifesto to Hemingway's writings on artistic honesty, from Adolf Loos to Le Corbusier in architecture, and in virtually every visual movement from Futurism to Dadaism to Surrealism. In order to fetishize artistic form, modernism argued for its seamlessness, its unity, the universal internal connectedness of its every element. Ornament, in contrast, implies a concept of the artwork as essential structure and incidental surface – beauty as add-on, and the process of beautifying as adding something whose only function is to beautify. 'Every concept, every emotion,

presents itself to the vivid consciousness in some primary form. It belongs to the art of this form,' Pound wrote. 'Since the beginning of bad writing, writers have used images as ornaments. The point of Imagisme is that it does not use images as *ornaments*.'[65] Ornament was anathema to formal unity, and so it joined woman as a modernist outlaw.

Throughout aesthetic history, woman and ornament have functioned as analogues. Women wear ornaments (more consistently than men), and have been considered, for better or for worse, ornaments to society and the home. Ornaments epitomize the aesthetic; their primary function is to be beautiful in themselves and so to add beauty to the larger wholes in which they figure. Thus, the aesthetic symbolism of ornament involves a gesture of 'pleasing', an openness of appeal that is conventionally gendered feminine. It is part of the ideology of charm, the use of beauty to exercise power through pleasing. The contradictoriness of this gesture, which exerts power over another by fulfilling the other's desire, has produced an age-old history of distrust and anger. To be 'merely ornamental' is purportedly to be useless or without practical effect, and yet the ornamental is also taken as a black magic of utility and power associated with deception and the meretricious. This helps to explain why, in Kant's insistence on disinterested interest as the basis of aesthetic judgement, he separates charm from beauty.

Ornament is thus at the heart of deep-seated anxieties about beauty's relation to freedom. Kant wanted to create an aesthetic realm of absolute freedom, where no question of constraint would enter in. He had to banish, therefore, a good deal of what draws people to beauty in the first place, the realm of allure that Harold Brodkey describes as efficacious:

> Looks are meant to have an effect. They show a degree of physical intelligence, *social* intelligence. Of course, there are degrees of strikingness, degrees of hurt and of winning out . . . How much nerve and good humor, how much *strength*, how much cold-and-hot gambler's nerve (and defiance) does it take to be good-looking?[66]

Because of the confusion and anxiety surrounding the power of beauty, the open appeal of ornament has made it a perennial scapegoat. A good deal of the history of misogyny and of anti-art puritanism can be summed up in the use of the word 'ornamental', however much it may appear that only fineness of taste is at issue. In describing the virtues of the Attic style, Cicero argued that 'just as some women are said to be more beautiful when unadorned, because this suits them, so this plain style delights, even though it lacks embellishments'.[67] Almost two millennia later, the architect Louis Sullivan, a proponent of functionalism (who later used ornament freely), wrote that architects 'should refrain entirely from the use of ornament for a period of years in order that our thought might concentrate acutely upon the production of buildings well formed and comely in the nude'.[68] Clarity of design can result only from the stripping away of adornment to reveal naked beauty.

In 1908, the Viennese architect Adolf Loos wrote a diatribe against decoration entitled 'Ornament and Crime'. Loos equated the impulse to embellish with eroticism, barbarism, and immorality. Decorating a building is like tattooing one's body, he argued, a modern transgression for both women and men. 'The Papuan,' writes Loos, 'tattoos his skin, his boat, his oar, in short, everything that is within his reach. He is no criminal. The modern man who tattooes himself is a criminal or a degenerate . . . If a tattooed person dies at liberty, it is only that he died a few years before he committed a murder.' 'The *evolution* of culture is synonymous with the removal of ornament from objects of daily use.' And in a sentence anticipating the postmodern connection between graffiti and ornament he writes, 'One can measure the culture of a country by the degree toward which its lavatory walls are daubed.'[69]

Just half a century earlier, Owen Jones, a nineteenth-century historian of ornament, had used these very arguments to demonstrate that decoration was a positive barometer of civilization. The desire for ornament, Jones writes, 'is absent in none, and it grows and increases with all in the ratio of their progress in civilization . . . Man's earliest ambition is to create. To this feeling must be ascribed the tattooing of

the human face and body, resorted to by the savage to increase the impression by which he seeks to strike terror on his enemies or rivals, or to create what appears to him a new beauty.'[70] Tattooing for the nineteenth-century Jones was proof of the primordially human need for creativity and beauty, which only grows stronger and more sophisticated with the 'advance' of civilization. Jones here reveals the mindset of his day, steeped in ideas of progress and historical continuity. For modernists such as Loos, however, progress meant breaking away from the past, jettisoning the body and its decoration in favour of the purity and sublimity of form.

This purification was, as ever, understood in misogynistic terms. Charles Blanc, a late-nineteenth-century historian of dress, interpreted the new sobriety and uniformity of men's clothing as 'an external declaration of the principles of civil equality and liberty, inaugurated in the world of the French Revolution'. For him, ornamentation belonged to the less civilized: women and primitives. 'In proportion to their elevation above savages, men disdain jewels, leaving them for women. They only retain those worn as remembrances, emblems of attachment and fidelity, jewelled and wedding rings, lockets, trinkets, or rich scarf pins, which excuse their beauty by their utility.'[71] An ornamental beauty was excusable only as an incidental by-product of utility, as if pleasure and functionality must invariably be a trade-off, with functionality the only ethically sound choice.

Since women spend so much energy on self-adornment, the elimination of ornament from high art was another way of denying the female and with it, bourgeois taste and domesticity. Ornament is utterly entangled in pre-modernist notions of domesticity and family feeling. This excerpt from a poem by the decidedly non-avant-garde E. J. Scovell reveals the connection strikingly:

Embroidery

Child, when I swing you up and down
You make a chevron pattern travelling over time
Like the embroidered zigzag stitch I use to seam

The shallow yoke of your nightgown;
And when I walk along lifting and lowering you,
On the walls and the air you make this pattern too.

You are the adornment of our days,
Your life so pattern-regular, your looks so pretty
They seem a golden thread embroidered on our city.[72]

Whereas such nineteenth-century, Gilded Age painters as Cecilia Beaux or Mary Cassatt or John Singer Sargent can show the interconnection of child, woman, home, and middle-class values in the visual rhyming of lace dresses and golden curls and mantelpiece carving, the twentieth-century avant-garde systematically destroyed these echoing structures. For them, the model for art was the machine, an analogue that had as destructive an effect on domesticity and the family as Frankenstein's monster.

The purism of Sullivan and Loos flourished in Constructivist and Bauhaus architecture, and versions of such functionalist thinking can be found in all the arts. These movements generated a critique of ornament that derives much from earlier formulations. Ornament is, first, non-structural, non-functional, and inessential; it creates upsetting discontinuities from architectural space; it belongs in the category of waste and sham; and its connection to fashion causes it to age, showing its roots in the fleeting moment rather than in a non-contingent, universal sphere. All these criticisms have been applied, *mutatis mutandis*, to women. No wonder that Braque wanted to exchange the ornamental woman for 'a plan, an elevation and a section'.[73]

Sant-Elia and Marinetti's criticism of the buildings of their day, thus, is typical: 'What is called modern architecture is a stupid mixture of the most varied stylistic elements used to mask the modern skeleton. The new beauty of concrete and iron is profaned by the superimposition of carnival decorative incrustations.'[74] The word 'carnival' is instructive here, for through it, ornament is associated with the whole spectrum of phenomena that the Russian aesthetician Mikhail Bakhtin would later

term the 'carnivalesque'.[75] It belongs to the realm of play rather than work, and its dominance implies the upset of the practical, pragmatic world. Ornament threatens the notion of universal truth and value, being most subject to obsolescence. The dominance of an ornamental aesthetic would imply the suppression or outright dismissal of atemporal and ahistorical claims for art. Art would be understood as contextual, unabashedly advertising its disdain for eternity.

Ornament also implies multifunctionality. In so far as a building can never be purely ornamental without becoming a statue,[76] architectural ornament introduces heterogeneous purposes in an artwork, and hence multiple and inconsistent interpretations. The impulse towards 'purity', and therefore monofunctionality, is apparent in the modernist revolt against such decorative movements as Art Nouveau where, predictably, woman and ornament are virtually indistinguishable. Gustave Klimt's *Frau Adele Bloch-Bauer* and Alphonse Mucha's *Sarah Bernhardt* are dramatic examples of this conflation.

Pictorial abstraction achieved this purity by eliminating not ornament but representation. As Gombrich notes, 'It was in the period when the creation of decorative forms was increasingly suppressed in favour of functional utility that what is called abstract art made its entry into the preserve of painting and sculpture.'[77] If architecture was to be exclusively practical in function, painting was to be purely aesthetic. However, reducing the semantic function in abstract painting led to a virtual collapse of the distinction between ornamental and pictorial art. Of course, this possibility is always present. As F. Paulhan wrote, 'great art such as painting or sculpture is, in one way, equal to the decorative arts: the purpose of a painting or a statue is to decorate a hall, salon, façade or fountain'.[78]

Early in the century, the Nabi artist Maurice Denis openly approved this equation: 'I think that above everything else a painting should be an ornament. The choice of subjects for scenes means nothing. It is through coloured surfaces, through the value of tones, through the harmony of lines, that I attempt to reach the mind and arouse the emotions.'[79] Denis, like the brilliant Pierre Bonnard, saw no threat in

the ornamental function of art (as we shall see in Chapter 5). But these artists, and indeed, most of their Nabi circle, were written out of the history of modernism for this very reason. They were comfortable with the domesticity, femininity, charm, and multifunctionalism that their sublime counterparts could not tolerate. Modern artists, faced with the blurred boundary between pure painting and ornament, stressed colour, texture, scale, and line to insist that they were creating essential, pure art rather than wall decorations. But there is a certain irony in the fact that Abstract Expressionism looks so good over sofas.[80]

This disconcerting collapse of the opposition between the pure and the decorative is apparent in many modernist paintings. Between 1913 and 1916, architectural ornaments such as entablatures appear as pictorial elements in Picasso and Gris's Synthetic Cubism, with the same degree of 'thingness' as chairs and glasses and newspapers. The beautiful woman receives much the same treatment. In Matisse's *Harmony in Red*, the background and foreground are collapsed in an ornamental flatness of design, though the female figure is still differentiated. But consider the title of Matisse's *Decorative Figure on an Ornamental Ground* **[Pl.14]**. The 'figure', the nude woman, is so stylized in her eroticism that she becomes merely decorative, in the same sense as the 'background' is. There is no important difference between them – or by implication, between pure art and ancillary ornament. In making everything essential, the modernist makes everything secondary, and the blank, uncompelling face of the nude in this work indicates the suppression of both desire and the desired in such an aesthetic. As John Elderfield has written of this painting:

We see the . . . mirror lodged in the pattern of an ornamental screen, whose rich floral profusion may be viewed as simultaneously acknowledging and displacing the model's sexuality, which is, of course, erased from representation of the model herself. Indeed, a gendered pronoun seems inappropriate in describing this figure: because it is shown as a kind of sculpture (both in its handling and in the miniaturization of it effected by its setting); because it seems

androgynous; and because it substitutes for the (petrified) male painter in the preceding, companion picture [*The Painter in His Studio*, 1916], thus presenting itself, in effect, as a phallicized female image.[81]

Elderfield goes on to argue that Matisse shows the same anxiety about focusing the gaze on any object. In this 'dispersal of vision', the representational Matisse was in fact fleeing representation. But again, it is through the transformation of the female subject into an exoticized neuter that Matisse conducts this flight. As he wrote of his odalisques, 'The emotional interest they inspire in me is not especially visible in the representation of their bodies, but more often in the lines or special values distributed over the whole canvas . . . It may be sublimated sensual pleasure.'[82] Elderfield suggests an individual pathology here, that Matisse was fixated on his daughter Marguerite, whom he turned into an impersonal odalisque, unavailable to her new husband's view. Whether this is so or not, the transformation of the female body into 'lines and special values distributed over the whole canvas' in a 'sublimated sensual pleasure' is a classic formulation of the strategy of twentieth-century avant-garde artists, who replaced the female subject and ornament with form and fetish.

It is interesting to consider what has happened to domesticity and living space in the process. At first glance, Matisse's art would seem to be the antithesis of the development I have been describing. It is filled with nude women. It is also relatively representational, though certainly stylized; brilliantly colouristic, indeed, belying any notion of sensory reduction or deprivation; and usually unconcerned with the machine or urban alienation.[83] Most people would not hesitate to call it 'beautiful' in a sense that has little to do with the thrillingly reductive sublimity of the twentieth-century avant-garde. Yet so many of Matisse's interiors turn domesticity into the seraglio, exoticizing women and posing them nude, turbanned, decorative in a distinctively non-Western style, however Western their features. They have been remade as fetishes. We might recall that Matisse's teacher, Moreau, painted beautiful women

sporting tattoos that were actually incised into the paint, a trans-
formation of represented tattoo into formal tattoo.

If Beaux or Sargent likened woman to ornament as an expression of
bourgeois values, Matisse does so to deny those values utterly, and
indeed, to eliminate the very agency of his female subjects. Woman
may be sexually alluring, but in Matisse she plays no conscious part in
the seduction. She is not an active agent, not situated in a setting that
expresses her will or action. In this way, modernism revised the tradi-
tional association between the ornamental woman and the domestic
setting she creates in her image. Manet's Olympia may not have been
meant to provoke a nesting impulse, but she does express through her
'interior design' a female consciousness who has made decisions about
how to communicate her desires. Matisse's blank-eyed stylizations do
not express themselves in their domestic spaces but might as well *be* the
inhuman curlicues and grilleworks that surround them.

One could go on enumerating the anti-ornamentalism of modernism
art by art – in the formalism of literary theory in this century, the
polemics of poets against decoration, and the issues raised overtly in
many works of art. In literature, for instance, just as stylistic ornament
was forbidden, the job of the poem was to turn all cultural debris into
meaningful elements of a significant whole. Poems epic in length – *The
Waste Land, The Cantos*, William Carlos Williams's *Paterson*, Hart
Crane's *The Bridge* – set as their task the integration of history and art
into a complex vision in which everything is vital, hyper-semantic,
over-determined. Tragedy lies in loose ends, but of course, tragedy is
inescapable.

In short, in architecture, painting, literature, and criticism, modern-
ism advocated purity and monofunctionality, attempting to manage
disjunction and diversity (the 'infinite variety' of Cleopatra and all
fetishized women) either by suppressing or vilifying them. This goal led
architects to cut out ornament directly. In painting, it produced the
paradox of artworks all but indistinguishable from ornaments, and so
provoked an ongoing polemic on the part of artists against the vulgar,
practical use of their canvases as interior decoration. And in literature,

monofunctionalism was expressed as the urge to synthesize and vitalize. Thus, in so far as ornament implied excess, supplementarity, and play, modernism might be characterized as a period as hostile to ornament as it was to the female subject.

It is striking how openly the early twentieth century connected the demise of ornament with the undoing of the romance heroine. Edith Wharton's *The House of Mirth*,[84] originally called 'A Moment's Ornament', presents a woman who actually dies for relying too heavily on the traditional relations among beauty, art, and feminine power. Perhaps we should not be surprised at this, since in 1897, before she had written any of her novels, Edith Wharton published a book on interior design that inveighed against the excessive ornament of the Victorian era. This book, *The Decoration of Houses*, which Wharton co-authored with the architect Ogden Codman, Jr, recapitulates in many respects the avant-garde anti-ornamentalism of her day.

The Decoration of Houses begins with an epigraph from Henri Mayeux's *La Composition décorative*: 'A form must be beautiful in itself and one must never count on applied decoration to redeem its imperfections.'[85] Not an aesthetic band-aid, modern ornament should be integral to the structure of the house, but sadly, decorators have seldom achieved this ideal. '[W]e have passed from the golden age of architecture to the gilded age of decoration,' Wharton complains. Her introduction thus begins with the following contrast: 'Rooms may be decorated in two ways: by a superficial application of ornament totally independent of structure, or by means of those architectural features which are part of the organism of every house, inside as well as out.' Obviously, the second procedure is the one Wharton favours. It involves using the architectural features of a house – the mouldings, architraves, and cornices demarcating doors, windows, floors, ceilings – to create decorative interest. Instead of adding curtains and tapestries and rich upholsteries, 'the architecture of the room became its decoration'. That is, the functional elements of a structure should provide the occasion of its ornaments: 'Structure conditions ornament, not ornament structure.' Proportion and stylistic decorum are positive

virtues; gimcracks, bric-à-brac, and bibelots are anathema.

Though Wharton's language sounds very much like that of the avant-garde who were to follow, the rooms and furniture she uses as illustrations have little in common with what would emerge as modernist design. There the aim would be to eliminate ornament from architecture rather than to create a harmonious integration of structure and decoration. Wharton's thinking, in fact, was an effort to preserve a traditional notion of interior design: dignified, but also domestic and feminine. The image of the human condition that it reflects is not related to commerce or technology, and Wharton often sounds much closer to William Morris than to Marinetti.[86]

The House of Mirth is in many respects a fictionalization of *The Decoration of Houses*, with its heroine, Lily Bart, an instance of woman-as-ornament. Lily presents herself, and is taken by others, as a work of art.[87] But unlike an artwork, she cannot exist in pure isolation, complete in herself. She is dependent on the world of exchange, or real interests. She is beautiful, but she finds she must use her beauty as strategically as the most skilled artist. An extensive system of metaphors highlights her against drab and enhancing backgrounds, compares her to a jewel in need of a proper setting, and establishes her as a genius of visual effect. She is a strange amalgam of creator and creation, agent and object, and in this respect she embodies the contradiction implicit in the idea of ornament – something beautiful in itself that also adorns and supplements what is around it. Lily would prefer to be freer than that, but her father became bankrupt long ago, and practical necessity is never far from her thoughts. Her friends in smart New York society have very mixed feelings about a beautiful woman of good family who has no fortune: she must find a setting, or she might sully her beauty in the wrong sort of exchange. They assume that Lily's beauty cannot exist outside of exchange, as Kantian beauty must.

Even the philosophic Laurence Selden is bothered by ornamental beauty. 'I don't underrate the decorative side of life,' he states. 'It seems to me the sense of splendour has justified itself by what it has produced. The worst of it is that so much human nature is used up in the

process.'[88] In Selden's criticism, the problem of ornament is that it attempts to stand outside the realm of practical contingency, while still involving a cost. As the literary scholar Judith Fetterley points out, 'the ornamental cannot exist without a solid economic base',[89] a base which the poor but expensive Lily cannot bring herself to acquire. All through the novel, she keeps foiling her chances of marrying rich but uninteresting men. For worldly though she is, she has fallen under the spell of the ideology that most empowers her beauty – the literary romance – and in that system of values she cannot be a transcendent love object if her beauty is merely the coin that buys her wealth and station. The difficulty for Lily is that to be a romance heroine she feels that she must be a monofunctional creature, a purely aesthetic object, unsullied by vulgar or immoral associations. Yet in the early twentieth century, in all realms – business, politics, architecture – the practical function was becoming the monofunctional choice.

In *The Decoration of Houses*, Wharton seems still to believe that some common ground between aesthetics and capitalist exchange is a possibility. In considering whether reproductions are suitable for the home, for example, she writes, 'The United States customs laws have drawn a rough distinction between an original work and its repro-ductions, defining the former as a work of art and the latter as articles of commerce; but it does not follow that an article of commerce may not be an adequate representation of a work of art.'[90] Here art and commerce seem to strike an acceptable compromise, but by the time Wharton was imagining Lily Bart, they had become utterly incom-patible in her thinking. The narrator indicates the clash between the marginalized ornamental function and the dominant practical one in a passage towards the end of the novel: Lily 'had been fashioned to adorn and to delight; to what other end does nature round the rose leaf and paint the hummingbird's breast? And was it her fault that the purely decorative mission is less easily and harmoniously fulfilled among social beings than in the world of nature? That it is apt to be hampered by material necessities or complicated by moral scruples?'[91]

The incompatibility of the aesthetic and practical functions is the

perennial dilemma of the ornamental woman, mainly, it seems, because it causes an intolerable confusion in her 'audience'. For example, in *Paradise Lost*, a text alluded to throughout *The House of Mirth*, Adam tells us that nature bestowed on Eve

> Too much of Ornament, in outward show
> Elaborate, of inward less exact.
> . . . yet when I approach
> Her loveliness, so absolute she seems
> And in herself complete, so well to know
> Her own, that what she wills to do or say,
> Seems wisest, virtuousest, discreetest, best;
> All higher knowledge in her presence falls
> Degraded.[92]

Even Satan is stopped in his tracks by Eve's beauty, becoming for the moment 'stupidly good', like Frankenstein's monster a century and a half later. Milton, despite his puritanism, shows great susceptibility to the ornamental woman – or at least his character Adam does. But this power divorced from real-world concerns turns out to be undependable. By the twentieth century, the stock of the ornamental woman had tumbled.

And what is the power that makes an Adam or Satan neglect all truth and reason, if not the pure, self-referential completeness of the aesthetic object? Like Lily's seal – the word 'Beyond!' beneath a flying ship[93] – the artwork's isolation from practical contingency is the condition necessary for its transcendent value. Ornament, however, is always dependent on something to adorn, and thus it is always ancillary, contingent, split. So is its analogue, the ornamental woman, whether as a subject in art or in life. This split state is another reason for the nineteenth-century association of art with the prostitute, as we shall see in the next chapter. Ornament was likewise considered meretricious, attracting value through base, false, deceptive means. 'One is tired of ornamentations,' wrote Pound; 'they are all a trick.'[94]

The analogy between woman and ornament implies that woman is

not only artificial but incomplete. There is no denial of a woman's humanity so seemingly complimentary as the adjective 'ornamental'. Marx argued that when capitalism alienates workers from their labour, they can feel themselves freely active only in their 'animal functions – eating, drinking, procreating, or at most in [their] dwelling and in dressing-up'.[95] As a result, in their human function (work) they are like animals; 'what is animal becomes human and what is human becomes animal'. A woman of Lily's class could not work in the world (she is finally destroyed by trying to do so); domestic work is below her socially, and domestic management is also impossible, since Lily refuses to trade herself in for a fashionable connubial establishment. Thus, she is left with 'dressing-up', which for Marx and other men is only an animal function. Lily's death as plot device and symbol is inescapable, for in an ideology that defines the human as self-expressive work, she cannot escape inhumanity, alienation.

Wharton's thinking, though unlikely much influenced by Marx, does reflect dismay at the situation of women when aesthetics and domesticity are at war. We saw Mary Shelley's horror at the Kantian sublime, whose hostility to charm and allure destroys the scientist's entire family and makes him an exile from home, pursuing his nemesis over the Arctic ice floes. Late in her life, Edith Wharton depicted the woman 'emancipated' from the home as a monster bereft of warmth and well-being, free but dehumanized: 'that ancient curriculum of house-keeping . . . was so soon to be swept aside by the "monstrous regiment" of the emancipated: young women taught by their elders to despise the kitchen and the linen room, and to substitute the acquiring of University degrees for the more complex art of living'.[96]

Edith Wharton, of course, was a woman of prodigious learning, a friend of Bernard Berenson and Henry James and other artistic luminaries of her day, among whom she had a respected standing. We can be sure that she did not spend her time happily scrubbing pots. She was not advocating any *Kinder, Kirche, Küche* world for women, but insisting on the value of integrating art and the art of living through the symbolic identity of woman. Wharton wrote *The House of Mirth* as an

elaborate allegory of the fate of woman and ornament at the advent of modernism, a time when the feminine and the domestic had been banished from art and sentimentalized or denigrated in life.

At the height of the period, the plight of the ornamental woman entered popular debate. Zelda Fitzgerald wrote repeatedly in high-circulation magazines about the dilemma of the flapper, the Follies girl, and the vamp. In 'Paint and Powder', she claims that 'with prosperity and power, comes art, the desire for beauty, the taste for the decorative'.[97] Women use paint and powder in order to 'choose their destinies – to be successful competitors in the great game of life'.[98] By doing so, they turn themselves into ornaments 'masquerading' as themselves, becoming 'objets d'art' who are 'not to be confused with the vital elements of American life'. They wear their embellishments 'as superficially as a Christmas tree supports its ornaments', and in both wearing and being adornments, they become magnets of male response. As a result, they suffer the same contradiction as Lily Bart: that their beauty is both a value in itself and an exchange value, an instrument. Zelda Fitzgerald's Follies girl 'wore herself out with the struggle between her desire for physical perfection and her desire to use it'.[99]

In the midst of this struggle, the flapper encounters the modern man's disdain for ornament. David, a thinly disguised fictionalization of F. Scott Fitzgerald, complains in Zelda's novel *Save Me the Waltz*, 'You've become nothing but an aesthetic theory – a chemistry formula for the decorative.'[100] All that Zelda Fitzgerald could do to defend the decorative woman was to appropriate the current defence of art: that in the benighted reality of the twentieth century, the artifice of female beauty is a compensation and redemption.

And so if our women gave up decorating themselves we would have time to turn sad eyes on the bleak telegraph wires, the office buildings, like homes of trained fleas, the barren desolateness of city streets at dusk, and realize too late that almost the only beauty in this busy, careless land, whose every acre is littered with the waste of day before yesterday, is the gorgeous, radiant beauty of its girls.[101]

Sadly, for modernists such as T.S. Eliot, the ornamental woman was not a distraction from the Waste Land but instead, one of its blasted horrors. The pathos and inadequacy of Zelda Fitzgerald's defence of ornamental beauty were proved out in the ruin of her madness, her life consumed in a desperate attempt to achieve perfection as a dancer, writer, painter.

Ornament and the female subject became Marlene Dumas's 'image as burden', addressing their unwelcome charms to modernists too pure or too self-aggrandizing for such appeals. The response of male artists, as we shall see, was devastating, virulent, fearsome. It turned the female subject into a monster and ornamental art into a provocation utterly alienating to its audience. However brilliant the achievements of twentieth-century art – and it is a time of blinding brilliance – they have been bought at the expense of all parties to aesthetic experience.

THE INFAMOUS PROMISCUITY OF THINGS AND OF WOMEN

In order to provide sustenance for themselves and their families, as they had ceased foraging, [the fathers of civilization] had to tame the earth and sow grain. All this for the salvation of the nascent human race. Meanwhile, scattered through the plains and valleys and preserving the infamous promiscuity of things and of women, there remained a great number of the impious, the unchaste, and the nefarious.

– Giambattista Vico, 1744

Like Victor Frankenstein, who set out to become the benefactor of humankind by denying everything human, the twentieth-century avant-garde pursued its mission of public enlightenment by purifying art of pleasure – the vulgar desire for comfort, charm, warmth, attraction, empathy. Since these despised virtues were identified with woman, the female subject in art underwent a violent transformation in meaning from the early nineteenth to the early twentieth century: from a supreme symbol of beauty to an object lesson in the need for aesthetic

discipline. Ornament suffered a similar fate. Art was to be an experience of psychic freedom rather than seduction, a freedom guaranteed by the purity of form.

Under the circumstances, the inclusion of exoticism and the fetishistic in avant-garde art was a bravura touch: the modernist could demonstrate his invulnerability by presenting desire and power and emotion as a primitivism that he had yoked to his formalist purposes. The African mask or Oceanic sculpture was someone else's impurity – mysterious, enigmatic, awesome, but not 'ours'. The artist stood above that. However, he could appreciate its 'honesty' and 'spontaneity', its absolute contrast to bourgeois convention, and therefore he was eager to incorporate it in his overall picture. His mastery was confirmed when he took these avatars of chaos and passion and integrated them into his challenging composition.

But why not take this brinksmanship a step further? Why not journey to the very heart of impurity to bring back the formal treasure? The logic of the avant-garde led ineluctably to the obscene, the porno-graphic, the abject. The public could not help but be bewildered at what appeared to be contradictory claims: art transcends normal experience, existing in a sphere beyond vulgar interest; art demonstrates its transcendence by including, indeed celebrating, every form of transgression. The most pathbreaking works of high modernism almost always struck their first audiences as shocking or obscene. Kant and de Sade seemed to egg each other on in the forward march of the avant-garde.

Virtually every milestone in twentieth-century art involved some combination of representational and moral transgression, a shock to both the senses and the sensibilities of the general public. Picasso's *Les Demoiselles d'Avignon*, for example, typically identified as the beginning of modern art, is set in a brothel. There was nothing new in that; Ingres and Degas had done the same. What *was* new – and disorienting in the extreme – was that Picasso topped some of his prostitutes' shoulders with African masks – exotic religious fetish objects – and placed them in a setting impossible to integrate as three-dimensional reality. The

painting connected prostitute and savage, and merged the deper-
sonalizing gaze of the brothel client with the invulnerable, formal gaze
of the painter or viewer. In looking at this work, we do not register the
trespass and allure of the prostitutes, but instead a disorienting spatiality
and a mysterious exoticism – distorted, numinous. We focus on the
grotesquerie of mask fused with female form and the vertigo of spatial
ambiguity, marvelling at the first and struggling to grasp the second,
challenged to understand. In the process, we have been inducted into
the inhuman acuity of the Frankensteinian artist in a vision that justified
Mary Shelley's every fear.

This invulnerability in the presence of feminine allure is a modernist
adaptation of the sublime, though obviously a vulgarization of it. Kant,
of course, would not have associated the sublime with anything like
prostitution. But Picasso was setting his viewer a rationalist lesson by
showing us sexualized women and making us see instead a problem in
ethnography and space relations. For viewers who could not see beyond
the transgressive subject matter or who did not value the experiment
with representational conventions, such works provoked anger and
outrage. People wondered why art should trade beauty for vulgarity,
primitivism, disorientation.

Though Picasso's *Demoiselles* did not meet with violence or censor-
ship, many other modernist masterpieces did. The open sensuality and
experimentalism of Stravinsky's music and Diaghilev's choreography
for the *Rite of Spring* caused rioting in the streets of Paris. James Joyce's
Ulysses ended up a landmark case in US pornography law; likewise D. H.
Lawrence's *Lady Chatterley's Lover* in England. It took photography
somewhat longer to enter legal history since its claim to the status of high
art was for so long questionable, but eventually Robert Mapplethorpe's
classicistic renderings of gay sado-masochism provoked the textbook
court decision for the arts of mechanical reproduction.

We might wonder about the odd dialogue between art and obscenity
in the twentieth century. Certainly, the most direct product of Kantian
aesthetics – abstraction – is devoid of pornographic taint, an art of pure
form that protects viewers from any hint of an interested response,

never mind a libidinous one (unless they are so vulgar as to covet the painting as an ornament for the living-room). Abstraction was an extreme case though, dependent on a purity on the part of artist and viewer that struck many people as simplistic and ultimately unrewarding. The vast majority of modernists created a much more complicated problem for their audience, a kind of dare: 'Read *this* as formal, or *this* or *this*.' The ante kept rising as to what traps and confusions could be placed in the path of the perceiver of pure form. In effect, the audience was faced with two dilemmas: a sublime uplift that felt like sterility, and a lubricity that was supposed to be beside the point. The audience that could discern beauty while being tweaked in these ways was the modernist audience *par excellence*.

Mary Shelley, we recall, found the sublime monstrous, because the awe and distance involved in this experience prevented any possibility of mutuality among artist, artwork, and audience. She symbolized this situation with a scientist/father who could not love the hideous spawn of his cold reason. In place of this horror she offered a metaphor for artistic creativity in which the artist loves what she creates because she recognizes herself in it and is moved by its beauty, charm, and even allure. The myth of Psyche and Cupid shows that this 'soft aesthetics' need not be tied to gender – that a female viewer can be moved to love and pleasure by male beauty as much as the reverse.

However, the artists and thinkers who shaped the ideology of the avant-garde found mutuality and warmth incompatible with their sublime intent. Instead, the prostitute was their preferred female subject, since her allure could be bought at will and discarded just as easily. The female subject reconceived and controlled in this way was in certain respects the monster Frankenstein had intended to produce: an artificial construction of ideal parts immune to human vicissitude or human concern. We might call the experience of this Frankensteinian monster the 'prostitutional sublime'.

Though Picasso inaugurated modernism by encapsulating it in *Les Demoiselles d'Avignon* of 1907, artists and thinkers had long associated art and prostitute. The prostitute is a creature of paint and false illusion, and

like all artworks, she is undiscriminating in her appeal, 'smiling on all alike'. This was the problem with female beauty that Alexander Pope depicted in the tautologically named belle, Belinda, in *The Rape of the Lock*. Belinda's universal appeal 'justifies' her symbolic rape at the Baron's hands; it had to be curbed, limited to one man, in order for her to be a proper member of her society. But a true prostitute's effects are indifferent to class, like the diseases she spreads. Her allure does not respect constructed differences among groups, and thus she is a danger to society, erasing class differences in her appeal and contagion. For the avant-garde artist in revolt from the bourgeoisie, what better symbol of art could possibly exist?

Nineteenth-century artists and writers quite openly proclaimed the analogy between prostitute and art, altering the meaning of the female subject and the beauty she symbolized. 'Woman is a product of man,' wrote Flaubert.

> *God created the female and man created woman*; she is a result of civilization, a factitious work. In countries where there is no intellectual culture, she does not exist (because she's a work of art, in the humanitarian sense; is that why all the great general ideas have symbolized themselves in the feminine?) What extraordinary women the Greek courtesans were! But then, what extraordinary art Greek art was![1]

In this 'reasoning', the forces of civilization are male. They turn females into women, who are therefore artefacts, works of art. And in a magical elision, this artefactual woman morphs into a prostitute or courtesan, a civilized transgression which is the highest product of the male imagination. Greek courtesans are tributes to masculine creativity, perfectly shaped to male ideals and perfectly reinforcing of male pleasure.

Unfortunately, nineteenth-century France, in Flaubert's view, had not done as good a job as ancient Greece in turning females into 'women'. Prostitute and non-prostitute alike, they were dominated by their bodies, their sexuality, their merely natural creativity, which they

deployed in the great marketplace of society. They were merely bodies for sale in brothels or marriage, with no sublime elevation as value added. Like Frankenstein's monster, they were a disappointment to their creators. 'The attitude of Flaubert and his friends toward women's sexuality was brutally disdainful,' Charles Bernheimer notes. 'As sexual beings, women were carnal organs for sale.'[2] It was up to the artist to recreate them in the image of the classical courtesan – a product a man could be proud of, a product filled with his sophistication and the will to serve his pleasure.

Bernheimer's study of the prostitute in the arts of the past century, *Figures of Ill Repute*, argues that the fallen woman played a central role in nineteenth-century aesthetics. Baudelaire famously asked, 'What is art?' and answered, 'Prostitution.'[3] He did not mean that the artist was lowering himself by entering a sordid economy of exchange, but that he stood outside bourgeois morality altogether, open to any experience. In this sense, not only is art prostitution, but the prostitute is a dead ringer for the poet as *flâneur*. The *flâneur* is the modern artist of the city, for whom experiences flash by like the figures on the crowded side-walks of Paris. He passes through this world anonymously, imprinted with fleeting sensations and emotions. 'This wandering soul', as Baudelaire depicted him in *Le Spléen de Paris*, 'gifted from birth with a "love of disguise and masks"', is the prostituted soul, for whom any one particular body is no more than a provisional identification. "What people call love is a very small, restricted, feeble thing compared to this ineffable orgy, this holy prostitution of the soul that gives itself entire, poetry and charity, to the unexpected that appears, to the unknown that passes." '

The male poet finds his analogue in the street-walking prostitute, who also experiences passion in random multiples. Interestingly, this *flânerie* sounds very much like the Kantian sublime as well. Baudelaire describes the pleasure of wandering through crowds as 'a mysterious expression of the enjoyment of the multiplication of number'[4] just as Kant saw the sublime as an experience of limitlessness, magnitude, and power.[5] As we shall see, pornography, a word which originally desig-

nated 'writing about prostitutes', is structured on repetition, unending sequence, and the indiscriminate proliferation of interest and pleasure.

The bourgeois woman, in contrast, was considered unequal to the mental state of the *flâneur*[6] since she approached the variety of people and goods in the city as a consumer, out to buy, to invest, to select, and hence to limit the infinite possibilities of experience on offer. This would become a real problem for any woman who wanted to be taken as an artist. Among the many other adjustments required, a woman aspiring to be an artist would have to alter her relation to consumerism. Thus, in the early decades of the twentieth century, Gertrude Stein wrote pointedly about her pleasure in wandering through Paris, looking in shop windows but not buying. She composed 'portraits' of window-shopping and of favourite stores such as the Bon Marché, and depicted the elements of the home – rooms and food and household objects – as 'portrait' subjects that captured her attention like items in a display or passing strangers in a crowd. As with so many aspects of modernism, window-shopping is a fascination with an Other without any commitment to it, a disinterested interest directly contrastive to bourgeois acquisitiveness. Looking, not buying, was the key.

However, the distinction between bourgeois woman and prostitute in the nineteenth century was not as stable as one would expect. First of all, respectable Parisiennes in this age of style, makeup, and public appearance 'on the town' were often impossible to tell apart from prostitutes. This dilemma was a source of complaint amongst those who liked their categories unambiguous. Bernheimer reports that contemporary medical studies examined the genitalia of 'women of the street' and 'honest wives', but could observe no difference between them. He quotes Proudhon's warning that 'We are tending toward universal prostitution', summarizing the misogynist suspicions of the day:

Bourgeois daughters slip out at night for a little excitement, working women pick up extra money on the side, professionals are omnipresent. Performing love without feeling, depraving their senses, these women discover 'the principles of pleasures *contre nature*'. And

by emancipating themselves and associating often with men, they lose the inherent, natural characteristics of their sex and are masculinized. Thus, the prostitute becomes for Proudhon the model of any *femme émancipée*.[7]

In contrast, sentimental fictions often showed 'good girls' in unfortunate circumstances who were not treated with due respect, for example, Charlie Chaplin's flower girls or Eliza Doolittle at the beginning of *My Fair Lady*. Such waifs often become the objects of men's transforming artistry, as the title of Shaw's *Pygmalion* suggests. This play, a modernist reprise of the myth of Pygmalion and Galatea, recasts the sculptor as an up-to-the-moment scientist, a dialectologist. He civilizes a female into a woman by sculpting her accent and manners. His art thus lifts the girl of the streets into the lady of the house and shows that the difference between them is only a matter of arbitrary social custom and the brilliant talents of a man motivated by pure, intellectual concerns. Eliza, whose middle-class indoctrination is more thoroughgoing than Professor Higgins had imagined, is unwilling to be merely a successful experiment, but wants to be recognized as the lady she is and to enter a domestic arrangement with the reluctant bachelor. 'Why can't a woman,' Higgins grumbles in the musical, 'be more like a man?'

The avant-garde, however, would have none of this sentimentality. Nineteenth-century painting, as the Musée d'Orsay attests, is crowded with titillating images of women, frequently shown in the nude or in alluring poses and suggestive settings. According to scholars, the models for these works were almost surely prostitutes.[8] Nowadays we see this as an irrelevant consideration: the living model's circumstances have nothing to do with the work of art, and the alluring image she inspires stands apart from moral vicissitude. The naked becomes the nude through the aesthetic magic of form, as Sir Kenneth Clark instructed,[9] however transgressive that nakedness may in actuality have been. This sanitizing of response is yet another example of the replacement of woman by form, with all the mastery and mystification that came with

this move. Any thought of the female model as a flesh-and-blood person subject to moral and existential vicissitudes was ruled irrelevant to the experience of art. Twentieth-century modernists stopped using models altogether, and for a good portion of the century, art and architecture schools eliminated life classes from their curricula.

Historians claim that the poses shown in many nineteenth-century paintings of women were positions in which only a prostitute was likely to have been observed. Bourgeoises would not be available to view as Degas's bathers are, according to Eunice Lipton, since this would constitute 'an unthinkable breach of decorum', and moreover, moral and physical strictures made bathing a rare activity for respectable women altogether.[10] 'As late as 1900,' writes Tamar Garb, 'one woman spoke of "plunging into water" as "pagan, even sinful" and many upper-class girls were still bathed in their nightshirts.'[11] Prostitutes, on the other hand, regularly bathed and often did so in the presence of their clients. It comes as a shock to us that these images could have openly represented a prurient and degraded subject, since we have been so successfully trained by formalist criticism to dissociate female nudity in art from moral transgression. But scholars have shown that nineteenth-century artists and writers were obsessed by prostitution, with all the libidinous thrill that the sex/money/art nexus entails.

The figure of Danaë penetrated by Zeus's shower of gold takes on new possibilities in this light, and indeed, this mythological subject is ubiquitous in late nineteenth- and early twentieth-century painting. In Max Slevogt's *Danaë* **[Pl. 13]**, for example, the naked, grossly fore-shortened 'maiden' sleeps as her ugly servant catches gold coins falling into a scarf. Zeus does not penetrate Danaë with a shower of gold but pays her with it. She seems to have missed the exaltation of the experience – the godhead behind the shower. Like her colleague Leda, there is some question as to whether 'she put on his knowledge with his power'.

Prostitute or bourgeoise, woman was an imperfect analogue of the male artist – capable only of designing herself, creating her image, interpreting the fashion of the day. As the ideology of the avant-garde

was taking shape in the nineteenth century, the 'designing woman' was a distorted mirror in which male artists could see their greater power reflected. 'Woman performs a kind of duty,' Baudelaire wrote in 1863, 'when she endeavours to appear magical and supernatural: she should dazzle men and charm then, she is an idol who should cover herself with gold so as to be adored. She should therefore borrow from all the arts the means of rising above nature so as to better subjugate the hearts and impress the minds of men.' This is a recipe not for the bourgeoise or the heroine of romance, legendary for her purity, but for the *femme fatale*. According to Bernheimer, 'Baudelaire praises makeup because it permits woman to construct herself as a fetish, as a dazzling shiny surface that covers over and obscures the corrupt sexual nature beneath.'[12] Designing woman, in this perverse logic, is the consummate artwork, though as an artist she is still inferior to man.

Baudelaire's image of the fetishized woman as an all-powerful, beautiful surface covering a sewer accords with the horrific final view of Zola's once beautiful Nana decomposing in death into a mass of pus and ordure. The body's cover is blown at death; art can no longer mask necessity, contingency, the real. Wilde shows the desperate horror and pathos of art-as-makeup in *The Picture of Dorian Gray*, where the painting is a prostitute in effect, bearing the image of a man's corruption to allow the real man to remain beautiful. In this Christ-like aesthetic sacrifice, art 'saves' human beauty from the appearance of decay and dissipation by taking on that appearance itself. It tells the ugly truth about life in order to protect life's illusory beauty, as if Psyche descended to hell to preserve the illusion of Cupid's immortality. Just so, modernism turned woman into a scapegoat – an exotic, 'primitive' fetish whose taint supposedly had nothing to do with the male purity and transcendence that produced it.

Keeping the taint separate from its author in this way was quite a trick, similar to one of the great nineteenth-century triumphs of engineering, the creation of a hygienic sewer system whose aim was to keep human waste away from its creators. Bernheimer discusses a Parisian sanitary engineer, Alexandre Parent-Duchâtelet, who was an

expert in biological decomposition and its containment. After writing several books on the subject, he recognized the parallel to another problem: prostitution and its containment. He explicitly proposed a parallel between the two: 'If . . . I was able to enter the sewers,' Duchâtelet wrote, 'why should I blush to tackle a sewer of another kind?'[13] In *De la Prostitution dans la ville de Paris* (1836), he argued that the waste of prostitution should be managed just as if it were sewage. Prostitutes should be isolated in '*parthénions*', rigidly regulated para-worlds, like the realm of art separated from reality by a magic circle of disinterested interest. In this safe alternate reality, men could visit them without danger of contaminating the respectable world outside.

The problem for the sanitary engineer is that the seal (on sewers, on art) is always imperfect and some contamination seeps through. As a result, the purist must always redouble his efforts, even if they threaten the very values he wishes to protect. As we saw earlier, Balzac's 1832 novella, *Le Chef d'oeuvre inconnu*, depicts an artist, in the name of purity, progressively obliterating his female subject's allure, body, individuality, and finally her very form altogether. His 'masterpiece' is an unsightly scribble with nothing but a female foot and leg still visible – a little fetishistic tease poking out of the garbage. Though the aim of this aesthetic mess is to safeguard purity, the work is aesthetically nil (or would be until the advent of Minimalism in our day redeemed such earnest nullity as art).

The theme of waste was especially important in nineteenth-century realism, whose goal was to reveal the underside of life hidden in the lies of the bourgeoisie, and hence the ugly truth masked under the glittering surface of woman. It still comes as a surprise that the 'real' and the 'naturalistic' of realism and naturalism are so obsessively correlated with the misfortunes and degradation of women, often phantasmatic in their abjection. For the artist, 'the real' was the story of garbage, because garbage (literally, the by-product of conspicuous consumption; figuratively, the loss of value through commodification) is what the bourgeoisie produces and at the same time denies it produces, pretending waste does not exist.

If realists used art to reveal the waste of the human condition, the aestheticists hoped that art could redeem that condition, covering or mitigating death and disorder with the beauty of form. But as Balzac and Wilde had shown, formal purity is never completely effective. No matter how fervently Yeats believed we could not 'know the dancer from the dance', it is all too apparent that the 'body swayed to music' and the 'quickening glance' entail the 'degeneracy' of sex, reproduction, and the final waste of death. Baudelaire's woman as sphinx, Valéry's *danseuse* who is neither dancer nor woman, all the blank-eyed acrobats and clowns and living dolls and dead prostitutes of the avant-garde cannot eliminate the body or desire or death – the enemies of the waste manager.

An allegory of this situation is *Dracula*, in which an irresistible foreign force threatens to turn all women into deathly seductresses. Fetishized woman, the body, and the vampire simply will not die, despite all the efforts of bourgeois men, pure women, and the latest technological innovations in communication. Dictaphones, typewriters, telegraphs, and letters are all marshalled to defeat the blood-menace by keeping the protagonists in communication with each other. If they can only stay in touch, the pure heroine will not turn into a vampire. This contest between communication and deathly corruption is, of course, one of the deep meanings of the waste management theme, the idea of art as creating shared meaning and hence redeeming the garbage of fragmentation and meaninglessness that is modernity. Though the heroine of *Dracula* is a consummate secretary in this epistolary novel, her 'correspondence school of art' is no match against the threat of corruption and death that looms over it. Only the collective violence of loving, self-sacrificing men can win the day against the 'foreign menace'.

But of course, the menace was not so much foreign as alienated, not Transylvanian but bohemian. Bram Stoker at the turn of the twentieth century was reacting to the aesthetics of the Symbolists a generation earlier, who had rendered the experience of waste as a brush with sublimity. Who was responsible for the devastation – the bourgeoisie

with its dirty materialism or the avant-garde with its taste for prostitution and artificiality? Telling the story of a world turned transgressive is sometimes hard to distinguish from celebrating transgression. The *flâneur*'s indiscriminate thirst for experience may thus appear to be less a moral response to middle-class existence than a moral problem in itself. Disdaining a world of bourgeois limits, the avant-garde blamed the bourgeoisie for the unconstrained commodification that destroyed value, standing above this consumerism, above the masses, above exchange. But the way it saw fit to do so was, paradoxically, to fill art with waste, transgression, and obscenity.

For the middle-class audience of art, it is the artist who is to blame for this filth, producing it intentionally and with vicious motive. And so the mutual hostility grew: the bourgeoisie affronted and at the same time humbled; the avant-garde self-righteous and yet implicated in the devastation. It cannot have been utterly without strain for an audience to be moved by an art that despised its values, or for an artist to follow Flaubert's hypocritical dictum: 'one should live like a bourgeois and think like a demi-god'.

The pathos of waste is to some degree the story of modernism. Twentieth-century modernists suffered in a world where 'woman' equals 'prostitute' and reality equals 'waste'. Joyce's Stephen Dedalus is rescued from the evils of Nighttown by his nonce father Bloom, and Faulkner's Caddy has dirty drawers and Fascist connections. From Fitzgerald's 'Daddy's girls' to Breton's Nadja (a surreal Nana), modernism is as cluttered with fallen beauties as the fictions of Balzac and Flaubert and Huysmans and Hawthorne before them. Thus, Eliot's 'young man carbuncular' couples with a barely human typist whose sublime 'combinations' are spread to dry on the divan, and his Thames maidens lie abjectly supine on the bottom of a canoe. Even the magnificent Cleopatra presides over an opulence that cloys the senses, where the visual report of Philomela's rape is just a mantelpiece decoration. Like Stoker's telegraphs and dictaphones, no medium – artistic or technological – can convey an effective message in the 'heap of broken images' that is modernity.

The idea of waste – prostitutes, garbage, art, everything that needs to be relegated to an underworld – pervades twentieth-century culture. With its roots in the nineteenth century (Dickens's *Our Mutual Friend*, for example), refuse is a central preoccupation in Eliot's *The Waste Land*, Joyce's *Ulysses* (the recurring 'Throwaway'), Pynchon's W.A.S.T.E. system in *The Crying of Lot 49* and his sewers in *Gravity's Rainbow*. In Ray Johnson's New York Correspondence School of Art, art is random and disposable, and in Don DeLillo's *Underworld*, the hero is a waste manager by profession with an adulterous wife fond of heroin, 'shit'. Waste is the pathos of culture turned meaningless and its symbol is woman turned whore. Dostoevsky may have exclaimed 'hurrah for underground!'[14] and Dadaism may have merged garbage (*Merz*) with art. But the steady encroachment of waste in both life and art is for many twentieth-century artists and writers the tragedy of the modern condition.

Tragic as this story is for men, it has been doubly so for women, whose image has been used to symbolize both the victim and the victimizer in this wasteland. Huysmans's self-avowed 'formal project to "abolish the traditional plot" requires the suppression of "passion, woman"'.[15] Valéry compares the female dancer to a jellyfish (French 'medusa') ethereal on the surface and devouring underneath. Critics called Manet's figure Olympia a gorilla; the picture had to be hung high on the wall of the Salon to escape damage. Zola's claim that it was a picture about form turned the female subject into an abstract, inhuman entity, an aesthetic corpse,[16] though of course corpses carry their own grisly fascination. We recall Poe's view that the most poetic theme is the death of a beautiful woman, with the poet-lover forlornly locked in the refrain of 'Nevermore' – an obsessive reiteration of the beauty of loss, annihilation, denial.

Manet's painting is as powerful a symbol as has emerged of the fate of the female subject in modernism. Its subject is a beautiful, individualized woman who knowingly presents herself as beautiful to a fictive viewer who 'stands' in our shoes. She is a conscious being who has deliberately made herself into a nude, and these identities have

struck viewer after viewer as shockingly incompatible. Nearly a century after Zola bypassed the problem by declaring *Olympia's* subject to be not this woman at all but form, Sir Kenneth Clark still registered discomfort at the image:

> almost for the first time since the Renaissance a painting of the nude represented a real woman in probable surroundings . . . The *Olympia* is a portrait of an individual, whose interesting but sharply characteristic body is placed exactly where one would expect to find it. Amateurs were thus suddenly reminded of the circumstances under which actual nudity was familiar to them, and their embarrassment is understandable. And although no longer shocking, the *Olympia* remains exceptional. To place on a naked body a head with so much individual character is to jeopardize the whole premise of the nude.[17]

The assumptions here are extraordinary, for example, that realism, individuality, and 'character' are incompatible with the nude; that the beauty of the nude is unthinkable except as an abstraction from real women; that the circumstances under which men would have experienced such nudity would have been necessarily embarrassing, i.e. brothels and not matrimonial beds. Even if we make the dubious assumption that such a combination of individuality and nudity had never existed before Manet's painting, the extraordinary shock registered by the public then and by art historians ever since is hard to explain. But if we consider what 'individual character' in fact means, we realize that Clark was referring to Olympia's agency, her intentional presentation of herself to view as a beautiful woman. The audience of *Olympia* is subjected to a female subject who constructs her appearance as ideally beautiful. What a painful experience!

Even in our day, the art historian Donald Kuspit cannot accept Olympia as anything but 'a banal mannequin' dehumanized by a destructive male artist.

Such banalization – debunking, profaning – of what was once held sacred (love, woman) is as typically modern as the pursuit of spontaneity (the new sacredness), but it has the opposite purpose: to deaden everything living – to break its spirit, or to show that it is spiritless – so that it fits in the iron cage . . . Olympia, a prostitute, is indeed a social instrument, of value only for her sexual use. Her room is a kind of cage, and her spiritless presence that of a cunning but ultimately entrapped animal.[18]

Vampire, medusa, gorilla, corpse, mannequin, waste, banality, profanation, and caged animal: for the female subject, these are the alternatives available if 'she' is not to be reduced to pure form.

And what happens when a woman looks at *Olympia?* The unblinking female beauty of its subject has been as serious a problem for feminists as for the male audience of art. At least twentieth-century artists would have the decency to transform the nude woman into a formal machine. Manet, in contrast, gave us an unrepentant, individuated, sexualized woman. *Olympia* has offended feminists as the image of a woman who has deliberately succumbed to male objectification or – much the same thing – as an unmitigated male fantasy of woman in service to male desire. Her beauty is the shameful proof of her spinelessness or her victimization, and admiring her beauty or the beauty of the painting named for her amounts to admiring male oppression. The fact that men are appalled at Olympia, too, merely shows that they are embarrassed to think that the women who fulfill their desires are real human beings. Under the circumstances, self-conscious female beauty becomes intolerable for a woman or any right-thinking person.

But *Olympia* is beginning to elicit quite different responses from feminists. In the case of the art historian Eunice Lipton, for example, an engagement with the painting led to years of research into its model, the actual woman who took on this pose. And this research changed Lipton's entire understanding of art, love, and her own profession – a journey of feminist self-discovery that she narrates in *Alias Olympia: A Woman's Search for Manet's Notorious Model and Her Own Desire.*[19]

I too find this painting revelatory, not only of my own experience but of the history of beauty we are exploring in this book. When I look at *Olympia*, I find it hard to see what all the fuss is about. I do not see a gorilla, and neither do I see a purely formal composition or a corpse or an unliberated woman. Instead, I see a woman who is unquestionably beautiful and desirable, who has done a lot to make herself look that way, and who feels she has something to gain from her efforts. These 'facts' seem neither reprehensible nor mutually exclusive. Perhaps her gain is the pleasure her client will find in her appearance: perhaps it is her pleasure in the power she exerts through her self-enhancement. It is hard to say, and I find myself unworried that I cannot decide.

This is an image that arrests the viewer. The directness of Olympia's gaze seeks us out, and the extravagance of her self-presentation demands our response. She has arranged her hair and removed her clothes, except for those ultra-feminine, non-functional slippers, which she recklessly rests on the clean linen. Simultaneously naked and not-naked, she employs the classic ambiguity of the nude. She poses herself among voluptuous pillows and soft draperies, small and smooth, white and fleshly, and she looks at her visitor without apparent shame, with a tension and alertness that suggest this is not an encounter to which she is indifferent. She has surrounded herself with surrogates of herself that reinforce her allure by their relative lack: the servant woman who is like her in being a woman, but clothed, shapeless, dark,[20] and subservient, with her hair and virtually every other female marker hidden from view; the cat, soft and small and sensuous to the touch like Olympia, but not smooth or human; the bouquet of flowers, beautiful and suggestive of fecundity, but good only for viewing and not for discussion or touching or sex. Olympia is like all these, she implies in her self-composition, but better.

Though she presents herself as a visual tableau, her nakedness and the tension of her gaze invite a response beyond mere gazing. She offers herself in an appeal that promises pleasure, and this anticipated pleasure might be hers as well as her visitor's. But history tells us that she is a prostitute, that there will be a price to pay for this pleasure. The

intrusion of capitalist exchange puts an entirely different complexion on her self-presentation. Or so we must assume, since the public of her day took her as a prostitute and were outraged at Manet's unwillingness to mask her sexual invitation in allegory or myth. Presumably, so frank a marshalling of props for male seduction would go on only in a 'house of pleasure', though scholarly research has been unable to identify exactly what sort of house Olympia in fact inhabits.[21] She does not fit the profile of any of the enormous array of types and classes within the 'universal prostitution' of her day. But then, of course, she is not a photograph of a social type but a figure painted by an artist in a picture that has outlasted its time.

To this viewer from a later era, shaped by a certain feminist logic, Olympia is a powerful image of woman: daring, self-promoting, unhypocritical. It is hard to believe that she is merely initiating a financial transaction, since she has already given away so much for free – the mystery of her body, the pleasure of the visual scene she has created, the fact of her own desire. How do we know that what she intends as the response to the tableau is not as valuable to her as to her viewer? And if so, money would seem an incidental, and certainly an ambiguous factor. But of course, part of what the client is buying may be this very fiction: a seductive advance that is in reality only an early act in a paid performance.

And yet, even if the female seduction here is merely a pose, it is surely an interesting one. If Olympia is a prostitute, she is an artful prostitute in more than one sense of the word, and her client must be paying for the virtuosity of her performance. If so, his pleasure will be something like that of any man about to have sex with a woman who moves him. And for Olympia, the creation of such excitement and pleasure is like that of any woman about to have sex with a man who moves *her*. Why prostitution or commodification is necessarily the issue here is the question. The painting is very much about the psychic meaning involved in a woman's deliberately presenting herself to a man's view for the purpose of seduction, and as such, it is an interesting analogue to a male artist's deliberate presentation of an artwork to

an audience's view for the purpose of aesthetic seduction. To say that artists do more than seduce in making art is neither here nor there. Women also do more than seduce in presenting themselves to view.

Whatever is inscrutable about Olympia's much disputed pose and gaze – the little hand covering her pubis, the ambiguity of her look (defiant, alluring, self-absorbed, self-contained) – is not really so hard to understand. For though she has already revealed so much of herself, the interchange to follow will discover more, and there are limits to any form of communication. She, like any woman – or any man, for that matter – is a separate being from the one who sees her or sleeps with her, and if she looks a little nervy or even aggressive, surely the nature of the invitation she is extending, the risk she has taken in making such an extravagant appeal, and the inter-subjective challenge that lies ahead would explain her expression.

And yet, she is a prostitute. Surely she is. By definition, no respectable woman would ever present herself this way, or not in Manet's day at any rate. And let us be even more unflinchingly truthful: she is not an aesthetically astute prostitute but a male artist's construction of a prostitute or at least of a woman who solicits attention, as prostitutes do. For of course, a respectable woman would not do so, regardless of her interest in clothing, makeup, interior design, and her own face and body (which, needless to say, interest her only on aesthetic grounds). And her identity as a prostitute is obviously important, regardless of the fact that the male artists and writers of Manet's era claimed that every woman was at heart a prostitute, unable to transcend her animal self and happy to be paid in either coin of the realm or the domestic 'support' provided by marriage.

We must not forget either that Olympia's self-artistery is finally Manet's aesthetics. He has invented her, and she functions as an image of his art. 'She' is really 'he', awaiting not a client but a beholder, and all her contradictory allure and threat, her civilization and animality, her self-expressive freedom as a desiring subject and her enslavement to the control of her creator and the mores and sympathies of her

audience are merely aspects of Manet's conception of art. 'Olympia' is the name of both a painting and its subject, and Manet has thereby made explicit the paradoxes implicit in the idea of art as prostitution.

We might interpret the painting as an implicit reply to Kant. The disinterested interest of aesthetic judgement leads to a paradoxical status for the work of art. On the one hand, its judgement is pure, removed from any matters of personal desire, advantage, utility. But because it is not 'for' anyone's interest, it is promiscuous, like a woman who displays herself shamelessly to everyone alike, with no intent toward anyone in particular. 'Universal' is 'promiscuous' after all, when it comes to a female subject. She can be briefly bought but never owned, just as 'cultural property' has an ambiguous relation to legal torts and definitions of the obscene. She can be interpreted by any 'client' intent on limiting her meaning, until the next interpreter comes along who is willing to pay the price for such attentions.

But again, where *Olympia* differs from other prostitute-art is that she looks back. She is like Robert Mapplethorpe's devilish self-portrait in this way, the one in which a bullwhip protrudes from his anus like a tail and he gazes over his shoulder towards the camera, towards the viewer. This blatant acknowledgement that the subject knows we are watching is a way for artists to insist on the 'personhood' of the model and the communicative ideal of art. Olympia does not lend herself to others' desire without showing that she knows what she is doing. In this way, she forces viewers to think consciously about their desire in viewing. She remakes the viewer as a self-aware beholder/desirer, and this no doubt leads to the defensive violence that *Olympia* (and Mapplethorpe's work) has endured. But that is a risk that art perhaps must take if a genuine interaction, a communication, an experience of Other as self and self as Other is to occur. I believe that artists, critics, and the audience of art are moving towards this conclusion.

We might refer back to the ideal of aesthetic experience offered in the introduction. Cupid begins as a passive sleeping image, like an artwork, who is 'found' beautiful by an observer. But he rises up furiously and eludes her grasp until she can raise herself to his level.

Only in this equality and mutuality can beauty lead to Love and Pleasure. Olympia, like Cupid, is anything but passive. She is found beautiful, but her piercing look finds her observer out. Many viewers have been afraid to see Olympia as beautiful because they are afraid to recognize beauty – or themselves – in such a naked image of desire. Olympia does not feign an innocence, obliviousness, or passivity that would allow the observer to treat her beauty as a static object, a property divorced from a consciousness; instead, this beauty, like Cupid's, incites an interaction. Olympia challenges viewers to recognize their need in hers, to recognize *her* as their desiring analogue. This need or desire is ostensibly sexual, but sexual knowledge is only a special case of the desire to be known, recognized, approved, gratified, and loved: the ultimate object of the searching gaze.

Of course, a painting is not a person, and one might object that the interaction I describe is a heavy symbolic burden to place on art. But the reason we value the experience of beauty is that it models this very interaction. The conscious beauty of a female subject symbolizes the highest ideals of communication and love.

Kant credited beauty with quite a different benefit. According to the literary scholar Tobin Siebers, since Kant believed that freedom cannot be understood on the basis of reason alone, he 'seizes upon the work of art to provide an analogue to freedom. Art's vivid symbolization of autonomy . . . represents the single most powerful motivation for Kant's writing of the third *Critique*.' Art plays this role for Kant because 'Remarkably, objects of beauty have somehow freed themselves from the mind's grasp, shining forth as only themselves and asserting their own unique form and integrity as presences dwelling both with us and apart . . . To use modern vocabulary, objects of beauty present us with the experience of "otherness".' In showing us something beyond our grasp, art makes it 'possible for us to imagine both the "appearance (*Schein*) of freedom" and "an image of the end of power"'.[22]

Because this experience of otherness is public and, for Kant, universally shared, it creates communities. In Sieber's moving words,

The vision of the beautiful object is also a vision of a beautiful 'we' because it compels individuals to expose private feelings to the judgement of other people while at the same time imagining them as members of an affective community that shares common goals and objects. Aesthetic judgement, then, provides the perfect analogy by which to imagine ideal forms of political judgement . . . Beauty is, in short, politics' idea of utopia, and although it be utopian, a wonderful idea it sometimes is.[23]

The meeting of self and Other in a 'beautiful we', the end of power, the experience of freedom: these are achievements, one might think, for which society should protect beauty with all the means at its disposal. However, on second thought, this image of community is perhaps not so utopian: a collection of radically autonomous individuals, each having experienced freedom by analogy to the Otherness of the work of art. What holds the group together is the common autonomy of its members. This sounds a little like the society of isolates in Pynchon's *The Crying of Lot 49*: 'Inamorati Anonymous', a group whose aim is to prevent connection. They all maintain their glorious separation, preserving their kinship by agreeing never to meet or even communicate once their 'membership' has been accepted. In Siebers's picture, of course, the members would meet and communicate, but all they would have to discuss would be their independence.

Freedom is a wonderful ideal, and modernism has used art to assert individual freedom in virtuoso ways. 'That alienated vantage', as Jerome McGann calls Kant's disinterested interest, may be 'poetry's critical gift to every future age'.[24] However, this 'gift' of late has turned to 'poison'. The violent gyrations by which twentieth-century art defined itself, constantly recuperating shocking obscenity as reified form, have left little experience of social consensus, empathy, or the respect between self and Other implicit in a 'beautiful we'. This is a terrible failure, in which expert and layman, avant-garde and bourgeoisie, man and woman, have lost all mutuality.

Release from contingency and connection, contact with a super-

human limitlessness and chaos, the thrill of safe annihilation: these attributes of the sublime do not seem to me the highest ideal of beauty, and the pleasure they provide is too attenuated to be nourishing. Preferable by far is the mutual recognition of self and Other. This mutuality may arise through our experience with art objects, but it cannot be *symbolized* in art through a passive, objectified female subject. It demands instead a picture of equal agency, and Manet was prescient and brave in creating such a challenging subject. Unfortunately, he was unusual in his day and even in ours, and the culture's defence mechanisms against this challenge are mighty. They are summarized in the equation of female beauty with depersonalization and the 'knowing' female subject with the prostitute. These have also been defence mechanisms of men aimed at the threat of an equal, desiring, and non-objectifiable female Other. A woman viewer who sees in Olympia's frank gaze an image of female agency and self-fashioning artistry can only flinch at the hostility the painting has met from male critics throughout its history.

Simply put, the defensive manoeuvres of aesthetic judgement in this case are two: that Olympia is a prostitute and therefore that the work in which she figures is obscene, or that Olympia's identity is incidental and that the work in which she figures is a formal masterpiece. We will not be able to tolerate the beauty of woman and ornament in art until we recognize the masterpiece of Olympia's identity and the obscenity of *Olympia's* form when detached from that identity. This detachment was the terrible 'achievement' of the avant-garde sublime, which presented transgressive subjects that its audience was meant to 'look through' in order to get to form.

The procedure has turned the reception history of modern art into a repetitive farce, each episode of which typically begins with outrage concerning some shocking subject matter packaged in unprecedented formal means, and ends with an act of aesthetic mystification: the taming, denaturing, and stilling of threat by the calming discovery of form. It is a little allegory of Enlightenment triumph – a cold triumph by our day. In the shrill, scandalous, often *un*enlightening history of

modernism, the rewarding values of aesthetic experience – communication, mutuality, understanding – are seldom in evidence. Instead, our attention is focused on social fault lines, differences in belief and behaviour dramatized by sublime scandal. In eliminating the female symbol of beauty-as-interaction, the analogy between art and human intersubjectivity is destroyed, and the result has been an exaggeration of the cruelty of unmitigated reason.

Artists feel they must shock; audiences in the know feel they must applaud shock. The thrill of repulsion has become a positive and sought-after experience in itself, a nihilistic sublime in which horror, disgust, and lack of sympathy are accepted ends. To assimilate the latest challenge as art does not involve a victory of fellow feeling across the community but a proud gesture of superiority on the part of experts toward lay people supposedly incapable of such feats of stamina and discernment. Moreover, in so far as those in society who are officially labelled as Other – women, minorities, immigrants, the insane, the disadvantaged, the poor – learn their situation by analogy to art, the lesson has been chilling. In the model art has recently presented, an Other can be only colonized or expelled, denatured or killed. It is outrageous, utterly outrageous, to believe that the most poetic subject is the death of a beautiful woman, however sincerely her grieving artist/murderer might mourn her loss.

To some degree, one might object, the lurching from outrage to acceptance is the reception history of all art. Impressionism, for example, struck some of its first viewers as an outright assault on beauty, whereas today it seems all too beautiful. But it is the pace and violence of the shock-redemption-assimilation plot in the twentieth century that is new. The proliferation of arts commentary in the universities and media is in part a response to the accelerated challenge that this reception strategy keeps posing. Locked in this pattern, artists feel they are not making art unless they keep generating new challenges, and the public is equally trapped. 'Is this pornography or art?' the question phrases itself, and not, 'Why do I like or fear art or pornography – or women, for that matter?' Why has an ideology prospered that presents

the status of art and women in such a disturbing and insensitive fashion? Art as modernism conceived it has been inextricable from the category of pornography, and the whole drama of twentieth-century aesthetics consisted in the discovery of arguments to undermine the allure of art and shore up the independence of the interpreter. It has proved a pyrrhic victory, I think, for all concerned.

The reception history of modernism resembles an aesthetic recycling project. Works claiming the status of masterpieces are first received as transgressions, only to be redeemed as classics through intense critical discussion. In so far as this progress indicates a new comfort with the body and sexuality, it is to be applauded. But the idea that defining a work as art requires denying it as pornography is peculiar, to say the least. Considering modern art pornographic was taken as a sign of philistine vulgarity: an inability to separate formal beauty from transgressive subject matter, and the assumption that the work of art, by showing an ugly truth, was somehow responsible for that truth. In time, art and élite education instilled this set of principles in the middle classes: that to appreciate high art they must be willing to enjoy negative representations of their own values and they must look through the scandalous irrelevance of content to the sublime ideality of form. Thus, 'pornographic art' became a contradiction in terms. Once 'redeeming social value' or 'formal achievement' or whatever other criterion was seen to offset the violation of bourgeois conventions, the work became 'art'. Calling it 'pornography' or 'pornographic art' then became a category error.

It is worth noting that this pattern of usage is inconsistent with legal terminology. 'Obscenity' is not protected under the law, but 'pornography' is. A work can be exonerated of the charge of obscenity if it has redeeming social value, including artistic value. In that case, it may revert to the category of pornography, which is protected. Thus, from a legal point of view, 'pornographic art' is not oxymoronic, one of the few instances in which the legal conceptualizing of art is aesthetically precise. That is, a work can belong to the category of art (symbolic representation related to certain norms of response and

structure) and still be transgressive and titillating – unless you are a strict Kantian. Strict in its Kantianism, common usage, however, does not admit this duality. It either banishes transgression from the realm of art or reinterprets transgression in art as something unrelated to interest – something in quotation marks, something ultimately not the point, something only on the surface. In ruling out the possibility that works can be both artistic and prurient, common usage errs, but in the process, it teaches a crucial lesson about the modern ideology of beauty.

Let me explain this claim through a personal anecedote. After *The Scandal of Pleasure* was published, I gave many talks in museums and universities, presenting a standard liberal account of artistic freedom of expression. When I would discuss the Mapplethorpe trial and show slides of the infamous *X Portfolio* with its extreme images of homosexual sadism and abjection, some members of the audience would always register shock or discomfort. In the question period I would acknowledge their response but argue that there is nothing illegal about giving offence or creating upset in a viewer. Individual preference should not dictate legal control.

But lately, audiences have responded differently. If people are shocked or offended, they do not show it. The challenges instead come from audience members interested in hearing a case made for pornography but impatient with my examples. 'Everyone knows Mapplethorpe is art,' they object. 'Let's talk about "real porn".' Some aesthetic alchemy has taken hold. Mapplethorpe's images – however deeply forearm burrows into rectum or urine arcs into mouth – have metamorphosed into art, and once this change has occurred, they seem to be morally neutral – unassailable, uncontroversial, and uninteresting in a discussion of pornography. Instead, a discussion of freedom of expression needs to consider 'real porn' – artistically unredeemed trespass. This turns out to be the works produced by the pornography industry – films, magazines, books – that present themselves as mass, commercial products and make no claims to the status of art. Critics generally do not concern themselves about this work, except as an

object of 'cultural study'; museums do not normally exhibit it; its creators do not apply for grants from government agencies. This pornography is the challenge for the First Amendment, according to my audiences, not works already deemed art. How wrong they are!

Of course, any expert who felt like expending the effort could take a work of 'real porn' and show why it might belong in the category of art, but most critics would not bother. For in our culture, experts on the arts are invested in works that do make claims to high aesthetic value. They study mass culture – of which 'real porn' is a part – as a revelation of norms and beliefs, which are, in turn, motivated by desire. Aesthetic achievement for post-Kantians, however, is a matter of disinterested interest, not desire. Thus, the artistic establishments in universities and museums are content to leave 'real porn' to its own devices and to devote their redemptive efforts to high artworks that confuse the public and its lawmakers by lifting subject matter previously found only in the 'low' sphere of commercial pornography into their lofty regions.

For these reasons, art and pornography tend to remain separate spheres in popular thinking. 'Real porn' keeps decorously in its place – sub-literary, sub-aesthetic, and highly profitable. It occupies only certain rooms in video stores, certain neighbourhoods in cities, and certain categories in our minds – a modern realization of Parent-Duchâtelet's '*parthénions*'. It is those dangerous category-jumpers – James Joyce, D.H. Lawrence, Vladimir Nabokov, Henry Miller, Allen Ginsberg, Robert Mapplethorpe – who fill up newspaper headlines for a while, only to settle righteously into their status as classics of art. Dirt is dirt; art is art – until we go through the next paroxysm of shock and redemption. Every time a critic argues that a scandalous work is in fact an artistic triumph, and every time an audience or the courts are won over to this point of view, a moment in the unceasing revision of the category 'art' has taken place. Garbage in, art out. Garbage in, art out. If this is the way to redeem the waste land, redemption will be never-ending, for the output depends on an input of sleaze and shock virtuosic in its invention.

From this point of view, Walter Kendrick is surely right that pornography names a concept, not a thing.[25] So many 'things' have been labelled pornographic only to be relabelled as art that a reified notion of pornography is untenable. We might consider some works that have not been censored or suppressed. Take Titian's *Danaë*, which shows its alluring heroine being impregnated by Zeus's shower of gold; Fragonard's *The Swing*, with its young spark looking up the skirt of a pretty lady; or Courbet's *La Femme aux bas blancs* and *L'Origine du monde*, which would be called 'beaver shots' if they were found in an adult bookstore. These works are proud holdings in art museums, on daily public view. Only someone ignorant of the 'magic circle around art' or the distinction between 'nude' and 'naked' would suggest they were pornographic – unless it was an aesthetician trying to make a point.

Per contra, if we look at works that *have* been censored or suppressed as obscene, the designation seems equally arbitrary. Michelangelo's ultra-canonic *David* once sported a figleaf, and the modern cleaning of acknowledged masterpieces such as Massaccio's *Expulsion from the Garden* reveals a much more sexually explicit original, which we accept without embarrassment today. Brancusi's *Princess X* was refused entry to the United States in 1922 because the customs official on duty considered it unsuitable for American eyes. Not only has it been exhibited since then, but it is hard to believe that anyone could have seen in it the genitalia that so offended the customs agent. How relative the label 'obscene' seems when we recall that the Degenerate Art Exhibition in Nazi Germany included one of Picasso's classicistic works of the 1920s, *Woman*, for failing to conform to the Third Reich's ideal of femininity.

The flipflop between art and pornography works both ways. Mapplethorpe's transgressions – experienced as so unseemly a decade ago that the National Endowment for the Arts almost fell for having sponsored them – are now canonized artworks. In contrast, the writer Andrea Dworkin, who crusaded for the legal ban of pornography, was almost the first author whose work was forbidden entrance into Canada

under this new legislation. In short, 'pornography' shifts objects as promiscuously as its protagonists. There is no sexual content that does not appear in some artwork. When people are convinced that a work is indeed art, they simply disregard the transgressive quality of the content in question. Moreover, given the right motivation, there is no content that cannot be taken as sexual, thus propelling the work in which it is contained into the realm of pornography.

The optical installation artist James Turrell tells a story, which he claims is not apocryphal. He had created a booth into which the spectator was expected to enter, close the door, and remain for a couple of minutes in darkness. Once the door was shut, the booth would be completely dark, except that Turrell had drilled a tiny hole in the interior through which the occupant would eventually discern a pinpoint of red light. As the spectator's eyes adjusted to the darkness, she would come to make out a tiny red glow which would expand and change with the passage of time. Turrell claims that on one occasion, the door of the booth was flung open and a horrified spectator came dashing out screaming that he had been forced to look at an indecent image in the darkness and that the exhibition should be shut down. Truly, obscenity is in the eye of the beholder when it comes to the red light district of art.

If anything can be taken as pornographic and any pornography can be redeemed as art then pornography does name an idea and not a thing. Even 'real porn' is not dependable, but simply left for the moment to its profitable transgressions. A controversy over pornography is almost always a process of reclassification in which some population – usually the non-expert, the conventional, the uncool – learn a lesson. They learn that something that seemed non-artistic and shocking was actually artistic and therefore – in the ideology that holds 'pornographic art' to be a contradiction – not appropriate to be shocked about. Those who do not learn the lesson remain uncool and alienated from the aesthetic perception of experts, and hence outside the coterie with the power to define art. Or, if those who refuse to learn the lesson are powerful, then the work is banned as obscene, falling victim to

illiberalism. It usually lies fallow for a while, awaiting vindication in the unceasing moral alchemy of modernity. Or, comparatively rarely, it stays a naughty footnote in the history of culture. As long as it remains a footnote, however, as long as it is remembered in any fashion and available to be read or seen, it has the capacity to undergo the metamorphosis from dirt to art.

This reclamation process, modulated by changing organizations of power in society, class, education, religion, etc., is perennial. It is a category drama for a notion, art, that is constantly under negotiation – as controversial as 'pornography' itself. And yet, as I argued in *The Scandal of Pleasure*, what looks like a category drama is in fact a disguised debate over value. The question is not: 'Is this art?' though we are conditioned to ask it this way. *Ulysses* and *Philosophy in the Bedroom* and *Debbie Does Dallas* are all works of art (and interestingly, the first two have at least as much sexual variety and trespass as the third). But they are not equally good art. It is crucial to realize, though, that bad art is still art and good pornography is still pornography. The boundary between sexual excitement and aesthetic rapture is hazier than Kant would admit. Think how complex Psyche's feelings must have been as she looked upon the sleeping Cupid; any struggle seemed worthwhile if it would lead to their immortal Pleasure.

The avant-garde, however, liked to police this boundary. The message of their high-art transgressions was: 'This is not pornography (bad) but art (good).' In the process, 'good' and 'bad' were no longer aesthetic but moral terms, and aesthetic 'goodness' – beauty – dropped out of discussion altogether. The avant-garde hid beauty under a smokescreen of moral scandal and tied the very definition of art to pornography. To be art was to be 'not pornography'.

Sometimes the line between the two is very slight. John Hawkes self-consciously pivots between 'tragedy' and 'travesty' and 'design' and 'debris', and Octavio Paz reads Sade's transgressive fictions as post-modern philosophy. To show the hair's breadth separating avant-garde masterpiece and pornographic tease we might consider Albert Camus's *The Myth of Sisyphus*, a recognized classic of modernism. Sisyphus's

eternal punishment is to push a boulder up a hill in Hades. Invariably, it falls down when it reaches the summit, requiring his painful efforts in another pointless push. His heroism, we learn, lies in his unflinching realization that this doomed effort is his inescapable fate. In full consciousness, he walks down the hill again. Such is the modern condition. However, we can imagine an equally revealing version of this story as follows: that Sisyphus's punishment is to be forced to reach orgasm and then come down, knowing that he will only have to reach it again and still again. Though this suggestion might appear a travesty of a great philosophical work, it reveals the connection between existential absurdity and the structure of pornography. This genre is ideally suited to a world devoid of value, meaning, and grounded truth, in which pleasure is reduced to mere sensation, endlessly and joylessly repeated.

This revised 'myth of Sisyphus' might explain the twentieth century's official distaste for pornography and its inability to do without it, its confusion of public and private, of individual and social, of feeling and sensation. The public blames tasteless artists for this state of affairs; artists say they are merely reflecting bourgeois commodification. No wonder that the topic of beauty seems beside the point under these circumstances, or relevant only if beauty is turned into a commodity filled with frightening power. It is no accident that the turn from the female subject and beauty coincides with a century of successful inroads of pornography into the realm of high art.

Pornography has recently made inroads into scholarship as well, though the idea that professors could legitimately present themselves as experts in pornography would have been met with utter incredulity a mere decade or two ago. This intellectual respectability has coincided with a breakdown of the distinction between high and low culture[26] and a massive appropriation of pornographic imagery in 'high art' during the 1980s and 1990s. As a result, the phrase 'pornographic art' is beginning to seem less contradictory than it did before. These forces may finally uncouple beauty from gender, to the point of allowing an experience of aesthetic discovery and self-projection independent of traditional morality or sex. Indeed, some day it might be possible to

resurrect the analogy between art and woman (or art and man) in an experience of value, beauty, and even love that does not deprive any of the parties involved of agency. But this is to jump ahead of the story.

Among the most helpful scholarly studies on pornography are the essays in the historian Lynn Hunt's collection, *The Invention of Pornography*. These explore transgressive sexual writing in the period from roughly 1500 to 1800. Like Eric Hobsbawm's *The Invention of Tradition,* the title involves a piece of wit: that a phenomenon thought to be primordial – pornography – turns out to be an artifact of history. Eroticism may be a constant in art, but pornography did not always exist as we know it. Rachel Weil points out that in Restoration England, it was hard to draw a clear line between political slander and pornography,[27] and Robert Darnton notes that pornographic books in France were called '*livres philosophiques*', a category indiscriminately comprising obscene, political, and philosophical writings. He writes in *Edition et Désition* that these '*mauvais livres*' were smuggled across borders with their pages 'married' with the leaves of respectable books.[28] Only after the French Revolution, according to Lynn Hunt, did the pornographic novel leave 'behind its political past. Pornography did not lose all contact with social and political reality . . . but it now embarked on a career as a separate and distinct genre, clearly consigned to the underside of bourgeois, domestic life in the nineteenth and twentieth centuries.'[29] This timing coincides with the replacement of the male by the female subject as a symbol of beauty in art, and as the normative gender for the nude. Idealized female nudity filled high art; transgressive female nudity filled pornography. In the middle stood bourgeois domesticity. We can see why the avant-garde would turn to pornography in their baiting of the middle classes.

Hunt claims that both the popularity and the censorship of pornography were effects of print technology, for 'it was only when print culture opened the possibility of the masses gaining access to writing and pictures that pornography began to emerge as a separate genre of representation'.[30] By the French Revolution, the promise of pornography was the assurance that sexual representation would be

available to everyone. Marie Antoinette, for years the most popular figure in French pornography, could be 'shared' in this way by the entire population.[31] Pornography was explicitly connected to freedom of the press. As Louis-Sébastien Mercier complained in 1798, the production of licentious books 'is based on that unlimited liberty of the press which has been demanded by the falsest, most miserable, and blindest of men'.[32] Even in the nationalist movements of the 1880s, the rise of mass politics was accompanied by an explosion of indigenous pornography, a fact that Hunt finds 'suggestive of the link between pornography and democracy'.[33] If we recall that Kant considered beauty an experience of freedom from constraint and contingency, we can perhaps understand the developing connection between pornography and avant-garde aesthetics.

However, the 'philosophy' espoused in pornography was everything that Kant had set out to oppose: materialism. According to Margaret C. Jacob, the same late-seventeenth-century generation that mechanized and anatomized physical nature invented a new materialist and pornographic discourse exploring 'bodies in motion'.[34] This pornography preached a libertine ethic of desire driven by 'the relentless motion inherent in matter'. As the heroine of *Thérèse Philosophe* instructs, 'It is the arrangement of organs, the dispositions of the fibres, a certain movement, the liquids, which make up the genre of the passions . . . nature is uniform.' Bodies are moved by the same laws, composed of the same parts, productive of the same pleasures. Materialism collapsed spirit into matter, and in the process subverted the authority of church and monarchy. With the exceptions of Hobbes and Spinoza, materialist writing was forced underground, censored as vigorously as the pornography that it spawned. This was the very materialism that formed the basis of capitalism, and that the avant-garde so eagerly wished to reveal as the unacknowledged value system of the bourgeoisie. To establish the liberating ideality of art, paradoxically, they rubbed middle–class noses in materialist pornography.

According to the historians in Hunt's collection, the libertinism espoused in pornography grew directly out of late-seventeenth-century

scientific materialism. And libertinism was not the province of men alone. 'In a materialist universe,' writes Kathryn Norberg, 'the only reward is bodily pleasure, and women are as entitled to this reward as any other human.'[35] The 'libertine whore' thus dominates pre-nineteenth-century pornography, and indeed, the earliest meaning of pornography is 'writing about prostitutes'. In confessions of her adventures or conversations with naïve initiates, 'the prostitute's chatter simply *is* much of Western pornography, and no other character, male or female, pimp or rake, can dispute her dominance in the world of the obscene'. Though the libertine whore overlapped with the 'virtuous courtesan' and the Enlightenment's new cult of womanhood, she was 'a creature of the rococo, of an age enamored of materialist philosophy and comfortable with sensual pleasure, especially "varied" pleasure'. She had nothing but scorn, then, for the ideology of sexual difference, with its belief in the innate modesty, domesticity, and virtue of women and its limits on female freedom and enjoyment. Independent, sensual, sensible, and skilled, the prostitute was a businesswoman and an artist, a materialist philosopher and an *arriviste*, laughing at social distinctions and fooling her 'betters'. The heroine of Brian De Palma's *Dressed to Kill* is a descendant of this hard-headed, rationalist whore.

The libertine prostitute nonetheless was not, according to Norberg, a liberated woman *avant la lettre*, but a male fiction invented for male consumption. When the forces of sexual differentiation carried the day in the nineteenth century, this fabulous creature disappeared from literature, replaced by harlots who struggled on with hearts of gold towards ostracism, victimization, and death, or vampiric sirens who required vanquishing by brave, right-thinking men. We have already witnessed the nineteenth-century equation of woman with prostitute. It is at this time, too, that the word 'pornography' came into use in Western Europe, the British Library established its Private Case, and the Bibliothèque Nationale its Collection de l'Enfer. According to Walter Kendrick, medical sociology and archaeology were the first areas to use the term. We saw from Charles Bernheimer the importance of the connection between prostitution and sanitary engineering, and

Kendrick describes the impact of the excavation of the sexually explicit frescoes at Pompeii. He considers the broadening of the reading public at this time another factor: 'cheaper printing methods, rising literacy rates, and dissolving social arrangements made it less and less certain into whose hands a book or picture might fall',[36] and therefore regulation became a crucial concern for social 'authorities'.

By the mid-nineteenth century, pornography had lost its overt philosophical and political content and could build on the fantastic excesses of its close relation, gothic romance. *Frankenstein*, as we have seen, points out the connection between the Kantian sublime and the thrilling inhumanity of male, scientific creativity. It was no accident that the modernists' rehabilitation of the Marquis de Sade began with one of the most doctrinaire of avant-garde purists, Guillaume Apollinaire, who earned his living by writing pornography and who advocated an art of sublime form. According to Roger Shattuck, 'In 1909 [Apollinaire] called Sade "the freest spirit that has ever lived," who might become "the dominant figure of the 20th century".'[37] Apollinaire's prophesy came to pass, as the Kantian ideal of aesthetic freedom became most often realized in the defiant legalization and consumption of transgressive art.

This historical excursus perhaps explains the contradictions that plague us in contemporary disputes over obscene art. On the one hand, early-modern pornography glorified the liberated individual unconstrained by convention or authority, free to experience pleasure without guilt, to indulge the curiosity and obsessiveness of a scientist in the exploration of the senses. But on the other hand, this ideology entailed a levelling and depersonalizing rigour – an objective non-discrimination among bodies, all equally interesting as interchangeable holes and plugs. Pornography suspends value and preference in favour of novelty and variety; its plot is an additive sequence of equivalent encounters rather than a directed progression toward unique fulfilment.

Hunt notes in passing that though the rise of the novel and pornography coincided, their audiences did not. 'Women were thought especially susceptible to the imaginative effects of the novel,

while men were usually assumed . . . to be the primary audience for pornographic writing, at least until the end of the eighteenth century.'[38] Today, we would substitute the popular romance for the novel in this opposition, the romance a woman's genre, pornography still a man's. The central drama at work in virtually any popular romance today is the conflict that libertine materialism introduces into the female sphere – interchangeability versus uniqueness, the indiscriminate pleasures of immediate and repeated gratification versus the sacrifices required in a continuing, irreplaceable commitment. In the romance world, a woman who indulges her sexual freedom may lose forever the possibility of true love, and a man deceived by his appetites may fail to recognize perfection when he sees it. In pornography, in contrast, the hero or heroine is constantly beset by those who misunderstand 'the game', falling in love with the libertine, imposing rules and limitations, employing vulnerability or necessity as a brake on behaviour. In the romance, unique value prevails; in pornography, it is a sentimental, naïve target.

The literary romance depends on the supreme valuing of a unique ideal – the most beautiful person (Laura, Beatrice) or transcendent object (the Holy Grail), whose attainment is worth any sacrifice. Pornography is the reverse. It celebrates the continuous enjoyment of non-unique, interchangeable values (women, consumer objects). As the genre par excellence of commodification, pornography presents every-thing as subject to exchange. The burlesque star Lili St Cyr, notorious for emerging on stage from a bubble bath, understood this well: 'Sex is currency. What's the use of being beautiful if you can't profit from it?'[39] As we saw with a different Lily, Edith Wharton's heroine in *The House of Mirth*, turning beauty to profit is a romance impossibility. We can thus understand the connection between the romance and Catholicism, feudalism, monarchy, élitism, and conservatism, whereas pornography is associated with atheism, mercantilism, capitalism, republicanism, democratic egalitarianism, and liberal freedoms. The ideal hero of romance is a Christian knight; the ideal hero of pornography would be a tyro in the field of mergers and acquisitions – or perhaps an avant-

garde artist.

When the romance ideal is a woman, it is the wholeness of her being that the hero strives to attain through marriage. In pornography, her body and the character traits that enhance her allure are the only interest. Thus, the hero may be aroused by the smallest part of her body and utterly ignore her as a fully achieved human being. Martin Buber explains the difference between 'Thou' and 'It' specifically in terms of this whole-part contrast:

> Just as the melody is not made up of notes nor the verse of words nor the statue of lines, but they must be tugged and dragged till their unity has been scattered into these many pieces, so with the man to whom I say *Thou*. I can take out from him the colour of his hair, or of his speech, or of his goodness. I must continually do this. But each time I do it he ceases to be *Thou*.[40]

Thomas Pynchon's *V.* is one of the most thoroughgoing literary examinations of the contrary pulls of the romance quest for wholeness and the pornographic fixation on parts, with its elusive heroine constantly threatened with disassemblage into her constituent pieces. If the romance leans towards an obsession over an ineffable, irreducible whole, pornography leans towards a fetishization of minor parts.

These attitudes towards value produce opposite plot structures in romance and pornography. The romance plot is teleological, proceeding single-mindedly towards a much blocked and delayed end which validates all the preceding struggles. Pornographic plots, in contrast, are picaresque and meandering, characterized by desire ignited, consummated, and reignited in an endless series. Episodes require no justification beyond the satisfaction they provide, and so one of the greatest problems for a pornographer is how to produce an ending without subverting this additive structure. The two genres tend to comment on each other. Romances embed accounts of lechery – for example, the House of Fame in Spenser's *The Faerie Queene* – as an ordeal or a temptation that a romance hero must overcome. Knights

errant and quivering virgins, in their turn, are the most delicious targets of pornographic seduction.

By the twentieth century, the popular romance and pornography were as polarized as two genres could be – separate in terms of audience and structure and ideological base. And yet, from *Ulysses* to Picasso's *Suite Vollard*, from Pynchon's *The Crying of Lot 49* to Warhol's celebrity silkscreens, the century's artistic landmarks mingle pornography and romance in inextricable combination. Nabokov's *Lolita* is one of the most programmatic of these masterworks, sexually shocking to this day, when child abuse is still a non-negotiable border against tolerance. *Lolita* presents itself as both a paradigmatic love story and the story of art, and it takes off specifically from Edgar Allan Poe's claim that the most poetic of subjects is the death of a beautiful woman. Nabokov's protagonist, Humbert Humbert, is himself a literary echo and a fake, a humbug. As a boy, he suffered the loss of his first love, Annabel Leigh (a version of Poe's Annabel Lee), and this deprivation forces him to seek a substitute. *Lolita* explores the obsessive desire for ideal, e-*lit*-e beauty in a reality filled with vulgar contingency – little Lo – comically and tragically inadequate to the ideal. In its flipflop between pornography and high romance, this brilliant novel reveals the quandary of avant-garde aesthetics, championing freedom at the expense of meaning, value, and pleasure.

Defenders of avant-garde art, we have seen, insisted that its value lay in its formal beauty. Form is ideal, free of contingency and 'interest'. The expressionist Wassily Kandinsky, however, claimed that 'The artist must have something to communicate, since mastery over form is not the end but, instead, the adapting of form to internal significance . . . That is beautiful which is produced by internal necessity, which springs from the soul.'[41] If the artist does not have this imperative to communicate, then the work is a mere thing, an object, and as such, it is part of a materialist ethos. 'At those times when the soul tends to be choked by materialist lack of belief,' Kandinsky wrote, 'art becomes purposeless, and it is said that art exists for art's sake alone.' This materialism collapses value and alienates the artist from his audience, 'until at last the public turns its back,

or regards the artist as a juggler whose skill and dexterity alone are worthy of applause. It is important for the artist to gauge his position correctly, to realize that . . . he is not a king but a servant of a noble end.' Kandinsky's words are a diagnosis of the communicative malaise of modernism (to which he and other great artists, to be sure, are exceptions). Despite its claims for the ideality of formal beauty, modernism achieved instead an alienated, pornographic freedom, the sensationalism spelled out in Apollinarie's 'sublime', the logical response to which is the desire for more of the same.

Under the pressure of Kant's 'disinterested interest', the avant-garde's hostility to the bourgeoisie, and the misogyny built into this aesthetics, pornography was constructed as the inverse of high art, but has never been more central to it. It is an inextricable element of modernism: *Philosophy in the Bedroom* the shadowy underside of *The Myth of Sisyphus*. 'Beauty' in modernism is a monstrous sublime, as Mary Shelley predicted, but it is a monster that we must acknowledge ours if the shock strategy of the avant-garde is ever to end. For what has been fenced off into the fetish realm of pornography – desire, allure, charm, sexuality – is necessary to art, however much denied in the official statements of the avant-garde. It is time then to return to the interplay of form, fetish, ornament, and the female subject where we left off in the previous chapter.

THE QUOTATION OF BEAUTY

Not fundamentals. Fundaments.

— John Fowles, 1973

By mid-century in the west, high culture was avant-garde culture. Artistic beauty lay in form, not woman or ornament, and the pornographic fetish took care of whatever form left out until the work settled down into 'art'. Critics rewrote the past accordingly, as when Sir Kenneth Clark claimed in 1956 that the nude, from the ancient world onward, 'is not the subject of art, but a form of art'.[1] Art at this point was uncompromisingly pure (Abstract Impressionism) or outspokenly impure (the Beats, jazz), and artists were still in flight from the 'soft' values, as they conceived them, implicit in beauty. As Barnett Newman stated in 1948, 'The impulse of modern art is the desire to destroy beauty.'[2] In *Tiger's Eye*, he published an essay called 'The Sublime Is Now', in which he made explicit the founding move of modernism: the replacement of the beautiful by the sublime.

The chasm between high and middle-brow taste yawned in 1950s America. Bourgeois values were embodied in the suburbs — respectability, conformity, stability — despite the proliferation of escapist soap operas, steamy movie melodramas, comic-book romances, and some of the century's greatest musicals, with their examination of injustice and emotional denial. Feminine beauty and allure flourished in the popular

arts, but high art more ferociously than ever shunned such non-aesthetic 'interest'.

The academy in both Europe and America was dominated by formalist criticism – the US New Criticism, the French 'explication de texte', the German 'immanente Interpretation', and the fusion of Russian and Prague theory in the pan-disciplinary structuralism disseminated by European émigrés after World War II. In art history, Clement Greenberg had translated into theoretical terms the practice of modernist painters: 'No "painterly" striving for emotional or atmospheric effects, no recognizable images, and above all no illusionistic spatial depth that might divert attention from the essential *flatness* of the canvas support, the "integrity of the picture plane".'[3]

Exemplifying this programme, Abstract Expressionism achieved international recognition in the 1950s, and New York for the first time became the art capital of the world. The huge Abstract Expressionist canvases were pure, superhuman, sublime: art *objects* in the most literal sense, but objects whose very refusal to mean gave them transcendent meaning. Jackson Pollock invented his splatter technique, his heroic athleticism and genius producing an apparently spontaneous abstraction springing from the very life forces within him. We saw earlier the ease with which such works fall in with ornament, and the outrage artists felt when this philistine interpretation was proposed.

A photograph by Cecil Beaton published in *Vogue* **[Pl. 15]**, like Matisse's *Decorative Figure on an Ornamental Ground* before it, demonstrates the subordination of the female subject and ornament to form at this time. The photograph presents a splatter painting too massive to fit within the photographic field. It might almost be taken as wallpaper on a surface behind the glamorous woman shown, except that she is, instead, the window-dressing for the painting. She is a high-fashion model, an unindividuated female form defined by the norms of the day, whose appearance in this photograph has been designed as a witty replica of the work of art behind her – fashion and female beauty as trivial adjuncts to high aesthetics. The painting has in effect called her into being as a decorative add-on; the absoluteness of its formal beauty

reduces any other sort of beauty to mere ornament. This stand-off between model and artwork appears repeatedly in 1950s fashion photography, as in the work of Louise Dahl-Wolfe, and reflects the still ambiguous status of photography, poised somewhere between art and fashion.

In literature, Alain Robbe-Grillet's programme for a 'new novel' carried avant-garde aesthetics a step further, attempting to separate art from the human sphere entirely. Fiction must present the world as it is, he claimed: a landscape of objects. Down with anthropomorphic descriptions! Objects are merely objects and not reflections of our emotional or spiritual states. It is about time that novelists outgrew the pathetic fallacy and risked whatever might be 'the logical consequences of asserting personal freedom'. Intent on 'this cleansing operation', Robbe-Grillet set out to produce descriptions as objective as physics or geometry,[4] with no fetishistic cheating allowed.

These were brave words. Attempting to out-avant-garde the avant-garde, Robbe-Grillet offered an example of such description in his manifesto-like article, 'Three Reflected Visions'. It is a maddeningly level account of a room, and would be quite boring were it not at the same time a demonstration of a revolutionary literary programme. However, amid all the objectivity of interior space relations, Robbe-Grillet comes back to the dressmaker's dummy in the room several times, although he registers the other furnishings only once. Woman has been reduced to a dressmaker's form, as Beaton's model is just a couturier's mannequin, but she still exercises enough fascination over her perceiver that he returns to her in a compulsive repetition.

Insisting on formal objectivity, artists could not seem to escape desire, and this subversion of their best efforts made female beauty seem all the more sinister, fetishistic, sublime. Likewise protesting too much, Jean Dubuffet denounced the female subject in 'Landscaped Tables, Landscapes of the Mind, Stones of Philosophy':

Having been attached for such a long time – a whole year – to the particular theme of the body of the naked woman, it was to this

theme again that I first linked my experiments with new techniques
. . . When I ask myself what has brought me to this subject, so typical
of the worst painting, I think it is, in part, because the female body,
of all the objects in the world, is the one that has long been associated
(for Occidentals) with a very specious notion of beauty (inherited
from the Greeks and cultivated by the magazine covers); now it
pleases me to protest against this aesthetic, which I find miserable and
most depressing. Surely I aim for a beauty, but not that one.[5]

Rejecting the beauty of the female subject, Dubuffet turned to a whole
array of primitivist alternatives: the art of the insane, the prehistoric, and
the non-Western. The proliferation of these fetishistic replacements still
continues with other artists in our day, as we shall see in the next
chapter.

Robbe-Grillet and Dubuffet were forced into this stridency, I
believe, because avant-garde aesthetics was losing its sting. By mid-
century, sophisticated taste was only too happy to welcome formal
innovation. Though a certain portion of the public insisted that Abstract
Expressionism was not art, the movement had early achieved classic
status with the cognoscenti, and seemed no threat to the bourgeois
values of its owners. Rothko, for example, was appreciated for the
contemplative stillness of his achievements in colour, though he saw
himself as an artist in militant revolt against society. The struggle and
anger of the sublime artist were becoming an emasculated cliché as
Abstract Expressionism found its way into corporate boardrooms, major
museums, and lavishly decorated living-rooms. Moreover, this struggle
was being recast, in Cold-War thinking, into an assertion of American
democratic values. Evidence is beginning to emerge that the inter-
national dominance of Abstract Expressionism was clandestinely
promoted by – horror of horrors – the CIA. 'Langley's Ivy-trained
spooks did what no intelligence service has ever done, or will ever do
again: they bankrolled the avant-garde.'[6]

Though this suspicion would have devastated Rothko and his ilk,
avant-garde purity, sublimity, and freedom had become the establish-

ment's idea of high art. This state of affairs is parodied in Norman Rockwell's 1962 painting *The Connoisseur* [Pl. 16], with its 'well-tailored bourgeois scrutinising what seems to be a Jackson Pollock drip painting . . . Rockwell dripped the paint himself, and the effect is what might be expected: an excellent technical rendering of a dripped surface.'[7] The criticism that 'anyone can throw paint at a canvas and call it a work of art' finds apparent proof in this appropriation of Abstract Expressionism by America's arch-middlebrow realist. But *The Connoisseur* parodies more than modernist abstraction. It is also a sly dig at Caspar David Friedrich and the German sublime, as it pictures a figure from behind, contemplating an inhuman, transcendent sphere of art that exceeds the boundaries of the painting, just as Friedrich's *Fensterbilder* show figures staring through windows at the beyond [Pl. 17]. The middle-brow Rockwell could poke fun at a sublimity so entrenched in high art as to have become an unexamined cliché for artist and patron alike.

As abstraction was achieving this standard of tastefulness, the mid-century was rocked by one literary obscenity scandal after another: *Peyton Place, Lolita, Tropic of Cancer, Fahrenheit 451, Howl, Catcher in the Rye*.[8] The provocation – pornography or art? – was in full force. It was in 1954 that Hugh Hefner founded *Playboy* magazine, arguing that the tastefulness of the high-literary figures he published (Nabokov, Pinter, Mailer) was of a piece with the tastefulness of the female nudity in his centrefolds. Suddenly, it was possible to look at coloured images of naked women in public. In *Lolita*, Nabokov openly equated aesthetic bliss with eroticism and the thirst for beauty as lust for a pubescent girl. And despite legal difficulties, the novel was published and distributed. *Peyton Place*, as popular as *Lolita* was élite, violated one of the last bourgeois pieties: the sanctity of small-town, middle-class life. Overnight, the bourgeois appeared just as naughty as the bohemian, and mass-market fiction as transgressive as high art. Compared to the seething emotions of apple-pie America, the purity and spirituality of Rothko and the learned allusions of Nabokov seemed safe, respectable, indeed noble.

This unaccustomed respectability did not make the avant-garde

happy. Conceptual Art attempted to restore the edge to avant-garde
aesthetics by depriving its audience of not only ornamental and female
beauty, but all beauty beyond ideas as such. In 1963, Robert Morris
typed his *Statement of Aesthetic Withdrawal*, which he then had notarized
and exhibited in the Museum of Modern Art. 'The undersigned . . .
withdraws from said construction all aesthetic quality and content.'[9] As
in Balzac's *Le Chef d'oeuvre inconnu*, the surest way to protect the
aesthetic was to eliminate it. John Baldessari captures this notion in a
work of 1967-8 called 'Pure Beauty', in which the title is simply painted
in black caps across a neutral background. The *purest* beauty is the
phrase 'pure beauty', and nothing but. Here artistic beauty asserts itself
even more blatantly than in *Olympia*. But since the vehicle is language
rather than an alluring female subject, the message provoked thought
rather than outrage. Through hyper-rationality and sensory
deprivation, conceptualism breathed new life into the sublime monster.

Arthur Danto traces this move back to the Dadaists' insight that
beauty is not a necessary condition for art.

> That art need not be constrained by aesthetic considerations was
> probably the major conceptual discovery in twentieth-century art. It
> effectively liberated artists from the imperative to create only what is
> beautiful, and at the same time freed the philosophy of art from
> having to concern itself with the analysis of beauty, which had been
> the central preoccupation of the discipline of aesthetics since its
> establishment in the eighteenth century, and which, in my view
> accounted for the so-called dreariness of the subject . . . it follows that
> creating beauty is but one option for artists, who also have the choice
> of injuring or merely disregarding beauty.[10]

If conceptualism and minimalism took purity a step further than
dada, Pop art opened up new vistas by embracing *im*purity. Warhol and
Lichtenstein took on the beast where it lived in the very den of
bourgeois consumerism: advertising, public relations, the media.
Whereas the middle class had been trained to think of its money-

making ways as definitionally philistine and inimical to art, Pop artists would turn the commercializing and commodification of culture into a new phase of the avant-garde. In this way, it might be argued that Pop was merely making explicit what lay behind abstraction all the time: a pure materialism, art as a thing expressive of nothing beyond itself but perhaps the demise of earlier values.

The rise of Pop art and the return of representation that it heralded altered the relationship among form, fetish, ornament, and the female subject in art and forced a reinterpretation of beauty. As conceptualism tried to eliminate the possibility of beauty altogether, there was talk in other quarters of an artistic beauty not limited to form. John Cage praised Robert Rauschenberg's collages of urban junk for revealing that 'Beauty is now underfoot wherever we take the trouble to look.'[11] In the 1960s, even ornament was making a comeback.

Much of postmodernism, in fact, is an extreme reaction to the functional restriction of modernism. To Mies van der Rohe's 1923 dictum, 'Less is more,' Robert Venturi quipped, 'Less is a bore.'[12] Charles A. Jencks called modernist architecture 'inarticulate building', so intent on the purity of its language and the perfection of its solution that it ignored the particular needs of its clients, the social significance of given buildings, in short, the whole question of decorum, the suitability of artistic means to ends.[13] Ornament, it turns out, is crucial to some of these ends: 'there are a number of practical necessities that ornament is uniquely able to satisfy. The most obvious is the need for identification: telling people what an object or building is, for what purpose it is intended . . . ornament makes places legible.'[14]

It is striking how unrevealing in terms of meaning or purpose the work of even the most distinguished modern architects can be. People unfamiliar with Le Corbusier's Convent of La Tourette [Pl. 26], for example, cannot discern its function from its form, and the absence of ornament is part of the problem. Form without ornament is uninstructive, no more likely to signal the function of religious dwelling in this case than secular library, office building, university department, or parking garage.

In the postmodern view of modernism, form is a uniform. It does not follow function, but insensitively ignores it. One might argue that this is the case with any paradigmatic style, for example, neoclassicism, where buildings with a variety of functions – bank, museum, railroad station – may echo the façade of a Greek temple. But there the evocation of a noble tradition is meant to confer importance and respect on these functions. In contrast, modernism blanks out function as clean lines create anonymity in buildings regardless of their cultural value – from the humblest house to the most numinous religious or educational or political institution. Distinctions are signalled through the costliness of material rather than the artfulness of ornament; for all their anti-bourgeois prejudice, avant-garde value is materialist through and through.

Postmodern architecture deliberately parodied the modernist insensitivity to function by lifting the tasteful restraints of the earlier movement. Elements of every past style could be appropriated in this game – a classicist colonnade here, a romanesque arch there, a baroque moulding, a neon sign. The historical styles plundered in post-modernism might not add up to a lasting vision, but postmodernism was not about monumentality and uplift; it was about exuberance and fun. It had discovered a delightful paradox: the attempt at a monofunctional architecture results not in ideal, perfect buildings, but in uniformity, repression, and semantic deprivation. Ornament, allegedly functionless and insignificant, is an important element of architectural meaning.

Accordingly, in his visual 'treatise' *Matrix* of 1993, Robert Venturi calls his buildings 'decorated sheds', and advocates the use of ornament to create pattern, symbolism, irony, and wit. Robert Jensen and Patricia Conway[15] go so far as to call postmodern architecture 'Ornamentalism', 'a fascination with the surface of things as opposed to their essence; elaboration as opposed to simplicity; borrowing as opposed to originating; sensory stimulation as opposed to intellectual discipline. Sometimes it attempts to fool the eye, favoring humor and illusion over the honest expression of structure and function upon which Modernism has so long insisted.' This list reinstitutes the very

carnivalesque traits that modernism was so anxious to eliminate: humour, parody, mixed historical reference, disjunction, sensuality. It produces not the forced integration of modernism but Venturi's 'difficult whole', full of loose ends, questionable taste, and conflict.

In painting, postmodernism reintroduced representation, and ornament quickly followed. Indeed, the fragility of the distinction between the aesthetic and the decorative is the wedge that postmodernism used to discredit modernist painting. Thus, Peter Fuller wrote that 'within Modernism, perspective space and the imitation of nature fade, and there is a surge of emphasis on painting's roots in decoration and sensuous manipulation of materials, and a belief that such elements could provide a replacement for the lost symbolic order, destroyed by the decline of religious iconography, and the subsequent "failure of nature" to provide a substitute.'[16]

Pop art, photo-realism, and neo-expressionism reasserted the impurity of pictorial functionalism. These paintings are both representational and aesthetic – although in a highly subversive fashion. In Andy Warhol's *32 Campbell's Soup Cans*, for instance, the illusionistic cans are repeated in a pattern, commercial images morphing into art. Warhol's disaster series pushes the duality further. The grid of repeated atomic explosions or car crashes or race riots takes unique, disturbing, historical events and transforms them into the formal components of a pleasing design. The double vision produced by this strategy dramatizes the contrary pulls of visual art: towards form and towards representation. In contrast, Abstract Expressionism allowed form to dominate. In super-realist works of the late 1960s and 1970s, such as Richard Estes's *Horn and Hardart*, a similar polarization of representation and form is apparent. The painting mimics the realism of a photograph, which contains a reflection in a shop window of the geometric pattern of windows of the building across the street. The real seems militantly present, but at the same time, many times removed. The title itself might be a punning comment on the situation, with the hornlike concreteness of reality linked to the formal abstraction of 'hard art'.

If the standard – and devastating – critique of earlier painting had

been that it was merely decorative, 'nothing more than good design',[17] by adding the 'impurity' of representation, contemporary painting no longer had to protest against its decorative role. Several artists even insist on the connection between ornament and representation, for example, 'Pattern Painters', such as Robert Kushner and Robert Zakanitch, who arrange representational elements in repetitive designs. The relation between ornament and romance is apparent in Zakanitch's title, *It Always Happens When I Dance with You.*

Liberated by this new tolerance towards ornament, minimalists openly admitted the connection between avant-garde abstraction and decoration. '"I believe that art is shedding its vaunted mystery for a common sense of keenly realized decoration," [Dan] Flavin stated in 1967. ". . . We are pressing downward toward no art – a mutual sense of psychologically indifferent decoration – a neutral pleasure of seeing known to everyone." '[18]

The return of representation was accompanied from the start by artistic quotation and appropriation. Diane Waldman claims that 'American Neo-Expressionism depends upon the media for its mythology and imagery, exploiting pulp, porn, comic books, commercials, gangster films for a tabloid view of American life.'[19] Intertextuality and historicism were among the salient features of much postmodern fiction, too. Of course, aesthetic allusion abounds in modernist art and literature, but the attitude towards it was now different. Rather than maniacally synthesizing fragments or deploring their failure to coalesce, postmodernism basked in heterogeneity, in the vertigo of historical disjunction and interpretive indeterminacy.

Thomas Pynchon's *The Crying of Lot 49* presented interpretation as a cul-de-sac in which contradictory hypotheses coexist not tragically but stimulatingly, or rather, not only tragically, but also stimulatingly. Aesthetic history was just as unresolvable in this respect as life. John Hawkes quotes Michel Leiris to the effect 'that the poetic structure – like the canon, which is only a hole surrounded by steel – can be based only on what one does not have'.[20] With the aesthetic and cultural canon an empty weapon, postmodernists played astonishing games with history

and causality. Hawkes narrates past story events that have only the most glancing bearing on his narrative's present. Pynchon's novels teem with historical trivia: the Thurn and Taxis mail system, the development of aerial rocketry in World War II, the Pony Express. These are all potentially relevant to characters' problems, or perhaps irrelevant. They are all true, or perhaps distorted. The frantic field of details post-modernists assembled resists a single hierarchical organization, either by characters or by readers. It symbolizes the status of ornament at the time, when the marginal, the super-added, the supplemental threatened at any moment to become the centre, the essence, the heart of the matter.

Of course, not everyone celebrated postmodern eclecticism and indeterminacy. Charles Newman criticized the postmodern treatment of the past as

> a gesture of historical pathos without content, the restoration of historical images with no coordinates – a romanesque arch which holds up nothing, a Greek pilaster in mid air, a trapezoidal window in a neo-classical façade – the structural principle of which is a superimposition of images which refuse to dissolve with time, testimony not to a new eclecticism but merely the artist's erudition. What we have recently – in painting, music, and architecture no less than in literature . . . is an uncritical reception, an all-embracing nostalgia, in which *all* historical styles are dredged up simultaneously, history as gesture to a 'pastness' which disguises the real pain of history and struggle for knowledge . . . As Modernism has become the respectable culture, 'tradition' becomes the Avant-Garde.[21]

One could just as well argue, however, that early postmodernism dramatized the 'real pain of history and struggle for knowledge' in entertaining the possibility that history and knowledge might be ungraspable, alien, other, accidental, uncontainable, and at the same time that they might be nothing of the kind. Pynchon contemplated this state of affairs through information theory, imagining a world of absolute order as the extreme of redundancy, and a world of pure

randomness as the pole of entropy. Information, the goal that triggers interest and energy and life, is some intermediate state that requires the two extremes, and to be alive means to thread between the two possibilities. Neither can be confirmed or disproved and one must not succumb to either through alienation or suicide. *Interest* is the key, and Pynchon ties the spheres of business, psychology, and aesthetics together in this pun. It is an attempt to recast Kant's 'disinterested interest', which had promised transcendent freedom and delivered anomie and despair instead.

E. H. Gombrich explains the attraction of ornament and the sense of order through the same information-theoretical ideas. For him, 'the most basic fact of aesthetic experience [is] the fact that delight lies somewhere between boredom and confusion'.[22] From this standpoint, far from callousness or insensitivity, postmodernism represented the return of openness, flexibility, and aesthetic delight. Unlike modernism and its tasteful apologists, postmodernism credited all the competing functions in a given art. It was a period of inclusion, humour, irony, complexity, and permissible disjunction. But of course it was over the top. Once it had dynamited the fortress of modernism, its overstatement and rebelliousness lost their justification and a different cultural investigation set in.

For example, ornament made its comeback in postmodernism, as we see in Roy Lichtenstein's pop *Entablature* **[Pl. 18]**, which raises ornament and disjunction to subjects in their own right. In the 1980s, however, Jean-Michel Basquiat turned ornament into a social as well as an aesthetic matter in his graffiti art.[23] If Lichtenstein rendered ornament as an independent object, Basquiat turned the act of ornamentation into the act of art-making as such. Graffiti, like ornaments, are normally supplements. They are added on to the built world. Art that looks like graffiti transfers that act of supplementation, criminality, exuberance, and self-assertion to the world of high culture that real graffiti set out to deface. The specificity of the graffito – one person's idiosyncratic 'signature' – and its fragility, ever about to be washed off or painted over, made it a perfect contrast to the universalist claims of modernism.

Graffiti art set up some interesting oppositions: not only between painter and audience, but between those in either category who had been graffiti artists (with a small 'a') and those who had not, between those who lived with graffiti on their homes and those who did not. This division guaranteed widely differing interpretations, in part conditioned by the same variability in viewers. Graffiti art demonstrated not only its own rootedness in a time and place, but its audience's historicity. The graffito was thus as scandalous to a modernist sensibility as the tattoo, and postmodernism was fascinated with them both, as it now is with the Outsider art that has become our contemporary 'primitivism'.

At the same time, photography was insisting on the ornamental and fetishistic nature of its subjects and, analogously, of art. With Robert Mapplethorpe's images, this move set off fireworks. The expert testimony in the Mapplethorpe trial, that photographs of transgressive acts should be valued for their arcs and diagonals, turned the beauty of form into a joke. This trial was, in fact, a break point in the history of twentieth-century art.[24] But by the 1980s photography was full of such solecisms. Cindy Sherman's images are a full-scale investigation of the meaning of clothing, acting, disguise, impersonation, appropriation, and pastiche. The power of Sally Mann's work often arose at this time from the stylization, adornment, and staging of her children.

In art criticism, the iron grip of formalism relaxed by 1970, largely through the influence of literary theory. Derridean deconstruction was a kind of institutionalized scholarly carnival, and it is no accident that this period also dredged up Bakhtinian aesthetics from its Siberian exile in the past. '*Différance*', indeterminacy, the carnivalesque, disjunction, and irrationality were celebrated in postmodern aesthetic theory, and the concept of the supplement provided an explanation for the new role of ornament in all the arts.

The theorist Jacques Derrida examined ornament in *The Truth in Painting*. He noted that Kant, in trying to define the proper object of the judgement of taste, had distinguished it from the 'seductive ornament', for example the gilded frame, the colonnade, clothes on statues,

the frame, and draped caryatids. This Kant termed 'the *parergon*, the perversion, the adornment'. But by our day, Derrida argued, Kant's distinction between art and frame or between structure and gilded surface had become elusive. 'I do not know what is essential and what is accessory in a work . . . the whole analytic of aesthetic judgement forever assumes that one can distinguish rigorously between the intrinsic and the extrinsic.' Deconstruction, like its artistic equivalent, pastiche, blurred this opposition, and in postmodernism the anarchic novel replaced the overdetermined poem as the dominant literary mode.

According to the logic of aesthetic history, if postmodernism reintroduced ornament, we would expect to see it do the same for the female subject. And for some male artists it did. In John Fowles's 1974 novella, 'The Ebony Tower', a young abstractionist and an old representational artist get into an argument about whether form or desire is the essence of art. The older artist, accompanied by his nubile 'Mouse' (a postmodern version, one assumes, of a Muse), insists on desire, deriding form as impotence. He says to the young abstractionist, David: 'Perhaps abstraction, the very word, gave the game away. You did not want how you lived to be reflected in your painting; or because it was so compromised, so settled-for-the-safe, you could only try to camouflage its hollow reality under craftsmanship and good taste. Geometry. Safety hid in nothingness.'[25] David finds this contention outrageous and protests:

'But if philosophy needs logic? If applied mathematics needs the pure form? Surely there's a case for fundamentals in art, too?'

'Cock. Not fundamentals. Fundaments.' He nodded at the girl beside him. 'Pair of tits and a cunt. All that goes with them. That's reality. Not your piddling little theorems and pansy colors.'

. . . the Mouse interpreted, in an absolutely neutral voice. 'You're afraid of the human body.'

'Perhaps simply more interested in the mind than the genitals.'

'God help your bloody wife then.'

David said evenly, 'I thought we were talking about painting.'[26]

In this passage, David reveals the outdated assumptions behind his abstraction. Modernism had split the artwork from the artist. The viewer was to contemplate an object independent of its flesh-and-blood, historical creator, an object that belonged to a universal, transcendent order of being unburdened with practical contingency. Likewise, the subject of the artwork was to be considered irrelevant to its aesthetic status. Fowles identifies these assumptions with the mindset of an earnest young artist who has little experience of either art or life. Such purity no longer seems noble or brave but just misguided. At this moment, we might expect the Mouse/Muse, an updated version of woman as symbol of beauty in art, to have made her comeback, along with the topic of beauty.

But the old artist is old for a reason. His simple equation of art with a Lawrentian sexuality sounds impossibly anachronistic, crude, and chauvinist. It involves the kind of gender insensitivity apparent in a 1960 performance piece by Yves Klein, in which models are used as 'living paint brushes', nude and slathered in pigment. Before a genteel audience in formal dress, Klein's naked women dragged each other across a huge canvas to the accompaniment of a cello ensemble. Their bodies marked the canvas according to Klein's instructions, becoming truly the instruments of his art, and this art, though made from bodies, was at the same time quite abstract. The resulting works were called 'Anthropometry', the measure of man, human geometry. Here Klein perhaps unknowingly echoed Samuel Beckett's stuttered 'Acacacacademy of Anthropopopometry of Essy-in-Possy', the obscene legacy of rationalism that has shrunk the realm of the human 'one inch four ounce per caput' since the death of Bishop Berkeley and caused man to 'waste and pine waste and pine'.[27]

Resurrections of the female subject such as Fowles's Mouse and Klein's living paintbrushes were an early attempt, perhaps, to recover from modernist purism, but they reinstituted the passivity of female beauty in the process. By this time, feminism was becoming such an important cultural force that a simple reversion to premodern treatments of the female subject was impossible. The complexity of the

problem shows up in art by women in particular. The British feminist Angela Carter, for example, dramatized the contradiction between female beauty and agency in her novel *Shadow Dance*, in which young men destroy the extraordinary beauty of a woman's face with acid because it exerts too disturbing a power over them. We might imagine this acid-ravaged face as a painting of Woman by de Kooning. The message is all too clear: it was impossible to reinstate the female subject as a symbol of beauty while the misogyny of avant-garde aesthetics was in place. Paradoxically, at the very moment in the 1960s and 1970s when postmodernism had created an opening for ornament, the problem of female agency still kept the door closed on woman as a symbol of beauty.

At this time, feminism denounced the beauty contest for dehumanizing women. 'With new feminist eyes,' the activist Susan Brownmiller recalls, 'it suddenly clicked that Miss America was a very oppressive thing – all those women parading around in bathing suits, being judged for their beauty.'[28] One of the songs chanted by demonstrators in Atlantic City went, 'Ain't she sweet, making profits off her meat. Beauty sells she's told so she's out pluggin' it. Ain't she sweet?'[29] In 1969, Dana Densmore, a member of Cell 16 of Female Liberation in Cambridge, Massachusetts, wrote an article called 'The Temptation to Be a Beautiful Object', in which the term 'sexism' was coined. The intrinsic unfairness of the distribution of beauty among the female population, the entailment of passivity in the role of the 'to-be-observed', and the equation of value with mere surface led feminists to consider beauty a tool to keep women subservient to men and competitive towards each other. The feminist leader Gloria Steinem, whose beauty made her a media darling, was an object of suspicion and unease within the women's movement regardless of her best political efforts.[30]

At this time, too, the beauty question became central in race politics. To be beautiful is to be valued, and thus the claim: 'Black is beautiful'. African-Americans read the tyranny of white supremacy in the ubiquity of the Caucasian ideal of beauty – blond, blue-eyed, white-skinned. In *The Bluest Eye*, Toni Morrison explored the psychic damage done to

black women when value is equated with only white women's features. Unlike their white counterparts, black feminists did not condemn society's stress on female beauty, but insisted that black beauty be recognized and appreciated as such. The development of a multiracial approach to female beauty is still very much in process in US culture today.

Though the female subject had been absent or disguised in élite art throughout the century, she was omnipresent in the popular arts, and feminists took film and the media to task for perpetuating the beauty myth. In 1975, the film critic Laura Mulvey published her pathbreaking article, 'Visual Pleasure and Narrative Cinema', whose influence on feminism, cinema studies, literary theory, and art history has been incalculable. According to this article, not only is the viewing of pornography an act of male supremacy, but so is spectatorship at *any* film. In film's 'hermetically sealed world which unwinds magically', any cinematic experience is a brush with Freudian 'scopophilia', in which one reads 'woman as image, man as bearer of the look'.[31]

According to Mulvey, the movie screen becomes a mirror in which men are confirmed in their masculinity as powerful agents and women become the passive objects of men's scopophilic pleasure. This use of 'scopophilia' adds mightily to the 'burden of the image' in our day, making the enjoyment of filmic images of women a veritable psychological disorder. The man who finds aesthetic uplift in the image of a woman is, from this viewpoint, experiencing a neurotic confirmation of his own power.

For Mulvey, film always deprives women of agency, and its pleasure for men lies specifically in the experience of agency at their expense. Rather than Psyche's awe at Cupid's beauty and her subsequent elevation and gratification, woman is the sleeping, passive object of filmic perception and exalts only male spectators. Women's pleasure in film is an alienation from their female identity, for it proceeds from their inhabiting a male standpoint. Moreover, unlike Psyche, male viewers do not strive to become worthy of the beauty they contemplate. The female image gives them an undeserved sense of worth. The pleasure of

cinema in Mulvey's view results from its mitigation of male inadequacy, transforming the female star into a fetish available to them, an overvalued cult object that is 'satisfying in itself'.[32] Mulvey wants to junk this aesthetic. 'It is said that analysing pleasure, or beauty, destroys it. That is the intention of this article.'[33]

In the 1960s, the pop images of woman as go-go girl or Twiggy or flower child left much to be desired in terms of liberation politics. The same year Mulvey published her influential article, 1975, the outspoken Angela Carter was also thinking about female beauty: 'I spent a hallucinatory weekend, staring at faces I'd cut out of women's magazines, either from the beauty page or from the ads – all this season's faces – I tried to work out from the evidence before me (a) what women's faces are supposed to be looking like, now; and (b) why. It was something of an exercise in pure form, because the magazine models' faces aren't exactly the face in the street . . . but more a platonic ideal face.'[34] Here Carter becomes a modern Zeuxis, assembling a composite female beauty out of parts of real women, except that the 'real women' are already works of art, idealizations based on earlier standards of female beauty. Carter is as nonplussed by the results of her cutting and pasting as Dr Frankenstein before her, but no one has gotten any closer to 'real female beauty' than this infinite formal regress.

For feminists, female beauty as presented in advertising and the popular media has been dangerously alienated from real women, and beauty is still a suspect term. By 2000, feminists and health experts were launching a full-scale campaign to discredit the emaciated standard of female beauty pervading the culture.[35] Cecil Beaton's depersonalized model needed to be reborn as a creature of flesh and will.

The feminist critique of woman in the photographic arts falls in with a very different anti-ornamentalism. Male critics who denounced post-modern architecture on modernist grounds often did so by comparing it to 'woman'. David Harvey, for example, deplores 'an architecture of spectacle, with its sense of surface glitter and transitory pleasure, of display and ephemerality, of jouissance' associated with 'orgasmic effect', 'pleasure, leisure, seduction and erotic life . . . lust, greed and desire'.

Mark Wigley correctly points out that 'all of these terms are traditionally applied to the artefact "woman", the culturally constructed figure of both sexuality and surface'. This thinly disguised misogyny, added to the feminist disapproval of the fetishized female image in film, produces one of those unholy partnerships of left and right – feminism and anti-feminism – so common in contemporary aesthetics.

A third partner is what we might call the 'aesthetic activist', who disdains beauty as the enemy of change. Arthur Danto wistfully describes this position. Only after he had attended a conference on 'Whatever Happened To Beauty?' did he remember something the painter Brice Marden once said to an interviewer: 'The idea of beauty can be offensive . . . It doesn't deal with issues; political issues or social issues. But an issue that it does deal with is harmony.' Had he remembered this during the conference, Danto says, 'I might then have proposed that every beautiful work can be viewed as an allegory of political well-being, and disharmonic work as an allegory of social pathology.' Instead, he mentioned

Robert Motherwell's *Elegies to the Spanish Republic,* inasmuch as they were incontestably beautiful and also had an undeniably political content. To be sure, one elegizes only what is beyond help because dead, and while it is interesting to speculate on why beauty seems our spontaneous need in the presence of loss . . . one is left wondering whether beauty has any place at all when one employs art to change rather than merely lament a political reality.[36]

In this passage, beauty is either harmonious and symbolic of social peace and stability, or it is a mitigation of death and loss. In both cases – as a vision of a utopian order or a refuge from the unendurable here and now – beauty flies from real-world agency. It is always the 'not here' – the harmony that will exist only in an ideal future, the transcendence that exists only as a delusory escape from an intolerable present. As long as beauty is understood in Kantian terms, this separation from agency will prevail.

But if the experience of beauty is located in less pure states of mind, its efficacy will be proportionally greater. Ornament, paradoxically, is an opening to such impurity, and symbolizing beauty as woman – a fully realized female subject and not a merely passive object – would be a step toward an efficacious art. We can barely describe at this point what the impurity of efficacy would do to our sense of artistic beauty, in part because of our automatic distaste for the 'vulgarity' of such an aesthetics. But if we could see woman-as-agent as beautiful – Olympia as a person *and* a nude – we would be on the right track.

James Hillman insists that opening up the topic of beauty, previously 'perverted by the fascist appropriation of the subject', is 'reclaiming for the democratic tradition some of the abandoned terrain'.[37] This would seem to be a crucial undertaking for art, for women, and for democracy. But so far, it has been hard to disconnect beauty from objectivization and oppression. The female subject in particular, as we have seen, provokes the fears of well-intentioned people on all sides – feminists, art experts, political activists – and so the use of the female subject as a symbol of artistic beauty still might appear a retrograde, repressive enterprise.

The tenacity of the modernist legacy in this respect is striking, an unquestioned orthodoxy that pervades our culture. How many recent films have been made about the threat of the beautiful woman: *Dangerous Beauty, Fatal Attraction, Fatal Obsession, American Beauty*? Marie Ponsot, a prize-winning poet in her late seventies, says that her poems 'are meant to be beautiful. That's a very unfashionable thing to say. So unfashionable. Transgressive.'[38] Jorie Graham names a recent book of her poetry *The End of Beauty*. When the Swiss architects Jacques Herzog and Pierre de Meuron create dazzlingly beautiful surfaces, 'contemporaries like Rem Koolhaas have questioned their work's intellectual substance. Can truly good architecture use decoration so blatantly? Can it be so happily sensuous? Can it be so attractive?' All the modernist enmity towards ornament and allure is evident here, with the prejudice against craft following in quick order: 'Should Herzog & de Meuron be designing a line of clothing or fabrics instead?'[39]

Architecture is the art in which this Frankenstein aesthetics remains most persistent. A shockingly literal instance was a 1999 exhibition at the Hayward Gallery in London called 'Cities on the Move: Urban Chaos and Global Change – East Asian Art, Architecture and Film Now'. A team of architects designed the show to fill the Hayward with a multi-media presentation meant to evoke the experience of a futuristic Eastern city. Their inspirations constitute a compressed survey of modernism: Marinetti on the 'beauty of speed' (1909), Siegfried Kracauer on 'the cult of distraction' (1926), Kurt Schwitters on the Merzbau.[40] The upper gallery was filled with an architecture of heroic abstraction and monumental scale: the kind of projects that replace the squalidness of urban life with rationalist control and modernist purity.

Down the Hayward ramp into the lower gallery, however, the walls were papered with photographic posters of women – injured, impoverished, degraded. Identical life-sized statues of a gross, bleached-blonde prostitute rubbing her naked breasts turned up unexpectedly around every corner. One photo on the wall did contain the image of a male prostitute with a needle in his arm, but most of the photos were of women and girls, eastern and western. A huge, bulbous balloon doll bobbed over the devastation.

It is striking how unselfconsciously these architects – leaders in their field – presented this degraded image of the female as an essential counterpart of the purity of contemporary design. As the catalogue essay notes, 'Wang Du's *International Landscape* brings statues of Western prostitutes into Asian cityscapes as part of what he terms the "landscape of the Other". In Lee Bul's *Hydra*, on the other hand, it is the Eastern woman who is monumentalized and memorialized – as a huge blow up doll, a toy for the onlooker to play with.'[41] In this exhibition, the ideal future is a sphere of masculine purity, whereas the actual present is the female degradation of prostitution and disease. 'We'll do newness, like airport construction,' says Rem Koolhaas, 'but we'll also do decay, sex and drugs like in a real city.'[42] In a conversation in the catalogue between him and the exhibition curator Hans–Ulrich Obrist, Koolhaas comments on the difficulty of dealing with sex without exoticism.

'How to connect to it? We'll put all the architecture together, into a sterile room of architecture . . .' 'A torture chamber of architecture?' Obrist suggests. 'Let the works contaminate each other in an interesting way,' comes the answer. Feminine decay and male purity are two sides of the same sublime aesthetic. 'The walls of the whole ground floor should be covered with wallpaper, wallpaper of urban images, of urban realities . . . The wallpaper is a background, a grey presence everywhere, kind of overwhelming. That's the whole point of cities, a nightmare in a way. An overkill. Urban overkill inside the Hayward.'

In so far as the female subject has returned to art in a positive way – and she *has* begun a sort of comeback – she frequently seems a belligerent throwback to premodernism. For example, Pop art was full of female appropriation: Andy Warhol's *Marilyns* and *Jackies*; Roy Lichtenstein's comic-book blondes in the throes of love; James Rosenquist's enormous nudes intercut with images of kitsch flowers and furnishings, smooth and stylized and observed as if through the spaces in Venetian blinds. But these are quotations of the beautiful female subject – camp, ironic, and mediated by the reference to advertising and mass culture.

Pop art's glorification of the celebrity created an equivalent of the nineteenth century's 'universal prostitution'. Everyone will be famous for fifteen minutes, according to Warhol. Notoriety, fame, visibility, and recognition become values in themselves, and they are all a function of repetition. As we have seen, repetition is the structural hallmark of pornography, too, and in Warhol's statement that 'Repetition adds up to reputation',[43] the Pop maestro signalled a new age of pornography where everyone is a star for fifteen minutes and the difference between art and life is effaced. Whereas the prostitute sells her body, the celebrity sells her (or his) image to an equally undifferentiated audience, but outdoes her nineteenth-century counterpart by far in promiscuous self-exposure. The 'universal prostitution' of Proudhon's fears is the universal celebrity of Warhol's deadpan punditry – equally fictitious, equally a projection on the artist's part, equally a reflection of social anxiety about representation and gender. The celebrity is pure,

reproducible image: 'the medium is the message'; 'beauty is shoe'.

The analogy between beautiful woman and Pop icon affects not only how women are imagined in art but how women imagine themselves in order to be seen this way. Harold Brodkey has described the psychology of the star:

> the will to be beautiful, to be considered beautiful, to be sexually efficacious as an image and irresistible (to a large audience) and to be exploited for it – and then to escape from this exploitation – makes up the history of those people who become Hollywood symbols of the first rank.[44]

The alternation here between self-display and self-concealment is central, for the woman is to be present only as appearance. The camera loves her; indeed, if it did not love her she would not be a celebrity. In this situation she is unavailable for love of any other kind. This representation and the idea it offers for women to emulate are the sort of fabrication Dr Frankenstein might have happily engineered: a creature beautiful and utterly undemanding. To live in the aura of such a being is indeed to experience freedom and self-realization. To form oneself to be so loved is likewise a sublime self-fashioning! Thus, the Madonna of our day is a symbol of the desirable woman who had been banished – Marilyn driven to suicide – the beautiful woman forbidden. She comes back a 'Material Girl', rejoicing in the feminine superficiality and ornamentalism that had been so long despised. Camille Paglia, a professor fascinated with Madonna, herself became an intellectual pop star after celebrating femininity in *Sexual Personae*.

The formal expression of this intimacy without connection is the close-up, which, according to Brodkey, reveals the celebrity as orphan. The close-up, 'like a glamour-photo, is an image of desolate isolation which elicits infatuation'.[45] The photographer Cindy Sherman has played with this dynamics of exposure and concealment as much as any artist, and shows nothing but ironic disdain for the grief and frustration it elicits. For her, the death of a beautiful woman may be the most

poetic subject for male artists, but women artists are free to mock such poetry. 'Most depictions of women, pre-feminism, were exploitative, but I take that for granted,' she states. 'The female nude in art is something we've got to live with because people will always use it as a symbol of beauty. It bores me to tears.'[46]

Instead, Sherman photographs herself imitating film stills or canonic paintings of women [Pl. 19], or composes shots of fake body parts (often disassembled, as in Pynchon's *V.* or in pornographic description). She pushes feminine masquerade as far as it can go, exposing the body to hide the woman:

> Nudity is such an obvious attention-getting device that when I started using fake body parts in my photographs the idea was to make fun: people would see the works from afar and think, 'Oh, she's using nudity,' then realize I wasn't. I wanted that jolt. Some people have even asked me why I never used myself nude, and that's so stupid; they think that my photographs are actually about me, that I'm somehow revealing myself in them, so why shouldn't I totally reveal myself?[47]

Sherman might as well be Joyce describing the artist standing back from the work like God, uninvolved, paring his fingernails. Here, the nude may have returned to aesthetic representation, but as a joke, a tease, an absence. In effecting this return, Sherman denounces the image of beauty she inherited and the grotesquerie of fetishized woman.

The next step is a work like Neil Jordan's brilliant film *The Crying Game*, in which female beauty and allure are thoroughly fetishized, but not in a woman. Seemingly, the only way to house beauty, gentleness, love, and desirability – the traditional ideals of woman – is in a transvestite imitation. In this film, the traumatic climax in the Freudian fetish – the discovery by the male child of the 'castrated woman' – is replaced by the revelation that the woman is *not* castrated. For she is not in fact a woman but a male simulacrum of femininity that *requires* castration – the cutting of 'her' luxuriant hair – in order to become a man. In this

wildly paradoxical logic, complete with a 'real' woman IRA operative who acts more violently than the men, femininity becomes a set of infinitely desirable traits that can be found only in the rarest of creatures, least of all a woman.

This transvestite aesthetic is everywhere visible in photography. In Robert Mapplethorpe's photographic series of the female bodybuilder, Lisa Lyon, idealized female beauty is the stuff of muscle definition and the classicistic male pose **[Pl. 20]**. The women who actually develop their bodies in this way enter into the impossible gender conundrum of beauty. The 1985 film, *Pumping Iron II*, is a case in point. Here the traditional beauty contest, ('Who's the fairest of them all?') leads to a true dilemma. Who has built the fairest body: the woman with the biggest muscles or the most womanly body-builder? This documentary claims to be showing the sport at a crossroads, poised between the ideals of allure and brawn. The woman with the best physique by male standards is denied the prize, supposedly because the openly chauvinist judges fear that if her masculine appearance is rewarded, women will no longer enter the sport. A group of men (and one very unsympathetically presented woman judge) decide how the ideal female body should look. They purport to be reflecting what *women* think of as female beauty, but this is as elaborate an alienation of women's appearance from their control as any in twentieth-century aesthetics.

In this film, the most feminine and alluring of the bodybuilders does not win either, for she has refused to abide by the contest rules. Her revealing swimsuits are twice declared illegal, and she ruins her performance by drinking a sweet liqueur meant to give her an unfair advantage. In this morality play about beauty, aesthetic form, and feminine allure, the sexualized woman is meretricious, whereas the honest literalist, who disjoins bodily form from feminine allure, is 'unjustly' denied the crown. The implication is that when attitudes change, the judges will have the courage to reward the deserving competitor and not a compromise between the sexes, like the winner this time: a well-developed woman who is smaller than the masculine loser but much nicer than the feminine one. The dilemma remains: a

woman who fashions herself as a woman is incomplete and morally lacking, but one who fashions herself as a man is not recognizable as a woman. Damned if she does and damned if she doesn't, the female bodybuilder is finally not the one doing the fashioning anyway. She undergoes the pain of the 'sport', but men set the rules.

This ventriloquized self-authorship – an eerie analogue to Gertrude Stein's *The Autobiography of Alice B. Toklas* – is the perennial subject of women's performance art. Performance works, so many of which focus on the unclothed female body, are yet another chapter in the century's misleading quandary: pornography or art? In *Show*, for example, Vanessa Beecroft has women who are sometimes not models standing semi-nude in a room, on view before an audience. The women change position only occasionally, allowing their bodies to be seen in all their imperfection vis-à-vis supermodels and each other. Though the artist claims to be revealing 'the true beauty of women [which] has never been reflected in art or fashion',[48] it is hard to avoid judging that beauty according to artistic or fashion canons. We are all too conscious of their bulges, cellulite, flawed proportions, and faulty posture, and do not know whether to feel embarrassed for them at being exposed to such scrutiny or embarrassed at ourselves for harbouring such unworthy concerns. Though naked, they are not very sexy – nothing like pin-ups or statuary. One wonders whether others in the audience feel the same way and takes a peek, but this seems much more prurient an act than looking at the women. And then the whole thing just seems too fraught and one passes on, for surely 'the true beauty of women' is not to be discerned by staring at their naked, immobile bodies in an art gallery. Beauty – whether of men or women – involves an experience of pleasured empathy, and cannot occur with an Other reduced to a mere appearance, whether ideal or 'real'.

The question of pornography is inescapable in such performance art. The infamous work by Karen Finley, from which the NEA rescinded its support, shows Finley covered or adorned or besmirched – depending on your reading – with melted chocolate. Is this excremental nudity Finley's graffiti art – an obscene affront to the public (like all

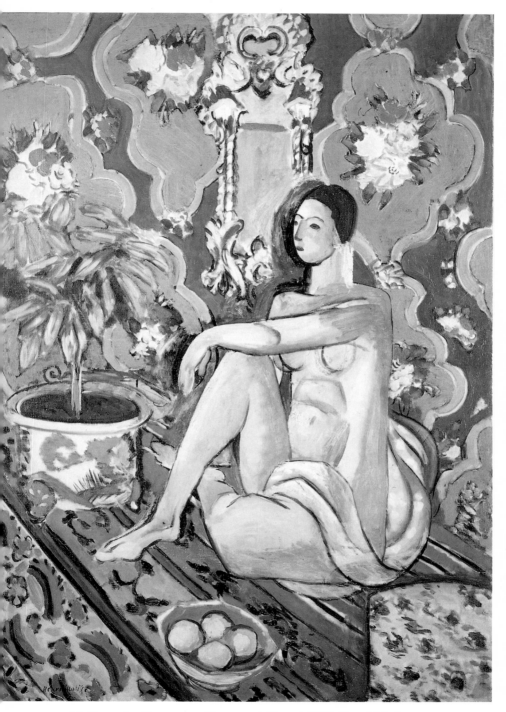

14. *Decorative Figure on an Ornamental Ground*, 1927. Henri Matisse
Photo: AKG London.

15. Cecil Beaton photograph (1950/1), published in *Vogue*:
model against a Jackson Pollock background.
Photograph courtesy of Sotheby's London.

16. *The Connoisseur*, 1962. Norman Rockwell
Printed by permission of the Norman Rockwell Family Trust.
Copyright © 1962 the Norman Rockwell Family Trust.

17. *Woman at the Window*, 1822. Caspar David Friedrich
Photo: AKG London.

18. *Entablature #10*, 1972. Roy Lichtenstein
Courtesy of the Estate of Roy Lichtenstein. Photo: Robert McKeever.

19. *Untitled #216*, 1989. Cindy Sherman
Courtesy the artist and Metro Pictures.

20. *Lisa Lyon*, 1982. Robert Mapplethorpe
Copyright © The Estate of Robert Mapplethorpe.

21. *"a"*, 1990. Mark Tansey
Oil on canvas.
Courtesy of Curt Marcus Gallery.

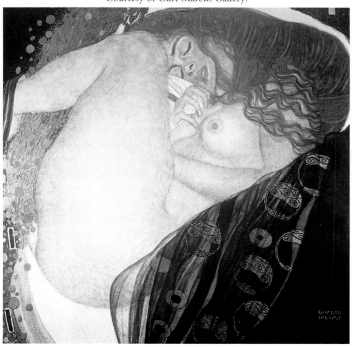

22. *Danaë*, 1907/08. Gustav Klimt
Photo: AKG London.

23. *Intimacy*, 1891. Pierre Bonnard
Photo: The Bridgeman Art Library.

24. *Table Before a Window*, 1934. Pierre Bonnard
Private Collection.

25. *Nude in Bathtub*, ca. 1941–46. Pierre Bonnard
Carnegie Museum of Art, Pittsburgh. Acquired through the generosity of the Sarah Mellon Scaife family.

26. Le Corbusier's Convent of La Tourette, 1957–1960.

27. *Daughter of Art History (Princess A)*, 1989.
Yasumasa Morimura

28. *Joe Lewis*, c. 1975. Sam Doyle
Courtesy Fleisher/Ollman Gallery, Phila., P
Photo Joe Painter.

those avant-garde male transgressions before her), or is she demonstrating graphically what the treatment of women's bodies at the hands of men amounts to? With a woman as the artist, it is hard to tell who the Frankenstein controller and who the monster in fact are. Beecroft's *Show* raises a similar problem. As Roberta Smith reports, 'That Ms Beecroft is a woman is essential to her work. Women are her material but also her surrogates. It is also important that her control of the piece goes only so far. Unlike Yves Klein, who used naked women as human paintbrushes and arranged their paint-covered bodies on canvas, Ms Beecroft is out of the picture once the performance begins.' The difference is not as clear as Roberta Smith suggests though, since the artist prescribes the dress, makeup, and general behaviour of her models/performers. It may be less troubling for a woman to be the creation of another woman than of a man, but *Show* is certainly not a case of self-fashioning.

But at least women are artists in such works. Clearly not Schopenhauer's talentless daubers or the passive studio help of artist-husbands or -fathers, contemporary women now occupy the role of artists in their own right. Often they set out to undo the damaging aesthetic history that preceded them. For example, Magdalena Abakanowicz and other women artists made fabric a high-art material during the 1970s, helping to break down the opposition between art and craft. In 1971, Adrian Piper performed *Food for the Spirit*, 'in which she photographed her physical and metaphysical changes during a prolonged period of dieting and reading Kant's *Critique of Pure Reason*, as "the catalytic moment for the subjective black nude, introducing her into a history from which she had been excluded, symbolically castrated and/or stereotypically depicted as nurturing mammy or insatiable jezebel".'[49] These interventions in history, incidental or profound, aim at creating a new aesthetics that undoes the damage caused by Enlightenment assumptions about gender and race.

Perhaps the most central problem for women artists is how to manage the symbolic identities of subject and object suddenly merged in them. This is frequently an unbearably painful exploration to

observe. Marina Abramovic dramatizes the masochism of the feminine masquerade in 'Art Must Be Beautiful; Artists Must Be Beautiful'. In this performance, she violently grooms her face and hair with a steel brush and comb, pulling and tangling her hair and scratching herself with these 'beauty tools' as she recites the two sentences in the title over and over again. A woman who makes art also makes herself in the process, for woman is still an archetypal symbol of beauty in art. In treating herself as an art object, however, she performs violence upon herself to make herself – her art – beautiful. However active she may be in this procedure, the inhumane analogy is obviously beyond her control. She has the air of a desperate puppet, urged on by forces beyond herself to repeat these imperatives and carry out the painful acts they prescribe. Like Sisyphus, all that her art, her consciousness, her agency give her is the ability to understand that this is, in fact, her fate, and to enact it as publicly and compulsively as the ugliest pornographic violence.

We might recall that male modernists were also concerned with their status as agents. An artist, in making a work, seemed to be in a position of dominance, but since the work revealed something about *him*, he might end up an object construed by his audience. This was the sympathy and warmth evoked in romanticism towards the generous spirit who 'reanimated' the world through art. But modernists did not trust their audience to understand or empathize with them; indeed, the sublime rules out such empathetic connection. Instead, modernists called for an 'impersonal art' in which the focus was on the work, and the artist, like God, stood back from his creation, sublimely unknowable. The audience, awestruck or alienated, channelled their emotions into admiration for the artist's brilliance. Female artists evoke a very different response in their dual function as creators of female images and bearers of those images themselves.

Some recent feminist art and criticism do take on the heroic lucidity of their male predecessors. Lynda Nead, for example, claims that

To write, or more generally to represent, is to take power; it is to tell

your own stories and draw your own lines, rather than succumb to the tales and images of others. Of course, there is a risk involved; you might not end up telling a fairy-tale with a happy ending, but at least you are the narrator and are in control of the means of narration.[50]

This control is cold comfort. As we shall see, artists of both sexes are becoming tired of this wasteland heroism, yearning more and more to discover a legitimate way of telling fairy-tales with happy endings, to have and give up control.

For the moment, cross-dressing and other forms of inter-gender symbolism are providing some relief in this trouble with beauty. Yesterday's scandal becomes today's wit, as Yasumasa Morimura merges the female masquerade of art with the transvestite masquerade of femininity. Morimura, like Cindy Sherman, photographs himself in a hundred poses, but his are mostly imitations of famous paintings. For a Japanese man, impersonating the beautiful female images of Western art is quite a challenge, and often he is remarkably (and absurdly) successful, for example, in *Queen and Dog* or *Portrait (6 Brides)*. Other works are wonderful jokes on the history of art. His *Olympia* helps us understand the nineteenth century's horror at this monster, and just when you thought there was nothing more that could possibly be added to the commentary on Velasquez's Infanta, Morimura's impersonation in *Daughter of Art History (Princess A)* **[Pl. 27]** shows unexpected possibilities in the painting that launched a thousand theories.

In the midst of such developments, suddenly we find the art historian Dave Hickey proclaiming that 'The issue of the nineties will be *beauty*'[51] and the critic Peter Schjeldahl writing that 'Beauty Is Back'.[52] The 1990s seem like an antic dance in which form, fetish, ornament, and woman approach each other and back off, changing partners, appropriating each other's steps. Janine Antoni decorated an installation at the Whitney with shelves of lipsticks and outdid Jackson Pollock and Yves Klein by swishing paint over canvases with her own hair as brush. Young female artists are overtly presenting themselves as sexy and fashionable: 'One is never so naked as when dressed for a party,' quips

Jessica Craig-Martin, whose art focuses on body language.[53] The boundary between fashion and art has blurred out, as one major museum after another mounts exhibitions by historical couturiers such as the surrealist Elsa Schiaparelli. The Japanese designer Issey Miyake prints a pleated sheath dress with an image by Morimura of Ingres's *La Source* entwined with a picture of Morimura's own body. When a woman wears this dress, the confusion among ornament, art, woman, and fetish is complete.

At the turn of the millennium, we can detect a decisive move away from modernism and its recent offshoots. Conceptual art has been declared 'over'[54] (although many artists seem not to have heard this pronouncement). Some critics have lost patience with even the most sublime of the Abstract Expressionists, Mark Rothko, finding his work not beautiful but 'gloomily elegant'[55] and describing his alienated life as a 'long, troubled preparation for a failure that eluded him'.[56] The internationally successful play *Art* shows how minimalism can strain friendship and love, with the sublimity of white-on-white an impediment to human attachment. Exhibitions that a decade ago would have been considered impossibly sentimental, kitschy, or vulgar – the Pre-Raphaelites, Petty's pin-ups, Norman Rockwell – are suddenly the norm rather than the exception, including a show of Julia Margaret Cameron's mid-nineteenth-century photographs of legendarily beautiful women made 'great thro' Love'.[57] This show, we should note, appeared at the Museum of Modern Art, perhaps the most important force in institutionalizing modernist formalism. We have already mentioned the Hirshhorn show 'Regarding Beauty' and the exhibitions of '*La Beauté*' celebrating the millennium in Avignon; it is hard to keep track of all the books, conferences, and courses on beauty springing up across Europe and America.[58] A female scholar, Leslie Heywood, recently described the modernist reduction of beauty to form as 'male anorexia'.[59]

But as with the image of women in art, the meaning of beauty in our culture is contradictory and confusing. The epitome of female beauty, the fashion model, is alternately disdained as a commodification of

woman and elevated to the status of culture hero. Plastic surgery has allowed some women to achieve a normative beauty previously unavailable to them, but at the cost of pain, possible injury, and confusion as to who is in control of their beautification. Though women doctors are more and more common, female plastic surgeons are rare. According to one expert, this is 'the Pygmalion angle' at work: 'Just look at the number of male plastic surgeons whose second wife was once their patient. It's unbelievable.'[60] A similar ambivalence surrounds the political meaning of beauty contests. They objectify women, demand absurd pledges of moral purity from them, and are associated with the commodification and murder of child beauties such as JonBenet Ramsey. But postcolonial critics argue that these contests define and create communities in previously colonized cultures and that the presence of racially diverse contestants in first-world shows empowers minorities.

Equally contradictory is the situation of beauty in the gay community. The lesbian 'femme' cultivates her feminine allure and beauty; the 'butch' does not. The homosexual ideal of male beauty seems not to have changed since ancient Greece, with its effeminate youths and muscular athletes. Discussing a recent exhibition of Baron Wilhelm von Gloeden's mid-nineteenth-century photographs, which first made 'male nudes popular subjects for both homosexuals and heterosexuals', the critic Vicki Goldberg writes: 'the long-term superiority of the male nude in western art depended on classical Greece, where a homosexual preference was openly expressed in vase painting and in literature. Later, though the sexual nature of the female nude was always evident, the homoerotic element of male nudity was seldom explicit or even acknowledged, though it could be implied or inferred.'[61] With sexuality so much more open since the Stonewall riots, however, classicism becomes a model that need no longer be sanitized of sex. Robert Mapplethorpe's photographs evoked classical and renaissance statuary, sometimes straightforwardly and sometimes ironically, expressing an ambivalence towards the past as fostering ideal and temptation to cliché.

Gay men and women encounter the same problems as straight

women when they step into the realm of beauty. 'Much of urban gay male culture,' writes Michelangelo Signorile, 'swept up in consumerism and commercialism, promotes a rigidly defined body ideal along with a particular value system and lifestyle, one that many gay men have found to be dispiriting, confining, and even destructive.'[62] Jonathan, a thirty-five-year-old gay living in Washington, DC, told Signorile that 'it depressed me to think that here is the ideal of beauty and I personally fall so short of that mark'.[63] Reed Woodhouse mocks Signorile's worries about the tyranny of 'body fascism' and the demands of 'the cult of masculinity' for the beauty of 'a hot body with that "big, *big*, look" ': 'How pathetic that so many successful gay men should believe they are actually *enjoying* this irrational and artificial life! Isn't their very beauty paradoxical proof that, deep down, they feel inadequate and ugly? Isn't the "life inside" . . . indistinguishable from life in a prison? And if so, how can we say that gay life has provided anything like liberation for the imprisoned cultists who so blindly persist in thinking themselves free?'[64] With the smallest verbal adjustment, this could read as a parody of feminist diatribes against the tyranny of beauty for women.

Straight and gay cultures share the same myths about beauty. Tom Bianchi's photographs have given gay men the status of Galatea: living sculptures created by a controlling artist. 'One speaks of an unusually beautiful man as "a Bianchi" rather in the way one spoke of beautiful women in the 1920's as "Ziegfeld Girls".'[65] So controversial was this notion of beauty in the gay community that Bianchi published a book, *In Defense of Beauty*,[66] which runs through every argument raised about female beauty in modernism, including the claim that male beauty can redeem the urban wasteland created by callous men. Beauty is the individual's defence against inhuman power, but at the same time it can be seen as a product of that very tyranny.

Even science is being used to explain gay beauty. Evolutionary psychology treats female beauty as an adaptive trait: it attracts men and therefore gives beautiful women a reproductive advantage. Thus, female pulchritude is closely allied to signs of general health and reproductive vigour (symmetry, the pinkness of good blood circulation,

the large breasts and hips of the oestrogen-unchallenged). Women like strong, handsome men for corresponding reasons. This line of argument has passed into gay debates: 'The physical qualities which are generally found attractive in both males and females are those which promise the ability to produce, protect, and nurture offspring . . . The gene for adoring an athletic male build and a maternal female one is universal . . . It is natural and inevitable that we love muscular young men.'[67] Here Nature rather than Bianchi has determined gay men's attraction to 'muscular young men', on the grounds of their reproductive and nurturing potential!

With straight men, male beauty and male nudity are equally mystified and mystifying. Just as modernists substituted exotic fetishes for the beauty of women, the beauty of men is easier to accept in outsiders. Tarzan has an excellent track-record for acceptable straight male nudity. Margo Jefferson describes the currency and adaptability of his awe-inspiringly beautiful body for much of the twentieth century: 'Tarzan has the racial pedigree of a white man and the mythic aura (and practical skills) of a noble savage: the perfect fusion of Empire and Nature. He is a conservationist . . . He is a warrior too . . . [and] he is sexually pure, having been reared by apes and kept apart from any native woman. It is Jane, the vivacious British heiress who introduces him to sexual desire and domesticity; together they make him utterly virile but keep him winningly puerile. Tarzan can barely speak English. He'd be a classic dumb blond if he weren't a Nordic god and a jungle king.'[68]

As a culture, we still find it hard to see passion and love dissociated from beauty, especially among the powerful: Prince Charles's preference for his mistress over his young, striking wife or Clinton's risking impeachment for the likes of Monica Lewinsky. The novelist Diane Johnson joked that in Paris, 'everybody agreed that her looks were a matter of American national honor, that the beauty of the leader's mistress reflects on the whole country; can you take seriously a nation where the leader does not lay claim to the most desirable females?'[69] But even in France, female beauty is not a simple matter. In

trying to update the symbol of the French Revolution, Marianne, the country found itself embroiled in a debate as to whether the model for this national ideal should be merely beautiful or in addition, an accomplished member of society. The beautiful model won out, but not without international headlines.[70]

At this topsy-turvy moment in the history of art and gender, the tattoo, not much seen in twentieth-century art since Adolf Loos's diatribe, 'Ornament and Crime', is suddenly everywhere. But in this case the tattoo is not worn by a Papuan or a criminal, but by respectable members of society. Sometimes it is even an idealized image of female beauty, as when the pin-up paintings of Alberto Vargas and George Petty are appropriated for tattoos. But now, women themselves wear tattoos. The tattooed woman is the fetish-marked fetish, the ornament ornamented, and as such she has been the occasion for re-examining the relations among form, fetish, ornament, and woman.

The tattoo indicates a commitment to beauty. '*Il faut souffrir pour être belle*', and Angela Carter considered the tattoo permanent proof of that perverse martyrdom.[71] Perhaps, but the social meanings of the tattoo are as various as those of art, and the boundaries between art and tattoo are closing. Outsider art galleries have full-scale shows of the work of tattoo artists. At the Venice Biennale in 1999, the Czech Pavilion's installation was a tattoo bar in which visitors could walk away branded with an artwork, in the image of Gorbachev's birthmark. The tattoo is a human analogue, moreover, for the graffiti on buildings.

The tattooed woman is a particularly useful symbol of the fetishizing of female beauty, for the tattoo, unlike most conventional ornament, cannot be detached. It fuses with the woman who wears it, an inextricable addition that participates in the postmodern ambiguity between essence and accident, intrinsicness and extrinsicness, form and subject matter that Derrida described. By writing on herself or being written upon, the woman becomes the bearer of the tattoo's message; her identity is signified in her carrying out this signifying act. The issue is: what control does she have over this picture etched upon her, and what control over others does it exercise?

Consider the fetishistic tattoo in John Hawkes's early-postmodern novel *Travesty*. Here a man drives his best friend and his daughter at high speed towards a thick stone wall, his words to them during the journey forming the novel's narrative. During this existential drive towards death, he spends a lot of time discussing his wife, who is also his muse and his friend's lover. He observes that this woman, Honorine, might appear an ordinary woman of her class, but 'the beauty of Honorine is that . . . she contains within herself precisely the discretion and charm and sensual certainty we could not have imagined'.[72] She signals this unexpected allure with a tattoo. 'There, adorning that small area between navel and pubic hair, there you see . . . the cluster of pale purple grapes on yellow stems . . . yellow stems! . . . that coils down from the navel of our Honorine or, to put it another way, that crowns the erogenous contours of our Honorine . . . Grapes, *cher ami*, a tattoo of smoky grapes that move when she breathes or whenever there is the slightest spasm or undulation in her abdomen. After seeing them, who would risk any constricting definition of our Honorine?'[73]

Honorine's tattoo transforms this ordinary, genteel woman into a principle of desire, an object capable of generating plots. By having had herself tattooed, she switches from bourgeoise to artist. Hers is not just sexuality but a sexuality that signifies itself; she is not just a woman but an artist of the self, a witty defier of decorum through the act of self-decoration. Hawkes's *Travesty* is not, I think, retrograde in the symbolic use it makes of female allure. Though Honorine, this glamorous 'lady of the dark chateau', might resemble a jazzed-up Lily Bart, dredged up from oblivion by an old-style fetishist who does not seem to know that the days of such fantasy women are over, she is anything but the helpless figure of doom that Lily represented. She writes herself through her tattoo, like Mark Tansey's female graffiti artist in his painting "*a*" [Pl. 21] (itself a sympathetic rewriting, perhaps, of 'the scarlet letter'). Honorine has a wide range of self-expressions, a cause of frustration and resentment for her husband, who clearly likes to be in the driver's seat, even if that means committing suicide. Her power, at the same time, is not a tyranny over others, but the more acceptable violence of

fascination, which coexists with disappointment and weakness. To play the fascinating woman is thus as risky as wearing a tattoo, but not to risk it is to lead a life marked only by banality. As one of Jenny Holzer's rubber stamps puts it: 'LACK OF CHARISMA CAN BE FATAL'.

In fact, the real problem with *Travesty* is not that Honorine is forced into the role of the beautiful fetishized woman, but that gender relations are represented purely as a power struggle. Honorine rises above the bourgeois woman by tattooing herself, making herself into an object of fascination who is also an agent. But her husband performs all sorts of acts to express his independence, his greater power. His ultimate rebellion, the car ride intended to smash himself, their daughter, and Honorine's lover into a stone wall, is presented as a parody of existential philosophy. The car whizzes past a fountain of *clairvoyance* or 'lucidity', threading the narrow line between 'design' and 'debris', 'tragedy' and 'travesty'. This time the most poetic subject is not the death of a beautiful woman mourned by her lover, but the death of all those who are loved by a beautiful woman, a death engineered by the man for whom she will grieve. This is not the sort of liberation that most feminists or aestheticians have in mind.

The clash of contemporary sexual ideologies is being written through the tattoo–ornament, but the question of agency always lurks in these performances: who controls the masquerade? For the feminist, Andrea Dworkin, the tattoo is a sign of women's powerlessness. The protagonist of her novel *Mercy* sees male violence writing itself upon women's bodies as a forced deformation of the freedom and selfhood that should have been their lot:

The only signs of existence are on you, you carry them on you, the marks, the bruises, the scars, your body gets marked where you exist, it's a history book with the signs of civilized life, communication, the city, the society, *belles lettres*, a primitive alphabet of blood and pain, the flesh poem . . . your body the paper and the poem, the press and the ink, the singer and the song; it's real, it's literal, this song of myself, you're what there is, the medium, the message, the sign, the

signifier; an autistic poem. Tattooed boys are your friends, they write
the words on their skin; but your skin gets used up, scraped away
every time they push you down.[74]

In Dworkin's image, the woman's body *is* the tattoo; it signifies what
it is. It collapses the distinction between sign and reality in its
'literalism', and the self it bespeaks is a victim. Men can tattoo
themselves, but women are tattooed by men, and the tattoo is not a
pretty design but an obliteration of design (and of the self) that is
indistinguishable from design – the skin, violently/artfully scraped
away. Instead of a positive mark, the woman's tattoo is a wound, an
effacement, an erasure. That, for Dworkin, is the real meaning of
conventional female identity – the tattoo, the ornament, the fetish laid
bare as pain and absence.

But other contemporary writers have pictured the flesh tattoo still
differently. In Toni Morrison's *Beloved*, the slave Sethe is beaten till her
back is raw. This cruel marking becomes the occasion for a white girl's
kindness – a girl called Amy, meaning 'friend' or even 'beloved'. Amy
lays healing cobwebs on Sethe's back and renames the wounds a
'chokecherry tree'. The scar turns into a tattoo – from a sign of injury
to a piece of fancy, as reality begins to mark Sethe with love rather than
hatred.

These literary tattoos indicate the range of conflicting attitudes
towards the female subject both inside and outside of art. However, the
female subject has been so contested of late that people are becoming
exhausted with the whole topic. One of the funniest presentations of
this battle fatigue is A.S. Byatt's story 'The Chinese Lobster' in *The
Matisse Stories*. In it, the female chair of an Art Department named Dr
Himmelblau must handle the complaint of a radical feminist graduate
student. She is writing a dissertation on 'The Female Body and Matisse',
and Dr Himmelblau has given the job of directing her thesis to a
distinguished visiting scholar called Perry Diss – a man.

Though the student's illiterate letter of complaint does not inspire
confidence, her view of Matisse's female subjects is not without its

merits (or so I hope, since it coincides rather closely with the one offered here in Chapter 2).

> I had written some notes on Matisse's *distortions* of the Female Body with respect especially to the spercificaly Female Organs, the Breasts the Cunt the Labia etc etc and also to her ways of accumulating Flesh on certain Parts of the Body which appeal to Men and tend to imobilise Women such as grotesquely swollen Thighs or protruding Stomachs. I mean to conect this in time to the whole tradition of the depiction of Female Slaves and Odalisques . . . Also his Women tend to have no features on their faces, they are Blanks, like Dolls, I find this sinister . . . [The Distinguished Visiting Professor] argued with me and went so far as to say I was hostile and full of hatred to Matisse. I said this was not a relevant criticism of my work and that Matisse was hostile and full of hatred towards women. He said Matisse was full of love and desire towards women (!!!!!) and I said '*exactly*' but he did not take the point.[75]

Dr Himmelblau invites Dr Diss for lunch in a Chinese restaurant in order to investigate the graduate student's claims. He is indeed hostile, totally unsympathetic to her charges against him and Matisse. Why not 'that old goat, Picasso,' he fumes, 'who did things to women's bodies out of genuine *malice*? Why *Matisse*?' And then he answers his own question. It is not how Matisse treated women that bothers the student, but how he treated beauty: 'he paints silent bliss. *Luxe, calme et volupté*.'[76]

Luxe, calme et volupté is the title of one of Matisse's paintings, and Dr Diss proceeds to quote the artist's words on the subject: 'What I dream of, is an art of balance, of purity, of quietness, without any disturbing subjects, without worry, which may be, for everyone who works with the mind, for the businessman as much as for the literary artist, something soothing, something to calm the brain, something analogous to a good armchair which relaxes him from his bodily weariness.'[77] 'Pleasure is *life*,' Dr Diss concludes, 'and most of us don't have it, or not much, or mess it up, and when we see it in those blues, those roses,

those oranges, that vermilion, we should fall down and worship – for it is *the thing itself* '[78] Dr Himmelblau is left trying to imagine how she could ever explain this to the angry student.

Matisse's – and Dr Diss's – retreat into modernist form is a nostalgic state of bliss. We might sometimes yearn for it, but at the same time, we cannot help but be suspicious of this yearning. The fetishistic mystification it entailed has been revealed, and 'luxury, calm, and voluptuousness', though a lovely phrase, does not describe the art of Matisse or of the twentieth-century avant-garde in general. The pleasure it offered never came unalloyed. For the moment, then, we are back where we began, with Marlene Dumas's *Image as Burden* as our final exhibit. The burden of the image – of female beauty and aesthetic pleasure – has grown heavy indeed.

THE BRIDE OF FRANKENSTEIN: AT HOME WITH THE OUTSIDER

Without the Other there is no eroticism, for there is no mirror.

– Octavio Paz, 1961

Beauty is the pursuit of 'the Other'.

– Louise Bourgeois, 1997

Beauty . . . you came back. But I didn't notice. I was too busy defining myself.

– Carter Ratcliff, 1998

Marlene Dumas depicts the burden of the image in gendered terms, with a male artist or viewer oppressed by a female image. A former object of delight, the female subject has become a dead weight. This artistic *pietà* is not limited to the realm of aesthetics, however, but extends into life: a sad assessment of the power relations between men and women and the empathy possible between them.

The traditional ground for deep knowledge between the sexes is the

home. Domesticity has been the private space of male-female inter-subjectivity, and the family the circle in which the barriers between self and Other were most frangible. In its war against bourgeois values, however, modernism had no patience with domesticity. The home was a world of convention, responsibility, femininity, and decorative craft: in short, a sphere where beauty was tied to everyday interest. It was everything an art museum was not. Striving for charm and pleasure and harmony, domesticity was the antithesis of the universal status of the beautiful and the sublime. In the twentieth century, it is little wonder then that 'Qualities associated with "femininity", such as "decorative", "precious", "miniature", "sentimental", "amateur",' writes the art historian Whitney Chadwick, 'have provided a set of negative characteristics against which to measure "high art".'[1]

The new woman had a quarrel with hearth and home as well. We recall Edith Wharton's despair at 'that ancient curriculum of house-keeping . . . swept aside by the "monstrous regiment" of the emancipated − young women taught by their elders to despise the kitchen and the linen room, and to substitute the acquiring of University degrees for the more complex art of living'.[2] In Wharton's day, insisting on the artistry of housekeeping was already a retrograde act, for to have equal rights women needed to extend their identity beyond the home.

Modernist misogyny and women's liberation are only two of the factors that dissociated self-realization from the domestic sphere. Throughout the history of fairytales and literature, the search for identity entailed setting out on an adventure − leaving home. One thereby entered an unfamiliar space in which normal assumptions no longer applied. In the course of confronting the unfamiliar, the 'Other', one found out one's own identity and in the process, expanded it. Or at least, this is the theory of the literary romance, picaresque novels, and adventure stories.

The greatest unknown, the challenge of challenges, is another person. Love stories at their most fundamental are the confrontation between a self and an Other − the self reaching beyond its own limits to encompass a beyond, and in the process coming to know itself, or the

new self it has become. We saw in the myth of Psyche that love may be driven by the desire for beauty. Seeking to be worthy of a beauteous Other, Psyche performed ordeals that took her outside her mortal state and elevated her into a different world that eventually became her new home, the site of her pleasure. In romance, the point is not to plunge oneself into strangeness and alterity forever, but to experience an Other so as to come home a new self.

Modernism, wedded to the heartless sublime, blocks any such accommodation. To the avant-garde sensibility, the achievement of a satisfying self-realization with an Other is a compromise, a retreat from transcendence. Thus, when the Surrealist André Breton famously opens his 'novel' *Nadja* with the words, 'Qui suis-je?'[3] his double-entendre constitutes almost a theory of the modernist treatment of the Other. The search to know oneself – 'Who am I?' – is indistinguishable from the pursuit of another – 'Whom do I follow?' To be is to be constantly in search of something strange, to follow it but never catch up. The self has to stay this Other, elusive and ever to be known.

The Russian Formalists thus declared 'defamiliarization' the central goal of art. In his 1914 manifesto, *The Resurrection of the Word*, Victor Shklovsky complained that not only past art but domestic life had become so automatized that one could no longer feel it. 'We have ceased to be artists in our quotidian life; we do not like our houses and clothes and easily part with a life that we do not perceive. Only the creation of new forms of art can bring back to man his experience of the world, resurrect things and kill pessimism.'[4] The need to experience intense sensation devalued familiarity in favour of constant formal innovation.

Gertrude Stein presented a more domestic conception of modern identity – 'I am I because my little dog knows me' – except that the parties in this interchange are not equal. Identity is confirmed through the dependable reaction of a familiar, a pet. But though the little dog's 'knowing', or more verifiably, its predictable response, is sufficient to confirm Stein's sense of herself, the dog is subhuman and ultimately unknowable. Stein may in turn respond consistently to the dog, but we

cannot know whether that response allows the dog to gain a sense of its identity, or indeed whether that is even a meaningful idea. The dog's consciousness, even more than that of people not ourselves, is unavailable as an object of knowledge, except by projection – a sentimental anthropomorphizing. We are usually content to limit our understanding of the little dog to the fact that it 'knows' us. If we do try to know our little dog, we enter the realm of the uncanny, the gothic, and leave the comfort of canine domesticity behind. I believe that modernism could imagine only these two alternatives – the perpetual pursuit of an idealized, sublime Other (and hence an alienated self), or the patronizing of a lesser, domestic Other (and hence an unacknowledgeable self). We might recall Frankenstein's monster here, irredeemably alien, but constantly yearning to have a home.

The avant-garde sensibility called for a deliberate estrangement of the artist from his subject. This estrangement comes in a thousand guises, but all of them involved the limitation of the subject to something less than human. 'There was little room in Renoir's painterly vision for an encounter with the consciousness of the Other,' according to Tamar Garb. 'Renoir preferred his female models to exude the animal-like passivity of cats. Women, he often proclaimed, were much like cats in their self-absorption and mindless narcissistic obsessions . . . Even Sigmund Freud . . . likened women's enduring narcissism with the enviable self-containment of cats and beasts of prey.'[5] We see here the doubleness of the modernist attitude to the Other – awe and disdain – as with the simultaneous fascination and disgust at the prostitute. The female subject, like the savages and cats to which she was compared, was not such a far cry from the predictable poodle of Stein's domesticity. A male artist who set out to define himself through such an Other might very well never come home.

The narrator of *Nadja*, Breton, is anything but a modernist stay-at-home. He is a Surrealist and an artist-*flâneur* schooled in Baudelaire's urban sublime. For him, the question of identity takes shape amid the alienating streets of the city. Home and wife (dogs are not much in evidence) are not part of the adventure, but merely a neutral backdrop:

down-time in the quest for identity. Seeking himself, Breton follows an Other, a street person named Nadja – the Russian diminutive of Nadjezda or Hope. Nadja represents a spiritual ideal of freedom that is the equivalent, in effect, of the Kantian experience of the sublime. She is open, *disponible*; she takes in whatever chaos and randomness come her way in a fearlessly heightened state. Nothing threatens her, because her ego, her interests, are never at stake. Her every waking moment contains the immediacy and authenticity of aesthesis, for she has escaped from instrumentality altogether. Or so Breton imagines. Nadja is a model for him – a surrogate he pursues in order to become. In doing so, he seeks a sublime self-expansion into the whole of experience, a merging of life with art.

For a while, Breton achieves this heightening. He performs titanic feats of aesthetic pattern-recognition, seeing connections everywhere in the streets of Paris and its *banlieues*. Puns, coincidences, and accidents reveal significance everywhere, and suddenly he realizes that there is no randomness or meaninglessness in the city after all. As long as he allows experience to write itself upon him, to speak through him, there is no space between him and the world. He must simply suspend rationalist sorting and sifting and treat everything as equally filled with significance. There is an elation that comes of this self-enlargement – an intoxication. It feels like love, and Breton believes that in Nadja he has met his soulmate. He feeds her and buys her presents and follows/leads her everywhere.

But before very long he realizes that Nadja is a madwoman, and that she needs Breton and wants things from him. She is not disinterested, just disoriented. At this point, with all the gratitude that comes of enlightenment, Breton drops her, not much concerned with what befalls her once she has lost her usefulness to him. He repays her contribution to his Surrealist training by immortalizing her in word and image. *Nadja* tells the story of this unsentimental education, the homonymity of the title lending the woman agency in art where she had none in life. The photographic 'illustrations' within the book show the places the two went, the signs they encountered, the objects that

amazed or amused them. There is no photo of Nadja herself, another of
the women whose absence fills modernism.

Nadja is an early image of the Outsider artist of the 1990s and of the
monster (or female as monster) behind modernism. She is the 'bride of
Frankenstein' in both senses: the synthetic female the doctor almost
assembled for his monster and the doctor's own bride, his soulmate, his
Other. Nadja is a 'natural' artist, untutored in Surrealist tenets because
she does not need instruction. She is the genuine article: embodying
Surrealism, enacting Surrealism, and therefore not needing to know
Surrealism. She is at the same time marginal, irredeemable as 'normal'.
In this logic, it is okay for Breton to treat her like an exotic version of
Gertrude Stein's little dog. She teaches him to experience art and
himself as Surrealist artist, but he has no responsibility to enter into her
consciousness, for that would be impossible anyway. In so far as one
tries to enter the mind of the outsider or deludedly feels one has
succeeded, one is a sentimentalist. The Surrealists and the rest of the
avant-garde, hardened against bourgeois sentimentality, were unlikely
to fall into such cloying error. They were happy to learn from a
monster, but also to leave the monster the outsider she was. Besides, the
thrill of such learning comes specifically from the fleeting touch it
provides with an irredeemable Other. You cannot put the sublime in
your pocket. If you do, by the time you get home it has either burnt
out the lining or turned to goo.

The aesthetic history of the twentieth century is tied up with ideas of
the Other as just such an outsider. As we have seen, a great deal of
modern art has involved a deliberate equation of the beautiful with the
merely charming, and a rejection of it in favour of the sublime. This
move has entailed an alienation from woman and ornament and
bourgeois domesticity, symbols of that shifting sphere of harmony,
proportion, comfort, and stasis. Artists reconceived the ornamental
woman as a corpse or a prostitute or a blank, and replaced her with the
purity of form and the thrill of the exotic fetish. Since the woman was
a male creation to start with, and since all creations are made in their
creator's image (however much he may deny them), this stratagem left

male avant-garde artists with a gratifying self-reflection. They could identify either with the rationality and heroic restraint of pure form, or, for those moments when a more gripping exteriorization of self was in order, they could flirt with the exoticism and thrill of the fetish. The fetish provided the fear and simultaneous safety of a sublime trans-cendence, as Nadja did, for it stayed in the realm of the Other, unredeemed as human, unrecognized as oneself. The artist could remain a superhuman mystery to himself, for there need be no romantic 'falling off' from the heights when a fetish stays Other, monstrous.

This is a perfect formula for pornography, too, as the Other leads the protagonist into new realms of exotic sexuality without ever requiring recognition as a being in her own right. Moreover, always foreign, never recognizable as the protagonist's self, she is available for unlimited repeat performances without provoking boredom or commitment. It is striking how consistent has been the connection between ethnography and pornography, notably in France, where Surrealism had such a strong foothold. Michel Leiris, Georges Bataille, Roland Barthes, Michel Foucault, and other French thinkers have seemed equally fascinated with the exotic other as cultural being and as sexual object. Leiris wrote a catalogue essay on Giacometti and the fetish, and supplied the epigraph for John Hawkes's novelistic treatment of fetishism, *Travesty*. According to Anthony Shelton, 'Leiris's essay "Le caput mortuum ou la femme de l'alchimiste" is among the first indications of the European reaffirmation of the possibility of creating the sexually exotised woman at home, and "fetishising" her body.'[6] This strategy for domestic bliss is the basis for all those plots – prurient and comic – in which wives become amateur costumers and directors, staging scenes of thrilling exoticism to keep their husbands enthralled. More often, however, the domestic has functioned as the boring opposite of the fetishistic sublime.

The fetish, exoticism, primitivism, and woman as outsider left domesticity, as in *Nadja*, a non-subject. It is understandable, then, that modernists should have had little interest in an artist who never borrowed from tribal art, who ignored the Frankensteinian aesthetics of

Kant, and who painted woman not as prostitute but as wife. This was Pierre Bonnard, who had a sort of Keatsian negative capability that opened him to the Other – to woman, to nature. For the arch-modernist Picasso, Bonnard was guilty of sub-artistic 'sensibility', weakness. Picasso hated the 'indecision' that led Bonnard to paint the sky blue and then add some mauve, not because Bonnard wanted mauve there himself but because he saw it in nature. 'Piddling! That's piddling work!'[7] Picasso railed. Painting is 'a question of seizing the power, taking over from nature, not expecting her to supply you with information and good advice'.[8] Bonnard, in contrast, wanted to share power with nature, entering into a mutual creativity with 'her'.

Bonnard wanted a domestic art, a record of those moments when nature offered up her advice and information lovingly to her delighted artist. In accepting nature's lead, in entering into life with an Other, he was opening himself to an ideology traditionally gendered feminine and tied to the art of the home: that Kantian misfit, craft. This orientation accounts for critics' sense of his affinity to Proust and Virginia Woolf, creators of that 'soft modernism' which in our century has been the aesthetic road less travelled. Domesticity is incompatible with the sublime, since home is specifically what one leaves in order to go off in search of the thrilling limitlessness of alienation and chaos.

But what if an artist was fascinated by the domestic at a time when the ideology of the monster, the outsider muse, the bride of Frankenstein was the engine of modern art? It is not much of an over-simplification to say that this was Bonnard's dilemma. He spent his whole career painting surpassingly beautiful, ornamental images of domestic intimacy and tranquillity. Formally brilliant but never purely formal, his work has little to do with the pornographic, and yet the female nude was one of his most frequent subjects. The fetishes he borrowed were limited, as we shall see, to archaic and pastoral art, and suggest none of the strangeness and alienation of the exotic. Form, fetish, ornament, and woman interact in his work in a fashion anomalous for modernism, and as a result, Bonnard stands as a seeming exception to the history of twentieth-century art that this book explores. His is an anti-story in the modernist

treatment of the domestic, the Other, the outsider, and for that reason it is especially instructive.

Bonnard was a greater exception even than Matisse, whose canvases were likewise lush and beautiful and full of women, but who conforms so obviously to the fetishistic pattern we have been describing. Matisse can paint the quiet of an afternoon piano lesson in a pleasant apartment, but we never forget line and plane in the process. He gives us beautiful women but we experience the exoticism of the seraglio. With Bonnard, there is a specific woman, his wife Marthe, and sometimes a specific man, himself. And though the formal beauty of the painting is so exquisite that we all but drown in an ecstasy of colour, this is form not as a suspension or stylization of sensuous experience but as a magnifier of it. The aim is satisfaction, without irony, subversion, or trans-cendence. One of Bonnard's critics, André Fermigier, quotes Stendhal, that 'The beautiful is a promise of happiness', concluding, 'no body of work in the twentieth century appears to have kept that promise better than Bonnard's.'[9] Fermigier here ignores a certain darkness in Bonnard's painting, but he is surely right that no artist of the century so openly expresses the *desire* for such happiness.

This exceptional status helps to explain Bonnard's long exclusion from the history of the twentieth-century avant-garde, and indeed, from many histories of modern art altogether. According to Timothy Hyman,

> His place in the story of Modern Art, as it began to be codified, now lay far back in the 1890s. He was excluded from Roger Fry's first Post-Impressionist exhibition in London in 1910, as from the Armory Show in New York in 1913 . . . By 1914, Bonnard was being 'denounced' (according to Leon Werth), as 'the bearer of the taint of Impressionism in its degeneracy'.[10]

After Bonnard's death in 1946, Christian Zervos published an editorial in *Cahiers d'art* asking whether Bonnard were a great painter and answering that he was not.[11] Though Hyman explains this as partly a

matter of bad timing – the war had made domesticity and decoration irrelevant, and the worldwide rise of abstraction ruled Bonnard out as a modernist precursor – we have seen that the prejudice against ornament and the female subject went much further back than World War II. Bonnard is instructive for us in that his painting attempted to evade the sterility and inhumanity of sublime purism, seeking a relation to the Other that was not monstrous.

Bonnard began painting in the last decade of the nineteenth century, influenced by the Symbolists, Gauguin, and the makers of Japanese woodblock prints who were so important to his circle, the Nabis. The flatness of the picture plane was a formal given for this '*Nabis très japonard*',[12] and the whole group shared a consciously decorative aesthetic. 'We want walls to paint on,' stated an associate, Jan Verkade. 'We want nothing to do with perspective. A wall must remain a surface, it must not be breached by the representation of infinite horizons. There are no pictures. There are only decorations.'[13] 'Painting must above all be decorative,' Bonnard echoed,[14] but though he disdained the sublimity of infinite horizons, he was militantly representational.

Point by point, Bonnard defied the logic of the Kantian sublime. He urged the artist to represent 'Nature when it is beautiful', and believed that 'Beauty is the satisfaction of sight.' These are not the words of an artist of death, chaos, incommensurability, or abstraction, but of one who welcomed beauty as a sensory benison. Such art answers an interest – embodied pleasure – and is that most despised of Kantian epithets, 'charming'. Bonnard certainly shared a formalist sensibility in part, holding that the satisfaction of beauty came through simplicity and order, which were created by 'the legible division of surfaces, the groupings of sympathetic colours, etc.'[15] But form was always tied to human physiology and hence the body. Vision becomes almost a romance quest in Bonnard's famous remark that painting is 'the transcription of the adventures of the optic nerve'.[16]

Bonnard's art freezes time in the wholeness of pattern, as in *The Game of Croquet*, fusing past and present in a visual world shot through with memory. As Timothy Hyman describes it, 'What he has to record

is a sudden stabbing involuntary vision of things, and of his place among them. Jean Clair writes of Bonnard's being "giddy in the astonishment of the relived moment". He is a myopic spectator, moving through a "floating world", until arrested by a sudden focus.' The sudden focus is not one isolated datum in a continuing stream but a self-conscious grasp of habitual situations involving memory, a marvelling realization of wholeness, a perception of pattern and that beauty of 'legible division' and colour group that is the satisfaction of sight.

Pattern for Bonnard was both representational and expressive. Just as he 'realized that colour could express anything',[17] pattern was a formal feature that could be used for very non-formal purposes. In *The Game of Croquet*, as in Kandinsky's early paintings, pattern represents not only the flatness of pictorial form but a piece of clothing or home decoration. Tiles, lace, carpets all make use of repeated design elements, and Bonnard thus could use pattern as a bridge between form and domesticity. The abstractionist grid finds its domestic equivalent in bathroom tile. We recall that ornament and craft were too impure for avant-garde formalism, but not for Bonnard.

This decorative aesthetic fills objects with mystery and, at the same time, intimate connection. The strategy provided the name for the early work of Vuillard and Bonnard: Intimism. As Hyman notes, 'Intimism . . . entailed a merging of the separateness of things, the recasting of the everyday as a mystery of light and pattern.'[18] Fermigier has called Bonnard 'the last poet of bourgeois sensibility',[19] and though he does not hold the artist's class allegiance against him, many modernists did. Indeed, how could they not, when the very definition of the avant-garde involved a critique of bourgeois values? Again, Gertrude Stein is the exception here with her extolling of middle-class living, but we might remember Flaubert's (somewhat hypocritical) assertion that 'one should live like a bourgeois, and think like a demi-god'.[20] The demi-god spent a lot of his time reviling the middle-class mentality that provided him such a comfortable way of life.

Bonnard's 'bourgeois sensibility', however, like his approach to ornament and form, was far from the avant-garde's stereotype of the

middle classes. In 1896, he was the chief designer for Alfred Jarry's play *Ubu Roi*, which was anything but an expression of bourgeois respectability. Bonnard also illustrated Jarry's *Almanachs du Père Ubu*, which contains the charitable line, 'The spring sun shines even for the bourgeois; even for the curate.'[21] Bonnard regularly contributed drawings to *La Revue blanche*, a magazine that the police described as 'the most important source of literary anarchism'.[22] His lifelong friend, Félix Fénéon, worked there too, having famously been arrested for terrorism, and the other writers and artists who contributed to the *Revue* constitute a roll-call of the turn-of-the-century avant-garde.[23] Clearly, if Bonnard was immersed in bourgeois sensibility, he was well aware of its critique, and was sought out by its greatest detractors as a friend and collaborator.

The proprietors of the *Revue* were the Natanson brothers, three extremely rich Jewish anarchists whose values and religion gave them the contradictory status of bourgeois Outsiders. Thadée Natanson had married a talented pianist called Misia Godebska, who had studied with Fauré, and the couple created an unorthodox salon, which Hyman describes as a 'kind of cultural circus'. Living like bourgeois but thinking like anarchist demi-gods, the Natansons commissioned many works from Bonnard specifically designed for their home. The technical term for these pieces executed by Bonnard and other Nabis was *décorations*, and they stood in opposition to large, independent easel paintings, whose technical name was *machines*. 'Decorations' were generically domestic; 'machines' were generically public, heroic, and high-art, epitomized by the huge canvases of Poussin or Géricault. There could not be a more telling opposition for modernist aesthetics than that between the domesticity of the 'decoration' and the impersonality of the 'machine'. Bonnard's aesthetic problem throughout the 1910s and 1920s was how to combine the two: how to achieve the scale and aesthetic complexity of a machine in painting designed to enhance the home and express the values of personal life.

Bonnard eventually solved the conflict between decorative subject and monumental scale by creating the dense surfaces and optical drama

of his later interiors. Hyman discusses the importance of the great Rococo painters here – Watteau, Fragonard – who allowed Bonnard to master large scale with his pastoral impulse intact. Pastoralism is the basis of his decorative, domestic sensibility. It is a form of the romance, that artistic mode attacked in the name of purity throughout the nineteenth and twentieth centuries. Bonnard presented the peace and poise of the Golden Age as domestic ideals, as opposed to the rigours of epic striving or the sufferings of tragedy.[24]

Bonnard's pastoralism and domesticity involved him in a particular version of romance that at first brought his work closer to the Symbolism of the previous generation: Mallarmé's *L'Après-midi d'un Faune* and Débussy's musical rendering of that work, Signac's *In the Time of Harmony*, and perhaps even the scenes of working-class leisure in Seurat's paintings, for example, *La Grande Jatte*. We might call this pastoral sub-genre the romance of latency. Like William Blake's *Songs of Innocence*, they attempt to express an unfallen state of consciousness. Romances, which go in and out of this prelapsarian state, are filled with references to the Garden of Eden and the Golden Age. They often open with a scene of pastoral perfection analogous to childhood, as in the alleged first romance, Longus's *Daphnis and Chloë*, which Bonnard illustrated in a 1902 edition. After some problem threatens Arcadia, the hero of romance restores the pastoral idyll and returns with new insight to live within it. Or sometimes, as in Shakespeare's *The Winter's Tale*, a romance will embed a golden-age pastoral within the disorienting adventures at its centre as a kind of model, complete with the archaic machinery of rough shepherds and dainty shepherdesses and the music of pipes and timbrels. The heroes then return to the real world after the idyllic interlude, carrying the pleasures of Arcadia in their memory as an unfading nostalgia or an unsettling dream. Ever vulnerable to change, intrusion, and their archetype, sex, the pastoral is a fantasy of perfection made valuable by its very fragility. As such, it is utterly artificial, though presenting itself as natural, innocent. Its temporality is the charmed suspension of Bonnard's romance of optical adventure.

Pastoralism takes on a historical pathos in early modernism. The first decade of the twentieth century was the end of a long period of European peace, which had found rich expression among its artists. Even in the 1910s, amid the absurdism and violence of movements intent on 'making it new',

> Bonnard was still haunted by those Golden Age yearnings, those 'utopian moments', which he shared with Roussel, with the sculptor Aristide Maillol (who made his own suite of illustrations to *Daphnis and Chloë*), and even with the Matisse of *The Dance*. Mallarmé's *L'Apres-midi d'un Faune* would dazzle Modernist Paris when danced in Débussy's setting by Nijinsky in 1913. (Proust was at the premiere, in Misia [Natanson's] box, with Rodin and Renoir also in attendance). In French culture, Arcadia still stood for a time before society destroyed human liberty – a nostalgia, and an inspiration, that would become all the more poignant in the midst of war.[25]

Though Bonnard's decorations grew in sophistication and artistic intensity, they continued to use pastoral subjects throughout the 1910s, and Bonnard developed a domestic pastoralism thereafter. World War I, which shocked so many modernists into despair, cynicism, or provocation, did not interrupt Bonnard's idyll. It may, on the contrary, have confirmed his earlier views by showing the evils of a specifically masculine enterprise. Indeed, Bonnard and Vuillard considered their 'Intimism' a refuge against a specifically male world. As Vuillard observed in his journal entry of 27 July 1894, 'When I turn my attention towards men, I can see only infamous calumnies . . . It's never so in the case of women.'[26] We might compare Frankenstein's late realization that 'if no man allowed any pursuit whatsoever to interfere with the tranquillity of his domestic affections, Greece had not been enslaved, Caesar would have spared his country, America would have been discovered more gradually, and the empires of Mexico and Peru had not been destroyed'.

This 'feminine', pastoral orientation helps to explain the peculiar

nature of Bonnard's primitivism. As critics note, he did not borrow from tribal art. Instead, archaic kouros and other ancient works were his favourite sources. Sarah Whitfield lists a classical Venus and a Crouching Aphrodite in the Louvre, figures on Greek steles, gothic saints, a bronze from Angkor in the Musée Guimet.[27] Hyman notes that the Nabis' use of the term 'icon' for their work was a reference to the early Italians and Byzantines whom they admired, and that Bonnard's painting expresses a childlike pleasure in naïve caricature.[28] These various primitivisms have little to do with the exoticism and libidinal or ritualistic energy of tribal art, but are tied instead to the beginnings of styles and civilizations, and of human life itself. It was Bonnard's task to introduce this cultural freshness and innocent energy into the home:

> Bonnard has no difficulty in making the gestures and poses of classical sculpture appear both natural and of his own time. Moreover, he emphasises the modern by following Degas' lead in domesticating the traditional subject of the bather by bringing her indoors.[29]

The naiad in the fountain becomes the wife in the bathroom, a transformation that Bonnard handled without falling into either pornography or banality. His and Vuillard's[30] work are surely alone in the modernist period in deserving the appellation of 'Intimism'; Bonnard comes close to finding the Other, recognizing her, and even becoming her. However unavoidable the failure of this domesticated *Nadja*, it is redeemed by the very aspiration to succeed and by the artistic brilliance of the attempt.

One of Bonnard's earliest works is in fact called *Intimacy* **[Pl. 23]**, and visualizes this dream of intersubjectity. Painted in 1891 before he had met Marthe, it is a domestic scene of Bonnard, his sister Andrée, and her husband Claude in their living-room. Claude is smoking a pipe, his gaze and body sunk in repose, with Andrée standing to the side looking in his direction, perhaps with a cigarette in her raised hand. The smoke rising from Claude's pipe forms a curlicue pattern that looks like wall-paper. In the foreground we see Bonnard's left hand holding another

pipe, with a wisp of smoke emerging from it as well. A curlicue of smoke covers Andrée's dark clothing, linking husband and wife and artist in a common design, a visual equivalent of the intimacy that binds these family members in a relaxation so complete they need not even acknowledge each other's presence. The artist himself is an integral part of what he creates. Subject and object become one in the metaphor of domestic intimacy. Though the three consciousnesses are separate, there are no outsiders here.

Two years later, Bonnard met Marthe. In 1893, according to Hans Hahnloser, Bonnard 'saw a young woman alight from a Paris tram, followed her to her job (sewing artificial pearls on to funeral wreaths) and persuaded her to leave her work, her family and friends, to share his life until she died in 1942'.[31] If this story is true, it implicates Bonnard in the impulsiveness and innocence of love at first sight. But like the German romantic Novalis's instantaneous love of Sophie, as we shall see in a later chapter, this meeting of the self in the Other does not guarantee a mutual recognition. Bonnard worries this problem throughout his work. Marthe blends into his home, his vision, his art, but still remains enigmatic.

The biographical evidence supports Bonnard's puzzlement. Marthe was secretive about her background, reporting her name differently from one occasion to another. For much of her life she seems to have been afflicted with a disease – perhaps schizophrenia – that was treated by frequent bathing. If nineteenth-century images of nudes in the bath were almost surely representations of prostitutes, Bonnard's bather may have been an even more unfortunate woman. Moreover, Bonnard took a lover, Renée Monchaty, in an affair that ended in her suicide. It seems likely that Marthe knew of this relationship, since Renée appears in his paintings. Marthe's pictorial reserve and withdrawal may represent her response to this violation of her marriage.

However problematic the Other who inhabited this domestic space, many of the images Bonnard created suggest the peace and pleasure of a durable détente. Indeed, the intensity of these pictures is spread across everything in the domestic scene, rather than localized in its female

inhabitant. His painting shows people immersed in their setting, their daily life, as Marthe so often was in her bath. The home Bonnard presents is filled with pattern, colour, lushness, and sensory abundance. Nature seems to grow inside the open windows in *Dining Room in the Country*, turning tablecloths and tiles and furnishings into a garden. The home gives itself to the observer Bonnard as this lushness, but that is because he is part of it, paying it the most minute attention and being rewarded by the beauty and intricacy of an interior that is *his*. There is not a blank or slighted corner. Everything is light, colour, pattern, and reflection. In *The Mantelpiece*, a woman in the pose of an ancient sculpture of Niobe views herself in a mirror which also contains the reflection of a nude by the Nabis painter, Maurice Denis. Here is the beautiful woman denied by modernism, made present in a funhouse of realizations. Art reflects life and life reflects art in the mirror of Bonnard's domestic hearth.

In Bonnard's all-over colour and pattern, nature and domesticity become mirror images of each other. But more importantly, Bonnard places himself in these domestic spaces. His eyes and awareness form the circumference of the painting, and likewise his wife Marthe is to be found lurking around the edges – reading, sewing, setting the table, sitting lost in thought. She is half-way inside the painting sometimes (*Provençal Jug*) and half-way out. And so is Bonnard himself. 'His vision is not about "capturing" or "imprisoning" the object of his gaze,' Hyman reminds us; Bonnard 'is forced to observe himself, as a consciousness which is inescapable and almost imprisoning, as that which *surrounds* his vision of the world'.[32] He frames the mirror of the painting he creates, and at the same time he sees himself in that mirror – comically, humbly, in the trace of a bent knee, an arm.

The difference in sensuality between himself and Marthe does not seem to bother him, neither rousing him nor eliciting a desire to dominate. In *Large Yellow Nude*, for example, Marthe stands before a mirror, a life-sized Medici Venus in high heels. She is an up-to-date, gleaming nude, and the artist, uninteresting as an artistic subject in himself, takes in this golden wonder during a pause, perhaps, in reading

his newspaper. A pipe-and-slippers newspaper-reading observer, he shows us that his attention may occasionally be susceptible to a certain distraction. This is one of his funniest and naughtiest images of Marthe, but it is also a funny and naughty image of himself.

Hyman calls Marthe a Danaë here,[33] and if she is, Bonnard has redeemed the myth from the materialism of some earlier inter- pretations. In the Secessionist Max Slevogt's *Danaë*, we recall, the nymph is a sort of prostitute, lolling after intercourse as her servant collects a shower of Jovian coins. The god does not come to her as a wondrous cloud of gold, but leaves one afterwards in payment. Gustav Klimt's *Danaë* of 1907–8 **[Pl. 22]**, is fleshly, sleeping, and unaware of the sexual gold between her thighs, and Egon Schiele's treatment a year later reduces her to a horizontal yellow texture with a banal face. In contrast, Bonnard's Danaë stands, gazing in the mirror, golden from head to high-heeled toe, transformed by the Midas touch of Bonnard's vision and his art. We cannot see her view of herself in the mirror, but only her husband's, but there is nothing nostalgic or passéist about this radiant flapper.[34]

However, Bonnard generally did not paint Marthe and himself as such a happy couple. Apart from his self-portraits, Bonnard retreated to the edges or beyond the frame of most of his works, with Marthe shown on the margins in various states of absorption, withdrawal, or con- cealment. The tension between husband and wife, whether sexual or psychological, is not denied, but neither is it dramatized. In *Table Before a Window* **[Pl. 24]**, for example, Marthe stands to the right of the window, merging with the curtains and wall behind her. To the left of the window, a wavy curtain takes on the contours of a female nude, probably Marthe as well. The wife as domestic familiar and the wife as erotic Other have been absorbed into the interior/interiority of the observer as shapes incised in the décor.

In recent years, Fermigier's image of Bonnard as an artist of perfect happiness has been replaced by a darker view. Gabriel Josipovici's fictionalization of Bonnard's life, *Contre-Jour*, dwells on the oppressive- ness for Marthe of Pierre's constant observation.[35] Marthe's withdrawal,

the unhealthy-looking mauves with which she is often painted, and above all her isolation in the coffin-like bath have seemed tragic or sinister. Bonnard represented her as a young woman even when she was in her fifties,[36] but her face is never depicted according to the canons of female beauty, and though her body is beautiful, it is strangely unalluring. Some commentators have interpreted this lack of sensuality as a deliberate withholding of love and affection. For example, John Elderfield writes that

Marthe, when immersed in her bath, is pictured as an Aphrodite who, instead of rising from her shell to bring desire and pleasure into the world, retreats into her shell in denial of *aphrodisia*, is lost in her self-immersion. The avoidance of love, the retreat of desire, the elusiveness and unavailability of women: these associations that attach to Bonnard's poignantly pessimistic works have in common the motif of hiding.[37]

Of course, it is hard to know who is hiding here, the unknowable woman or the artist/husband who paints this unknowability. But the mood is as often celebratory as dejected. Rather than coffins, these baths resemble magical thrones for an earthly goddess, or coffers for a jewel of surpassing beauty. In *Nude in the Bath*, for example, Marthe looks like a sleeping princess waiting to be awakened by a kiss. The bathtub becomes a sort of chrysalis in which a wonder – this woman – is coming into being. A golden light gleams off tiles and windowpanes and hair, and it is impossible to say whether it emanates from the outside into the room or outward from the very body of this goddess-to-be.

The late bath paintings are so extraordinarily beautiful as art and transmit such a sense of preciousness and achieved perfection that whatever poignancy they convey is only a small part of their meaning. People *are* separate from each other after all, however familiar and loved. And sometimes they are magical. In *Nude in Bathtub* **[Pl. 25]**, for example, the entire painting has become a fantasia of dappled squares – tiles of all sizes in intense turquoise and gold and red-browns.

One of these squares is a tiny bathmat from which a dog looks up at us with ruby eyes. The curved bathtub with Marthe inside is the only contrast to the variegated grid. The bathwater forms a bubbled frill where it meets her upper body. Her legs, underwater, are elongated and blurred. As with the earlier canvases of dining-rooms and other interiors, Marthe merges with her surroundings in a state of suspended consciousness. She and the domestic interior are one, and if there is an isolated, contrastive being in this painting it is the comic little dog, whose dark brown body and eerie red eyes suggest an outsider whose being will never fuse with these intensely aesthetic and imaginative surrounds. Unlike Matisse's *Decorative Figure on an Ornamental Ground*, this painting does not reduce the female subject to a sexual cliché or a repeatable design element. Marthe is a dreamer in the tub projecting a jewel-like domesticity, as her husband in turn dreams her and it into art.

Bonnard's paintings are records of moments of discovery – of Marthe, of beauty, of himself in the act of discovery. Unlike the avant-garde view of domesticity in which a flash of intersubjectivity opens a lifetime of mechanical routine, Bonnard's intimacy is a never-ending series of 'findings'. To be sure, Marthe's self-enclosure is the opposite of Olympia's challenging gaze. Marthe never searches the viewer out herself, but is there to be found by the hovering Bonnard, and to be found beautiful and at times miraculous because his own sensibility is capable of reaching these heights. It is too bad that we have so little access to Marthe's own discoveries. But throughout the œuvre, we at least see what Bonnard sees. He gives us a history of visions and discoveries of her and of himself, amused, awed, and occasionally annoyed by what he finds.

The analogy Bonnard suggests between aesthetic judgement and these 'domestic discoveries' made him a marginal artist until the 1960s, but as postmodernism reintroduced ornament and representation, Bonnard's work gained new importance. This shift began with a retrospective at the Royal Academy in London in 1966; in 1998, Bonnard received a full-scale exhibition at the Museum of Modern Art in New

York, the institution most responsible for the identification of twentieth-century art with avant-garde aesthetics. Bonnard's reception can thus serve as a diagnosis of the twentieth-century 'trouble with beauty', when for so long the inexorable march from abstraction to minimalism was all the art news fit to print.

All through this time, the audience of avant-garde art had been placed in a difficult situation. It demonstrated its tastefulness and sophistication by disdaining all that was popular and low, aligning itself exclusively and ostentatiously with élite culture. In the process, art lovers became solemn champions of an art that despised them. Consumerism, capitalism, complacency, comfort – these were the sins of the audience of Samuel Beckett or Jackson Pollock as much as of James Michener or Grandma Moses. The sense of self-value that came with 'appreciating great art' thus entailed a certain anxiety and even humiliation, apparent in the spoof of 'cultured ladies' played by Margaret Dumont in Marx Brothers movies. Looking ridiculous was the price one paid for superior taste, but it was well worth the sacrifice if one could be in the presence of uncompromising ideals: the kind that produced an art of garbage, babble, obscenity.

But what if those ideals were not so uncompromising? What if high art were just an Emperor's New Clothes? Why put up with insult if artists showed neither insight nor talent and lived better than most of the bourgeois who paid their exorbitant prices? These were questions even the most sophisticated art audiences entertained as the century wore on. A revolt was inevitable, and when it came, it was a stroke of pure poetic justice: the championing of 'Outsider art' by a bourgeoisie reviled in high art and 'commodified' by popular culture. Alienated on all sides, the buyers of Outsider art embraced an extraordinary paradox, discovering their aesthetic values in artists who were billed as social misfits. After a century of artistic ridicule and alienation, the middle classes welcomed the ornamental, charming, humorous, and, at times, unashamedly beautiful work of the naïve, the mad, and the marginalized. It was as if they had suddenly recognized a common cause with the female subject exiled by the avant-garde. They wrested the

paintbrush from avant-garde fingers and rushed to place it in her hands.

The reception of Outsider art resembles an aesthetic feeding frenzy. In the fourth annual New York Outsider Art Fair held in January 1996, 'Everything was up,' reported Sanford L. Smith, the fair's producer. 'Gate, sales, catalogues.' Thirty-five dealers displayed the work of hundreds of artists, from the famous Adolf Wölfli and Howard Finster to the lesser known Carlo and Michel Nedjar. Three hundred people attended an opening dinner given by the Museum of American Folk Art, where each guest was invited to 'become an insider'. By the fifth annual fair the following year, Roberta Smith would write, 'Lately, little seems more "in" than outsider art',[38] and two fairs later, in 1999, Ken Johnson reported that 'The outsider art phenomenon is like a gold rush. Driven by an irrationally enthusiastic market, speculators have been feverishly scouring the world for self-taught geniuses, looking in mental hospitals, prisons, the backwoods and flea markets for anything marked by folksy vigor if not visionary originality.'[39]

In 1996, *The Price of Madness*, a play by Catherine Filloux, opened Off Broadway at the Intar Theater. In it, a 'serious' sculptor named Henri, depressed by his artist's block, discovers the work of his mad aunt Aloïse (named for one of the psychiatric patient-artists beloved of Jean Dubuffet). Aloïse draws with crayons and toothpaste. When Henri arranges a show for her, a reviewer describes her work as a celebration of 'the cosmogony of the woman, the feminine pulsation'. Aloïse's work is an instant sensation, and artists all over town copy her, testing toothpaste as an expressive medium. Her dealer is ecstatic, and Henri gets over his block.

The revolt against high art replaces alienation with an often grotesque dissolution of values, as is apparent in the collection of the American Visionary Art Museum, opened in Baltimore in 1996. This institution was created by a Congressional Resolution as 'the official national museum, repository, and educational center for American visionary and outsider art'. Congress defined it as art 'produced by self-taught individuals who are driven by their own internal impulses to create' and hailed it as 'a rare and valuable national treasure'. The

museum's opening exhibition, 'The Tree of Life', contained works in wood, from the stunning reliefs of the African-American Daniel Pressley to a huge model of the *Cutty Sark* executed in toothpicks. Artist after artist depicted the Garden of Eden as if pointing to the imperilled innocence of the Outsider artist. On the top floor of the museum, visitors could dine in the Joy America Café, directed by the chef Peter Zimmer, who, the museum explained, is also self-taught, possessing an 'intuitive genius' appropriate for an institution that champions 'raw inventive artistry'. One of his visionary dishes was 'Chinese dim sum with charred pineapple and coconut aïoli'.

Outsider art might appear at first glance a passing enthusiasm, but I believe it marks a turning point in twentieth-century art. After the liberation movements of the 1960s, the alleged suffering of the avant-garde artist looked rather tame next to the misfortunes of other groups. It was remarkable how few women and African-Americans, for example, had been recognized as mainstream artists up to this time. The 'untrained artist' of the 1980s was an extreme case of the minority and women artists who by the 1960s had begun polluting the purity of high culture with their various 'interests'.

This connection between the rise of minority high art and Outsider art is visible in the phenomenon of Jean-Michel Basquiat, who tore through the 1980s, an outsider on the inside for the brief space of his wild life. A black-Hispanic graffiti artist, Basquiat acted the outsider with manic brio. His career opened in 1981 to overnight fame and closed with his death by overdose in 1988 at the age of twenty-seven. In between, he painted in Armani suits, collaborated with Andy Warhol, played bells and triangles in a New Wave band, and rode in limos for the hell of it, or maybe because New York cabbies did not pick up black men. He also completed over five hundred canvases and many drawings, acting the Other, painting his state.

America's first black art star is now a canonized US artist, but his image as a racial and social outsider was initially as important to his artistic standing as his actual canvases. Paula Cooper kept him living and painting in the basement of her gallery, and brought prospective buyers

to watch him at work. He was an attraction at openings in his own right, just as his graffiti were both marks he painted and signatures of himself. He had first become known because of these graffiti, signing himself on walls and canvases as SAMO to signify 'same old same old' or 'same old shit', according to his friend, Fab 5 Freddie.[40] This signature can be seen as a cool, throwaway analogue to Camus's absurd: 'Rising, streetcar, four hours in the office or the factory . . . Monday Tuesday Wednesday Thursday Friday and Saturday according to the same rhythm.'[41] Basquiat embodied the absurd, lived it, and the hype that made and distorted him was that very celebrity that is the post-modern version of prostitution. His mentor Andy Warhol understood this connection very well. Once an artist is famous, he has no need to sell his body, for he can sell not only his images but his image. In Basquiat's case, his audience treated the two as much the same thing.

The curator Robert Storr has coined the best term for Basquiat's work: 'Eye Rap'.[42] Basquiat was a punster in the tradition of Warhol and Nauman, but his puns had an outsider edge. He painted on refrigerators because he was cool, and made graffiti art to leave his mark. For this black–Hispanic rapster, racism was a routine throwaway among the rest of the urban garbage. When he scrawled TAR on his canvas walls he was also writing ART. In his art-graffito SAXMO, he linked SAMO to Louis 'Satchmo' Armstrong, but also, as Klaus Kertess has noted, to Little Black Sambo;[43] Basquiat was signing himself as culture-hero and Uncle Tom in the same word. Wilfully obscure and obtuse, no sooner did he write himself in than he erased himself. And the erasure just made him more visible. 'I cross out words so you will see them more; the fact that they are obscured makes you want to read them.'[44] Maybe one of Basquiat's greatest achievements was to awaken this desire to read, while all the time letting us know that the desire would not be satisfied.

In this game of here/not here, Basquiat revelled in language and signs. He found a handbook of hobo symbols – a secret language for social outsiders – and added them to his canvases. He copied out book indexes with entries misspelled or crossed out, as if to match in words

his travesties of anatomical drawings. His meticulous lists of historical dates and names always break down, for cultural transmission in his work is in a state of crisis. Trademarks, brand names, the copyright sign, the notary public's seal – Basquiat focused on words that create ownership, limit usage, replace the object they name. By painting them, he appropriated them for his own needs, and in the process, shifted their meaning. He is part of the symbol-politics of the 1980s, which acted as if 'signifying' on the white and the rich would redistribute power and wealth. In Basquiat's case, it did to some degree, and this 'signifier' did seem to have more fun.

Basquiat was a cultural crossroads. His parents were Haitian and Puerto-Rican and he grew up in Brooklyn in comfortably middle-class circumstances speaking English. Living with his father in Puerto Rico for a year and a half, he learned Spanish and later became fascinated with Santería and other Afro-Caribbean religions. He wrote graffiti on city buildings as a teenager, but took care to do so on SoHo galleries on opening nights, when artists and dealers were likely to be looking. He was at home in both New York slums and society parties, telling Henry Geldzahler that his subject matter was 'Royalty, heroism, and the streets'.[45] Basquiat saw Andy Warhol, with his platinum wig, as his spiritual father, but modelled his own hair-do on the Apollo Belvedere. His art is literally a picture of New York, a pastiche of graffiti words and drawings, of trademarks for products and the garbage they become. His figures are cityscapes, too – their brains a transcription of graffitoed walls (*Untitled Skull*) covered with scars and fences and signs. Basquiat painted about race and class and the ludicrous ironies they write across New York City.

But Basquiat's work is also about art, and his range and parodic invention are impressive. In *Boy and Dog in a Johnnypump* or any of the savage figure paintings, Basquiat dared to evoke primitivism as a usable tradition for a new-age primitive; yet at the same time, the dangerous teeth of his figures are rendered unmistakably as a modernist grid. His scale, brushwork, and colour look like Abstract Expressionism; his figuration and lettering suggest Pop and graffiti. Basquiat's influences

range from Warhol and Johns to Twombly, Leonardo, and the comics. William Burroughs was his favourite writer. His use of words encompasses both Art Brut naïveté and the semiotic sophistication of Concrete Poetry. In his visual-verbal writing, Basquiat gives new meaning to the Futurist phrase '*parole in libertà*'.

With this bottomless imitation and appropriation, Basquiat became the first Afro-Hispanic artist to enter the mainstream. As such, he ended up in the position of cultural translator to the enemy. When white artists have tried to deal with the culture of the Other, the results have often been patronizing, guilt-ridden, and embarrassingly sentimental. Basquiat, working from within, could act the primitive and gross out the politically-correct establishment. For all the hagiography of black boxers and jazz musicians and the litany of racist and capitalist evils in his work, he is an irreverent jokester, a master of the put-on. *Leonardo da Vinci's Greatest Hits* [Pl. 29] is not only Basquiat's homage to the Italian master, but a spoof of da Vinci's anatomical drawings. A botched rendering of a foot is labelled BAD FOOT; a heroic nude holds a machine-gun: the word TORSO stands in for what it signifies, except for Kilroy genitalia overrun by a ladder-traintrack-scar.

How can the celebrity outsider maintain a sense of identity or painterly authority when he is his own subject matter and his audience sees that subject matter as Other? It is as if Olympia were to paint herself beautiful, or Nadja talk back to Breton. Basquiat managed this situation rather well. In the triptych *Zydeco* [Pl. 30], for example, a cinematographer in profile looks through the lens of his movie camera. His head, in a Cubist pun, also reads as a frontal view, with the eyes looking outward at us. Janus-like, the film-maker keeps one eye on his viewfinder and two on his viewers, but what he shoots (or projects) is a stick figure painted on a canvas whose head is nothing but a rectangle with the word SUBJECT on it. Basquiat's subject is subjecthood, or language, or himself as a shifting signifier. Above the 'canvas' is the copyrighted warning, DON'T LOOK IN THE CAMERA, with the apostrophe (the sign of elision) made out of the tape or peg that holds up the canvas. With the copyright sign after it, the warning is itself a

quotation, 'owned', presumably, by Basquiat himself. But its message is totally ambiguous. It is a warning to the establishment: 'don't turn us into subjects'; advice to other outsiders: 'if you must be a subject, don't let the camera see your eyes'; or maybe a Medusa threat to the viewer: 'don't look into the mechanism of my art'. Prohibitions are incitements though, and by creating this occasion for disobedience, Basquiat draws the viewer, the subject, and himself into the same confronting gaze, a mutual recognition.

In a culture created by other people, Basquiat bent their signs and symbols to his own use and played on their stereotypes. He made his subjectivity elusive and multiple through the endless shifting of language. He had all the eccentricity of William Blake, another poet-painter, and he could outdo any modernist or postmodernist in the denial of pleasure and charm. Obscure and obtuse, Basquiat was at the same time as direct and in-your-face as the rappers he played with. But sadly, this virtuoso act precisely confirmed his monstrosity in the eyes of the establishment who had taken him on. This was an outsider all right, and one whose untimely death reminds us of Poe's beautiful woman whose demise provides art with its 'most poetic subject'.

Exposed to the most sophisticated artists of his day, Basquiat was also fascinated by an artist who had never seen New York, never mind a SoHo gallery. This was Sam Doyle, who painted on scrap metal with house paint and lived all his life in the islands off the coast of South Carolina. By the time Basquiat encountered his work, Doyle had been placed in the newly-labelled category of Outsider artist, a term astonishing in its political incorrectness, but equally so in its precision.

The artist Diego Cortez reports that after Sam Doyle had a show at Faye Gold's gallery in Atlanta,

Jean Michel Basquiat . . . saw those left over works by Sam Doyle sitting around the back of Faye's gallery. Jean said he wanted to trade all his drawings for all Sam's things and they struck a deal. Jean took all of them back to New York – fifteen in all and I came over there one day to his studio . . . Jean and me talked about his art sellers real

hard and when that huddle was finished I looked over and saw some new small paintings by Jean in the corner wrapped up in cloudy plastic covers . . . 'Can I see these pictures,' I told Jean . . . Jean said, 'No, these are Sam Doyle pictures!' . . . Jean didn't want to open them all up to show me so I looked close through the plastic and they really looked good.[46]

Though Basquiat owned the work of many artists, Cortez was greatly struck by the fact that his friend was so drawn to the paintings of this outsider. The backgrounds of Doyle and Basquiat would not suggest much affinity. Sam Doyle was born in 1907 on St Helena, one of the Sea Islands off the coast of Beaufort, South Carolina. He was one of nine children of farmworkers, attended school only up to the ninth grade and worked as a stock clerk and then a porter and a laundry employee. The population of the island were Gullahs, descendants of West African slaves who had brought to the barrier islands their traditional crafts of wood-carving, and their religion, a version of voodoo. In 1944, Doyle's wife and children moved to New York, but he did not want to leave his home, and it was at this point that he began painting. His medium was enamel house paint on large scraps of raised-seam sheet metal roofing. He displayed his works in the yard in front of his house. When people wanted to buy a painting, he created a copy for them, keeping the original in its place in the display. He left the islands for the first time in 1982 when he was seventy-six, when his work had its first public showing in the Corcoran's pathbreaking exhibition, 'Black Folk Art in America'. Doyle died three years later.

Basquiat's middle-class upbringing and his immersion in the bohemianism of the New York art scene in the 1980s could not be more contrastive, but there were many affinities between the work of the untaught rural artist and the high-art outsider. Both created a pastiche of art with environment, Basquiat through his graffiti and graffiti art, and Doyle in his arrangement of images in his yard. Basquiat mimicked graffiti artists, and Doyle borrowed the materials of house painters and sign painters. Basquiat's canvases and Doyle's yard had a

deadpan eclecticism. According to Diego Cortez: 'When you put Sam's pictures all together they are like a big country cartoon – witch doctors and men who dress up like women that Sam saw and farmers and chickens and mules and some events Sam remembered like when his brother died in the casket with the flag on top all floating up to Heaven.'[47]

Both artists created a hagiography of black heroes: Doyle's *Joe Lewis* **[Pl. 28]**, for example, and Basquiat's *Cassius (Clay)* or *Jack Johnson*. Louanne LaRoche writes that 'Doyle's pride in Penn School, his relatives, friends and their struggles and accomplishments resulted in his depiction of these people as heroes, along with the heroes of his race – Joe Louis, Jackie Robinson, Ray Charles, Nat King Cole and Martin Luther King.' This is much the same cast of heroes who receive Basquiat's *Haloes*, especially Ray Charles, whom Basquiat paints over and over again with deep reverence (for example, in *Charles the First* **[Pl. 31]**). Despite the difference in their class and surroundings, both artists also reflect the mysticism and religion of their African roots. As outsiders, they consciously engaged in 'blessing the dispossessed', as in Doyle's *Miss Boy* and Basquiat's *Zydeco*. Writing about Afro-American artists in general, Michael Brenson states that 'There is clearly an identification with what white America has been willing to dump and demean and a belief that by transforming it into art, this discarded and violated America will finally be seen and healed.'

At the same time, both Doyle's and Basquiat's work is formally consistent with much of the white mainstream tradition. They include white culture in their racial pastiches – Uncle Sam, Leonardo da Vinci. Their picture plane is flat – Doyle's *Veteran's Burial*, Basquiat's *Untitled Red Man* – and it is very tricky indeed to decide in each case whether this flatness is a function of naïveté or sophistication. Their images mix language and figuration and play on in-group speech: gullah and black street slang; jokes and puns; repeated formulas in Doyle and copyright signs in Basquiat. We might compare Doyle's *Unk Sam on a Goat* to Basquiat's *Light Blue Movers*, with its message: 'The whole livery line bow *like* this with the big money all crushed into these feet.' Here bits

of sentences and words are missing or crossed out, like chunks of metal missing in Doyle.

Most strikingly, their works are huge in scale and boldness. Roger Ricco and Diego Cortez, friends of Basquiat's, saw Doyle as very different from other outsiders in this respect: 'the others make those little miniature ideas all over the pictures and instead you see Sam making some very strong and bolder movements in the paint. His pictures seem more the same size and have the feel of many of those modern artists in the New York galleries. People tell me Sam's work reminds them of new people like de Kooning. Also Julian somebody and the singer Beefheart.'[48] 'New people like de Kooning', 'Julian somebody' – this is counter-primitivism with a vengeance, signifying on a heroic scale!

As Basquiat stared at the canvases he had acquired, these affinities must have struck him. His recognition marks a dramatic moment in twentieth-century art. Basquiat was a social outsider, but an artistic sophisticate and a star of the New York art scene. Doyle was an outsider on both fronts – in terms of race and class, and also in terms of his lack of high-art training and exposure. And yet, Basquiat recognized himself in this work, and liked it. The last shreds of modernism fell away at this moment of recognition, for here was formally innovative art that did not participate in the fetishistic repressions of the avant-garde. The Other looked back, and not only the alienated bourgeoisie but the sophisticated (minority) artist responded. The modernist rupture between artist and audience is bridged as both respond to the work of an Other. And though the meaning of this positive judgement might differ in each case, the commonality is noteworthy.

Of course, modernism had been filled with high artists influenced by outsiders. Picasso's *Portrait of Gertrude Stein* was famously launched by Iberian masks, and Picasso championed the Douanier Rousseau, a naïve painter whose work is now seen in major museums around the world. Primitive or transgressive subjects were everywhere to be found in twentieth-century photography, whether in the ethnographic treatment of 'savages' or social outcasts (WPA photos) or their transgressive

urban counterparts (Mapplethorpe). With primitivism one of the central facets of modernist fetishism, there is no shortage of interactions between artist and Other. But in Basquiat's recognition of Doyle, the outsider was not there for patronizing appropriation but as a valid voice in his own right.

The Outsider phenomenon began when another major artist, Jean Dubuffet, discovered the art of the Other midway through the century. His experience followed what by now should seem like a familiar modernist move: the rejection of woman as a symbol of beauty and the pursuit of an unassimilable Other. We saw him earlier denouncing the beautiful woman as an artistic subject because of the 'very specious notion of beauty' associated with the female nude in Western art. 'Surely I aim for a beauty,' he said, 'but not that one.' Instead, 'I enjoy . . . dissociating, to begin with, this pretense of beauty from any object I undertake to paint, starting again from this nought.' A new beauty will be found through a denial, a void, a 'nought' left by this artist who enjoys 'sweep[ing] away everything we have been taught to consider – without question – as grace and beauty'. In its place, Dubuffet substitutes 'another and vaster beauty, touching all objects and beings, not excluding the most despised – and, because of that, all the more exhilarating. The beauty for which I aim needs little to appear – unbelievably little. Any place – the most destitute – is good enough for it. I would like people to look at my work as an enterprise for the rehabilitation of scorned values.'[49] It is a pity that this important opening to the outsider had to come at the expense of the female subject, but in one way or another, so did virtually every development in twentieth-century art. It does not seem to have occurred to Dubuffet that the most scorned values of all were the ornamental, domestic, feminine.

In any case, in the 1950s, Dubuffet was struck by the work produced as therapy in insane asylums. He was the first to create a museum of asylum art and invented the term 'Art Brut', which was translated into English as 'Outsider art' some decades later, when it was used to encompass as well the folkloric production of identifiable individuals.

After some pathbreaking exhibitions in which curators brought the formal virtuosity of these works to public attention, a market for this art developed among sophisticated collectors. Outsider art thus began as a variation on modernist primitivism, complete with the avant-garde displacement of woman on to the alien Other.

Outsider art has a complicated relation to 'folk art'. Folk artists were understood as practitioners of the arts and crafts of traditional, often non-literate, societies, whereas Outsiders were untrained originals inventing and signing their usually idiosyncratic works. They had in common an alleged ignorance of Western high art. By our day, the assumptions distinguishing folk and Outsider art are disappearing, in particular, the claim that the folk artist's individuality is totally subordinated to communal forms and themes. For example, it has long been assumed in the West 'that anonymity was a norm in African folk art. In this thinking, African art is a collective, tribal phenomenon rather than a vehicle for individual expression, and objects of a specific type are . . . interchangeable.' But recently the Smithsonian mounted a retrospective of a Yoruba artist, Olowe of Ise (1875–c.1938), and at the Metropolitan Museum there was a symposium on 'Master Hand: Individuality and Creativity Among Yoruba Sculptors'.[50] The artist whose identity is totally submerged in the folk may turn out to be a fantasy based on the ignorance of enthnographers, or worse, on a racist denial of individuality to non-literate artists.

Moreover, the overall category of the untrained artist no longer makes much sense in opposition to the high artist. In the contemporary, media-saturated world, every artist is to some degree merged with a global 'folk' and no one is totally ignorant of high art. 'Outsider' is beginning to seem less an aesthetic than a racist or class tag. As Diego Cortez asked in an interview, 'Why is Basquiat any different from Cy Twombly or Jean Dubuffet, who were at least as much influenced by outsiders but not merged with them?'

We might ask what it would mean to 'merge' with Outsiders. They do not represent a school of art or a programme, and though many Outsiders have in common certain formal traits, such as bright colours,

schematic figures, and everyday subjects, a great many do not. To merge with outsiders entails something much more psychological than formal: the loss of cool, distance, historical consciousness. Once an artist has been to art school, she cannot be 'untrained' again, by definition, and so no merger on this ground is imaginable. Nevertheless, experts assume a recognizable look to Outsider work when they list affinities between self-taught and high artists, such as Philip Guston, H. C. Westerman, Ed Paschke, Jim Nutt, Roger Brown, Ed Kienholz, William T. Wiley, Roy de Forest, Red Grooms, Neil Jenney, Robert Moskowitz, Joe Zucker, Martin Puryear, Joel Shapiro. No doubt the list could go on and on as high art departs more and more from the orthodoxy of the avant-garde.

Yet, we are not quite at a point where we can collapse outsider and high art as long as avant-garde assumptions persist. We might take as an example the isolate Henry Darger, who produced huge numbers of innovative and highly idiosyncratic works as illustrations to a vast novel he was writing. They represent pubescent girls beset by unlikely armies of aggressors [Pl. 32]. The critic Holland Cotter suggested that Darger was an analogue to the sophisticated Matthew Barney, whose work is an ongoing filmic fantasy of transsexual fairies and otherworldly creations [Pl. 33]. But then Cotter reconsidered, since artists such as Barney, unlike Darger, place ideas before feelings, creating distance between the artist and the work. What makes Darger an outsider, for Cotter, is the absence of this psychic distance:

> His paintings, painstakingly traced and colored by hand, have the vulnerable immediacy of a personal signature. So that while the grotesqueries of a Barney film (or a Cindy Sherman photograph or a Damien Hirst whatever) come across as cool, self-possessed and public, Darger's art looks unguarded and exposed. It is even possible that the sense of disquiet that pervades [Darger's exhibition] . . . stems less from the images themselves than from the simple fact that we are looking at them. That is, after all, work never meant to be seen. In examining it, we are as much voyeurs as connoisseurs.[51]

What distinguishes a Barney from a Darger is attitude – cool versus undistanced – and we know that that difference exists because outsiders such as Darger are primitives and primitives can have no distance from what they produce. High artists, operating in the alienated tradition of the avant-garde, must be cool. Whatever validity there may be in such notions, they cannot help but make us uneasy.

Indeed, the sight of an Outsider dealer dressed in New York black in the 1990s, lounging coolly on stage as his delusional artist describes the extraterrestrials he draws, is reminiscent of nothing so much as the public exhibition of 'natives' brought to Europe two centuries before. The Outsider artist becomes a new Nadja, a spontaneous and brilliant Other, and what is 'really' valuable in her art is a formal beauty that she is not analytic enough to understand. This is the message of critic after critic: 'what makes outsider art memorable is not its outsider origins, but a level of artistry and power that withstands comparison with any other kind of art'; 'what convinces you about their work is not their weirdness but their formal elegance'.[52] Basquiat's response to Doyle was quite different, not a separation of form from sensibility but an acceptance of Doyle's form and sensibility as one.

The non-expert audience for Outsider art, the infamous bourgeoisie, were likewise unimpressed by the formal argument. The art of the social outcast had nothing to do with the abstraction and alienation of the avant-garde but instead with authenticity of emotion and an instinctive beauty. The lives of these artists might be a bit off-putting, but their art was not. The public took on the frequent prettiness, ornament, pastoralism, and charm of the Outsider artist, fed up with the purist denial at the heart of modernism. Accordingly, they turned the experts' approach to this primitivism on its head. Outsiders were not naïves to be saved by form, but instead true artists redeemed from formalist hypocrisy.

In contrast to the inflated market of the 1980s in which art had become an investment for the super-rich, Outsiders' work cost very little, for these unworldly creators were often oblivious to money. Is that not how the avant-garde had said artists should be? The dealers

were rapidly changing that, of course. As Elaine Louie notes, 'When the self-taught Alabama artist Bill Traylor, a former slave, died in poverty in 1947, he probably could not have imagined that his painting of a leaping stag might someday become a custom-made wool rug selling for $65 a square foot.'[53] But in the late 1980s and well into the 1990s, Outsider art seemed an alternative to the spectacularly commodified world of high art.

It was also a vindication of middle-class values. The public had been taught that art and capitalism were enemies; indeed, the public had been vilified by the avant-garde on just those grounds, and they had accepted their philistine status as the price they paid for comfort and security. The wealthier among them sought some expiation by buying art and supporting its institutions. In this way, they could also show their appreciation for the aesthetic and for the geniuses who made financial sacrifices for the sake of beauty . . . or was it truth? Their confusion as to just what contemporary art was 'for' was humbling proof that they needed to listen to the experts and be guided by them. But suddenly it was apparent that the demi-god artists were in fact living like bourgeois, indeed, outdoing many bourgeois in wealth and material comforts. Not only was it difficult or punishing to understand their art, but it was impossible to afford it. Something was wrong here. Somebody had forgotten that art was about authenticity and not commodification. Maybe the only people who really understood art any more were the middle-class public, and maybe authentic art was being produced only by ordinary people, or indeed, only by the humblest of people, and not by the money-hungry starvation artists of the galleries and museums and symposiums.

Of course, the notion of authenticity might strain our credulity just a bit. Motivated by the joy of making art, Outsiders are supposedly unaware of the history of art and the marketplace. They are like the public in being non-aesthetes, even though they are conventionally non-bourgeois in other respects: uneducated, insane, criminal, under-privileged. According to the myth, they create from inner need rather than aesthetic programme and their art requires no esoteric explanation

from critics. They are not cynics or sophisticates, but ordinary folks overcome by something bigger than the ordinary: faith, revelation, aesthetic sensitivity. The designation 'Visionary Art' reflects this aspect of their appeal, for they represent the possibility of creativity beyond rationalism, materialism, or formalism. 'You can understand why outsider art has so captivated our spiritually diminished modern imagination,' writes one critic.[54] Moreover, there is no reason to feel threatened by such artists or by the often undemanding objects they produce. These works aim to please, awash in 'pattern, optically soothing and stimulating, both ornamental and sexual'.[55] The bourgeois public looks at Outsider art and sees the brilliance of ordinary people. For the first time in the twentieth century, it sees itself in art!

The lives of Outsider artists, moreover, are frog-prince fairytales of redemption through art. The biographical labels beside Outsider works often upstage the pictures, telling stories of broken homes, poverty, physical or mental disability, or simply unrelieved bad luck, until at long last the sufferer takes up brush or chisel and finds fulfilment. This reversal of fortune frequently comes after a lifetime of mundane employment, when retirement frees up time for creative expression. In every respect, this is the opposite of the existentialist view at the heart of modernism. In *The Myth of Sisyphus*, for example, the hero, unlike the ordinary man, is the person with the strength to give up hope, 'achieving' the absurdist realization that nothing will change. Anything else is self-delusion and weakness: 'the everyday man lives with aims, a concern for the future or for justification . . . He weighs his chances, he counts on 'someday', his retirement or the labor of his sons.'[56] Outsider artists, according to the wall plates in the Museum of Visionary Art, do find happiness and fulfilment, often specifically in a long-awaited retirement. The public is understandably moved by this possibility of relief from modernist alienation, however sentimentalized the story might be.

However, we should not ignore the contradictions in the myth of Outsider authenticity. After all, Outsider art is bought, displayed, and criticized, and whatever purity it has is controlled not by the artists but

by those who sell and exhibit the work. The best works of William Edmondson, an African-American stone carver who had a one-man show at the Museum of Modern Art in New York in 1937 and then dropped from public view, now sell for six-figure prices. Major museums have acquired Outsider art, private collections accumulate it, and a canon of Outsider 'masters' has emerged.

Even the 'movement's name is a matter of confusion. 'Outsider', 'self-taught', 'visionary', 'folk', 'isolate', 'marginal', 'maverick', 'primal', 'naïve', '*brut*', 'inspired', 'raw', 'radical', 'pure', and 'unedited' are just some of the terms in use, and none seems quite appropriate. More troubling, there is not a single criterion of 'Outsiderness' that cannot be found in 'inside' artists. Van Gogh was mad. Joseph Cornell was self-taught. Caravaggio was a criminal. El Greco was a visionary. Chagall's paintings are as full of fanciful folk elements as any Outsider artist's, and everyone from Duchamp to Rauschenberg has made art out of scraps and refuse.

As television and computers become ever more pervasive, no one in the West will be totally innocent of high-art conventions, and as more critical and curatorial energy is directed at Outsider artists, they can hardly remain unaware of their audiences. In *The Price of Madness* Aloïse ends up dancing at an exhibition of her work, and Outsiders can frequently be seen at their booths in the New York fairs. As soon as a work enters the market and receives critical response, it is related to academic art traditions. The moment of discovery of an Outsider artwork is the beginning of its expulsion from Eden.

Perhaps no artist so vividly reveals the problems in the category of Outsider art as Purvis Young. Possessed of an inventiveness, energy, and technical virtuosity on a par with major high painters of the century, he has been treated as a sort of noble savage – grouped with folk and naïve artists, protected from sophisticating influences, his work interpreted in light of middle-class stereotypes of poverty and deprivation. Young reinforces the cliché that creativity can thrive in the simplest of souls, and the Outsider label provides a justification for keeping him simple.

As is typical of Outsiders, Purvis Young's life reads like a conversion

narrative. Born down-and-out in 1943 in the slums of Liberty City, Miami, Young was serving time for armed robbery by the age of eighteen. While in jail he discovered his talent, and shortly after his release, a book on Chicago mural artists showed him his vocation. 'I said, Man I ain't gonna stand on no street corner all day, I'm going to *paint.*'[57] Young began drawing and collaging books, taping up his walls with sketches and paintings, covering scraps of wood and bottles and carpet rolls with washes of colour and exuberant figuration. Now his murals appear in his neighbourhood on the Culver/Overtown branch library and the Northside Metrorail Station; he has had over two dozen one-man exhibitions in France, Canada, and the United States; and his work has been bought by museums in New Orleans, Newark, Harlem, and Miami. Saved by art, he has not lost the common touch. 'Rembrandt walked among the peoples and that's what I do,' he says,[58] a self-proclaimed historian of the 'hood'. Despite his growing fame and prosperity, he lives in the same streets and style as ever.

The contrast between Young's talent and his outsider status has been the controlling fact in his reception. But any number of high artists have been impractical, unworldly, and inarticulate. What sets Outsiders like Young apart from them is the insistence on his aesthetic innocence. It makes Young's work somehow off-limits to critics, and exempts him from developing the internalized critical sense needed for self-editing. When asked whether Young's work has changed significantly over the years, the gallerist John Ollman answers no, that the only difference is that it looks a bit less cluttered than before, since pieces are removed by eager dealers before they have been on the walls long enough to be densely worked over. This lack of artistic evolution, though not necessarily a bad thing, suggests an artistic practice without reflection, in which the natural growth of an artist's consciousness over time, expressed in changes in the work, would somehow be a violation of the Outsider's value as a creator.

Spontaneous, unwilled, magically welling up, Outsider art is too close to creativity as such to submit to editing. The artist is Nadja, and we have accepted her madness, her otherness, with no need to feel

guilty for not intervening. Indeed, her creativity depends on our protecting her from our understanding, from an integration with our point of view, or from her own rational control. She must be maintained a noble savage, outsider, Other, in order to have value as an artist. Thus, Young's massive and very uneven productivity, which in an artist like Picasso has been criticized as self-indulgence, is treated as proof of his genuineness – something to be fostered and protected. The Outside label makes a virtue of what in an insider is a fault, implying that the learning and development that go on in the normal interaction between artist and audience are either beyond the powers of the Outsider or for some reason undesirable in people of a certain back-ground. It implies, too, that Young's talent is so fragile that even after a twenty-five-year practice it could be ruined by high-art influence.

If we look at the few artistic ideas Purvis Young is given credit for having, however, they indicate no lack of sophistication. He reports that Rembrandt, El Greco, and Van Gogh are his favourite artists.[59] He disdains watching commercial TV and chooses public television, particularly shows on Africa and Native Americans, and he paints 'peoples who aren't happy, the homeless and people who are knocking each other trying to get over the blue eye'.[60] His figures with hands stretched high above their heads are, he says, 'reaching for a better life',[61] and his choice of artistic materials is in keeping with his social conscience. 'What you find on the street is yours,' he says. 'You don't have to pay man for it. It was there for you.'[62] This sounds like the outline of a full-blown artistic programme: an exploration of street life, in which the artist guards his independence from 'the blue eye' by appropriating the discards of official culture.

It is almost heretical to point out Young's affinities to the twentieth-century avant-garde, and yet they are unmistakable. Cubism sets the stage for his collage, Dada for his found objects, Abstract Expressionism for his paint splatters, Hundertwasser or Klee for his decorative city geometries. Young makes the wall between abstraction and figuration permeable, as his processions of stylized bodies in *Bearin' the Funeral* **[Pl. 34]** melt upward into an indistinct design. Like many high painters

and sculptors, he is an accomplished book artist. The fluent ball-point lines in his drawings resemble the bent wires of Alexander Calder in their expressiveness and seeming spontaneity, and his colour can be so luscious that one finds oneself thinking of Cézanne, Rothko, Hodgkin. In *Bearin' the Funeral*, in a deconstructive witticism, Young's picture plane becomes the frame around an actual framed painting inside it, and in *People All Busy*, the figures appear both on a central projecting plane and in the background 'frame' around it. Like Jasper Johns, Young paints on window shades, collages with measuring tapes, and joins painted panels with masking tape; his rough assemblages of urban debris remind one of Rauschenberg. And if influence is not what is at stake here, Purvis Young still looks as much like a high artist as a naïve. His work suggests not only primitivism but urban pastiche and an intercultural challenge to conventional ways of seeing. Or maybe it suggests that this distinction is no longer possible to maintain.

'Technique' may be too calculated a preoccupation for an Outsider, but the virtuosity of Young's technique is extraordinary. What difference does it make whether he had formal training in art and lives in a slum when one sees the dancing punctuation of heads across *547*, the counterpoint of rectilinear trucks and curved figures in his cityscapes, the graceful symmetry of his magnificent arched horse heads, his idiosyncratic blend of urban rawness and communal warmth? In the presence of such achievement, one wonders who the true naïve is: the artist or the critic who accepts the Outsider designation. Creative genius is always something of a miracle, whether it emerges amid the hardships of poverty and deprivation or the materialistic banalities of middle-class existence.

The Outsider is the latest incarnation of the trouble with beauty in twentieth-century art, a replacement for the female subject and the process of intersubjective discovery she entails. In its fetishism, modernism focused on various figures: the tribesman, the simpleton, the madman, the racial or social outcast. The avant-garde artist used the foreignness of the Other to perpetuate its sublime alienation. The self could be sought but never recognized in such an Other, who is available for

appropriation but never mutuality, empathy, respect. The public now-adays can use the Outsider as a quick fix for alienation, a guarantee of authenticity and traditional values. For some viewers, this might involve a real reaching across social and psychic divides into an expanded and enriched vision of self and Other. But for many, the process is certainly not that. The Outsider artist is our contemporary Caliban, an Other who exposes our ethical and aesthetic quandaries. But aesthetic power and allure cannot be quoted as mere form or bracketed off into the exotic for ever. There must come a time when we are able to say, as Prospero finally did in *The Tempest*, 'This thing of darkness I acknowledge mine.' As we shall see in the next two chapters, artists and writers are trying to discover how this acknowledgement might be made.

A JUDGEMENT OF PARIS

Man is hungry for beauty. There is a void.

— Oscar Wilde, 1889

The hunger for beauty is still a legitimate appetite.

— Mario Vargas Llosa, 1984.

At the dawn of the twenty-first century, we are at an aesthetic turning-point, increasingly unwilling to accept modernist depriva-tion, and yet not clear as to what the alternative might be. The topic of beauty has emerged as a reflex answer, a culture-wide intuition of what needs to be considered next, though still very much just an intuition. For example, though the exhibitions held in Avignon during the summer of 2000 celebrated '*La Beauté*', the cover of the programme showed a woman in an elaborate spider mask. This image comes straight out of the modernist sublime. As Camus put it, 'At the heart of all beauty lies something inhuman,'[1] and here we have the female subject back for another go as the deathly, unknowable Other.

The re-emergence of beauty from its modernist exile does not guarantee, in other words, that the wasteland has been redeemed, and many artists greet its challenge with uncertainty. 'The authority of beauty is a very irrational thing,' writes Philip Roth at the end of his 1997 novel, *American Pastoral*, surprised at 'the compulsion of the beautiful object' after the horrors of the twentieth century. But despite this widespread scepticism and confusion, it is clear that the avant-garde

blockade on beauty is being lifted. Books and articles on the subject are proliferating. The public refuses its masochistic role as philistine, seeking affirmation instead in an art of generosity and pleasure. The intransigence of feminists and anti-feminists has softened into an exhausted ceasefire, for an aesthetic in which beauty is incompatible with femininity is impossible in a culture where women in large numbers make art, and where many male artists yearn to stop hating themselves in the degraded disguise of a female Other. More and more, artists and writers such as Mario Vargas Llosa are insisting that beauty is 'a legitimate appetite'.[2] Indeed, the opposite claim is beginning to sound absurd. 'There is something crazy about a culture in which the value of beauty becomes controversial,' Peter Schjeldahl writes. 'It is crazy not to celebrate whatever reconciles us to life.'[3]

Domesticity is undergoing a full-scale reinterpretation as well, as working mothers and broken families become more the norm than the exception. Predictably, the home has become a preoccupation in the media and politics, with the 'family values' of the Right and the marketing of domesticity through homebody CEOs such as Martha Stewart. The authors Peter Mayle and Frances Mayes have become millionaires by renovating houses in Provence or Tuscany and assuming the lifestyles dictated by the region. Popular films such as *True Lies* redeem the banality of domestic life, here turning a boring wife into a glamorous partner in her husband's espionage.

In recent fiction, too, this complex shift is in process, as the story of waste gives way to one of intersubjectivity and pleasure. However, we are now very much in a transitional moment, with the previous myth still dominating novels and an inchoate alternative just beginning to emerge. This chapter is an attempt to capture the shift. It does so through an almost random selection: the five novels nominated for the 1997 National Book Critics' Circle Award for Fiction. Any slice of contemporary fiction would provide much the same picture, but it happens that I was one of the judges for this award and was privileged to hear my expert colleagues' deliberations on these fictions.

The avant-garde gave us wasteland works – the pained, nihilistic

masterpieces of modernism and postmodernism too, which punish the reader with the misery of the world. Their extraordinary length is a sign of their life-rivalling scope; their difficulty is an initiation rite so demanding that the investment approaches that needed for living itself. The reader enters this meaning-loaded meaning-vacuum with each new work, prepared or unprepared for the bludgeoning to follow. This is the masterplot of twentieth-century art: a 'true' story in the sense that for almost one hundred years it was the only story anyone could tell without compromise. The pleasure of such art is Sisyphean – the cold triumph of understanding devastation.

Though wasteland worries may still be on our minds, so is beauty. The novels nominated for the NBCC award all reflect the desire to turn away from the brutality of wasteland aesthetics towards a softer vision. The three by Americans dramatize the pain of the modernist sensibility; the two by Europeans, interestingly, seem to have escaped it. Thus, the judges' debates as to the winner became an unwitting referendum on modernism. And as with the mythical Paris, beauty won out. It was a decision redolent with nostalgia for a lost pleasure in art: a reluctant nostalgia, to be sure, since the backward glance has been so thoroughly discredited. But however split the twenty-four judges were among the merits of the nominees, the final choice was telling. The waste scenario, with its punishing length and fragmentation, its plot of disillusionment and stoic endurance, and its dismissal of the traditional traits of femininity – love, comfort, charm, beauty, peace – had lost its power. It was time to cry 'Enough', and the judges handed an American prize for fiction to a British woman for bringing to life the love story of a German romantic, Novalis. It was as if we were turning back the clock to the quarrel between Immanuel Kant and Mary Shelley, and trying out *her* aesthetics this time.

The five NBCC fiction nominees were Don DeLillo's *Underworld*, Penelope Fitzgerald's *The Blue Flower*, Charles Frazier's *Cold Mountain*, Andrei Makine's *Dreams of My Russian Summers*, and Philip Roth's *American Pastoral*. *Cold Mountain*, which had already won the National Book Award for fiction that year, was a runaway best-seller. Touted as

a historical novel about the Civil War, it was actually a story of frustrated love. Its success lay partly in its appeal to both a male and female audience; it was a sort of Civil War *Waste Land* crossed with *Little House on the Prairie.* Laura Wilder's domestic values were shown to be unavailable even in Civil War days, an anachronistic casualty of modernist thinking.

Cold Mountain begins with the hero jumping out the window of a schoolroom in the midst of a history lesson, one of many pieces of heavy-handed symbolism meant to establish him as a man fed up with violence, politics, and war, seeking value instead in personal experience. He falls in love with an accomplished but impractical woman who is marooned on a farm during the war. The two are separated almost immediately when the hero is conscripted. He defects, braving all odds to make his way home to her. In a numbing alternation, the author allots one chapter to the heroine's Robinson Crusoesque coping, the next to the hero's encounter with danger or temptation; then back to her, coping and yearning; then back to him, struggling and yearning, and so on. After seemingly unending trials and learning experiences – and much more yearning – the hero stumbles home, claims his love, and is promptly killed because of bad luck and bad people. It is the absurd tricked out in Blue and Gray, with home held up as an ultimate though unattainable value.

The American public loved this book. But with sentences such as 'Inman awoke in a mood as dark as the blackest crow that ever flew'[4] and enough mixed metaphors and clichés to cast doubt on the future of American letters, the book's success is hard to understand. The only explanation would seem to be that it touched a crucial chord through its rejection of dehumanizing war and its yearning for the fostering comfort of nature and family. Art that captures that need and the agony of its frustration is speaking to something so deep in the American psyche at the moment that the public and some experts are willing to disregard literary solecisms of all sorts.

Another nominee for the fiction award was a novel by Philip Roth that announced an alternative to the wasteland myth through its title

American Pastoral, and the pervasiveness power of that myth in its section heads: 'Paradise Remembered', 'The Fall', and 'Paradise Lost'. It locates the idyllic pastoral of America in the immigrant dream of security, happiness, and wealth, the bourgeois ideals so hated by the avant-garde. But of course, this book is an anti-pastoral, for the American dream has been brutally disrupted. The source of this devastation, ironically, is the value that the dream holds up as its ideal: a girl child, Merry. Merry is a third-generation American with a Jewish father who looks like a Norse god and a Christian mother who was a Miss America contestant. Born of their near-divine beauty, she should have been a great Pleasure, but she turns out to be a monster worthy of Dr Frankenstein.

It is the 1960s, and Merry, unable to endure the inauthenticity of her suburban upbringing, becomes a terrorist. Unlike her striving immigrant grandfather and her elegant assimilated father, she finds existential alienation the only valid picture of reality. 'Life is just a short period of time in which you are alive,'[5] Merry writes as a cosseted eight-year-old and future murderess. Her alienation is inexplication to her father, Seymour Lvov, whose name rhymes with 'love'. Nicknamed 'the Swede', Seymour was a star athlete in high school and the school hero. Oh, the 'steep-jawed, insentient Viking mask of this blue-eyed blond born into our tribe'.[6] Seymour married a gentile beauty named Dawn, made his glove factory prosper, and enlarged a country mansion where Dawn could raise cows and Merry.

It was Seymour's father Lou who had immigrated to America and started the glove business, 'Jersey Maid'. A Jewish Horatio Alger, Lou's values stand in outraged opposition to the modernist vision of waste. Lou believed in 'the romance of the glove business'[7] and made a muse of the New World he had come to: his Jersey Maid. For him, pornography is 'filth'. But of course, he is lacking in sophistication: one of those 'limited men with limitless energy',[8] as his son's generation consider him. Pornography is code for freedom, and restraining freedom is against the American way. 'Without transgression there isn't very much knowledge, is there?'[9] says a feminist professor, defending *Deep Throat* during Thanksgiving dinner at the Lvovs'. Linda Lovelace

is not a degraded being; she is having the time of her life. 'Adolf Hitler had the time of his life, Professor, shovelling Jews into the furnace,' says Lou. 'That does not make it *right*.'[10] Freedom and beauty are in a typical avant-garde stand-off at Thanksgiving.

Seymour and Dawn are both strikingly beautiful, and the book makes their beauty their fate. Beauty leads Seymour to marry Dawn against his father's wishes. The Swede 'could not say to him, "The authority of beauty is a very irrational thing." He was twenty-three years old and could only say "I'm in love with her." '[11] That arresting beauty, however, causes Dawn nothing but unhappiness. She hated being stared at in a bathing suit by 25,000 people in Atlantic City, where she finally missed the crown for political reasons, and she spent the rest of her life trying to convince people that she was not just a pretty face. Women react to her career as a beauty contestant as if she were a prostitute. 'Why is it that if a girl takes off her clothes in Atlantic City it's for a scholarship and makes her an American goddess,' asks the feminist professor at dinner, 'but if she takes off her clothes in a sex flick it's for filthy money and makes her a whore?'[12] The twentieth century turns the poetry of Dawn's beauty into pornography.

A star athlete and high-school hero marries a beauty queen, takes over the family business which he loves, and leads a morally unblemished life, only to have his wife commit adultery with an abstract artist and his daughter bomb the local post office, kill four people, and disappear into the counter-cultural underground of political terrorists and religious freaks. Roth shows the 1960s destroying the entire belief system of middle-class American life and its domestic idyll of suburban bliss. For Roth, this revolution accomplished what modernist art had only imagined: the total subversion of the bourgeoisie. Suddenly the ugliness of avant-garde art – its obscenity, misogyny, and hostility to the domestic – becomes the norm of suburban American existence. The beautiful woman is not a wholesome wife and mother but a depersonalized adulteress, yet again, and the pastoral romance is a hollow piece of sentimentality.

Roth even includes ornament in this destruction. He describes

buildings during the Newark riots being systematically stripped of architectural detail, the city become an Eliotian wasteland:

> From over the door of the house, the pediment was gone, ripped out; the cornices had been ripped out too, carefully stolen and taken away to be sold in some New York antiques store. All over Newark, the oldest buildings were missing ornamental stone cornices – cornices from as high up as four stories plucked off in broad daylight with a cherry picker . . . the frieze with the terra-cotta turkeys and the huge cornucopias overflowing with fruit – stolen.[13]

Like the argument over the dinner table, the riots desecrate the warmth of American tradition – Thanksgiving, with its cornucopias of comforting plenty. As Lou Lvov laments, 'this city isn't a city – it's a carcass!'

The only explanations for this disaster come from highly suspect voices: the modernist architect, Orcutt, who has seduced Dawn; the outspoken literature professor, Marcia, who has called her a prostitute. Orcutt is an abstract painter when he is not designing abstract houses. Dawn is in awe of his modernist creations, but Seymour cannot understand the appeal of 'a band of long gray smears so pale across a white background that it looked as though Orcutt had tried not to paint the painting but to rub it out . . . Why on earth would a guy like Orcutt, no stranger to the natural world and the great historical drama of this country . . . and a helluva tennis player . . . why on earth did he want to paint pictures of nothing?'[14] Orcutt strives for sublimity and the purity of abstraction. His private life is another matter, but like a typical modernist, he sees no connection between life and art.

Roth's novel uses the conflicts of twentieth-century aesthetics to describe the failure of the American dream that has left the world a carcass, a wasteland. That dream persists only in the form of nostalgia for a lost past. The Swede's nostalgia for the little girl he loved so much is Roth's nostalgia for beauty, no matter how irrational its authority. Both Merry and beauty are hopelessly lost, but at least Seymour and Roth have the humility to mourn that loss. The backward glance, full

of bewilderment and pain, is nevertheless better than the rage or hypocrisy of those who deny history to maintain their invulnerability. The NBCC judges were greatly impressed by this work.

Don DeLillo's *Underworld*, another nominee for the fiction award, is a monumental exploration of nostalgia and the wasteland in which it breeds. *Cold Mountain* begins with the protagonist escaping a history lesson, and *American Pastoral* takes off from a fiftieth high-school reunion. *Underworld* likewise opens at a key moment in history, when a distinctly twentieth-century terror interrupts the American pastoral, baseball. It is the final game of the 1951 National League championship series, and the Giants steal the pennant in the last half of the last inning. At this moment, the Soviets launch their first atomic bomb, precipitating the Cold War and ending American innocence for ever. A new phase of history begins with this loss and the yearning it sets in motion, for as DeLillo tells us, 'Longing on a large scale is what makes history.'[15]

As the winning run is hit and the atomic bomb detonated, the stadium overflows with waste. In the bleachers, the gluttonous Jackie Gleason vomits. Ecstatic fans throw anything that comes to hand, including a reproduction torn out of a magazine of Brueghel's *The Triumph of Death*. 'The dead have come to take the living. The dead in winding-sheets, the regimented dead on horseback, the skeleton that plays a hurdygurdy.'[16] Gleason's vomit, like the hail of refuse from the fans and the endless reruns of *The Honeymooners*, is the garbage of history – 'the people's history', to be sure – 'all falling indelibly into the past'.[17] J. Edgar Hoover stands apart from the game, being briefed on the bomb's fall-out.

In this moment of transcendent joy – a baseball apotheosis – as waste proliferates at a prodigious rate, so do secrets. An underworld magically springs to life:

There is the secret of the bomb and there are the secrets that the bomb inspires, things even the Director cannot guess – a man whose own sequestered heart holds every festering secret in the Western

world – because these plots are only now evolving. This is what he knows, that the genius of the bomb is printed not only in its physics of particles and rays but in the occasion it creates for new secrets. For every atmospheric blast, every glimpse we get of the bared force of nature, that weird peeled eyeball exploding over the desert – for every one of these he reckons a hundred plots go underground, to spawn and skein.[18]

At the same time as the upset pennant victory and the shift in the geography of official and unofficial knowledge, a young black truant named Cotter snatches up the winning baseball – Caught her! He defends it with difficulty from a man who had earlier befriended him and gets it safely home, only to lose it when his father sells it without his permission. This is one of many father/son betrayals in the book, including the narrator Nick's abandonment by a father who simply never came home one day, though his surname, ironically, is Costanza. It is Nick who eventually ends up with the historic baseball, but it takes almost eight hundred pages to track that ball down as it passes from buyer to buyer and underworld to underworld. The ball is the symbol of the pastoral paradise of America lost to the Cold War. When paradise is lost, its remains turn into fetishes, the objects of an obsessive desire to return to that earlier state, to regain a source of value. The novel is organized as just such a loss of value and beauty. The scene at the baseball game takes up the first sixty pages, told in some of the most lyrical prose in twentieth-century fiction. The nearly eight hundred pages that follow never achieve that poetic beauty again. The tortuous shifts and convolutions of plot and character put the reader through a stylistic pain that mimics the dislocation and disillusionment of Cold War America. Nick, a Dodgers fan, never watched baseball again after the Giants won that day.

In tracking the tangled history of the baseball and the myriad characters – fictional and real – whose lives intersect with it, DeLillo echoes and re-echoes Pynchon. Nick works for a company called Waste Management, and supervises the disposal of nuclear waste. 'My

firm was involved in waste. We were waste handlers, waste traders, cosmologists of waste . . . Waste is a religious thing. We entomb contaminated waste with a sense of reverence and dread. It is necessary to respect what we discard.'[19] In the underworld of waste, it is almost impossible to tell filth from treasure. For, as with Pynchon's entropy, without interference everything degenerates into waste. Nick's adulterous wife Marian (a Virgin become Whore) amuses herself with heroin, 'shit'. Nick at first thinks a ship with a cargo of sewage is a CIA smuggling operation for illegal drugs. 'See, it's not a boatload of heroin,' he realizes. 'It's a boatload of shit.'[20] Before the bomb had a proper name, Robert Oppenheimer called it 'merde. He meant something that eludes naming is automatically relegated . . . to the status of shit. You can't name it. It's too big or evil or outside your experience. It's also shit because it's garbage, it's waste material.'[21] Illegal drugs, the bomb, excrement: these become indistinguishable in the mouldering wasteland of modernity.

But it is not only the military–industrial complex, the drug trade, and woman that create waste. The art counterculture, another underworld, plays its part. The comedian Lenny Bruce turns up, riffing on the word 'schmuck' as penis and heroin. Mick Jagger's mouth looks like an anus: 'completely satirical, it was caricaturish, a form of talking anus from the countercomics of the sixties, and all the jeers and taunts we'd uttered, all the half sentences we'd mumbled had come out of the same body opening'.[22] Just as the protagonist of Pynchon's *Gravity's Rainbow* dives down a toilet and swims from there into the vast system of the world's sewers, or Graham Greene's corrupt Harry Lime makes his magical appearances and disappearances through the postwar sewers of Vienna, we are all, according to DeLillo, lost in an enveloping tide of effluvium that threatens at any moment to drag us under.

DeLillo is wickedly ironic when he has Nick say that 'All waste aspires to the condition of shit',[23] a parody of the Symbolist tenet, 'All art aspires to the condition of music.' Waste is like art in that both create civilization. According to a UCLA professor, Sims, by producing rats and paranoia, waste forced people 'to develop an organized response.

This meant they had to come up with a resourceful means of disposal and build a social structure to carry it out – workers, managers, haulers, scavengers. Civilization is built, history is driven –' He breaks off and we complete the sentence for him: 'By waste'. The word 'by-product' also comes to mind. Waste is not (or not only) sludge but a product of some value that comes inadvertently into existence through another process. Here, verbally, a small gesture is made to redeem the wasteland.

But the artist Klara Sax takes a dimmer view of waste than Sims. She is working in the desert, engaged in a monumental project to reclaim abandoned war planes for art. Nick is coming to see her in order to pay 'a debt to memory'.[24] It is 1992 and the Cold War initiated by the atomic test during the opening baseball game is over. Surely this moment in history should mark the end of the modernist wasteland as well. Klara aims to help by turning the equivalent of swords into ploughshares. Hers is a graffiti aesthetic in which the handmade mark humanizes the deathly mass-produced machine:

> See, we're painting, hand-painting in some cases, putting our puny hands to great weapons systems, to systems that came out of the factories and assembly halls as near alike as possible, millions of components stamped out, repeated endlessly, and we're trying to unrepeat, to find an element of felt life, and maybe there's a sort of survival instinct here, a graffiti instinct – to trespass and declare ourselves, show who we are. The way the nose artists did, the guys who painted pinups on the fuselage.[25]

The nose artists were pilots who personalized their planes by decorating them with images of their girlfriends. The decoration that Klara likes best is the one of Long Tall Sally: 'not amazonian or angelic or terrifically idealized',[26] according to Klara, but an individualized woman. Klara wants to 'salvage' her.

Klara is salvaging not only junked airplanes and a pilot's lover – part real, part song lyric – but herself. She is lost because 'Things have no limits now,' she says. 'Money has no limits . . . Violence . . . has no

measure anymore, it has no level of values.'[27] What Klara describes is in fact the Kantian sublime, an experience of immeasureability, infinity. It is not thrilling any longer, but too painful to be tolerated. Suddenly we are wandering the polar ice-caps with Frankenstein, agonizing over the monster we have created but cannot own. Klara responds to the limitlessness of the world by recycling war machines into art installations through pin-up graffiti: sentimental, sexually impure ornament. Her art reprises an original gesture of decoration when a young pilot created his signature out of a woman's image, an assertion of love in response to war. In the salvage of the pilot's act, the whole value system of Kantian aesthetics is turned on its head by a woman artist's saying 'Enough!'

Klara recalls an old picture from the Vietnam era taken at Truman Capote's Black & White Ball at the Plaza Hotel. On the edge of the picture is a woman whom she is surprised to realize is herself, dressed in a black sheath and a white cat mask. 'What is it about this picture that makes it so hard for me to remember myself?' she wonders. Everyone is wearing black and white, and everyone is famous or powerful and responsible in some way for the war. For the occasion, Klara had turned herself into a black-and-white abstraction with an animal mask – the mixture of form and fetish that displaced the beauty of woman throughout modernism. She is horrified at her complicity in this masquerade of death and wants 'to paint it over, paint the photograph orange and blue and burgundy and paint the tuxedos and long dresses . . . and maybe this is what I'm doing . . . And let's not forget pleasure. The senses, the pleasures, the body juices.'[28] Returning colour, pleasure, ornament, and woman to art, Klara sets out to redeem modernist abstraction.

Underworld presents advertising as a much less noble strategy for controlling waste by filling material objects with value. Like Richard Hamilton's ironic Pop art collage, *Just What Is It That Makes Today's Home So Different, So Appealing?*, ads construct a glittering world of consumer products whose promise is happiness: 'Better Things for Better Living through Chemistry'. Chemistry, of course, is responsible

not only for advances in the kitchen but for the bomb. In one of the most brilliant parodies of domesticity in all of literature, DeLillo shows the happy Cold War housewife, Erica, unable to keep sense or value in her world, despite her rigorous practice of domestic science. Erica lives her life through 'Better Things', the material objects in her home:

> All the things around her were important. Things and words. Words to believe in and live by.
>
Breezeway	Car pools
> | Crisper | Bridge parties |
> | Sectional | Broadloom[29] |

She is disappointed that Sputnik belongs to the Soviets and not 'us'. 'Were there other surprises coming, things we haven't been told about them? Did they have crispers and breezeways? It was not a simple matter, adjusting to the news.'[30] Here a woman is completely identified with commodified domesticity, the 'gentle domestic brute' of Mary Wollstonecraft's criticism two centuries ago.

Like Klara's desire to salvage the wasteland with colour and bodily juices, Nick's waste management takes off and his marriage eventually improves. But that does not stop a twelve-year-old in the projects from being raped and murdered, or the media from exploiting the story. When the dead girl's face shows mysteriously through a billboard sign – a miracle peeking from the underworld through the consumerist surface – the nun who cared about her, Sister Edgar, dies. This is the novel's climax, and DeLillo pictures the nun in cyberspace, 'exposed to every connection you can make on the world wide web'.[31] In cyberspace, everything is connected; all information is retained; there is no waste. Sister Edgar can visit the H-bomb web page and watch a thermal flash. She can see God – but no, it is a Soviet bomb that exploded above the Arctic Ocean in 1961. She does see fusion bombs, and then she fuses with J. Edgar Hoover who has been hyperlinked to her, for 'Everything is connected in the end.'[32] Cyberspace is like art in this way, and in particular, like *Underworld*.

But DeLillo's cyberspace is also reality: virtual reality, or maybe real virtuality. Cyberspace does make it hard to decide where reality is. 'Is cyberspace a thing within the world or is it the other way around? Which contains the other, and how can you tell for sure?' If cyberspace is everywhere and contains everything, it must contain the world, but the world is full of waste, disconnection. And if cyberspace is only a piece of the world then it does not contain everything and connections are not universal. This is a paradox reminiscent of Gödel's, that no system can be both complete and consistent at the same time. Waste seems inescapable.

At this point, one page from the end of the novel, DeLillo allows a merciful word to float up on to the screen, though he does not tell us at first what the word is. We must wait to the very end to hear it. It is apparently a very good word, full of positive meanings that fill us with the desire to make it a reality: 'you try to imagine the word on the screen becoming a thing in the world . . . a word that carries the sunlit ardor of an object deep in drenching noon, the argument of binding touch'.[33] The word evokes many beautiful literary words that indicate its value and make us yearn for it. It inspires words as beautiful, in fact, as those with which the novel began, returning us, in the virtuality of cyberspace or art, to the lost pastoral of the prologue. This word might return us to First Words.

The word that spreads this longing is the same word, translated into English, that Eliot used to end *The Waste Land:* His was 'Shantih'; DeLillo's is 'Peace'. It is a prayer, a hope, a greeting, and a goodbye. It conveys a 'sense of serenities and contentments . . . [a] whisper of reconciliation . . . the tone of agreement or treaty, the tone of repose, the sense of mollifying silence'. But ultimately, the narrator tells us, it is just a word: 'a sequence of pulses on a dullish screen and all it can do is make you pensive – a word that spreads a longing through the raw sprawl of the city and out across the dreaming bourns and orchards to the solitary hills. Peace.'

And that is how the book ends, not with a bang but a whimper: 827 pages of exhaustingly brilliant fiction to show us that the only difference

between today and 1922 is a series of historical events that were as hard for people to process as World War I was for Eliot. 'Shantih shantih shantih', indeed. Waste novels are the shaggy dog stories of modernism, and the joke has gone on long enough. Or at least, a small majority of the NBCC judges thought so. *Underworld* lost by only a hair though, for the seduction of this sublimity is still all but impossible to resist.

The two other novels under consideration were by Europeans: Penelope Fitzgerald's *The Blue Flower* and Andrei Makine's *Dreams of My Russian Summers*. Makine had already won the Prix Goncourt and the Prix Médicis for this novel, an autobiographical fiction that even in translation reads with the luscious intensity of Proust. In it, the narrator recalls his growing up in Soviet Russia during the 1960s and 1970s, and his summer visits to his French grandmother Charlotte, who lived in Siberia. The sophistication of the French culture she embodies teaches the boy that 'a man was nothing but a dreamer about women'. But this is a message written against the brutality of Russia, which he finds to his confusion equally compelling. Learning of his grandmother's rape during the war he is appalled; learning of Beria's nightly rapes in his limousine the boy is fascinated. 'Yes, I was Russian. Now I understood, in a still confused fashion, what that meant. Carrying within one's soul all those human beings disfigured by grief, those burned villages, those lakes filled with naked corpses. Knowing the resignation of a human herd violated by a despot. And the horror of feeling oneself participating in this crime.'[34] The problem for the boy and man is to manage this double identification – with feminine beauty and male violence.

Makine's novel is a thoroughgoing reversal of the modernist aesthetic we have been examining. It specifically associates beauty with women. At the beginning, the narrator looks in a photo album at smiling relatives, the smiles a fleeting revenge 'for the rareness of beautiful and true things in this world. Had I known how to say it at the time I would have called this way of smiling "femininity".'[35] As the book goes on, he shows us how he came to this term by considering the beauty of his grandmother. 'I tried to understand what it was in this face, in this simple dress, that radiated the beauty whose existence I was almost

embarrassed to recognize.'[36] It was Charlotte's harmony with nature, he decides, her fearlessness of ageing, and her likeness to art that made her so beautiful in his eyes. This beauty allowed her in turn to confer an 'astonishing harmony on this desert space'. 'The contours of her body merged imperceptibly into the luminosity of the air; her eyes, in the manner of a watercolor, mingled with the warm brilliance of the sky; the movements of her fingers turning the pages wove themselves into the undulation of the long willow branches . . . So it was this fusion that hid the mystery of her beauty!'

The beauty of woman merges in this book with the abundance of ornament. Charlotte lives in an Art Nouveau apartment house in Siberia, built just before the 'October Revolution put a stop to all these decadent tendencies of bourgeois art'.[37] It is unashamedly ornate, full of 'oval bulls-eye windows and ornamental rose stems around the doorways', an arch-example of the 'architectural excesses' condemned by Soviet ideology. The boy and his grandmother recover the sculpted face of a pretty bacchante fallen from the façade and place it on the balcony, where the grandmother each evening opens her French trunk of culture and tells the stories that fill up the boy's imagination. Her sentences bear the patina of the building itself, with their 'belle époque flavor'.[38] 'It was as if all the sinuosities, twists, and curves of that architecture had flowed in a stream from its European source and, diluted and partly effaced, had reached the depths of Russia.'[39]

Feeling this pre-modernist connection of beauty, art, woman, and ornament, the narrator recovers history, both his own and that of the two countries that shape his imagination. He learns the true identity of his mother as he comes to understand his relation to the Russian and European events of his grandmother's life. He learns, too, that knowing oneself and knowing the world are continuous processes dependent on memory. His identity is made and remade, but this process has nothing to do with the modernist dictum, 'Make it new.' Instead, identity is always a function of the past, a past whose understanding depends on growth and an artistic attention to detail, for life comes at us in a violent chaos. 'Life, in fact, was an endless rough draft, in which events, badly

organized, encroached on one another, in which the characters were too numerous and prevented one another from speaking, suffering, being loved or hated individually.'[40] Some aspects of life, such as Soviet totalitarianism, reinforce that chaos; others, such as feminine, pleasure-filled art reinforce understanding through memory. This is the aesthetic of the backward glance as life practice. The constant and often painful revisions of life that the narrator values beyond all else take place on the balcony of memory during Siberian summers and in the dream balcony of all the years thereafter.

Such a short summary cannot do justice to this generous, moving novel. The judges could do little more than acknowledge its beauty and wish they were reading it in its original language. The virtuoso English of DeLillo and Fitzgerald was too compelling to put aside for the filtered art of a translation. However, the fact that *Dreams of My Russian Summers* had been awarded France's highest literary honours indicates that not only American judges were crying 'Enough!' to the aesthetics of waste. Makine's novel is an example of what amounts to a new paradigm in fiction, a novel of pleasure, beauty, and joyous excess, in which woman and her artistic analogue, ornament, are the agents of an ever fuller experience of memory, identity, and history.

Penelope Fitzgerald's *The Blue Flower* was the English exemplar of this trend in the NBCC competition. If Makine embraced the past through Proustian autobiography, Fitzgerald did so through a more sober biographical writing, though equally fictive. *The Blue Flower* is a novel about the romantic poet-philosopher Novalis, whose name was Friedrich (Fritz) von Hardenberg (1772–1801). It is a love story between philosophy and domesticity in which the sublime and the everyday are co-extensive.

The novel opens with Fritz and a university friend returning to the von Hardenberg estate where the yearly washing is in progress – hundreds of shirts and undergarments and sheets washed and spread out to dry. 'So many things,' exclaims Fritz's friend. 'Then [Fritz] shouted suddenly: "There is no such concept as a thing in itself!" '[41] Thus, the laundry becomes a philosophy lesson, exemplifying the problem of the

Ding-an-sich, an entity experienced without reference to anything else, perhaps Kant's moment of pure judgement in which one apprehends an object independent of interest, indeed, independent of everything. But the young philosophers find it an impossible concept. Fritz parodies Fichte, instructing an imaginary classroom to consider the washbasket first in itself and then in terms of '*that* that thought the washbasket!' The object of thought gives rise to the thought's author. Fritz calls to a servant, asking for the whereabouts of his parents – *his* authors. Family is relationality and genesis: there is no self-in-itself, but only in relation to others. And before we get too far into this train of argument, Fritz's sister comes out to welcome the two students, with the result that Fritz's friend is aroused, disturbed. 'This is the sort of thing I meant to avoid,' he thinks. Laundry, abstraction, love, generation: the family is the breeding ground in which philosophy and life cannot be separated. Though much of this book mimics the serviceable prose of historiography, it shows that history-in-itself is never enough, quoting Novalis in its epigraph, that 'Novels arise out of the shortcoming of history'. If for DeLillo, history is a product of longing, for Fitzgerald, the compensation for that inadequacy is fiction, art.

Some years before this philosophical laundry day, the schoolboy Fritz had lived briefly at his noble uncle's house. There he had heard his intellectual elders talk stylishly at dinner about 'Nature-philosophy, galvanism, animal magnetism and free-masonry'.[42] It is the 1787 German equivalent of the conversations in the Shelleys' circle a generation later, the inspiration for *Frankenstein*. Fritz's brother Erasmus envies the wine and glamorous women whom he imagines at these dinners, but Fritz denies that there were any women present. 'No women!' cried Erasmus. 'Who then did the washing?' A world without women may be intellectual, but it lacks certain domestic necessities and pleasures. The uncle's household is not quite respectable, it turns out, and Fritz returns home.

A while later, in 1793, Fritz brings home a newspaper announcing the charges against Louis XVIII. 'It is possible to make the world new,' said Fritz, 'or rather to restore it to what it once was, for the golden age

was certainly once a reality.'[43] But Fritz's mother is distraught. 'The king is the father, the nation is his family.'[44] Her little 'angel' Bernhard answers, 'When the golden age returns there will be no fathers.' The mother does not understand this anti-familial politics and slides further and further into depression and isolation; the father declares that he will never read a newspaper again. The French Revolution is one of the first cataclysms of modern discontinuity: the imperative to make it new may return us to the universal, the primordial, the ideal, but it undermines hierarchy, authority, tradition, and the support structure of the family. Given what we have learned from the laundry, its effect on philosophy is also profound.

Fritz is sent to university in Jena, where he signs up for a course with the philosopher Johann Gottlieb Fichte, who is a Jacobin and the son of a poor artisan. Fichte had studied with Kant, but whereas Kant had believed in the existence of an external world (however shoddily evidenced by our senses and individual experience), Fichte considered this belief an old man's weakness. 'We are all free to imagine what the world is like, and since we probably all imagine it differently, there is no reason to believe in the fixed reality of things,'[45] he teaches his horrified students. We imagine the wall to be the way we see it because we create the world out of duty rather than imagination. German philosophy, says Fichte, is justified by its maximization of duty. The students meet at night in beer gardens to debate these radical views, driven wild by thought and alcohol. Suddenly Fritz leaps up. 'I see the fault in Fichte's system,' he shouts to the stars. 'There is no place in it for love.'[46] In one drunken moment he has diagnosed the problem with the relativist solipsism that would lead to modernism.

Fritz learns from an eclectic collection of masters. From the physicist Johann Wilhelm Ritter in Jena he hears that 'the ultimate explanation of life was galvanism, and that every exchange of energy between the mind and the body must be accompanied by an electric charge'.[47] Here mind and body are connected through electricity, whether one can detect the electricity or not. 'We must never judge by what we see,' claims Ritter. But Fritz often can see what others cannot; his

imagination and his senses are directly connected. When chided for complimenting ordinary things on their beauty, Fritz protests that 'everything was illuminated'.[48] He had seen 'not their everyday, but their spiritual selves. He could not tell when these transfigurations would come to him. When the moment came it was as the whole world would be when body at last became subservient to soul.' This will be a golden age of a very different sort, and Fritz has more and more clues as to its nature. Just as electricity links mind and body, mathematics links all human knowledge. 'Why should poetry, reason and religion not be higher forms of Mathematics? All that is needed is a grammar of their common language.'[49]

Fritz's father has no patience with such speculation and wants Fritz to have a position in the Prince's Salt Mines Directory, of which he is head. Accordingly, he enrols Fritz in a course in Mining, the proto-typical profession of all heroes of underworlds and undergrounds. It is at this time, as Fritz begins his life as an itinerant mining clerk, that he decides the failure of the French Revolution to bring about a golden age could be mitigated if the spirit of the Revolution were preserved in Germany. There 'it could be transferred to the world of the imagination, and administered by poets'.[50] Politics would disappear and the state would be 'one family, bound by love'.[51] Fritz comes upon a fable of universal language that moves him, in which all aspects of creation – stars, stones, plants, animals, man – talk to each other as equals. This universal connectedness of consciousness permits no separation of self and other, of the mind and its object of thought. Robbe-Grillet would despise it.

Soon after this, Fritz half-dreams the story fragment that gives the novel its title, 'The Blue Flower'. Its plot is simple: a young man lies in bed at night and is overcome with longing for the blue flower, but does not know why he should care about it or even what it properly is. Fritz has no idea why he finds this story opening so numinous, and neither do the others who read it. Not much later, though, he understands. He catches sight of a girl standing before a window. This pose – a figure seen from behind gazing through a window at a vista beyond – is a set

piece of romantic painting, the *Fensterbild*. (We saw a parody of it in Norman Rockwell's spoof on Abstract Expressionism, *The Connoisseur*.) The *Fensterbild* models the experience of the sublime through a surrogate consciousness that is unknowable and that is contemplating the fearsome enormity of nature. In Fritz's case, the figure in question is real, not painted, and her name is Sophie, Wisdom. 'Let time stand still until she turns around,'[52] Fritz prays. He has found his blue flower, though in the form of a twelve-year-old girl. He proposes on the spot that in four years they should marry, and when Sophie protests, 'I don't know you,' Fritz replies through the logic of his concept of vision: 'You have seen me. I am what you see.'[53]

Sophie's 'wisdom' is a desire for pleasure and connection that makes no attempt to explain or justify itself. Fritz explains that when he saw her standing at the window, he experienced 'a view of life true to itself, without any self-estrangement. And the self is set free.'[54] This is the beautiful; Fritz loves not the absolute *beyond* the self but the self contained, sufficient to itself. This does not mean, however, that Sophie is transparent to him. 'I can't comprehend her,' he writes in his journal. 'I can't get the measure of her. I love something that I do not understand.'[55] His response to the unknown is not awe and Kantian suspension, but the most 'interested' reaction possible: love, and a love, moreover, in which he feels entirely himself and entirely free.

Fritz, who dearly loves his family, is also fascinated by the abstraction of Fichte's theories. Trying to impress Sophie's step-father, Fritz says that 'Fichte explained to us that there is only one absolute self, one identity for all humanity.' 'Well, this Fichte is lucky,' cried the step-father. 'In this household I have thirty-two identities to consider.'[56] The essential one versus the collective many: philosophy is always measured against life experience in this novel, and abstraction comes up short because, as Fritz has declared, 'There is no place in it for love.'

The novel never tries to make any better sense of Sophie than the characters in it do. She is alternately loveable or repulsive, ideal or banal, depending on who is describing her. Even her appearance varies, with her hair at various times dark or light and her complexion rosy or

sallow. One thing seems clear though: Sophie makes no attempt to conform to anyone else's view of her. She tries her tutors' patience. She in unable to understand mathematics, but adores love songs and dancing. Fritz's brother Erasmus is appalled at Fritz's enthralment to this utterly ordinary girl. Her diary is made out of one-line entries, most of which read, 'Nothing much happened.'[57]

Fritz himself becomes concerned that he cannot form an image of her, except that she reminds him of a Raphael self-portrait. He hires a discerning artist to paint her. The painter spends a week or two living in the house and eventually leaves without executing the portrait, for he has found Sophie a 'decent, good-hearted Saxon girl, potato-fed',[58] who bears almost no resemblance to the Raphael self-portrait. 'Hardenberg, in every created thing . . . there is an attempt to com-municate . . . There is a question being asked . . . It is asked incessantly . . . Best for the painter, once having looked, to shut his eyes, his physical eyes though not those of the spirit, so that he may hear it more distinctly . . . I could not hear her question, and so I could not paint.'[59]

Fritz retreats into a churchyard where he sees a young man among the gravestones, a young man living but not human, visible but not real. Fritz says aloud, 'The external world is the world of shadows . . . The universe, after all, is within us.'[60] Sophie is as she is perceived by each perceiver. Fritz translates Fichte's linguistic and epistemological self-enclosure into the realm of love, a communion that has nothing to do with what others say or how they see reality, but with a reality within himself. He has found himself in Sophie; she is his home and his wisdom. By the following Christmas the sceptical Erasmus has fallen in love with her too.

The pain that Sophie soon experiences, however, is not of her own creation. In Berkeleyan empiricism, pain is a proof of the unshareability of consciousness, since no one can verify another's pain. Indeed, the novel describes Sophie's agony strictly from the outside, calmly reporting the series of operations she undergoes without anaesthesia and the fact that the wound keeps opening because of her propensity to laughter. At the first onset of her disease, Fritz writes, 'My Philosophy

was ill.'[61] She is diagnosed with a tumour on her hip, a symptom of tuberculosis, but she quickly improves.

Meanwhile, Fritz is casting his thoughts over the mining profession. Sophie is not only his Philosophy but 'Nature herself',[62] and mining is not a violation of nature's secrets but a release of them. To look into himself is to know Sophie; to look into the earth is to know nature, and hence Sophie. 'You must imagine that in the mines you reach the primal sons of Mother Earth, the age-old life, trapped in the ground beneath your feet.' It takes a poet and a thinker to 'understand the relationship between the rocks and the constellations', to experience inwardness turned outward. 'What must the King of Metals feel when he turns his face to the sunlight for the first time?'

The great Goethe comes to call on Sophie – the romantic poet/philosopher/scientist paying his respects to wisdom. Erasmus runs after the poet when he leaves, and Goethe, assuming that the brother wants to know whether Sophie strikes him as a suitable wife for Fritz, reassures him. Though Sophie is not Fritz's intellectual equal, 'it is not her understanding that we love in a young girl. We love her beauty, her innocence, her trust in us, her airs and graces, her God knows what.'[63] Everyone responds to Sophie's 'je ne sais quoi', her undefinability. But Erasmus stops the poet's effusions to say that what he actually had wanted to know was whether Fritz was a sufficiently desirable husband for Sophie!

Sophie falls deeper and deeper into illness and pain, and Fritz works at his mining during the day and retreats into algebra at night. 'Algebra, like laudanum, deadens pain,'[64] he writes. That is a value of abstraction that modernists would later understand. Meanwhile, Sophie, at home after more gruesome operations, asks her sceptical tutor to teach her about the ancient Romans' ideas of friendship. The whole household gathers in the sickroom to hear, including the dogs, who bound up on to the bed to lick her face. It is a scene of laughter and unruly love. The tutor closes his book thinking, 'After all, these people were born for joy.'[65] Fritz, however, is kept away from Sophie, his 'spirit's guide', for he would not be able to tell her the lies requisite for her to remain

cheerful. She dies soon, two days after her fifteenth birthday. Fritz is in his mid-twenties.

In an afterword, Fitzgerald concisely narrates that Fritz then became famous as a writer, taking on the old family name of 'Novalis', meaning 'clearer of new land'. Ten months after Sophie's death, he became engaged to another woman, his career in the Mining Directory progressing nicely. 'Still, I would rather be dead,' he wrote.[66] Within three years, he had his wish. By the age of twenty-nine, he and most of his brothers and sisters were dead as well, of tuberculosis, drowning, or war. We are left matter-of-factly at the bolted door of romanticism – the story of Mary Shelley as much as Novalis, except that she lived long and saw the result of this clearing of new land in the face of the dead beloved. These romantic tragedies form a break point in the history of love, when the pain of loss is too extreme to leave beliefs intact. Better algebra, abstraction, sublime transcendence than all that pain.

The glorious unity that Fritz experienced between imagination and sight, intellectualism and love, and self and family was destroyed by unrelenting disease and death. In its place arose a culture-wide self-protection in form, abstraction, and misogyny. Deprecate a joyful woman as 'ordinary' because you cannot see her beauty. If the world is full of hidden riches, do not see them as earthly constellations but exploit them for gain. If all the visible world is a miracle, rename it a wasteland before it has a chance to decay or die. If you might love your family, declare domesticity insupportable in case that family should disappear. And if you are in any danger of knowing, valuing, loving yourself, trade in such knowledge for the ineffable, immeasurable, annihilating sublime, for that is pure and invulnerable to desire, and hence incapable of causing disappointment. Above all, value freedom – from love, desire, family, objects – for then you will be immune to contingency and context: you will be truly a *Ding-an-sich*. And if a certain kind of art can create this feeling, then make that art your goal. There was a time when a simple, happy maiden could be the spirit's guide of a poet, but she died. To prevent this tragedy from happening again, the poets reconceived their muse as the always already dead, and

women, art, and poets have been the poorer for it.

Penelope Fitzgerald takes us back to this break in the history of the imagination and she does so by entering into consciousness on the cusp of the modern. The historical and philosophical detail effortlessly assembled in this brief novel is staggering, but most impressive is its storytelling restraint. Calmly, matter-of-factly, Fitzgerald narrates this story in which philosophy and love are one, in which ideas have the atomic weight of daily life, and in which self-realization and freedom are a function of connection to another person.

This novel not only beat out its accomplished competitors for the NBCC Award in 1997, but sold over 100,000 copies in America alone. I am not surprised that Michael Cunningham's *The Hours*, a sensitive reworking of *Mrs Dalloway*, won the Pulitzer Prize for fiction two years later. It is just possible that the wasteland has run its course and we are all ready to say 'enough'. Fitzgerald sends us back to the historical moment whose pain was so great that the Frankenstein's monster of modernism jolted into existence. Having tried fruitlessly to survive through anaesthesia and abstraction, we might try a more embodied Wisdom. Fitzgerald kindly reminds us of this alternative.

CONCLUSION:
MODELLING BEAUTY

on Beauty

(They say) Art no longer produces Beauty.
She produces meaning
 but
(I say) One cannot paint a picture of
or make an image of a woman
and not deal with the concept of beauty.

 – Marlene Dumas, 1995

B eauty and woman: so many ideas about value, in life as well as art, depend on the relation between the two, and yet who is prepared to cut through the forest of taboos surrounding them? From across this barrier, Olympia regards us with her searching gaze – a century and a half gone by with no answer. Her sister prisoners approach – Lily Bart, Nadja, Mary Shelley's poor monster – demanding when beauty will be wrested from death, rescued for life. Where is that kiss, that split second of world-shaking empathy?

How tangled the problem is. If it were only a matter of smiling at a song, a picture, a story we would happily do so. But no sooner do we reach towards that gentle bliss than the shades of Kant and Sade descend: life-disdaining idealism, spirit-destroying materialism. I speak in the language of fairytale, but these plots fill today's headlines. 'A New Body

Politic: Learning to Like the Way We Look'[1] reports a national campaign to prevent eating disorders, one of whose programmes takes girls to art museums to examine the female subject in art. 'After peering at an African fertility headdress, a noted Degas bronze and several oils depicting plump and rosy nymphs cavorting in veils', the girls are shown the image of a worn, emaciated woman, *The Widow*, by George Bellows. They decide that her thinness is a sign that she is unhappy, suffering a loss, and the psychologist leading the group explains that losing weight is an indication that 'something is very, very wrong'. The stylized, abstract ideal of woman in twentieth-century art and fashion is not compatible with procreation, happiness, self-worth. Viewing earlier art, physicians hope, will restore women to the imperatives of their bodies, allowing them to see themselves as beautiful in a more human sense – valuable, worthy of love.

Less than a week after that article appeared, the *New York Times* published a partial transcript of a conversation among dance experts who had gone to see the Hirshhorn exhibition, 'Regarding Beauty'. 'What Dance Has to Say About Beauty'[2] was quite different from what medicine was saying. The choreographer Ann Vachon recalls seeing a female dancer 'in a performance in which she was so incredibly focused on what she was doing that I almost was worried that she had lost touch with herself. That kind of total focus of the performer in the moment is beautiful.' For Manfred Fishbeck, the artistic director of a dance company,

there's no question about beauty in life, beauty in art, beauty as existence. When I experience something that is fully what it is – when it doesn't present itself as *being* something but just *is* – then I feel I'm witnessing beauty. Galloping horses are beautiful, but the horses are not galloping and thinking, 'Oh, we are so graceful.' If they were thinking this, then they might not be beautiful.

Here we return to the mindset that sees the self-aware Olympia as monstrous.

For the psychiatrists, beauty must not deny the female body and its rootedness in material contingency. For the dance experts, beauty comes into existence when a woman sacrifices herself to a formal ideal, a moment of depersonalization and deindividuation in which the dancer, to echo Yeats, becomes the dance, or at least we cannot tell one from the other. The avant-garde pushed these ideas about female beauty to repellent extremes – Sadean pornography, Kantian formalism – in their hostility to woman and the bourgeois domesticity she symbolized. And to this day, the two are seen as incompatible frames of reference: sensuous, bodily reality and a transcendent, spiritual ideal. But there must be some rapprochement possible between these; surely the charm and allure of the body and the ideality of form need not lead to such mutually exclusive dead ends. The problem is how to put them together, how beauty can be both a fostering experience of mortal existence and an elevating ideal written over reality.

Of course, this might not be a valid dilemma, but just a trick of metaphor. After all, there is a difference between real women and female figures in art, and beauty in one need not have much to do with beauty in the other. But unfortunately, they do. Our thinking about women is so entangled with notions of art and beauty that we cannot simply deny the connection. 'One cannot paint a picture of/or make an image of a woman/ and not deal with the concept of beauty',[3] Marlene Dumas tells us, and according to the critic Ellen Zetzel Lambert, 'the beauty question, the question of appearances, is *my* issue too, is *our* issue as women, is indeed *anyone's* issue as a human being. For the question of who one is on the outside is intimately bound up with who one is on the inside; appearances are a very part of our identity.'[4] We might recall that Frankenstein's beloved Elizabeth 'contemplated with a serious and satisfied spirit the magnificent appearances of things'.[5]

Lambert sees female beauty as an exteriorization of self-worth, lovability: 'beauty as the face of love'.[6] In this sense she is rewriting the Frankenstein myth in which the male creator cannot love his monster. The male gaze at a woman, so damaging for Laura Mulvey and her followers, is here recast. 'We can acknowledge that all gazes are *not*

alike, that there is a masculine gaze that looks at a woman's body with the eyes of love, as well as one that looks at that body with a desire for mastery over it.'[7] The possibility of being looked upon, in Lambert's feminist revision, becomes an opportunity for woman to know herself as Other, as speaking body. She quotes John Donne: 'Her pure and eloquent blood/ spoke in her cheeks, and so distinctly wrought/ That one could almost say her body thought.'[8] The kind of male gaze a woman can honour and enjoy, according to Lambert, is one 'where the desire to discover her beauty is linked to a desire to discover her otherness, both sexually and personally'.[9]

The desire to discover this otherness leads us to the model – in painting, fashion, literature. The model is the real woman behind the female image. We might not be surprised to find that she was neglected in avant-garde art, since modernism was anything but an attentive record of the real. One of the famous anecdotes of the era is a parable of modernism's dismissal of the model. In 1905, Gertrude Stein spent many hours sitting for a portrait by her friend Picasso. 'I posed for him all that winter, eighty times and in the end he painted out the head, he told me that he could not look at me any more and then he left once more for Spain . . . immediately upon his return from Spain he painted in the head without having seen me again and he gave me the picture and I was I still am satisfied with my portrait, for me, it is I, and it is the only reproduction of me which is always I, for me.'[10] Picasso had seen Iberian masks during this trip, and the portrait's stylized features were the result. Soon he was hard at work on what became *Les Demoiselles d'Avignon*.

Though the interaction between Stein and Picasso appears to have been filled with mutual respect and Stein 'owned' the resulting image of herself – 'it is I' – the episode symbolizes the barrier modernists erected between their models and their art. For the model is a special case of the representational subject, and no factor in the creative situation was as consistently de-emphasized in twentieth-century aesthetics as this 'she'. Life drawing was largely eliminated from art and architecture schools after centuries of this practice, only recently

making a return. Abstraction eschewed figuration altogether, a word carrying the same double meaning as 'model': both the human figure and representational content in general. Picasso derided Bonnard, we recall, for ceding to the represented world by letting nature dictate his colours. To his credit, Picasso did examine the interaction among artist, model, and artwork in his *Suite Vollard*,[11] but in many of these images it is impossible to see whether we are looking at a model or the artwork based upon her. We might recall John Elderfield's observation that the female subject in Matisse's *Decorative Figure on an Ornamental Ground* could as well be a statue as a woman.

The model – a person who 'poses' – is the link between reality and artwork, since she is both a human being and an idealization, abstraction, representation of herself. She is reality mobilized for art, her appearance participating in both realms, and in this sense she is the link between the contrasting ideas of female beauty in the two *New York Times* articles. If an artist is a woman, if her work represents a woman, and if the audience is made up of women and men-therefore-invited-to-see-as-women, then the female model dominates the aesthetic situation. Other factors are set to her; she models them, enacting both passive and active roles – creating, watching, being watched, being made. This idealized real woman becomes the essence of the aesthetic experience. Moreover, insofar as women in our culture participate in both reality and ideality on a daily basis, they are always models – spurs to aesthetic experience. Contemporary culture, in its turn towards beauty, is beginning to recognize the pivotal position the female/model plays.

For example, Brian McAvera's eight monologues in *Picasso's Women* allow the master's mistresses to have their say. McAvera notes that art historians have treated them unfairly – 'as dumb, venial, mental, vicious',[12] and that Picasso 'who claimed that women were either goddesses or doormats . . . was also a total bastard, using people and discarding them like spent condoms'.[13] His models are remembered merely as spurs to his genius, 'justified' by their inspiration of a brilliant man. But McAvera's plays have no sympathy with such a blanking out

of women. He calls Picasso's late erotic works

> a testament to a man who regarded women as stimuli for artworks, as occasions of sexual exploration, but rarely as individuals in their own right. The women have had the last laugh: it is the laugh of those who watch him spasm in a reflex of the wrist upon canvas, endlessly turning out repetitions of himself.[14]

Picasso was normative of those avant-garde artists like Breton, whose pursuit of a Nadja is merely a failure to recognize himself. At this point, the models who understood this sadistic aesthetics seem much more interesting than the dehumanizing geniuses mystified by it.

The art historian Eunice Lipton shows how moving such a switch in focus can be. She dedicated years to uncovering the life of the model for Manet's *Olympia*, and in the process claims to have discovered her own identity. She had been trained during the formalist 1950s when 'One wouldn't even risk noticing that de Kooning's *Woman II* had a woman in it.'[15] Lipton's research revealed not only that *Olympia* had a woman in it, but that that woman, Victorine Meurent, was a painter in her own right, and one serious enough to have been admitted to the Société des Artistes Français. Art historians had not cared enough about this model to bother to find out these facts. But if we approach art from the model's viewpoint, we see that Manet's 'reputation was made with her face and body',[16] and the image she lent him was of a woman who 'knew what she wanted. Everything. Or rather she wanted, she lacked, nothing. And *that* is why in the spring of 1865 men shook with rage in front of *Olympia*. She was unmanageable; they knew she had to be contained.'[17]

Lipton became so distressed by this injustice that she tried to recreate Meurent's words and thoughts in long passages of *Alias Olympia*, like McAvera, ventriloquizing the voice of the model. Soon she realizes that her voice and Meurent's are falling together. Like Freud's Dora and Manet's Olympia, 'I have emotionally and professionally contracted to fulfill the desires of others. First my father, then my professors, then

lovers. And so on. Where are the women? I am barren of women. Of a woman.'[18] Driven on by the modernist suppression of the female subject, Lipton becomes an inverse of Breton, finding herself in the search to realize another woman.

For some artists, self-discovery is not the issue, but instead the need to reorient art. For example, Cindy Sherman has created a model-centred photography by using herself as a model. What she models are the female subjects of film and painting. She is thus not a female impersonator but a female-image impersonator, begging the question as to whether the two are the same. And as an artist too she makes herself beautiful in these works according to one arbitrary canon or another, staging a confrontation with the viewer that matches Olympia's in its belligerence. The male photographer Yasumasu Morimura pushes this logic one step further, imitating female images in art. If the result is funny, grotesque, slightly monstrous, for once this is so because the subject is *not* a woman. Both these photographers make the model and the act of modelling a 'subject' of art, an essential theme rather than a studio aid to creativity whose existence becomes irrelevant once her image is 'taken'.

Perhaps no artist has more effectively used a model-centred art to cut through the monstrous legacy of modernism than the painter Marlene Dumas. Born white in South Africa, she was well placed to observe the ideological force of female beauty, though she has lived in Amsterdam since her student days. In South Africa, it was illegal to display images of nude whites, but 'black women could be depicted with bare breasts on postcards, thus underlining the difference between them and whites (nature versus culture)'.[19] Dumas's culture could not conceive an innocent representation of a woman. Though abstraction would seem a safe alternative, she rejected it. 'I cannot feel any respect,' she stated, 'for the many painters who still regard the problem of an exciting-painting-without-an-exciting-subject as the sole task of painting.'[20] Her work as a result is full of images of women, and interestingly for an artist in revolt against formalism, it uses paint and colour with an extraordinary lushness, exuberance, and self-consciousness.

Dumas's work is a throughgoing exploration of the model's role in art. What Dürer's *Instruction in Proportion* did to define this matter for the renaissance or Picasso's *Suite Vollard* for modernism, Dumas's œuvre will do for the period of art opening before us, a period in which beauty will not be such an automatic point of resistance. But unlike Picasso or Dürer, Dumas takes the model's viewpoint, placing her consciousness at the centre of art. As the model is treated, so art is treated. Modernist men – artist, audience – may have suffered with 'the image as burden' but that was because for them the beautiful woman was a *dead* weight. From the model's point of view, she is engaged in self-presentation, and hence she is vivid, alive. She carries herself with aplomb and is no one's burden.

As we might expect, Dumas's model is a tricky character. She may be Naomi Campbell today, a real model; tomorrow she may be Bathsheba or Snowwhite, storied objects of the male gaze. She is all too aware of the roles that have been prescribed for her. In *The Model Imitates the Dead* **[Pl. 36]**, she takes a pose identical to that of the naked corpse above her – horizontal, exposed, passive. After all, this passivity is what people expect of her. But by deliberately taking the pose, she undermines its passivity, and Dumas includes her point of view by inserting her words in the picture: 'The model disapproves. The model won't obey the rules.' If she is supposed to be prone, passive, dead, she figures she might as well enter the big leagues of such victimization. 'Snowwhite wants to compete with the Man of Sorrows. Snowwhite has to compete with the Man of Sorrows.'[21] Like the echoing of a *pièta* in *The Image as Burden*, Snowwhite's competition with Christ suggests how high the stakes are for the model, for women. Snowwhite takes Poe quite literally, reasoning that if the most poetic subject is the death of a beautiful woman, then that sacrifice should be treated with some respect.

Dumas makes art under the shadow of Poe's dictum, which she paraphrases, outraged: 'The death of a beautiful woman is unquestionably the most poetic topic in the world.' If Poe wants dead beautiful women, Dumas supplies them with a vengeance, with the model for these corpses angry, arch, subversive. Dumas thinks it is time to hear from the model, from women in general. 'I did not paint Freud,' she asserts;

'instead I painted his wife.' Dumas also has a bone to pick with Manet. Though the *Olympia* overtly presents its female subject as the prostitute that other artists were secretly depicting, that honesty does not do much for the model. 'If we return to the female nude and notions of ideal beauty, we come to Manet who broke the rules with his "Olympia", but then we see idealism replaced by the "realism" of the prostitute,' says Dumas. A model with the spirit to look back at her beholders should not automatically be taken as a whore. Indeed, there is no need to construe Olympia this way.

Dumas questions how real realism is, and decides that it is based on an arbitrary convention. She once painted a male nude in a horizontal pose and was astonished to be criticized for producing male pornography. In realism, horizontal means passive; passive means objectified; objectification is pornography: *voilà!* A horizontal nude is perceived as passive regardless of sex, associated automatically with transgression and prostitution. This is the way blacks are pictured in racist cultures, too, Dumas understood. The reality of the model's identity and the intentions of the painter are irrelevant in this rush to the stereotype. Dumas thus appropriates the name Manet gave to Olympia, 'A Queen of Spades', for her *Magdalena* **[Pl. 35]**. She makes this model emphatically vertical, however, towering over the viewer.

By equating homosexuals and women – black or white – with prostitutes, the viewer simplifies their meaning and social standing and tries to control them. Of course, they are still difficult to police, to pin down, but because of this ambiguity society finds them all the more necessary to police. As Dumas writes in 1991,

The Artwork As Misunderstanding

There is a crisis with regard to Representation.

They are looking for Meaning as if it was a Thing.

As if it was a girl, required to take her panty off as if she would
 want to do so, as soon as the true interpreter comes along.

As if there was something to take off.[22]

If we specify the meaning of the artwork as prostitute, pornographic,

black, gay, we have no further interpretive responsibility to it. Imaginatively, we have reduced it to a corpse. This is why Dumas's female subjects are models as such. They refuse to lie back and accept their role as anything other than a pose *im*-posed from the outside. They take off their clothes, but they are never laid bare in the process. As Dumas writes, 'My best works are erotic displays of mental confusions (with intrusions of irrelevant information).'

The artwork must be saved from a simplistically pornographic reading in which everything is known and therefore dead. Models must be saved from such a stereotyped treatment as well. The series *Models* makes a glancing allusion to Andy Warhol's *Marilyn*s or *Jackie*s: rows and rows of female heads. But Dumas's models are not multiples; each head is that of a different woman, and celebrities are mixed in with 'ordinary' women. Though Dumas depicts Mary Magdalene and Snowwhite and fashion models and Lolita, *Models* also includes scores of faces of unknown women, some old, unattractive, possibly insane – outsiders in terms of prevailing norms of attractiveness.

> It's not the fallen woman
> nor the temptress I'm after.
> It's not the babydolls I want
> nor the Amazons. It's everything
> mixed together to form
> a true bastard race.[23]

This bastard race is woman, who has no essence, no singular meaning, however much male modernists have wished to impose one on her.

Dumas puns on this situation in her exhibition and book title, *Miss Interpreted*, suggesting that to be female is to present an interpretive enigma that often leads to errors. Her 'intrusions of irrelevant information' contribute to the difficulty, and so do the feminine stereotypes from fairytales and the history of art that her models so often inhabit. They do so ironically and rebelliously, but clichés are easier to take at face value than to read through. This is too bad for women, and equally

so for art. In Dumas's work, the model's plight is identical to that of art. To misinterpret one is to misinterpret them both.

Moreover, this misinterpretation is not trivial. Dumas's epigraph for *Miss Interpreted* is a 1963 statement by Bertrand Russell concerning nuclear war. Russell warned that 'what is most likely in Berlin or elsewhere is simply *war by misinterpretation*. You may get a meteor or something like that showing up on a radar screen, and someone will press the button.' Just as DeLillo traces the wasteland to the Cold War, Dumas sees the elimination of woman from art as proceeding from a simplistic, Cold-War mindset. Nuclear war may not result from treating art as a meaning to expose or the female subject as a prostitute, babydoll, or Amazon, but the devastation of the Culture Wars and the gender wars has been real. No one did press the nuclear button, but a thousand deathly buttons have reduced beauty, art, and the model to corpses mourned by generations of bereft but relieved oversimplifiers.

In the 1988 drawing series, *Defining in the Negative*, Dumas shows what happens to the female image and hence to art at the hands of male artists. She calls Balthus's treatment of the nude 'sperm on a silk handkerchief' – an elegant record of the painter's virility. In David Salle, Dumas sees the nude emptied of meaning, abstract; Baselitz turns his nude upside down so that he can concentrate on pure painting. The other artists in the series – Eric Fischl, Allen Jones, and David Hamilton – exemplify the desire to detach art from woman and beauty from femininity, but even more, to deny the model her agency. For Dumas, these connections cannot be broken. Male artists may do so out of a desire for domination, for determinacy of meaning, but the result is pornography rather than erotics and a distortion of the very nature of art.

Dumas derides this attempt with her sarcastic works, *Waiting (for meaning)* and *Losing (her meaning)*, both from 1988. In *Waiting*, a black nude lies prone on a draped table, her legs limply dangling open at one end, her arm arched under her head in a classic pose of sleep or abandon. She is like a sacrificial victim waiting to be penetrated or a corpse defenceless against entry – the entry of meaning as sex, rape, the

impregnation of the passive non-meaning woman. In *Losing (her meaning)*, a nude leans over in a pool or lake, her face and the front of her body immersed in water. She appears to be merging with the water, perhaps a suicide. From the modernist viewpoint Dumas mocks, to lose determinate meaning is to cease to be, but the model knows better.

So does Dumas. She does not treat her subjects or her art as passive containers of meaning. Instead, the relation between the painter and her models is like that of a girl and her doll:

The Painter and her Models – or girl with a doll.
> Painting is my oldest subject
> Fashion is my newest
> and Beauty is my youngest.[24]

In this enigmatic poem, Dumas's subjects are art, fashion, and beauty. Just as a girl plays with her doll to act out motherhood, so a female painter uses her models to enact creativity. She loves her models, just as the girl loves the doll or the mother loves the child, for the model and the doll and the child are all versions of the artist herself. There is no alienation and refusal to nurture in this scenario, and because Dumas believes that 'One cannot paint a picture of/ or make an image of a woman/ and not deal with the concept of beauty',[25] this art about models is inevitably a meditation on beauty. An art that tries to separate beauty from the feminine in order to be 'pure' is not impossible, but only sterile, misogynistic, self-hating, or boring. It misinterprets woman, and makes beauty inseparable from death.

Dumas's response to this misinterpretation is like that of Angela Carter and many other female artists, and specifically *not* like that of Mary Wollstonecraft. We recall that Mary Shelley's mother agreed with the standard misogynist claims of her day – that women were ignorant, self-centred, frivolous, and purely physical, using their beauty to gain power over men and showing no ability to create or appreciate art. Blaming these faults on the inferior education women received, she argued for educational reform so that women could become more like men.

In contrast, Dumas accepts the most traditional idea of woman's interests, her work running over the same ground as women's magazines: art, fashion, beauty. But there has never been a woman's magazine like this. Suddenly, to be a woman is to be an artist, to explore beauty, and in the process to encounter an irresolvable paradox and a total denial of one's value. The only sensible response for a woman is to turn this situation back on to the men who create it. Snowwhite is a past mistress of this stratagem, exposing herself to the dwarfish gaze of her seven critics – little voyeuristic boys who stare at the sleeping nude – but at the same time showing them up. In *Snowwhite and the Broken Arm* **[Pl. 37]**, she is deprived of this revenge. With her arm broken, she can no longer take polaroids. *Dumas's* arm is just fine, however, and the 'shots' keep coming. She also takes other people's photographs and liberates the models in them. 'My people were all shot by a camera, framed, before I painted them,' she claims, and indeed, she very frequently paints not from female models in the flesh but from female models as they appear in photographs. In this way, she recovers models from their reductive images.

It is only fitting that Dumas should have produced her own idiosyncratic version of the modernist underworld. This is a group of portraits called *Underground* **[Pl. 38]**, which she made for the Dutch Pavilion at the 1995 Venice Biennale. Her little daughter Helena added coloured marks to these black-and-white heads. According to Ernst van Alphen, 'This joint or collective practice has the same shattering effect as the lived embrace . . . of mother and daughter . . . What we as viewers see is . . . not an ordered, distanced spectacle, an "other", but a "work" (not a product). A dynamic work which thematizes in its production the readiness or even desire to dissolve the boundary between self and other. By allowing an invasion of individual artistship Dumas as an artist "goes underground" . . . the collaborative embrace of . . . "Underground" highlights the aspect of "Models" that questions subjectivity as an opposition of individual autonomy and sheer exteriority.'[26] In Dumas's art, a child's scribble is not waste. Just as in *The Painter*, in which Helena is a nude toddler artist with blood- or paint-soaked

hands, in *Underground* she is a valued analogue to her artist-mother. Both are artists, and the love between them by far exceeds the value of the work they produce, however much it may express that love. Some of Dumas's paintings of the infant Helena show the baby as a froggish monster. By going underground as atomic selves, the two Dumases allow an extraordinary bond to surface in which the monster and her creator own each other.

In the 1960s, Susan Sontag, tired of interpretation and eager to celebrate formal beauty, urged 'in place of a hermeneutics . . . an erotics of art'.[27] But erotics *is* a hermeneutics of art; indeed, it is *the* hermeneutics. Marlene Dumas situates her work 'between the pornographic tendency to reveal everything and the erotic tendency to keep what it's all about secret'.[28] The erotics of art is a hermeneutic hook, the showing/hiding that lures all readers and viewers of either sex into fictive worlds. When Dumas describes her best works as 'erotic displays of mental confusions (with intrusions of irrelevant information)',[29] she is providing a definition of art for our day, just as Wordsworth's 'spontaneous overflow of powerful feeling' and 'emotion recollected in tranquillity' were for his. Confusions displayed are the very hiding and revealing essential to art, and the female subject is the perennial evocation of this complication. The evocation of beauty in art is thus not nostalgic pabulum or overblown pornography or disguised traditionalism, but an image of the very engine of art: the invitation, the enigma, and the virtuality that are its pleasures. In contrast, an erotics restricted to artistic form is Frankenstein's alienation and Poe's necrophilia: the monster loosed by Dr Kant on the hapless twentieth century.

Dumas takes us far on the road to finding woman beautiful, finding art beautiful, and accepting the beautiful woman as a conscious model rather than a passive symbol of the beauty of art. The time must come when we can accept the beauty of men in this fashion as well. Of course, Abigail Solomon-Godeau may be right that 'If indeed the imagery of nude, eroticized, musclebound or passive male models can be shown to appeal to female consumers . . . this does not automatically

attest to female empowerment, any more than the vogue for male stripteasers could be said to reverse the norms for feminine objectification.'[30] Perhaps not, but women, like Psyche, need to explore their relation to the male Other, to transform this monster into a self through the experience of his beauty.

There are few contemporary artworks that make this possible, but one that does is an extraordinary brooch called *Waterman* **[Pl.39]** by the Dutch metalsmith Gijs Bakker. Bakker uses Bruce Weber's photograph of a crouching male nude pouring a bucket of water backwards over his shoulder. But out of the photographic bucket, a cascade of real diamonds streams down the nude back. The diamonds come from an old cocktail ring belonging to the owner, Helen Drutt English. Bakker transformed this traditional ornament into a work of art, a brooch in which male beauty is used to adorn a woman. The man is virtual, a representation of an ideal. The diamonds are real, condensations of value and beauty. But in their conjunction, the virtual and the real mingle. The diamonds are representations of water streaming out of a bucket, or more precisely, of the high points where light glints off water. But the diamonds create real glinting, just as water would. The male subject may be a mere image, but he is an image of a real model, and the pose and the body evoke the real marble statues that they resemble. He – man, photograph, statue, mythological figure – becomes valuable by proximity to the diamonds, but the diamonds – banal in their previous setting – have become valuable by proximity to his beauty and significance. This beautiful man could be gay or straight; anyone might find him attractive. For a heterosexual woman, the male beauty in this image of artistic abundance cannot help but evoke pleasure, created for her gaze and for her enhancement. This is the very antithesis of modernist deprivation and denial.

In art and literature, women are now rethinking domesticity and the status of the outsider. Marilynne Robinson's novel *Housekeeping*, for example, eliminates the category of waste altogether in a space remade for sympathy. It is a work of staggering beauty, a bottomless pool of imagery and allusion rescued from the blankness of death. So desperate

is the struggle to create human connection in this world, that any sacrifice is justified.

Men are the first to be eliminated, but without the smallest trace of vindictiveness. Without their survival, the novel must redo the 'begats' of the Bible as a female lineage. Death, suicide, and desertion have left two little sisters with no hope of being parented, but Robinson can still imagine a way for them to be fostered through a female begetting. This line stretches back to Noah's and Lot's wives, women derided for their nostalgia, their need to look back at what they have lost or left behind. Women should not be mocked for this mourning, the novel implies, but pitied and honoured for their caring. At the same time, any price is worth paying to avoid the loss that launches the backward glance. Memory in *Housekeeping* is a lake of painful deeps; a family must keep above it on the bridge of the present.

It takes an outsider to understand this imperative. Sylvie Foster, the girls' aunt, is a different sort of housekeeper from the conventional ladies of the town of Fingerbone. She has been a wanderer for years, riding the rails of America. But when her nieces are left with no one to care for them, she returns to the family home. Sylvie's way of housekeeping is to open the house to nature, allowing dried leaves and squirrels and newspapers to collect inside, seeing no need to police the boundaries of her domestic space. Nothing is garbage to her; nothing is waste. Every object or word or image that society declares worthless can be accommodated within this house. But the family members in it are the most precious occupants. Sylvie has learned a lesson from the woods – etymologically, her element. They throng with the ghosts of lost children; she plays with them in the enchanted frost and reveals them to her niece Ruth, our narrator. At one point the frost creates a lacework garden in which the wasteland of Carthage sowed with salt bears flowers and fruit once more.

Ruth's sister, the more conventional Lucille, cannot tolerate her aunt's unorthodox housekeeping, and runs off to live with a Home Economics teacher. But with Ruth, Sylvie's fostering takes hold. Threatened with removal to a 'proper' home by the well-intentioned

townspeople, Ruth agrees to burn the house down and escape with Sylvie. If the only way to make fostering go on is to give up housekeeping, then so be it. Ruth and Sylvie flee the Hansel-and-Gretel nightmare of Fingerbone and end up riding the rails as transients. 'Now truly we were cast out to wander and there was an end to housekeeping.'

The final scene of the novel finds Ruth imagining Lucille seated in a restaurant in Boston years later, grown up and respectable, but with her family lost to her. 'No one watching this woman . . . could know how her thoughts are thronged by our absence, or know how she does not watch, does not listen, does not wait, does not hope, and always for me and Sylvie.' Lucille has opted for conventional domesticity and lost everything: 'Her water glass has left two-thirds of a ring on the table, and she works at completing the circle with her thumbnail.' Her horizon has shrunk to the size of a glass, whereas Ruth and Sylvie's is as broad as the landscapes through which they wander. They have given up housekeeping, stopped maintaining the line around the 'proper'. The price they pay is to lose everything and everyone but each other.

Ruth and Sylvie have become outsiders, and this novel is, in effect, a theory of the outsider that has nothing to do with the sentimentalizing involved in the reception of Outsider art. For domesticity here has been deliberately turned inside out. To keep house in Fingerbone is to lose privacy, connection, and love. The problem with conventional housekeeping is not that the individual is bored or denied fulfilment by the banality of family life, but that the individual is denied sympathy and mutuality. Ruth and Sylvie thus must destroy the house to preserve their connection. They cleave to each other in an echo of the story of Ruth and Naomi from the Old Testament: 'Whither thou goest, I shall go.' Unlike Frankenstein, stalking his monster through the Arctic wastes, or André Breton, hopelessly chasing himself in Nadja, Ruth and Sylvie's roaming preserves them to each other, with each other. The home becomes the world and domesticity is a companionate wandering, while those less enlightened suffer in the 'safety of their homes'.

29. *Leonardo da Vinci's Greatest Hits*, 1982.
Jean–Michel Basquiat

30. *Charles the First*, 1982.
Jean–Michel Basquiat

31. *Zydeco* (detail), 1984. Jean–Michel Basquiat

32. *Untitled* (Battle Scene and Approaching Storm), double-sided. Henry Darger (1892–1973)
Chicago, Illinois; n.d. Watercolour, pencil, and carbon tracing on pieced paper. H: 24" w: 75"
Collection of the Museum of American Folk Art, New York; Gift of Nathan and Kiyoko Lerner 1995.23.01.

33. *Envelopa: Drawing Restraint 7 (Kid)*, 1993. Matthew Barney
Black and white photograph in prosthetic plastic frame. 12 × 9¾ inches.
© 1993 Matthew Barney. Courtesy Barbara Gladstone.

34. *Bearin' the Funeral*, c. 1990. Purvis Young
Courtesy Fleischer/Ollman Gallery, Phila., PA.
Photo Joe Painter.

35. *Magdalena* (Queen of Spades), 1995.
Marlene Dumas

THE MODEL DISAPROVES. THE MODEL WON'T OBEY THE RULES. THE MODEL

36. *The Model Imitates the Dead*, 1987. Marlene Dumas

37. *Snowwhite and the Broken Arm*, 1988. Marlene Dumas

38. *Underground* (detail of group), 1995. Marlene Dumas

39. *Waterman*, 1991. Gijs Bakker
Brooch. PVC laminated photograph, diamonds; unique
15.2×7.6 cm. Private Collection, USA
Photo: Marlen Perez.

40. *Untitled* (Amber mattress), 1992. Rachel Whiteread
Courtesy Rachel Whiteread/Anthony d'Offay Gallery.

41. *House*, 1993. Rachel Whiteread
Commissioned by Artangel. Photo: Sue Ormerod. Courtesy Rachel
Whiteread/Anthony d'Offay Gallery.

42. *Untitled (One Hundred Spaces)*, 1995. Rachel Whiteread
Installation view, Carnegie Museum of Art, Pittsburgh.
Photo: Richard Stoner.

43. Mark Morris Dance Group, *Sang-Froid*.
Photo: Marc Royce.

With a similar lack of sentimentality, the British sculptor Rachel Whiteread transforms domestic absence into beauty. Whiteread is a sculptor of interior spaces. Her technique is casting, and plaster, rubber, concrete, and resin are her materials, which she pours into sinks and closets and the areas under chairs and tables, between floorboards, and, once, inside a whole house. In this way she turns empty space into solid sculpture. Her work is definitionally representational and mimetic, but it effects a reversal of positive and negative volume that reminds one of a photographic negative. Just as Robinson flips domesticity from the sphere enclosed within the boundary of a house to the wide horizons beyond it, Whiteread converts enclosed interior space into solid forms made suddenly valuable as they face outwards to the viewer. Both artists signal loss in this brave transformation. Like Robinson's haunted woods and memory-thronged lake, Whiteread's casts of 'the domestic landmarks of human experience' make empty space visible as 'an index of absence'.[31]

The giving and taking away in Whiteread's work are tricky, paradoxical, exhausting. On the one hand, she provides value and shape and substance to what was never before available for contemplation. On the other, she denies or even destroys what gave it its shape. As Fiona Bradley states,

> *Closet* . . . creates through destruction. It destroys a wardrobe (it was cast inside a wardrobe which was dismantled around it). It also destroys, by filling it, the space inside a wardrobe. The destruction of this space, of course, is what gives us back the wardrobe, both formally – the sculpture looks like a wardrobe – and conceptually – wardrobes exist in order to give us the space inside them, the space trapped by the sculpture. Crucially, *Closet* shuts us out.[32]

Whiteread's sculptures exist in a peculiar relation as well to abstraction. They are cast from the real, and adhere faithfully to the contours of real objects. Yet the solidified spaces of her art are frequently geometrical abstractions, which only their titles help us to

identify as part of the object world. As with many genuine abstractions, the qualities of the material become particularly noticeable: its colour, degree of opacity, and even smell. Almost always, though, these formal features of the medium become relevant to the objects represented. For example, when Whiteread casts a mattress in orange rubber **[Pl. 40]**, propped in a sagging curve against a wall, we wonder whether the rubber is flexible, like a mattress, and hence whether its shape is determined by its position against the wall or whether it would maintain that derelict sag if pulled out into the open.

In this case, by the way, as with many of the objects Whiteread represents, the casting is double. An object is enclosed in a material to make a mould which is then filled with the final material of the sculpture. We then have an object repeated in a new material rather than a negative space turned into a positive object-form. Many of the reconstituted objects, such as the mattress, achieve the wonder associated with any magical transsubstantiation, but at the same time, they constitute a rogue's gallery of urban junk. Seeing an exhibition of Whiteread's early double-castings, particularly in a brutalist New York gallery, is like visiting a squatter's apartment strewn with old mattresses, sinks, and bathtubs. Some of the objects or volumes represented – mortuary slabs, the space under the bed – make thoughts of death and emptiness inescapable. Whiteread has compared her procedures to the making of death masks[33] and the city buildings that surround her to 'mausoleums for ourselves'.[34] 'They have sick building syndrome . . . they have their own viruses: Legionnaire's Disease is transmitted through air conditioning systems. They are almost organic – you go into a building and it hums.'

To cast in this way is not only to copy but to preserve, and of course, the wit of Whiteread's art lies partly in what it chooses to memorialize: pieces of homely furniture and the empty spaces they enclose, into which our bodies enter on a daily basis. Like *Housekeeping*, this sculptural practice refuses to discard anything, instead preserving the humblest and most abject things as if they were precious objects. This alternative way of 'keeping house' constitutes a profound statement

about value. Whiteread extends it fittingly in her design for the Vienna Holocaust Memorial, a cast of the space between books and the bookshelf that holds them. If the Nazis destroyed books, Whiteread preserves the spaces those books defined in a fluted anti-shelf of cultural memory. This recuperative gesture and the serenity of the resulting sculpture nevertheless remind us of a human horror. For this reason, Stuart Morgan calls Whiteread's 'suave reversals' 'a set of manoeuvres more suited to a slaughter-house. In her work, sterility and silence serve as powerful reminders of the fate of the human body.'[35]

Perhaps more pacifically, in her most ambitious work to date, *House* [Pl. 41], Whiteread managed to preserve (temporarily) a domestic interior slated for demolition. She arranged for workmen to pour tons of concrete into the last house still standing of a Victorian terrace in east London, and when it hardened, to remove every trace of the original structure. What remained was a white replica of the internal contour of the entire house, complete with imprints of windows and doors and staircases. The result looked like a piece of International Style architecture – uniformly white, geometrical, and formed out of the functionalist material par excellence: poured concrete. The artist denied any interest in the fact that the solidified interior of a Victorian house should have the look of an impersonal modernist building, saying that she was not making a statement about architectural style at all.[36] But clearly the act of preservation always changes the thing preserved, and sometimes the change reveals an inimical Other hidden inside the original. Whiteread's intention, however, was that this sculptural house, which brought interiority inescapably into view, would serve as a protest against the destruction of the past in modern cities. The local council, predictably, had *House* torn down because it stood in the way of their plans. Whiteread's sculpture thus became a performance piece in which the political authorities acted out the modernist hostility to the domestic and to memory.

But other works of hers are playful and even magical. In *Untitled (One Hundred Spaces)* [Pl. 42], Whiteread has cast the space beneath one hundred chairs in orange, gold, and green resin. This army of geometric

forms glows with colour, preserving the traces of the surrounding chairs in the ridges and markings on each cube, ghostly shapes seen through the translucent resin. Domestic interiority has been transformed into pattern and ornamental design, and though the genesis of these sculptures involves the negative and deathly associations of all casting, the effect of their display is deeply pleasurable, providing an almost childlike aesthetic bliss. Here a woman has returned domesticity and ornament to art, redeeming the sterility of form through a wondrous recasting of emptiness!

The current effort to recover from the sublime is sending novelists back to the classical statement of the problem, *Frankenstein*. Rather than setting their fictions in Mary Shelley's day, however, they relocate her story in the historical event that most shaped the 'lost generation' of high modernists: the twentieth-century trauma of traumas, World War I. By lifting *Frankenstein* into the twentieth century, novelists show the accuracy of Mary Shelley's aesthetic prophecy, for it was at this time that the Kantian sublime was monstrously realized in avant-garde art.

Pat Barker's *Regeneration*, for example, is set in a psychiatric hospital during the Great War. Siegfried Sassoon, the young poet soldier, is forced to go there when he refuses to continue fighting, and so are large numbers of damaged men who cannot recover from the horrors they have witnessed. Hysteria here is a male disease, the Great War creating such a divide between the male soldier and the female civilian that, paradoxically, masculinity and femininity fall together. In the official view, men must relearn how to behave like men; in the psychiatric view, their female state is a logical and understandable response to the horror. As in Camus's *La Peste*, it is a doctor, Rivers, who is the hero of this novel, working tirelessly to touch each man with a caring that will allow him to overcome the memories of death and dismemberment that overwhelm him. Rivers himself suffers from stuttering and is at least latently gay; he wants to erase these men's touch with the absurd because he understands it. Untiring and brilliant at his psychiatry – an empathetic science – he often succeeds.

However, even more consistently successful is another doctor who

teaches the mute to speak and the paralyzed to walk. He is a monstrous authoritarian who 'cures' his patients by administering electric shocks until they overcome their difficulties. The doctor 'teaches' a mute veteran his alphabet like a behaviourist parent whose method is cruelty, violence, and coercion. This mechanistic, technological science is insupportable, however reliably it brings about a 'cure'. Rivers's sharing in hysteria is infinitely preferable, addressing the sufferer rather than the symptom. It also participates in extraordinary paradoxes. Siegfried Sassoon is in hospital because his friends have pulled strings to keep him out of jail for his unpatriotic pacifism. His 'cure', effected by Rivers, consists in his being sent back to war, to his death, so that he can avoid persecution as a homosexual. Problematic as this case of 'regeneration' may be, the gay scientist forges a connection with his creation, his monster, and in the process humanizes them both.

In Christopher Bram's remarkable novel, *Father of Frankenstein*, we have another rewriting of Mary Shelley's fiction involving World War I and homosexuality. In it, a tattoo, the Marines' motto 'Death Before Dishonor', decorates the muscular arm of a yardman who works for the film-maker Jimmy Whale. Whale in the novel, as in real life, directed the movie of *Frankenstein* and its sequel *Bride of Frankenstein*. Whale is gay; his filmic 'bride' is a drag-inspired confection; and his stars are of indeterminate gender, with, for example, the monster played by Boris Karloff pictured at a garden party cooing gently to his infant grandniece. In contrast, the tattooed yardman, Clay Boone, is straight. Whale considers the Greek-torsoed ex-Marine a potential boon, and, he hopes, clay to be moulded. 'Clay Boone: a lump of Clay, a Boone of contention.'[37] Clay's hair is cut in a flat-top (it is the 1950s in Hollywood), and with his size Whale finds him excellent monster material. He decides to sketch him.

The title of the film based on this novel, *Gods and Monsters*, refers to the celebrity status of Whale and his friends, and the difficulty of distinguishing such sublime gods from the monsters they impersonate. Though everyone may be a celebrity for fifteen minutes, this heightening is itself monstrous. Both these gods and their creatures are

unnatural fabrications, and both depend on an inhuman notion of beauty. Whale's housekeeper Maria is repelled by the Bride, played by Elsa Lanchester. ' "She is hideous," exclaims Maria . . . "She is beautiful," Whale declares. He is looking at Elsa in her Nefertiti hairdo, but he is thinking about Boone.' Nefertiti, like the Bride, is a male-constructed stylization of femininity, and the book equates it with the classically-proportioned Clay whom Whale covets as a model and a lover and, presently, as his murderer. For the real drama of this fact-based fiction is the monstrosity of life – from the World War I atrocities that haunt Whale to the mental deterioration at the end of his life that makes those memories unbearably real. Like *The Waste Land*'s Sybil, Whale wants only to die. He hopes that if he attacks Clay sexually, Clay will kill him, putting 'Death before Dishonor'.

But the Marines' tattoo does not control Clay; he is a kindly monster. Touched by Whale's misery, he uncovers his beautiful body because Whale so wishes to see it. Despite his stern heterosexual ethic, he has the generosity and strength to resist dehumanization, teaching Whale ' "There are no monsters . . The only monsters," – [Whale] closes his eyes – "are here",'[38] in the mind. That of course is the moral behind the two-hundred-year history of Frankensteinian aesthetics. A man looks into the mirror of art at what he has constructed and refuses to own it, cringing at the unhappy creature he has brought into being. In Bram's humanism (as in Prospero's), approaching death teaches the man/scientist/artist/magician to own the Other and to recognize him in himself.

Bram and Bakker and Barker show that a beautiful subject in art and an art that claims a corresponding beauty for itself need not objectify women or men, remove their agency, or initiate fetishism, prurience, or oppression. At least in these cases, we find some respite from the trouble with beauty. The obligatory relation between female passivity and male dominance may be relaxed into a more empathetic and reciprocal interaction, the ideal at which the story of Psyche and Cupid hints.

The choreography of Mark Morris offers wonderful possibilities in

this direction. His dancers' bodies are their own business – thin or plump, tall or short, classically proportioned or 'less than ideal'. They are models not of an impersonal norm but of themselves dancing [Pl. 43]. Mark Morris himself is blissfully heavy, moving with grace nonetheless, and signalling slyly from time to time that he is no longer the sylph he once was. It is extraordinary to see what dance motions look like on such a variety of bodies, and though we love to gaze at the normatively beautiful dancers, they become just one possible version of a body in skilled motion. The projection that goes on in viewing, as our muscles tense to the dancers' gestures, carries none of the usual feelings of inferiority provoked by classical performers. Though we may not know how to move as well as Morris's troop, that is not because our body types make us inherently unfit for dancing. Bodily beauty is not prescriptive or exclusive in this case; it holds the viewer and dancer together rather than pushing them apart.

When the whole company is on stage, the dancers only sometimes move in synchrony, and even then, the difference in their shapes make them look like a collection of individuals rather than a chorus. Men lift women, but they also lift men, and women lift both men and women, too. The effect is not just a liberationist statement – that all sexual affinities are condoned – but the realization that if lifting means 'taking care', caretaking has many varieties. Lifting, released from a purely sexual interpretation, can be seen, paradoxically, as a formal matter, too – one body raised above another, in all the combinations of body type the company contains. This is a new kind of formalism that classical ballet does not normally permit.

Morris's dancers react to the music in a variety of ways, becoming notes or instruments for a moment, flirting with a cellist playing on stage, offering gesture in response to tone as parties in a conversation. The dancers often do not keep together, and individuals break off from group choreography seemingly as the spirit moves them. Though many of their movements belong to the modern dance and classical ballet repertoire, folk, jazz, and other idioms are also present, and dancers sometimes let a move metamorphose from one idiom to another, as if

they were switching languages in mid-sentence.

The conventions of nineteenth-century ballet suddenly seem arbitrary in the extreme: the uniformity of body type, for example, or the sacrifice of personality to the abstraction of movement. Why should the members of the chorus merge themselves into an undifferentiated entity while the principal dancers are permitted to star as individuals? Why perpetuate that hierarchical difference? Why insist on perfection of bodily form and movement, divorcing dance from normal human motion? Classical ballet seems more like 'class ballet', a reinforcement of the very idea of inequality. And most troublesome of all: why the rigid differentiation of male from female roles? No doubt it is predictable that the art most associated with premodern concepts of beauty is also the art that most ruthlessly polices the traditional stereotypes of gender, but by now we have gone beyond the necessity for such anxious oppositions in art.

Eschewing these conventions, Mark Morris's dances offer a rare experience of beauty unburdened by the gender baggage of the ages. The denial and deprivation of modernist aesthetics have been left far behind. In their place is a dance inclusive, positive, witty, and warm, and dancer-models fully realized as individuals. This dance welcomes its audience rather than despising it, offering beauty as a spur to shared pleasure.

When such art admits premodernist conventions of beauty among its possibilities, we are permitted to go back in time to that 'belle époque' disdained for the past century. But at the same time beauty appears in a new perspective. A female subject may symbolize it, but so may one who is male. And those subjects combine the duality of models: both individual human beings and ideal forms. Such art is neither a blind for patriarchal oppression nor an ideal requiring the sacrifice of what makes us human, but an intense experience of value that can come in a thousand guises. If this is the millennium, it lives up to our wildest imaginations: a time when beauty, pleasure, and freedom again become the domain of aesthetic experience and art offers a worthy ideal for life.

NOTES

Proem: Psyche's Pleasure

1. Mario Vargas Llosa, 'Botero: A Sumptuous Abundance', in *Making Waves* (New York: Farrar, Straus & Giroux, 1996), p. 264.
2. Quoted in Neal Benezra, 'The Misadventures of Beauty', in *Regarding Beauty: A View of the Late Twentieth Century* (Washington, DC: Smithsonian Institution, 1999), p. 19.
3. Howard Barker, *Scenes from an Execution* (1984), in *Collected Plays*, vol. 1 (New York: Riverrun Press, 1990), p. 258.
4. Sir Kenneth Clark, *The Nude: A Study in Ideal Form* (Princeton: Princeton University Press, 1956), p. 127.
5. In a similar fashion, Clark sees the modernist departure from the traditional nude as a departure from traditional beauty: 'Two pictures painted in the year 1907 can conveniently be taken as the starting point of twentieth-century art. They are Matisse's *Blue Nude* and Picasso's *Demoiselles d'Avignon*; and both these cardinal, revolutionary pictures represent the nude . . . It is difficult for us to realize how complacently the official and cultured world of 1900 accepted the standards of degraded Hellenism, especially in France . . . the great official edifice of the *beaux-arts* seemed impregnable, and the concept of *le beau* on which it rested was still not very far from that which had governed Louis XIV in his admission of antique statuary into the Galérie des Glaces . . . a wide-awake and intelligent artist was bound to reject it.' (p. 358).

6. Ian McEwan, *Amsterdam* (New York: Random House, 1998), pp. 24–5.

7. For this reason, I shall be referring to the female subject as 'she' rather than 'it' throughout.

8. Mary Shelley, *Frankenstein: or, The Modern Prometheus*, 'Introduction', Maurice Hindle (London: Penguin, 1985 [1818,1831]), p. 212.

9. This myth apparently dates from the second century AD with Apuleius's *The Golden Ass or Metamorphoses*, trans. Robert Graves (Harmondsworth: Penguin, 1950).

10. William Wordsworth, Preface to the Second Edition of *Lyrical Ballads*, in *William Wordsworth: Selected Poems and Prefaces*, ed. Jack Stillinger (Boston: Houghton Mifflin, 1965), p. 455.

11. Benedetto Croce, *History as the Story of Liberty*, trans. Sylvia Sprigge (New York: Allen & Unwin, 1941), pp. 43–4.

Chapter 1: The Monster Sublime

1. Mary Shelley appears to have read Kant's *Critique of Judgement* only after she wrote *Frankenstein*, and to have admired it; see Emily W. Sunstein, *Mary Shelley: Romance and Reality* (Baltimore: Johns Hopkins University Press, 1989), p. 235. However, his ideas were certainly being discussed by the intellectuals and artists of her circle well before she read him. The parallelism between *Frankenstein* and the *Critique of Judgement* is too thoroughgoing to be accidental, though Mary Shelley may have seen her novel as a phantasmatic exaggeration of Kantian aesthetics. In terms of the twentieth-century avant-garde, it was hardly an exaggeration at all.

2. Sunstein, p. 107.

3. Madame de Staël, *De L'Allemagne*, vol. IV (Paris: Hachette, 1959 [1810; London, 1813]), pp. 111, 126, 113, 136, 137. The latter, in the original French, reads: 'Le pouvoir du destin et l'immensité de la nature sont dans une opposition infinie avec la misérable

dépendance de la créature sur la terre; mais une étincelle du feu sacré dans notre sein triomphe de l'univers . . . Le premier effet sublime est d'accabler l'homme; et le second, de le relever.'

4. Immanuel Kant, *The Critique of Judgement*, trans. James Creed Meredith (Oxford: Clarendon, 1952), p. 90.

5. ibid., p. 92.

6. ibid., p. 100.

7. Mary Shelley, *Frankenstein; or, The Modern Prometheus*, 'Introduction', Maurice Hindle (London: Penguin, 1985 [1818, 1831]), p. 106.

8. ibid., 'Preface', p. 58. Kant called Benjamin Franklin 'the new Prometheus' for his discovery of electricity, as Maurice Hindle points out in his 'Introduction', p. 30 – one of many hints that Mary Shelley connected the neoclassical philosopher with her inhumane scientist.

9. Sir Kenneth Clark, *The Nude: A Study in Ideal Form*, (Princeton: Princeton University Press, 1956), p. 13.

10. A modern twist on this formula is Lenin's equation: 'socialism = the Soviet government + electrification', quoted in Peter Steiner, *Russian Formalism: A Metapoetics* (Ithaca: Cornell University Press, 1984), p. 46.

11. Mary Wollstonecraft, *A Vindication of the Rights of Woman: With Strictures on Political and Moral Subjects*, in *The Vindications*, eds. D.L. Macdonald and Kathleen Scherf (Peterborough, Ont.: Broadview Press, 1997), pp. 314-15.

12. *Schopenhauer Selections*, ed. DeWitt H. Parker (New York: Scribner's, 1928), p. 148.

13. *Frankenstein*, p. 105.

14. Peter Gay, *The Naked Heart*, vol. IV of *The Bourgeois Experience: Victoria to Freud* (New York: Norton, 1995), p. 86.

15. *Frankenstein*, p. 58.

16. ibid., pp. 187-8.

17. Kant, p. 50.

18. ibid., p. 52.

19. ibid., p. 43.

20. ibid., p. 49.

21. ibid.

22. ibid., p. 52.

23. Interestingly, Mary Shelley translated Apuleius's 'Cupid and Psyche' while *Frankenstein* was in press. Her biographer, Emily W. Sunstein, describes the story as 'the myth of a girl's ordeal for love with which [Mary Shelley] identified,' p. 146.

24. *Frankenstein*, p. 200.

25. ibid., p. 201.

26. ibid., p. 200.

27. ibid., p. 86.

28. ibid., p. 85.

29. John Milton, *Paradise Lost*, Bk. IX, 11. 681-2, ed. Merritt Y. Hughes (New York: Odyssey Press, 1962), p.221.

30. *Frankenstein*, p. 241.

31. Signed by Percy Shelley, Preface to the 1818 edition of *Frankenstein* in Penguin edition, p. 62.

32. *Frankenstein*, p. 176.

33. Kant separated passion from beauty (p. 45) and Schopenhauer claimed that beauty lifted one out of desire and into calm contemplation (p. 124). Thus, they considered the *trompe l'oeil* representation of food in Dutch still life and the sensual representation of the body in non-classicistic nudes as incompatible with a judgement of taste.

34. *Frankenstein*, p. 201.

35. *ibid*.

36. William Wordsworth, Preface to the Second Edition of *Lyrical Ballads* (1800) in William Wordsworth, *Selected Poems and Prefaces*, ed. Jack Stillinger (Boston: Houghton Mifflin, 1965), p. 460.

37. *Frankenstein*, p. 121.

38. ibid., p. 213.

39. John Keats, Letter 43 to Benjamin Bailey, 22 November 1817: 'The Imagination may be compared to Adam's dream – he awoke and found it truth,' *Letters of John Keats*, ed. Hyder Edward Rollins,

vol. 1, (Cambridge, MA: Harvard University Press, 1958), p. 185.

40. *Frankenstein*, p. 103.

41. Kant, pp. 90–91.

42. ibid., p. 119.

43. William Blake, *The Marriage of Heaven and Hell*, Plate 10, l. 1, in *Blake: Complete Works*, ed. Geoffrey Keynes (London: Oxford University Press, 1966), p. 152.

44. Lynda Nead argues in *The Female Nude: Art, Obscenity and Sexuality* (London: Routledge, 1992), p. 29, that 'For Kant, while neither sex is entirely without the character of either the sublime or the beautiful, the 'merits of a woman should unite solely to enhance the character of the beautiful which is the proper reference point; and on the other hand, among the masculine qualities the sublime clearly stands as the criterion of his kind.' But in the light of the relationship between the sublime and the unbounded female body, we arrive at a more subtly nuanced understanding of the gendering of aesthetics. The sublime is not simply a site for the definition of masculinity but is also where a certain deviant or transgressive form of femininity is played out. It is where woman goes beyond her proper boundaries and gets out of place.' My point is that woman is doomed whether seen through the lens of the beautiful or the sublime. As the proper subject of the beautiful, she is part of that complacent harmony of bourgeois domesticity incompatible with sublime transcendence and always threatening to degenerate into mere charm and allure. But as this threat is experienced as such, it is the very occasion for sublime awe and fear. Woman is chaos, unreason, unboundedness, and appearance perverted into allure, or at least male artists intent on the sublime will make her into that in order to experience emotions Kant teaches them to value in art. As a result, the female subject, the Other, pervades aesthetics according to the psychic needs of male artists and audience. This issue is dealt with in greater detail in Chapter 3 in connection with the obscene. For an informed and original discussion of the relation between the

sublime and woman, see Barbara Claire Freeman, *The Feminine Sublime: Gender and Excess in Women's Fiction* (Berkeley: University of California Press, 1995).

45. Octavio Paz, *An Erotic Beyond: Sade* (New York: Harcourt Brace, 1993), p.46.

46. ibid., p. 53.

47. ibid., pp. 54-5. A fuller quotation of the passage in Paz is illuminating: 'Justine is Juliette . . . The libertine puts himself in his victim's place and thus reproduces the original situation: as an object he ceases to be reflected. The sadistic Juliette cannot see herself, she has become inaccessible, she continually escapes herself; in order to see herself she must be changed into her opposite, Justine, the all-suffering. Juliette and Justine are inseparable, but they are condemned to never knowing each other. Neither masochism nor sadism is an answer to the contradiction of the libertine' (pp. 54-5).

48. André Breton, *Nadja*, trans. Richard Howard (New York: Grove Press, 1960), p. 11.

49. Peter Gay, *Pleasure Wars*, vol. 5 of *The Bourgeois Experience* (New York: Norton, 1998), p. 24.

50. ibid., p. 25.

51. Gustave Flaubert, letter to Louise Colet, 1853, in *The Modern Tradition: Backgrounds of Modern Literature*, eds. Richard Ellmann and Charles Feidelson, Jr (New York: Oxford University Press, 1965), p. 195.

52. *Pleasure Wars*, p. 26.

53. ibid., p. 36.

54. Hans Arp, *On My Way, Poetry and Essays 1912-47*, in Ellmann and Feidelson, p. 50.

55. Tristan Tzara, 'Dada Manifesto', 1918, in Ellmann and Feidelson, p. 597.

56. Søren Kierkegaard, *Concluding Unscientific Postscript*, 1844, in Ellmann and Feidelson, p. 810.

57. Friedrich Nietzsche, *Beyond Good and Evil*, 1886, in Ellmann and

Feidelson, p. 815.

58. Gustave Flaubert, letter to Louise Colet, 1852, in Ellmann and Feidelson, p. 197.

59. Brian O'Doherty, *Inside the White Cube: The Ideology of the Gallery Space* (San Francisco: Lapis Press, 1986 [1976]), pp. 55, 61, 73.

60. Kant, p. 56.

61. Harry Steinhauer, 'Preface' to Johann Wolfgang Goethe, *The Sufferings of Young Werther*, trans. Harry Steinhauer (New York: Norton, 1970), p. 109; the quotation is an explanation of Werther's extravagant behaviour.

62. William Blake, *The Marriage of Heaven and Hell*, Plate 7, l. 4, in *Blake: Complete Works*, p. 151.

63. Wollstonecraft, pp. 119, 157, 127, 129.

64. Schopenhauer, p. 442

65. ibid., p. 335.

66. ibid., p. 441.

67. *The Naked Heart*, p. 178. This is a contemporary report of Winckelmann's opinions rather than his words as such.

68. Abigail Solomon-Godeau, *Male Trouble: A Crisis in Representation* (London: Thames & Hudson, 1997) pp. 7–8.

69. Clark, p. 158.

70. Whitney Chadwick, *Women, Art, and Society* (London: Thames & Hudson, 1996), p. 174: 'In the Salon of 1801 14.6% of the artists were women; by 1835 the percentage of women exhibiting had grown to 22.2%. Women excelled at portraiture and sentimental genre.'

71. Solomon-Godeau, p. 12.

72. Wollstonecraft, p. 330.

73. *The Naked Heart*, pp. 233, 248.

74. Wollstonecraft, p. 177.

75. Schopenhauer, p. 440.

76. Umberto Eco, *Art and Beauty in the Middle Ages*, trans. Hugh Bredin (New Haven: Yale University Press, 1986), p. 9.

77. George Eliot, *Adam Bede*, 1864, in Ellmann and Feidelson, p. 237.

78. Wollstonecraft, p. 147.
79. E. H. Gombrich, *The Sense of Order: A Study in the Psychology of Decorative Art* (Ithaca: Cornell University Press, 1979), p. 23.
80. Kant, p. 68.
81. Wollstonecraft, p. 167. By echoing this anti-feminist sentiment, Wollstonecraft gave an easy opening to her critics. One of the reviewers of her *Vindication of the Rights of Woman* advised her sarcastically: 'dear young lady . . . endeavour to attain 'the weak elegancy of mind', the 'sweet docility of manner', 'the exquisite sensibility', the former ornaments of your sex; we are certain you will be more pleasing, and we dare pronounce that you will be infinitely happier' (p. 432).
82. Quoted in *Pleasure Wars*, p.109.
83. ibid., p. 131.
84. Edgar Allan Poe, 'The Philosophy of Composition', *Edgar Allan Poe: Representative Selections, with Introduction, Bibliography, and Notes*, eds. Margaret Alterton and Hardin Craig (New York: American Book Company, 1935), p. 368.
85. ibid., p. 371.
86. Edmond and Jules de Goncourt, *Pages from the Goncourt Journal*, in Ellmann and Feidelson, p. 297.
87. Gustave Flaubert, quoted in *Goncourt Journal*, in Ellmann and Feidelson, p. 126.
88. Gustave Flaubert, letter to Louis Bouilhet, 1856, in Ellmann and Feidelson, p. 243.
89. Gustave Flaubert, letter to Mlle Leroyer de Chantepie, 1857, in Ellmann and Feidelson, p. 132.
90. Gustave Flaubert, letter to Louise Colet, 1853, in Ellmann and Feidelson, p. 195.
91. Kant, p. 65.
92. Wollstonecraft, pp. 113, 103.
93. Bram Dijkstra, *Evil Sisters: The Threat of Female Sexuality and the Cult of Manhood* (New York: Knopf, 1996), pp. 3, 26.
94. Anthony Shelton, Introduction, *Fetishism: Visualizing Power and*

Desire (London: South Bank Centre, 1995), p. 7.

95. J. Sheridan Le Fanu, 'Green Tea', *Carmilla and 12 Other Classic Tales of Mystery*, ed. Leonard Wolf (New York: Penguin, 1996), p. 359.

96. *Frankenstein*, p.95.

97. This formulation plays on Sally Price's title, *Primitive Art in Civilized Places* (Chicago: University of Chicago Press, 1989).

Chapter 2: The Burden of the Image

1. Charles Bernheimer, *Figures of Ill Repute: Representing Prostitution in Nineteenth-Century France* (Cambridge, MA: Harvard University Press, 1989), p. 117.

2. *Marlene Dumas* (London: Phaidon, 1999), p. 23.

3. According to Tamar Garb, 'When Armand Silvestre, the well-known critic and chronicler, published one of his annual surveys of *Le Nu au Salon* in 1889, he used a sample of nudes for the cover. All of these are female nudes, the vast majority showing women in natural surroundings and presenting the standard conjunction of women with water, women with foliage, women at one with the natural world.' *Bodies of Modernity: Figure and Flesh in Fin-de-Siècle France* (London: Thames & Hudson, 1998), pp. 194-5.

4. Lynda Nead, *The Female Nude: Art, Obscenity and Sexuality* (London: Routledge, 1992), p. 1.

5. Leo Tolstoy, 'Guy de Maupassant', in George J. Becker, ed., *Documents of Modern Literary Realism* (Princeton: Princeton University Press, 1963), pp. 421, 424.

6. Henry Adams, 'The New Multiverse' (written 1900, published 1918), in Richard Ellmann and Charles Feidelson, Jr, eds., *The Modern Tradition: Backgrounds of Modern Literature* (New York: Oxford University Press, 1965), p. 428.

7. Adams, in Ellmann and Feidelson, pp. 425, 426.

8. I. Terentyev, *Kruchenykh the Grandiosaire* (1919), in Anna Lawton, ed., *Russian Futurism through Its Manifestoes, 1912-1928*, trans.

Anna Lawton and Herbert Eagle (Ithaca and London: Cornell University Press, 1988), p. 179.

9. S. Tretyakov, 'From Where to Where? (Futurism's Perspectives)' (1923), Lawton, p. 206.

10. Lawton, p. 87.

11. ibid., p. 75.

12. F.T. Marinetti, 'The Foundation of Futurism' ['Manifesto of Futurism,' 1909] in Ellmann and Feidelson, p. 433.

13. D. H. Lawrence, letter to Edward Garnett, 5 June 1914, in Ellmann and Feidelson, pp. 435-6.

14. D. H. Lawrence, 'The Risen Lord', 1929, in Ellmann and Feidelson, p. 920.

15. Lawton, p. 66. Sometimes this hostility seems related to the homosexuality of a given artist. André Gide in the mid-1930s exhorts the artist to distance himself from the past by remembering that Achilles was invulnerable except where his mother touched him (*Later Fruits of the Earth*, 1935, in Ellmann and Feidelson, p. 416), and W. H. Auden in 1948 writes that 'The present state of the world is so miserable and degraded that if anyone were to say to the poet: "For God's sake, stop humming and put the kettle on or fetch bandages. The patient's dying," I do not know how he could justifiably refuse . . . The self-appointed unqualified Nurse says: "Stop humming this instant and sing the Patient a song which will make him fall in love with me."' ('Squares and Oblongs', 1948, in Ellmann and Feidelson, p. 214).

16. Lawton, p. 61.

17. ibid., p. 92.

18. 'Manifeste Cérébraliste de R. Canudo' (1914) in Bonner Mitchell, *Les Manifestes Littéraires de la Belle Epoque, 1886-1914* (Paris: Seghers, 1966), p. 176: 'Cet art marque la borne funéraire de tout l'art sentimental: banal, facile, enfin intolérable parce que insuffisant. On sait de plus en plus que le mélodrame où Margot a pleuré est sans doute un mélodrame stupide qui peut nous donner

la même émotion, immédiate, vaine, amoindrissante, qu'un fait divers. Aucune exaltation pour l'individu, aucune élévation pour l'espirit. Tandis que, contre tout sentimentalisme dans l'art et dans la vie, nous voulons un art plus noble et plus pur, qui ne touche pas le coeur, mais qui remue le cerveau, *qui ne charme pas, mais qui fait penser.'*

19. Marinetti, 'The Foundation of Futurism', in Ellmann and Feidelson, p. 432.

20. Lawton, p. 61.

21. Friedrich Nietzsche, *Beyond Good and Evil*, 1886, in Ellmann and Feidelson, p. 776.

22. T. S. Eliot, *The Waste Land: A Facsimile and Transcript of the Original Drafts Including the Annotations of Ezra Pound*, ed. Valerie Eliot (New York: Harcourt Brace Jovanovich, 1971), p. 22. My thanks to Bob Perelman for this reference.

23. Nietzsche, in Ellmann and Feidelson, p. 779.

24. *The Alwayser*, 1913, in Lawton, pp. 124–5.

25. Lawton, p. 180.

26. Ellis Amburn, *Subterranean Kerouac: The Hidden Life of Jack Kerouac*, quoted by Morris Dickstein, 'Beyond Beat', *New York Times Book Review*, 9 August 1998, p. 8.

27. W. B. Yeats, 'Anima Hominis', in Ellmann and Feidelson, p. 763.

28. Garb, p. 217.

29. Quoted in Gelett Burgess, 'The Wild Men of Paris', *The Architectural Record*, May 1910, p. 405. My thanks to the architect Keith Greene for bringing this article to my attention.

30. ibid., pp. 406–7.

31. Quoted in Garb, p. 179.

32. Gustave Flaubert, quoted in Edmond and Jules de Goncourt, *Pages from the Goncourt Journal*, in Ellmann and Feidelson, p. 126.

33. There is one child's face, too, but otherwise this is an experience of a sequence of beautiful women.

34. Ezra Pound, 'Vorticism', *Gaudier-Brzeska*, 1916, in Ellmann and Feidelson, p. 149.

35. James Joyce, *A Portrait of the Artist as a Young Man*, 1916, in Ellmann and Feidelson, pp. 136, 139.

36. Hans Arp, *On My Way, Poetry and Essays 1912-47*, in Ellmann and Feidelson, p. 49.

37. Tristan Tzara, 'Dada Manifesto', 1918, in Ellmann and Feidelson, p. 598.

38. Guillaume Apollinaire, 'On Painting', 1913, in Ellmann and Feidelson, p. 116.

39. Lawton, p. 152.

40. Pound, in Ellmann and Feidelson, p. 149.

41. Paul Valéry, 'Introduction to the Method of Leonardo da Vinci', 1895, in Ellmann and Feidelson, p. 175.

42. Paul Klee, *On Modern Art*, 1945, in Ellmann and Feidelson, p. 66.

43. Wallace Stevens, 'The Figure of the Youth as Virile Poet', 1944, in Ellmann and Feidelson, p. 224.

44. André Malraux, *The Voices of Silence*, in Ellmann and Feidelson, p. 517.

45. Apollinaire, in Ellmann and Feidelson, p. 119.

46. Brian O'Doherty, *Inside the White Cube: The Ideology of the Gallery Space* (San Francisco: Lapis Press, 1986 [1976]), pp. 80, 52.

47. Søren Kierkegaard, *Concluding Unscientific Postscript*, 1844, in Ellmann and Feidelson, p. 814.

48. Walter Pater, 'Conclusion', 1868, to *Studies in the History of the Renaissance*, 1873, in Ellmann and Feidelson, p. 184.

49. Michael Kimmelman, 'Photographs that Fed Picasso's Vision', *New York Times*, 11 January 1998, p. 45: Picasso owned 'about 40 postcards . . . by Edmond Fortier, a photographer based in Dakar in Senegal. Mostly they show West African women, bare-breasted, alone and in groups, squatting, balancing bowls on their heads, arms raised or akimbo.' 'Of course, one can also see in Picasso's use of the postcards a white European male artist exploiting images of naked black African women, making them models for prostitutes. The sexual and colonial politics are obvious; my point is slightly different. It has to do with the unsettling aspect not just of

'Demoiselles' but of many of the Cubist paintings that followed it. Picasso said he hated exoticism, but evidently he collected photographs of peoples from different cultures partly, it seems, for their strangeness and foreignness . . . Cubism is often talked about in such coolly formal terms that it's possible to forget how intractably alien, even hostile, it often looks.'

50. Apollinaire, in Ellmann and Feidelson, p. 116.
51. See Margot Norris, *Beasts of the Modern Imagination: Darwin, Nietzsche, Kafka, Ernst, and Lawrence* (Baltimore: Johns Hopkins University Press, 1985).
52. Jean Rhys, *Quartet* (New York: W. W. Norton, 1997 [1929]), pp. 6, 131.
53. Joan Rivière, 'The Feminine Masquerade', *The Inner World and Joan Riviere: Collected Papers 1920-1958* (London: Karnac Books, 1991).
54. Garb, p. 115.
55. George Bernard Shaw, 'Ideals and Idealism', 1890, in Ellmann and Feidelson, p. 238.
56. August Strindberg, Preface to *Miss Julie*, 1888, in Ellmann and Feidelson, p. 292.
57. Dawn Ades, 'Surrealism: Fetishism's Job', in Shelton, p. 67.
58. William Rubin, *Primitivism in Twentieth Century Art* (New York: Museum of Modern Art, 1984), p. 5.
59. Tzara, in Ellmann and Feidelson, p. 596.
60. Burgess, p. 405.
61. '*The beautiful captive* is one of the classical topoi of popular fiction. In the 'Melesian' heroic novels of the seventeenth century – novels that evolved into the Gothic novel and later into the *roman noir* of the Fantomas period – a beautiful hostage, like the mermaid, was a mythical image verging on the cliché.' Ben Stoltzfus, Introduction to Alain Robbe-Grillet and René Magritte, *La Belle Captive: A Novel* (Berkeley: University of California Press, 1995 [1975]), p. 3, fn. 4.
62. Ben Stoltzfus, 'The Elusive Heroine,' in *La Belle Captive*, p. 170.

63. André Breton, *What Is Surrealism?*, 1934, in Ellmann and Feidelson, p. 605.

64. Oscar Wilde, 'The Decay of Lying', 1889, in Ellmann and Feidelson, p. 20.

65. Pound, in Ellmann and Feidelson, p. 149.

66. Harold Brodkey, 'Sex and Looks', *Sea Battles on Dry Land* (New York: Henry Holt, 1999), p. 255.

67. Gombrich, *The Sense of Order: A Study in the Psychology of Decorative Art* (Ithaca: Cornell University Press, 1979), p. 19.

68. ibid., p. 59. Of course, Sullivan also wrote extensively on ornament as well as designing it.

69. Adolf Loos, 'Ornament and Crime', in *The Architecture of Adolf Loos*, ed. Yehuda Safran and Wilfried Wang (London: Arts Council of Great Britain, 1985), p. 100.

70. Owen Jones, *The Grammar of Ornament* (London: Omega, 1986 [1856]), p. 13.

71. Tamar Garb, *Bodies of Modernity: Figure and Flesh in Fin-de-Siècle France* (London: Thames & Hudson, 1998, pp. 35, 36.

72. E. J. Scovell, *Collected Poems*, vol III: 'Poems on Infancy' (Manchester: Carcanet Press, 1988).

73. Burgess, p. 405.

74. Robert Jensen and Patricia Conway, *Ornamentalism* (New York: Clarkson N. Potter, 1982), p. 8.

75. M. M. Bakhtin, *Rabelais and His World*, trans. Helene Iswolsky (Bloomington: Indiana University Press, 1984), ch. 1.

76. Jan Mukařovský, 'On the Problem of Functions in Architecture', *Structure, Sign and Function*, eds. John Burbank and Peter Steiner (New Haven: Yale University Press, 1977), p. 246.

77. Gombrich, p. 61.

78. Quoted by Jan Mukařovský, *Aesthetic Function, Norm, and Value As Social Facts*, trans. Mark E. Suino (Ann Arbor: Michigan Slavic Contributions, 1970), p. 38.

79. Gombrich, p. 15.

80. The connection between ornament and abstraction is, of course,

obvious, and it is surprising that modernists ignored this fact in their anti-ornamental polemics. Wassily Kandinsky's early work uses the patterning of female clothing to experiment with flatness and efface the boundary between figure and background. In *The Singer* and *Lady with a Muff* (both 1903), stripes and spots, respectively, create overall patterns. In the 1902 *Promenade*, the women are demarcated only by the flower print on their dresses over a black ground that covers the whole painting. In *The Mirror* (1907), the flowers on the dress run into the flowers in the grass. Kandinsky is influenced by the patterning in Russian folk art, too – another primitivism that shows the way from ornament to abstraction.

81. John Elderfield, *Pleasuring Painting: Matisse's Feminine Representations* (London: Thames & Hudson, 1992), pp. 21-2.

82. ibid., p. 24.

83. Of course, several of Matisse's paintings from the 1930s are exceptions to what I say here, but they stand out from the majority of his work like an unsuccessful experiment with other artists' concerns.

84. Edith Wharton, *The House of Mirth* (New York: New American Library, 1980 [1905]).

85. Edith Wharton and Ogden Codman, Jr, *The Decoration of Houses*, revised edn. (New York: Norton, 1997), p. xvi; other quotations in this paragraph, pp. 191, 1, 14.

86. Compare, for example, Wharton's strictures on decoration to William Morris's teachings on book illustration: 'We must remember one thing, that if we think the ornament is ornamentally a part of the book, merely because it is printed with it, and bound up with it, we shall be much mistaken. The ornament must form as much a part of the page as the type itself, or it will miss its mark, and in order to succeed, and to be ornament, it must submit to certain limitations, and become *architectura;* a mere black and white picture, however interesting it may be as a picture, may be far from an ornament in a book. On the other hand, a book ornamented with pictures that are suitable

for that book, and that book only, may become a work of art second to none, save a fine building duly decorated, or a fine piece of literature.' William Morris, *The Ideal Book: Essays and Lectures on the Arts of the Book*, ed. William S. Peterson (Berkeley: University of California Press, 1982), pp. 72-3.

87. This is by now a critical commonplace. See Judith Fetterley, ''The Temptation to Be a Beautiful Object': Double Standard and Double Bind in *The House of Mirth*', *Studies in American Fiction* 1977, 5: 199-212; Joan Lidoff, 'Another Sleeping Beauty: Narcissism in *The House of Mirth*', *American Quarterly* 1980, 32: 519-39; Elaine Showalter, 'The Death of the Lady (Novelist): Wharton's *House of Mirth*', *Representations* 1985, 9: 133-49; Cynthia Griffin Wolff, 'Lily Bart and the Beautiful Death', *American Literature* 1974, 46: 16-40 and *A Feast of Words: The Triumph of Edith Wharton* (New York: Oxford University Press, 1977), pp. 113-33.

88. *Mirth*, p.75.

89. Fetterley, p. 202.

90. *Decoration of Houses*, p. 188.

91. *Mirth*, p. 311.

92. John Milton, *Paradise Lost*, Bk. 8, ll. 538-52 (New York: Odyssey, 1962), p. 198.

93. *Mirth*, p. 162.

94. Pound, in Ellmann and Feidelson, p. 150. Shakespeare's *The Merchant of Venice*, a veritable philosophy of ornament, amply expresses this view: 'So may the outward showes be least themselves:/ The world is still deceiv'd with ornament' (III, ii. 73-4); 'Thus ornament is but the guiled shore/ To a most dangerous sea; the beauteous scarf/Veiling an Indian beauty; in a word/ The seeming truth which cunning times put on/ To entrap the wisest' (III. ii. 97).

95. Karl Marx, *The Economic and Philosophic Manuscripts of 1844*, in Ellmann and Feidelson, p. 742.

96. Quoted by William A. Coles in 'The Genesis of a Classic', a

critical essay appended to Wharton's *The Decoration of Houses*, p. 275, in the 1997 edition.

97. Zelda Fitzgerald, 'Paint and Powder', *Collected Writings of Zelda Fitzgerald*, ed. Matthew Broccoli (New York: Macmillan, 1992), p. 415.

98. ibid., p. 416.

99. Zelda Fitzgerald, 'The Original Follies Girl,' in *Collected Writings*, pp. 293, 297.

100. Zelda Fitzgerald, *Save Me the Waltz*, in *Collected Writings*, p. 50.

101. 'Paint and Powder,' p. 417.

Chapter 3: The Infamous Promiscuity of Things and of Women

1. Charles Bernheimer, *Figures of Ill Repute: Representing Prostitution in Nineteenth-Century France* (Cambridge, MA: Harvard University Press, 1989), pp. 132-3.

2. ibid., pp. 129-30.

3. ibid., p. 73.

4. ibid.

5. Kant, *The Critique of Judgement*, trans. James Creed Meredith (Oxford: Clarendon, 1952), pp. 90, 92.

6. Patricia Parkhurst Ferguson, 'The Flâneur On and Off the Streets of Paris', in *The Flâneur*, ed. Keith Tester (London: Routledge, 1994), p. 27: 'Women, it is claimed, compromise the detachment that distinguishes the true flâneur. In other words, women shop . . . She is unfit for flânerie because she desires the objects spread before her and acts upon that desire.'

7. Bernheimer, p. 208.

8. ibid., p. 171.

9. Sir Kenneth Clark, *The Nude: A Study in Ideal Form* (Princeton: Princeton University Press, 1956).

10. Bernheimer, p. 171.

11. Tamar Garb, *Bodies of Modernity: Figure and Flesh in Fin-de-Siècle France* (London: Thames & Hudson, 1998), p. 50.

12. Bernheimer, p. 63.

13. ibid., p. 15.

14. F. M. Dostoevsky, 'Notes from Underground', 1864, in *The Modern Tradition: Backgrounds of Modern Literature*, eds. Richard Ellmann and Charles Feidelson, Jr. (New York: Oxford University Press, 1965), p. 798.

15. Bernheimer, p. 264.

16. ibid., p. 114.

17. Clark, pp. 164–5.

18. Donald Kuspit, 'Venus Unveiled: De Kooning's Melodrama of Vulgarity', in *Uncontrollable Beauty: Toward a New Aesthetics*, eds. Bill Beckley and David Shapiro (New York: Allworth Press, 1998), p. 295, fn. 6.

19. Eunice Lipton, *Alias Olympia: A Woman's Search for Manet's Notorious Model and Her Own Desire* (Ithaca, NY: Cornell University Press, 1992).

20. The painting must strike us as racist in setting off Olympia's beauty against a black servant. After decades of multicultural discussions, race-based ideals of beauty are still ubiquitous.

21. Bernheimer, p. 114.

22. Tobin Siebers, 'Kant and the Politics of Beauty', *Philosophy and Literature* 1988, 22: 44, 35, 36.

23. ibid., p. 48.

24. ibid., p. 34.

25. Walter Kendrick, *The Secret Museum: Pornography in Modern Culture* (New York: Penguin, 1987), p. xiii: pornography 'is not a thing but a concept, a thought structure that has changed remarkably little since the name was first applied to it a century and a half ago. 'Pornography' names an imaginary scenario of danger and rescue, a perennial little melodrama in which, though new players have replaced old, the parts remain much as they were first written.'

26. See, for example, Ann Douglas, 'High is Low', *New York Times*

Magazine, 29 September 1996, pp. 175–80.

27. Rachel Weil, 'Sometimes a Sceptre is Only a Sceptre: Pornography and Politics in Restoration England', in Lynn Hunt, ed., *The Invention of Pornography: Obscenity and the Origins of Modernity, 1500-1800* (New York: Zone Books, 1993), p. 130.

28. Robert Darnton, *Edition et sédition: L'Univers de la littérature clandestine au XVIIIe siècle* (Paris: Gallimard, 1991), pp. 13–16.

29. Lynn Hunt, 'Pornography and the French Revolution', in Hunt, *Invention*, p. 339.

30. Lynn Hunt, 'Introduction: Obscenity and the Origins of Modernity, 1500–1800', in Hunt, *Invention*, p. 13.

31. Hunt, 'Pornography and the French Revolution', p. 326.

32. ibid., p. 312.

33. Hunt, 'Introduction', p. 23.

34. Margaret C. Jacob, 'The Materialist World of Pornography', in Hunt, *Invention*, pp. 158, 160, 181.

35. Kathryn Norberg, 'The Libertine Whore', in Hunt, *Invention*, pp. 249, 225, 228.

36. Kendrick, pp. 31, 188.

37. Roger Shattuck, 'Rehabilitating a Monster', *New York Times Book Review*, 28 November 1998, p. 31.

38. Hunt, 'Introduction', p. 36.

39. Robert McG. Thomas, Jr, 'Lili St Cyr, 80, Burlesque Star Famous for Her Bubble Baths', *New York Times*, 6 February 1999.

40. Martin Buber, *I and Thou*, 1923, in Ellmann and Feidelson, p. 873.

41. Wassily Kandinsky, *Concerning the Spiritual in Art*, 1912, in Ellmann and Feidelson, p. 710.

Chapter 4: The Quotation of Beauty

1. Sir Kenneth Clark, *The Nude: A Study in Ideal Form* (Princeton: Princeton UP, 1956), p. 5. Clark does assert that 'no nude, however abstract, should fail to arouse in the spectator some

vestige of erotic feeling, even though it be only the faintest shadow
– and if it does not do so, it is bad art and false morals. The desire
to grasp and be united with another human body is so fundamental
a part of our nature that our judgement of what is known as "pure
form" is inevitably influenced by it; and one of the difficulties of
the nude as a subject for art is that these instincts cannot lie hidden
. . . but are dragged into the foreground, where they risk upsetting
the unity of responses from which a work of art derives its
independent life.' (p. 8). Here, the impurity of the nude is
acknowledged, and made inimical to the 'independent life' of art.

2. Neal Benezra, 'The Misadventures of Beauty', in *Regarding Beauty: A View of the Late Twentieth Century* (Washington, DC: Smithsonian Institution, 1999), p. 17.
3. Calvin Tomkins, *Off the Wall: Robert Rauschenberg and the Art World of Our Time* (New York: Doubleday, 1980), p. 254.
4. Alain Robbe-Grillet, 'Three Reflected Visions', 1957, in Ellmann and Feidelson, p. 367.
5. Jean Dubuffet, 'Landscaped Tables, Landscapes of the Mind, Stones of Philosophy', 1962, in Ellmann and Feidelson, p. 154.
6. Josef Joffe, 'Intellectual Espionage', *New York Times Book Review*, 21 May 2000, p. 15.
7. David D'Arcy, 'Rockwell Rehabilitated?', *The Art Newspaper*, No. 97, November 1999, p. 22.
8. See Vic Tulley, 'Indecent Reading: Literature, Obscenity Law, and U.S. Culture 1952-1966', doctoral dissertation in English, University of Pennsylvania, 1999.
9. Benezra, p. 29.
10. Arthur C. Danto, 'Beauty for Ashes', in *Regarding Beauty*, p. 184.
11. Quoted in Michael Kimmelman, 'Clowning Inventively with Stuff of Beauty', *New York Times*, 19 September, 1997, p. E33.
12. Robert Jensen and Patricia Conway, *Ornamentalism* (New York: Clarkson N. Potter, 1982), p. 1.
13. Charles A. Jencks, *The Language of Post-Modern Architecture* (New York: Rizzoli, 1977), p. 15.

14. Jensen and Conway, p. 3.

15. ibid, p. 2.

16. Peter Fuller, *Aesthetics after Modernism* (London: Writers and Readers, 1983), p. 27.

17. James Surls, quoted in Richard Marshall, *American Art Since 1970* (New York: Whitney Museum of American Art, 1984), p. 112.

18. Quoted in Calvin Tomkins, *Off the Wall: Robert Rauschenberg and the Art World of Our Time* (New York: Doubleday, 1980), pp. 255-6.

19. Diane Waldman, *New Perspectives in American Art* (New York: Solomon R. Guggenheim Foundation, 1983), p. 9.

20. John Hawkes, *Travesty* (New York: New Directions, 1976), epigraph.

21. Charles Newman, *The Post-Modern Aura: The Act of Fiction in an Age of Inflation* (Evanston: Northwestern University Press, 1985), p. 182.

22. E. H. Gombrich, *The Sense of Order* (Ithaca: Cornell University Press, 1979), p. 31.

23. Pynchon, ahead of his time, had already structured his 1966 novel *The Crying of Lot 49* around a post horn scrawled on bathroom walls and under highway overpasses.

24. See my account in *The Scandal of Pleasure: Art in an Age of Fundamentalism* (Chicago: University of Chicago Press, 1995).

25. John Fowles, 'The Ebony Tower', in *The Ebony Tower* (New York: New American Library, 1974), p. 102.

26. ibid., p. 39.

27. Samuel Beckett, *Waiting for Godot* (London: Faber and Faber, 1956), p. 43.

28. Susan Brownmiller, *In Our Time: Memoir of a Revolution* (London: Aurum, 1999), p. 35.

29. ibid., p. 38.

30. Betty Friedan is only one of many women who were made uncomfortable enough by Steinem's combination of beauty and feminist fervour to discuss it publicly, although she claims that her

difficulties with Steinem stemmed from other causes. 'People liked to ascribe the rift between Gloria and me to jealousy on my part of Gloria's looks, charging that I resented her because she was prettier. It indeed had been a bane in my existence that I wasn't pretty . . . But I always saw Gloria's looks as an asset to the movement. She contributed a positive image of beauty and glamour which was invaluable in refuting the movement's negative image of man-haters and lesbians.' Betty Friedan, *Life So Far: A Memoir* (New York: Simon & Schuster, 2000), p. 255.

31. Laura Mulvey, 'Visual Pleasure and Narrative Cinema' (originally published in 1975 in *Screen*), in *Visual and Other Pleasures* (Bloomington: Indiana University Press, 1989), p. 19.

32. ibid., p. 21.

33. ibid., p. 16.

34. Angela Carter, 'The Wound in the Face', *Shaking a Leg: Journalism and Writings* (New York: Penguin, 1998), p. 109.

35. See Leslie Berger, 'A New Body Politic: Learning to Like the Way We Look', *New York Times*, Tuesday, 18 July 2000, Health & Fitness, p. F7; Ruki Sayid and Athalie Mathews, 'Does This . . . Lead to This? Docs Blame Anorexia on Media Waifs', *The Mirror*, 31 May 2000, pp. 12-13; Wendy Vukosa, 'BMA warns against skinny role models', *Evening Standard*, 31 May 2000, p. 5.

36. Arthur C. Danto, 'What Happened to Beauty?', *The Nation*, 30 March 1992, p. 418.

37. James Hillman, 'The Practice of Beauty', in *Uncontrollable Beauty: Toward a New Aesthetic* (New York: Allworth Press, 1998), p. 262.

38. Quoted by Dinitia Smith, 'Recognition at Last for a Poet of Elegant Complexity', *New York Times*, 13 April 1999, p. E1.

39. Diana Ketcham, 'Will the Caged Rock Fly in the Napa Valley?', *New York Times*, 21 May 1998, p. F7.

40. Mohsen Mostafavi, 'Cities of Distraction', *Cities on the Move* (London: Hayward Gallery, 1999), pp. 7, 9; Rem Koolhaas and Hans-Ulrich Obrist, 'An Accelerated Merzbau', *Cities on the Move*, p. 16.

41. Hou Hanru and Hans-Ulrich Obrist, 'Cities on the Move', *Cities on the Move*, p. 13.

42. 'An Accelerated Merzbau', p. 17.

43. Quoted in Christopher Finch, *Pop Art: Object and Image* (New York: Dutton, 1968), p. 150.

44. Harold Brodkey, 'Variations on Sex', in *Sea Battles on Dry Land* (New York: Henry Holt, 1999), p. 99.

45. Harold Brodkey, 'American Movies and Sex and Nazis and Moral Questions', in *Sea Battles on Dry Land*, p. 108.

46. Michael Kimmelman, 'At the Met with Cindy Sherman: Portraitist in the Halls of Her Artistic Ancestors', *New York Times*, 19 May 1995, p. C7.

47. ibid.

48. Roberta Smith, 'Standing and Staring, Yet Aiming for Empowerment', *New York Times*, 6 May 1998, p. E2. The performance I describe took place in Philadelphia at the Institute for Contemporary Art in 1995.

49. Whitney Chadwick, *Women, Art, and Society* (London: Thames & Hudson, 1996), p. 362.

50. Lynda Nead, *The Female Nude* (London: Routledge, 1992), p. 82.

51. Dave Hickey, 'Enter the Dragon: On the Vernacular of Beauty' (1993), in *Uncontrollable Beauty: Toward a New Aesthetics* (New York: Allworth Press, 1998), p. 15.

52. Peter Schjeldahl, 'Beauty is Back: A trampled esthetic blooms again', *New York Times Magazine*, 29 September 1996, p. 161.

53. Elizabeth Hayt, 'The Artist Is a Glamour Puss', *New York Times*, 18 April 1999, Section 9, p. 1.

54. Roberta Smith, 'Conceptual Art: Over, and Yet Everywhere', *New York Times*, 25 April 1999, Section 2, p. 1.

55. Michael Kimmelman, 'Rothko's Gloomy Elegance in Retrospect', *New York Times*, 18 September 1998, p. E31.

56. Robert Hughes, quoted in 'Rothko's Gloomy Elegance'.

57. Sarah Boxer, 'Lifting the Veil from Beauties Cloaked in Tragic Guise', *New York Times*, 29 January, 1999, p. E33.

58. See, for example, Bill Beckley and David Shapiro, eds., *Uncontrollable Beauty: Toward a New Aesthetics* (New York: Allworth Press, 1998); the Maryland Institute's XX Anniversary Residency Series: On Beauty; and for other examples, Scott Heller, 'Wearying of Cultural Studies, Some Scholars Rediscover Beauty', *The Chronicle of Higher Education*, 4 December 1998, p. A15.

59. Leslie Heywood, *Dedication to Hunger: The Anorexic Esthetic in Modern Culture* (Berkeley: University of California Press, 1996).

60. Alex Kuczynski, 'Why Are So Few Plastic Surgeons Women?', *New York Times*, 12 July 1998, section 9, p. 1.

61. Vicki Goldberg, 'A Man-made Arcadia Enshrining Male Beauty', *New York Times*, 13 August 2000, p. 30.

62. Michelangelo Signorile, 'Nostalgia Trip', *Harvard Gay & Lesbian Review*, Spring 1998, p. 26.

63. ibid., p. 25.

64. Reed Woodhouse, 'Gays flee to burbs. Fast lane speeds up', *Harvard Gay & Lesbian Review*, Summer 1997, pp. 33-5.

65. Patrick Giles, 'Better Dead Than Ugly', *Harvard Gay & Lesbian Review*, Summer 1997, p. 11.

66. Tom Bianchi, *In Defense of Beauty* (New York: Crown, 1995).

67. Robert Patrick, letter to the Editor, *Harvard Gay & Lesbian Review*, Fall 1997, p. 57.

68. Margo Jefferson, 'Empire, Nature and a Good Look at the Male Body', *New York Times*, 13 May 1998, Summer Movies section, p. 20.

69. Diane Johnson, 'Irritating Women', *New York Times Magazine*, 16 May 1999, p. 49.

70. Suzanne Daley, 'Mayors Choose a New Model of Vehicle for La République', *New York Times*, 8 October 1999.

71. Angela Carter, 'The Recession Style', *Shaking a Leg*, p. 133.

72. John Hawkes, *Travesty* (New York: New Directions, 1976), p. 50.

73. ibid., p. 51.

74. Andrea Dworkin, *Mercy* (New York: Four Walls Eight Windows, 1991), pp. 102-3.

75. A. S. Byatt, 'The Chinese Lobster', *The Matisse Stories* (New York: Random House, 1993), p. 102.
76. ibid., pp. 120, 121.
77. ibid., p. 123.
78. ibid., pp. 123-4.

Chapter 5: The Bride of Frankenstein: At Home with The Outsider

1. Whitney Chadwick, *Women, Art, and Society* (London: Thames & Hudson, 1990), p. 9.
2. Edith Wharton and Ogden Codman, Jr., *The Decoration of Houses*, revised edn. (New York: Norton, 1997), p. 275.
3. André Breton, *Nadja*, trans. Richard Howard (New York: Grove Press, 1960), p.11.
4. Quoted in Peter Steiner, *Russian Formalism: A Metapoetics* (Ithaca: Cornell University Press, 1984), pp. 48-9.
5. Tamar Garb, *Bodies of Modernity: Figure and Flesh in Fin-de-Siècle France* (London: Thames & Hudson, 1998), p. 162.
6. Anthony Shelton, ed., *Fetishism: Visualising Power and Desire*, (London: South Bank Centre, 1995), p. 29.
7. André Fermigier, *Pierre Bonnard* (New York: Harry Abrams, 1984), p. 7.
8. Timothy Hyman, *Bonnard* (London: Thames & Hudson, 1998), p. 212.
9. Fermigier, p. 40.
10. Hyman, p. 68.
11. Christian Zervos, 'Pierre Bonnard est-il un grand peintre?', *Cahiers d'art*, 22, 1947, pp. 1-6.
12. Fermigier, p. 14.
13. Sarah Whitfield, 'Fragments of an Identical World', *Bonnard* (New York: Harry Abrams, 1998), p. 10.
14. Fermigier, p. 11.

15. Hyman, p. 188.

16. John Elderfield, 'Seeing Bonnard', *Bonnard* (New York: Harry Abrams, 1998), p. 33.

17. Hyman, p. 16.

18. ibid., pp. 37-8.

19. Fermigier, p. 7.

20. Flaubert, 1853, in *The Modern Tradition*, eds. Richard Ellmann and Charles Feidelson, Jr. (New York: Oxford University Press, 1965), p. 195.

21. Fermigier, p. 23.

22. Hyman, p. 28,

23. 'Bonnard contributed his first drawing in 1892; over the following decade the magazine would publish images by Vuillard, Toulouse-Lautrec, Munch, Vallotton, Denis, Redon, Whistler, Serusier and Gauguin. The literary roll-call was equally impressive: Proust, Gide, Valéry, Verhaeren, Péguy, Jarry, Claudel, Apollinaire all published early work, with Debussy as music critic, and Mallarmé as presiding elder.' Hyman, p. 28.

24. Pastoral, epic, and tragedy are the three great divisions of literature, as understood by Virgil and other ancients.

25. Hyman, p. 105.

26. ibid., p. 40.

27. Whitfield, p. 22.

28. Hyman, pp. 19, 24.

29. Whitfield, p. 22.

30. According to Sarah Whitfield (p. 10), 'Vuillard's genius lay in finding a way to elevate the mundane subjects of domestic life to the level and scale of great decorative art (as in the sumptuous and mysterious panels he painted for Dr Vasquez in 1896).'

31. Quoted by Hyman, p. 31.

32. ibid., p. 178.

33. ibid., pp. 146-7.

34. However, in an early image, *Man and Woman* (1900), Bonnard presents the domestic couple less positively. Here we get almost a

schematic representation of sexual difference: the man a shadowed vertical, the woman a sunlit triangle of flesh sitting on the bed, with a screen between the two. Both nudes have their eyes lowered, and both are absorbed in their thoughts and their grooming, as if their time together in bed has left them strangers. One could hardly imagine a more definitive breach between man and woman than this image of Bonnard's, with the bond between the two broken by domestic arrangements.

35. Gabriel Josipovici, *Contre-Jour* (Manchester: Carcanet Press, 1986).

36. Whitfield, p. 28.

37. Elderfield, p. 46.

38. Roberta Smith, 'Art in Review', *New York Times*, 24 January 1997, p. C29.

39. Ken Johnson, 'A Spiritual Energy in Fanciful Realms', *New York Times*, 22 January 1999, p. E37.

40. 'Jean-Michel as told by Fred Braithwaite a.k.a. Fab 5 Freddy', interview by Ingrid Sischy, *Interview*, October 1992.

41. Albert Camus, *The Myth of Sisyphus*, 1942, in Ellmann and Feidelson, p. 823.

42. Robert Storr, 'Two Hundred Beats Per Min.', *Jean Michel Basquiat: Drawings* (New York: Robert Miller, 1990), n.p.

43. Klaus Kertess, 'Brushes with Beatitude', in Richard Marshall, *Jean-Michel Basquiat* (New York: Whitney Museum of American Art, 1993), p. 52.

44. Robert Farris Thompson, 'Royalty, Heroism, and the Streets: The Art of Jean-Michel Basquiat', in Marshall, p. 32.

45. ibid.

46. Diego Cortez, 'One Missing Person', Pat Hearn Gallery, New York, 1986, n.p.

47. ibid.

48. ibid.

49. Dubuffet, 1962, in Ellmann and Feidelson, p. 154.

50. Holland Cotter, 'Anonymous Tribal Artisans? Look Again', *New York Times*, 12 April 1998, pp. 38, 40.

51. Holland Cotter, 'A Life's Work in Word and Image, Secret Until Death', *New York Times*, 24 January 1997, p. C27.

52. Roberta Smith, 'Redefining a Style As It Catches On', *New York Times*, 22 January 1997, p. E37; Ken Johnson, 'A Spiritual Energy in Fanciful Realms', *New York Times*, 22 January 1999, p. E37.

53. Elaine Louie, 'Currents', *New York Times*, 2 October 1997, p. F3.

54. Ken Johnson, p. E37.

55. Holland Cotter, 'When Outsiders Make It Inside', *New York Times*, 10 April 1998, p. E38.

56. Albert Camus, *The Myth of Sisyphus*, 1942, in Ellmann and Feidelson, p. 847.

57. Paula Harper, 'Art as a Matter of Life and Death', *Purvis Young* (Miami: Joy Moos Gallery, 1992), n.p.

58. Maria Elena Fernandez, 'Hard Palette', *Miami Sun Sentinel*, 7 April 1993, p. 1E.

59. ibid., p. 6E.

60. ibid., p. 1E.

61. Elisa Turner, 'Anguished Vision of Street Life Empowers Purvis Young Exhibition', *Miami Herald*, 2 May 1993.

62. Fernandez, p. 6E.

Chapter 6: A Judgement of Paris

1. Albert Camus, *The Myth of Sisyphus*, 1942, in *The Modern Tradition*, eds. Richard Ellmann and Charles Feidelson, Jr. (New York: Oxford University Press, 1965), p. 823.

2. Mario Vargas Llosa, 'Botero: A Sumptuous Abundance', in *Making Waves* (New York: Farrar, Straus & Giroux, 1996), p. 265.

3. Peter Schjeldahl, 'Notes on Beauty', in *Uncontrollable Beauty*, eds. Bill Beckley and David Shapiro (New York: Allworth Press, 1998), p. 55.

4. Charles Frazier, *Cold Mountain* (New York: Atlantic Monthly Press, 1997), p. 10.

5. Philip Roth, *American Pastoral* (Boston/New York: Houghton Mifflin, 1997), p. 248.
6. ibid., p. 3.
7. ibid., p. 130.
8. ibid., p. 11.
9. ibid., p. 360.
10. ibid., p. 361.
11. ibid., p. 385.
12. ibid., p. 363.
13. ibid., p. 235.
14. ibid., p. 322.
15. Don DeLillo, *Underworld* (New York: Scribner, 1997), p. 11.
16. ibid., p. 49.
17. ibid., p. 60.
18. ibid., p. 51.
19. ibid., p. 88.
20. ibid., p. 330.
21. ibid., p. 77.
22. ibid., p. 383.
23. ibid., p. 302.
24. ibid., p. 64.
25. ibid., p. 77.
26. ibid., p. 78.
27. ibid., p. 76.
28. ibid., p. 79.
29. ibid., p. 520.
30. ibid., pp. 520–21.
31. ibid., p. 824.
32. ibid., p. 826.
33. ibid., p. 827.
34. Andrei Makine, *Dreams of My Russian Summers*, trans. Geoffrey Strachan (New York: Arcade, 1997), p. 146.
35. ibid., p. 3.
36. ibid., p. 190.

37. ibid., p. 18.
38. ibid., p. 191.
39. ibid., p. 18.
40. ibid., p. 149.
41. Penelope Fitzgerald, *The Blue Flower* (London: Harper Collins, 1995 [first US edn., 1997]), p. 2.
42. ibid., p. 23.
43. ibid., p. 26.
44. ibid., p. 27.
45. ibid., p. 28.
46. ibid., p. 29.
47. ibid., p. 45.
48. ibid., p. 49.
49. ibid., p. 51.
50. ibid., p. 60.
51. ibid., p. 61.
52. ibid., p. 67.
53. ibid., p. 71.
54. ibid., p. 84.
55. ibid., p. 86.
56. ibid., p. 80.
57. ibid., p. 108.
58. ibid., p. 123.
59. ibid., p. 124.
60. ibid., p. 126.
61. ibid., p. 127.
62. ibid., p. 152.
63. ibid., p. 189.
64. ibid., p. 217.
65. ibid., p. 220.
66. ibid., p. 225.

Conclusion: Modelling Beauty

1. Leslie Berger, 'A New Body Politic: Learning to Like the Way We Look', *New York Times*, Health and Fitness, 18 July 2000, p. F7.
2. 'What Dance Has to Say About Beauty', moderated by Ann Daly, *New York Times*, Arts Section, 23 July 2000, pp. 26, 27.
3. Marlene Dumas, *Models* (Stuttgart: Oktagon, 1995), p. 15.
4. Ellen Zetzel Lambert, *The Face of Love: Feminism and the Beauty Question* (Boston: Beacon Press, 1995), p. xii.
5. *Frankenstein*, p. 85.
6. Lambert, p. 10.
7. ibid., p. 15.
8. ibid., p. 67.
9. ibid., p. 66.
10. Gertrude Stein, *Picasso* (Boston: Beacon Press, 1959 [1938]), p. 8.
11. See my study, *Pictures of Romance: Form Against Context in Painting and Literature* (Chicago: University of Chicago Press, 1986), Chapter 5.
12. Brian McAvera, *Picasso's Women* (London: Oberon Books, 1999), p. 9.
13. ibid., p. 15.
14. ibid.
15. Eunice Lipton, *Alias Olympia: A Woman's Search for Manet's Notorious Model & Her Own Desire* (Ithaca: Cornell University Press, 1992), p. 1.
16. ibid., p. 48.
17. ibid., p. 4.
18. ibid., p. 115.
19. Selma Klein Essink, 'Introduction' to Marlene Dumas, *Miss Interpreted* (Eindhoven: Van Abbemuseum, 1992), p. 10.
20. ibid., p. 15.
21. From Dumas's 'The Return of the Non-Dead', written about the watercolour, *Waiting (for meaning)*, quoted in Essink, p. 52.
22. *Miss Interpreted*, p. 28.

23. Marlene Dumas, 'Magdalena or the Megamodel meets the Holy Whore', in *Models* (Stuttgart: Oktagon, 1995), p. 23.

24. *Models*, p.15.

25. ibid.

26. Ernst van Alphen, 'Facing Defacement: 'Models' and Marlene Dumas's intervention in Western Art', *Models*, p. 71.

27. Quoted by Essink, p. 9.

28. ibid., p. 19.

29. ibid., p. 16.

30. Abigail Solomon-Godeau, *Male Trouble: A Crisis in Representation* (London: Thames & Hudson, 1997), p. 41.

31. Fiona Bradley, 'Introduction' to Rachel Whiteread, *Shedding Life* (Liverpool: Tate Gallery, 1996), p. 8.

32. ibid., p. 12.

33. ibid., p. 14.

34. Bartomeu Mari, 'The Art of the Intangible', in *Shedding Life*, p. 62.

35. Stuart Morgan, 'Rachel Whiteread', in *Shedding Life*, p. 19.

36. Ms. Whiteread said this in reply to my question on the site of the construction.

37. Christopher Bram, *Father of Frankenstein* (New York: Plume, 1995), p. 136.

38. Bram, p. 225.

INDEX